Contemporary Art and the Home

Contemporary Art and the Home

Edited by
Colin Painter

Oxford • New York

First published in 2002 by
Berg
Editorial offices:
150 Cowley Road, Oxford, OX4 1JJ, UK
838 Broadway, Third Floor, New York, NY 10003–4812, USA

Berg is the imprint of Oxford International Publishers Ltd.

Library of Congress Cataloging-in-Publication Data
Contemporary art and the home / edited by Colin Painter.
p. cm.
Includes bibliographical references and index.
ISBN 1-85973-656-4 (cloth) -- ISBN 1-85973-661-0 (paper)
1. Art in interior decoration. 2. Interior decoration--Great Britain. 3. Art--
Marketing--Great Britain. 4. Sculpture, British--20th century. I. Painter, Colin.
NK2115.5.A77 C66 2002
709'.04'001--dc21

2002007333

British Library Cataloguing-in-Publication Data

A catalogue record for this book is available from the British Library.

Typeset by JS Typesetting Ltd, Wellingborough, Northants.
Printed in the United Kingdom by Biddles Ltd, King's Lynn.

Contents

Contents

List of Illustrations

Cover: Sandra's living-room with *The Old In Out (Saggy Version)* by Sarah Lucas. 1998 Cast polyurethane (41.3 × 50.8 × 36.8cm) (Courtesy Sadie Coles H.Q. London). Part of the *Close Encounters of the Art Kind* project, Victoria and Albert Museum, London, 2001/2 (Photo.Anne Painter)

All photographs of *At Home With Art* and *Close Encounters of the Art Kind* projects by Anne Painter.

Colour Plates

Black and White Illustrations

List of Illustrations

Acknowledgements

I particularly want to thank Andrew Brighton and Rebecca Leach for their parts in the conception of this volume. Linked to the *At Home With Art* exhibition in February 2000, Andrew organized a symposium at the Tate (now Tate Britain) on the subject of *Contemporary Art and the Domestic*. Rebecca chaired a section of the symposium and, along with Andrew, has provided me with much needed advice on the nature of this book. Several of the contributors to the book spoke at the symposium.

Thanks to Sara Selwood for her participation in the discussions with Antony Gormley and Alison Wilding which culminated in their contributions here.

Thanks, as always, to Anne Painter for her photographs and unfailing help and support throughout.

Notes on Contributors

Andrew Brighton is Senior Curator, Public Events at Tate Modern, a critic and occasional curator. He is a Trustee of Peer (www.peeruk.org) – an innovative arts charity for whom he was an editor on *Art for All? Their Policies and Our Culture,* edited by Mark Wallinger and Mary Warnock. He is a contributing editor for *Critical Quarterly* where he published: 'Towards a common culture: New Labour's cultural policy and Soviet Socialist Realism'. His writing has been published in journals such as: *Art in America, Art Monthly, London Review of Books, Studio International* and *The Guardian.* His book, *Francis Bacon,* Tate Publishing, appeared in 2001.

Alison J. Clarke lectures in material culture and design history at the Royal College of Art, London and as Visiting Professor of Design Theory at the University of Applied Arts, Vienna. Her work deals with the consumption of everyday material and visual culture. Previous publications include *Tupperware: the Promise of Plastic in 1950s America* (Smithsonian Press 1999) and 'The Aesthetics of Social Aspiration' in *Home Possessions* ed. D. Miller (Berg 2001). Her most recent project, tied to the AHRB Centre for the Study of the Domestic Interior at the RCA, is entitled 'Setting Up Home'.

Richard Deacon is a sculptor whose work is known internationally. In 1987 he was awarded the Turner Prize. His achievements were recognized in 1996 with the award of the Chevalier de l'Ordre des Arts et Lettres by the Ministry of Culture, France. In the 1999 New Years Honours List he was made CBE for his significant contribution to the arts in Britain. He is a Royal Academician and Professor at the Ecole Nationale Supérieure des Beaux-Arts in Paris.

Antony Gormley has created some of the most ambitious and recognizable works of the past two decades including *Field, The Angel of the North* and, most recently, *Quantum Cloud* on the Thames in Greenwich. He has created large-scale installations in Cuxhaven, Germany and at the Royal Academy, London, participated in group shows such as the Venice Biennale and Documenta 8, and had solo exhibitions at the Whitechapel Gallery, Serpentine Gallery, Tate St Ives and White Cube. He was made an OBE in 1997, awarded the Turner Prize in 1994 and the South Bank Prize for Visual Art in 1999.

Tanya Harrod is a Visiting Professor at the Royal College of Art and is the author of *The Crafts in Britain in the Twentieth Century*, Yale University Press 1999. From 1989 to 1994 she was design and architecture correspondent for the *Independent on Sunday* and she writes for *The Burlington Magazine*, the *TLS*, *The Spectator* and *Crafts*. Current projects include a study of Le Corbusier's interest in the vernacular and a biography of the potter Michael Cardew.

Anthony Hughes has published on many aspects of sixteenth- and seventeenth-century European art in *The Burlington Magazine*, the *Journal of the Warburg and Courtauld Institutes* and the *Oxford Art Journal*. He was a contributor and co-editor (with Erich Ranfft) of *Sculpture and its Reproductions* (Reaktion Press 1997) and author of *Michelangelo* (Phaidon Press 1997). He is at present preparing a book on the High Renaissance and another on the theory of sculpture from the Renaissance to the twentieth century.

Rebecca Leach is a Lecturer in Sociology in the School of Social Relations at Keele University. She was convenor of, and contributor to, the 'Meaning of Home' session at the Tate symposium *Contemporary Art and the Domestic* (2000) and consultant to a BBC Radio 4 series on home: *Where the Heart Is* (August 2000). Particularly interested in conceptualizing objects and the symbolic construction of home, she has written on embodiment and consumption, burglary victimization and ontological security, and on the cherished object.

Daniel Miller is Professor of Material Culture in the Department of Anthropology at University College London. Recent books include (ed.) *Home Possessions* (Berg 2001), *The Dialectics of Shopping* (Chicago 2001), (ed.) *Car Cultures* (Berg 2001), *The Internet: An Ethnographic Approach* (with Don Slater, Berg 2000). He is currently conducting research on the concept of value and for a book about the Sari (with Mukulika Banerjee).

Colin Painter is an artist/curator and writer whose work has centred on the home as a context for art since the 1980s. His work includes *At Home With Constable's Cornfield,* National Gallery, London, 1996 and *At Home With Art* which brought work by contemporary sculptors into Homebase stores. He curated the associated exhibition at the Tate Gallery, London, 1999/2000 and authored the book of the same title (Hayward Gallery Publishing, 1999). In 2001/2002 he curated the exhibition *Close Encounters of the Art Kind* at the Victoria and Albert Museum, London.

Tim Putnam is Professor of Material Culture at the University of Portsmouth and Head of Research and Postgraduate Studies in its School of Art, Design and Media.

His work focuses on the implications of research in material culture for creative practice, culture resource management and art and design pedagogy. He is the author of several studies on design practice in industry and home-making. He is the co-author of *The Industrial Heritage: Managing Resources and Uses,* co-editor of *Household Choices* and Editorial Secretary of the *Journal of Design History.*

Christopher Reed is Associate Professor at Lake Forest College, near Chicago, Illinois. He holds a PhD in the history of art from Yale University and specializes in twentieth-century visual culture. He has edited two books: *A Roger Fry Reader* and *Not at Home: The Suppression of Domesticity in Modern Art and Architecture.* His published articles cover topics as diverse as the visual aesthetics of Virginia Woolf's novels, architectural expressions of sexual identity, mass-produced 'sofa art' and theories of postmodernism. He lectures widely in the United States and in England.

Sara Selwood is a cultural analyst, based at the School of Communication and Creative Industries at the University of Westminster. She edits *Cultural Trends,* the UK's leading source of statistical information on the arts and wider cultural sector, and she represents the UK at European meetings on museum statistics. Her publications include *The Benefits of Public Art* (PSI 1995), which considered the extent to which claims made for public art were substantiated. Sara was formerly Head of the Cultural Programme at the Policy Studies Institute; prior to that she was a curator of contemporary art and an artist.

Alison Wilding is one of Britain's leading sculptors. Her work has been shown nationally and internationally in many group shows and her numerous solo exhibitions include those at The Museum of Modern Art , New York (1987/88), Tate Gallery, Liverpool (1991) and 'Contract' at the Henry Moore Foundation, Halifax (2001). She was a Turner Prize nominee in 1992. Alison Wilding is a Royal Academician and lives and works in London.

Introduction
Colin Painter

As its title indicates, this book addresses relationships between the culture of contemporary art – that which is treated as the art of our time by scholars and experts – and domestic cultures. Current interest in such a theme is rooted in the continuingly contentious status, within the contemporary art world, of the home as a *location* for art, born of modernism's definition of itself in contrast to the domestic. Put crudely, the home was characterized as comfortable and reassuring while modernism stood for challenge and progress.

In discussions of this polarization, the distinction between the domestic as subject in art, and as site for it, is often overlooked. Thus, some proclaim that the rejection of the domestic is a thing of the past on the basis that much recent art, notably work with feminist agendas, attends to the domestic as subject.[1] But the extent to which the domestic was ever rejected as subject seems arguable. Obviously the twentieth century included various forms of abstraction involving the abandonment of all figuration but many artists dealt with domestic subject matter. In fact it was part of the critique of the domestic to do so. This emphasis continues in work which is *about* the home and sometimes uses domestic interiors as temporary gallery spaces.[2]

If the domestic has never been rejected as subject, antipathy toward the home as the ultimate, and 'permanent', destination for art has been clear and persists more clearly. The art critic Tom Lubbock is not untypical when he says, 'I could say that the whole point of the modern work of art is that it does not fit into the world. It takes a stand against the daily run of life. It is a challenge, an alternative view, a piece of stubborn foreign matter. It is essentially undomesticated and the last place you should find it is in a home. Actually I do kind of believe this too' (Lubbock 1999).

This book considers the home as a place in which the work of contemporary artists might reside. It is generated from the simple observation that, on the one hand, the home is for many people their most formative and intense engagement with visual images throughout life and, on the other, few homes contain works by contemporary artists. The essays presented are a contribution to debates around the implications of that situation. They include theoretical and polemical statements from different, and sometimes contrasting, viewpoints, as well as research reports.

Distinctively, the anthology attends equally to both the sphere of domesticity and that of contemporary art. It explores values, priorities, social pressures and expectations associated with each. It brings together perspectives from within the world of contemporary art, including the history of art and design, along with those from such disciplines as sociology, anthropology and cultural theory. It discusses definitions of contemporary art and its dissemination in relation to concepts of the home, values and aesthetic priorities connected with it.

While having an independent identity, the idea for such a book came from a project I organized under the title *At Home With Art*. It was an experiment in which leading contemporary sculptors created work specifically for the home, for mass production and sale in Homebase stores. An associated exhibition was held at the Tate Gallery (now Tate Britain) in 1999/2000 and toured Britain for two years. A BBC2 documentary entitled *Home Is Where the Art Is* was made on the subject. The project was part funded by the Arts Council of England's New Audiences Programme which saw the exercise as consistent with its own concern to enlarge the audience for contemporary art. With some significant differences in emphasis, evident in my contribution to this book, I also saw it that way, viewing the home as a crucial potential space for the work of contemporary artists – a space through which their work might participate more widely in life.

The Arts Council's concern to reach 'new audiences' should logically involve an interest in the existing values and priorities of the people to be engaged. The relevance of the home to a concern with audiences, actual and potential, for contemporary art is, therefore, an underlying theme in the construction of this volume. What is the nature of the present audience for contemporary art? Should that audience be enlarged – and, if so, why and how? What is the relevance of the home to this? Why should works of art not be mass-produced? Is there a future for contemporary art in mainstream retailing?

Some contributions address such questions directly. Others bring much needed richness and realism to art-world thinking about the domestic, situating notions of art within wider aspects of the visual life of the home. These contributions illuminate the nature of the home and 'home decoration' as a social, interpersonal and creative project. Homes are visually elaborated places. What are the processes which result in the appearance of domestic interiors? What roles are images and objects performing? What are the values that distinguish between these artefacts and 'art'? On what basis can we distinguish the aesthetic value of functional objects from that of non-functional objects – fine art from craft or design? Is there something intrinsically hostile to the domestic in the tradition of modern art?

Because several of the essays refer to the *At Home With Art* project, the collection begins with a brief outline of it.

Given the underlying interest in audiences it is appropriate that an early contribution, from Sara Selwood in Chapter 2, considers what current evidence exists for the size and nature of the audience for contemporary art in Britain. The very existence of the Arts Council of England's New Audiences Programme assumes an absent public to be recruited. In 1999 Chris Smith, the then Secretary of State for Culture Media and Sport, stated that '50% of our fellow countrymen and women never ever, in the course of a year, set foot inside a concert hall, a theatre, an opera house, or an art gallery' (Smith 2000). Yet, as Selwood points out, much has been said recently in the media to the effect that contemporary art is now popular – mainly in the wake of the opening of Tate Modern. Assertions have even been made that more people visit art galleries in Britain than attend football matches. What do such claims mean and what is the evidence for them? Whatever the size of the audience as measured by, say, attendance figures at the Tate Galleries – how is it constituted?

Four contributors to this collection provide historical perspectives. Christopher Reed surveys the rhetoric – textual and visual – that mainstream modernism used to define and promote itself, noting how the category of 'avant-garde' was created in opposition to the domestic. The ideologies discussed in Reed's Chapter 3 can be seen to resonate through present uncertainties about the status of the home as a site for art.

Tanya Harrod offers in Chapter 4 a history of twentieth-century visual culture that accords greater significance to the applied arts. She draws attention to the interest shown in them by figures as diverse as Matisse, Asger Jorn and Eduardo Paolozzi. Taking the late nineteenth century as a starting point, individuals and groups are discussed whose forays into the fine arts represented a desire to break from the academicizing of easel painting. The chapter ends with a discussion of the current interest which young artists are showing in objects, in craft skills and in work on an apparently domestic scale. Finally, the home is identified as a problematic space for current art and applied art.

Tim Putnam discusses an outline archaeo-anthroplogy of domestic aesthetics in North-west Europe, focusing on the emergence of a 'classical' paradigm, mapping gender, generation and public and private space. The onset of a divorce between art and the domestic is connected with the emergence of a second, 'modernist', paradigm associated with science-based industry which redefines the home/family/public/private aesthetic alignments. Putnam discusses contemporary eclecticism, 'postmodern' aestheticized living, as viewed by home-makers and by 'design for the home' industries. He reaches the conclusion that there are reasons for optimism about the reception of contemporary art in the home.

In the fourth of the historically informed contributions Anthony Hughes in Chapter 6 considers reproductions. Attitudes toward forms of reproduction influence the extent to which work by contemporary artists is made available for

purchase. Degrees of status associated with distinctions between reproductions and originals are also influential in determining the objects and images people have in their homes and how they are understood. Hughes draws attention to underlying complexities of definition as well as changing attitudes historically. In the process many taken-for-granted assumptions are brought into question.

There follow three contributions which turn our attention to the social processes through which present notions of the home, as well as their interior appearances, take shape. Daniel Miller in Chapter 7 surveys research on the home mainly from the perspective of ethnographic studies, but with reference to a number of other approaches. Though not specifically concerned with art and design, he emphasizes the idea of the home as an aesthetic project in which the process of furnishing and decorating is understood as an integral part of establishing the domestic world. By 'domestic world' is meant the triangle made up of the household, the material culture of the house and the manifestation of the ideology of domesticity. 'Accommodating' is the process by which a home and its inhabitants come to terms with each other.

Alison Clarke's ethnographic research in which households were studied over a two-year period illuminates the 'actual processes through which taste is formed'. In Chapter 8, she discusses homes and possessions as 'active agents in the construction of taste and social relations'. Through observing the acquisition of an Ikea kitchen or a leopard-patterned teapot we see people negotiating and refusing aspects of potential relationships through taste. This particular ethno-graphic example focuses on the dilemmas of comparatively design-conscious households to show why the material evidence of choice (objects, interiors, etc.) generates so much anxiety. Even individuals with formal aesthetic knowledge must ultimately place their taste within the context of an immediate and intimate network of social relations with potentially hazardous consequences.

Rebecca Leach reports in Chapter 9 the findings of research which followed objects made by the sculptors in the *At Home With Art* project into the homes of people now living with them – having bought them from Homebase stores. She explores some of the dynamics which shape the meanings that the objects have acquired and the social settings that influence these dynamics, namely the discourse of home in Britain, family negotiations, orientations toward objects influenced by notions of design, attitudes to contemporary art, collecting and interior decor. It is argued that in the accrual of objects people interact with them, modifying meanings in complex ways. Moreover, Leach suggests that this is part of a general visual and material culture and part of the same judgement processes found in the art world.

The final three contributions to the collection look at the home from fine art perspectives. An essential voice must be that of the artist. Richard Deacon, Antony Gormley and Alison Wilding reflect in Chapter 10 on their participation in the *At*

Home With Art project in a way that makes clear issues at stake for them in attempting to make work reach wider audiences through the home. These include considering new retail outlets, mass-production, and the consequent ways in which work is contextualized and received. The three artists bring particular emphases, demonstrating commonalities and differences in response to the issues and bridging the culture of contemporary art and domestic cultures in a practical and graphic way.

The last two contributions both, in distinctive ways, affirm the value of contemporary art, but take different positions on the home as a location to which it might aspire. My own Chapter 11 comes from the perspective of an artist/curator, and draws on projects that I have undertaken over the last twenty years or so, exploring the ways in which images are used in the home and how these relate to priorities in my own professional culture. I discuss the professional culture of contemporary art as part of a diverse context of image making and argue that it limits its own influence by continuing to marginalize valid needs that people have for images in their homes. In discussing ingredients of this marginalization, I argue that existing priorities should be extended to embrace mass-production, reproduction and retail outlets beyond the gallery in making the work of contemporary artists more widely available for use in ways not currently endorsed as having anything to do with art.

Finally, from a position of commitment to the high culture of contemporary fine art as essentially critical, Andrew Brighton in Chapter 12 discusses differences between that kind of art and the kinds of art more commonly found in peoples' homes. He connects major characteristics of the uses of images in domestic life – nostalgia and group identification for example – with conservative and ultimately dangerous political ideologies and strategies. Governmental support for the arts in the West, associated with widening audiences, is seen as increasingly conditional upon the arts serving socially homogenizing ends, a kind of domestication of culture. Since the critical culture of contemporary art is inherently unable to fulfil such functions, it is thus endangered. Brighton concludes that the reconsideration of the domestic is of value to 'serious art' to the degree that it contributes to its criticality.

Notes

1. See, for example, Gill Saunders in the Leaflet associated with the symposium at the V&A Museum, London, 2001 titled *At Home: Domestic Imagery in Modern Art*.

2. For example, Richard Billingham, Rachel Whiteread, Mona Hatoum ... The exhibition *Claustrophobia* which originated at the Ikon gallery, Birmingham, in 1998 had 16 artists showing work on the theme of home. In 1996 *Art At Home* was a project in Copenhagen, in which ten artists made temporary installations in homes. In 2002 an exhibition was held at the Angel Row Gallery, Nottingham entitled *Housework: domestic spaces as sites for artists.* See also Greene 1996.

References

Greene, D. (1996), *Art and the Home*, Art and Design Profile No. 51, London: Academy Group Ltd.

Lubbock, T. (1999), *'Home Is Where the Art Is', The Independent,* 23 November.

Smith, C. (2000), 'Government and the Arts', Lecture at the RSA, London, 22 July 1999, in *Art For All? Their Policies and Our Culture,* London, Peer, p.15.

The *At Home With Art* Project: A Summary
Colin Painter

This brief summary, which draws upon the catalogue text (Painter 1999), is intended to provide background to the various discussions and references contained in the chapters of this book. In particular, see the retrospective thoughts of three participating sculptors, Richard Deacon, Antony Gormley and Alison Wilding, in Chapter 10 and Rebecca Leach's Chapter 9.

The project had three formal aims:

- to reconsider the home environment as a context for contemporary fine art and review ideas and values associated with the domestic
- to explore the possibility of contemporary art reaching a wider public through work being made specifically for the home
- to make available to the mass market objects made by contemporary artists.

The project was itself an artefact which questioned characteristic operations of the art world, establishing a network of relationships with unpredictable outcomes. Underlying the three aims cited above were three perceived practical obstacles to contemporary art finding a place in more peoples' homes. The first obstacle was ambivalent attitudes in the contemporary art world to the home as a serious location for art. The second was the absence of work by contemporary artists in places where the general public goes to buy things for the home. The third was the prices, higher than most people can afford, usually associated with contemporary art.

To confront these obstacles effectively, support and collaboration across a range of agencies was necessary. The Arts Council of England's New Audiences Programme provided support, and major players were Homebase, who met the cost of mass-producing the work of the sculptors and undertook to stock the work in their stores; Wimbledon School of Art which supported the research toward the production of prototypes; the Tate Gallery, London, which held an exhibition of the resultant work and the research processes underlying it. Tate Gallery shops also stocked the works in relatively small quantities. Also involved were National Touring Exhibitions from The Hayward Gallery who collaborated with the Tate on the initial exhibition and subsequently toured it.

Nine sculptors – Angela Bulloch, Tony Cragg, Richard Deacon, Antony Gormley, Anish Kapoor, Permindar Kaur, David Mach, Richard Wentworth and Alison Wilding – were each asked to make an object for the home through processes of mass-production. The emphasis, in the invitation, was on positive participation in domestic life as distinct from critique. The brief required that each artist began by visiting a household to observe the way in which visual objects and images were displayed and understood there. This was to ensure a genuine focus on domestic realities. We rarely bring to consciousness what is happening in homes. We all think we know what homes are like – we live in one, grew up in one – but it is illuminating to enter a strange home with the specific purpose of observing the visual surroundings, to talk with the householders about the things around them, how they came to be there, what they're doing. Perhaps it was 'consciousness raising'. Antony Gormley described it as 'grounding the project'.

The purpose was to make a mass-produced object for sale to the general public, so it was obviously not the intention that the householders should be treated as clients or that the work should be site-specific. The households were launching pads. They were recruited with the help of the head teacher of Latchmere Junior School, Kingston-Upon-Thames, who invited volunteers from parents and staff – both teaching and non-teaching. The nine households ultimately included were not selected as 'representative' in any way. They offered a variety of contexts – architectural, social and cultural.

The artists were specifically not asked to operate as 'designers'. They were asked to bring their preoccupations, knowledge, sensibilities and skills to the domestic arena. It was left to them to decide whether to make a functional or non-functional object. In the event, six produced functional objects and three 'pure' sculptures. Following the contact with the households it was for the artists to give some indication of what they might want to make. This was not a simple matter since much depended on what was possible; the availability, limitations and characteristics of particular materials; the realities of mass-production processes; the financial parameters – the project required that the mass-produced object should retail at under £90. (Prices were achieved which were significantly lower.) The process began and developed differently for each artist. In each case a search was made, with the help of Homebase, to identify a possible manufacturer based on the artist's tentative initial ideas about likely materials or likely product.

Once suitable manufacturers were identified, each artist carefully supervised the evolution of the work from initial idea to mass-production. The products are not mass-produced objects with the work of artists added to them. They are not reproductions – copies of originals that retain higher authenticity. They are an unlimited edition of objects, conceived and realized within the materials and processes of mass-production. In the art world the term 'multiple' is applicable though, as I discuss in my chapter later in this book, this project raises questions

about that concept. Table 1.1 shows the quantities initially produced. The differences in initial numbers reflect the expectations of Homebase about the likely demand for each. It can be seen that this is closely related to whether or not an object seemed to them to conform to their normal product range. The figures do not represent the size of 'editions' in art-world terms. Editions were 'unlimited' and further numbers could legitimately be produced, though Homebase did not decide to extend the project. (Plates 1–36 give a sense of the project).

Table 1.1 Quantities of Objects Initially Produced

Artist	Object	Initial Quantity	Initial Retail Price
Angela Bulloch	Sound sculpture	1,100	£56.99
Tony Cragg	Garden trowel	2,700	£23.99
Tony Cragg	Garden fork	2,700	£23.99
Richard Deacon	Metal sculpture	1,150	£36.99
Antony Gormley	Peg	12,750	£6.99
Anish Kapoor	Lamp	4,250	£56.99
Permindar Kaur	Shower curtain	2,300	£47.99
David Mach	Beach Towel	5,300	£17.99
Richard Wentworth	Ceramic plate	3,550	£28.49
Alison Wilding	Ceramic sculpture	1,450	£55.99

Sales began in November 1999 and, after an initial heavy demand, which took Homebase and manufacturers by surprise and thus caused supply problems, sales slowed and objects were later offered at reduced prices. Apart from residual items that continue to turn up from warehouses, all the objects were sold, but this summary is not the place for an evaluation of the retail and marketing aspects of the project. The Arts Council of England's New Audiences Programme has commissioned research on the public response in Homebase stores, and Rebecca Leach's Chapter 9 in this book is an element of that work.

Reference

Painter, C. (1999) *At Home With Art*, London, Hayward Gallery Publishing.

–2–

Audiences for Contemporary Art:
Assertion vs Evidence
Sara Selwood

Something has shifted in the national cultural psyche. Football, suddenly is out, Art is in . . . A nation once obsessed by soccer is suddenly mad for conceptual art (Riddell 2001).

If the press is anything to go by, it looks as if interest in contemporary visual art is one of the country's biggest growth areas. The critic, Matthew Collings, whose latest book is actually called *Art Crazy Nation* (2001a), maintains that the public 'definitely think it's for them', and that a mutual admiration society has grown up between artists and the public. Whereas they might once have said '"Sod the public!". . . now, artists think about the public all the time' (Collings 2001b).

It's not only journalists who are contributing to the hype. The professional alliance, the Visual Arts and Galleries Association, contends that 'people are flocking to see visual arts events as never before (*ArtsBusiness* 2001: 3). And pillars of the establishment are investing in make-overs which typically involve associating themselves with contemporary art. The V&A, for example, is banking on the fact that its proposed Spiral and centre for contemporary art and culture will transform the museum's fusty image (National Audit Office 2001: 25–7). The Foreign and Commonwealth Office has been using contemporary art and design to re-brand Britain:

Britain has a new spring in its step. National success in creative industries like music, design and architecture has combined with steady economic growth to dispel much of the introversion and pessimism of recent decades. 'Cool Britannia' sets the pace in everything from food to fashion (Leonard 1997: 13).

As well, both Young's, the brewers, and Bombay Gin have based advertising campaigns on the celebrity of young British artists – the former with a parody of Damien Hirst's *Away from the Flock*, and the latter featuring Tracey Emin herself (Millard 2001: 33 and 73).

But, not everybody is convinced. The Tate is usually credited with spearheading whatever change is perceived to have taken place – largely as a result of the Turner Prize (awarded annually, with one exception, since 1984) and the opening of Tate Modern. And, the evidence usually cited is the latter's phenomenal success in attracting a reported 5.25 million visits during its first year, well over twice as many as expected. So, it seems paradoxical that 'the man who made us love art' (Aidin 2001), aka the Director of Tate, Sir Nicholas Serota, is sceptical. He claims not to be 'deluded' and is only too well aware that many people 'are delighted to praise the museum, but remain deeply suspicious of the contents'.[1] In a recent lecture, he described the kind of headlines which the 1999 Turner Prize attracted as indicative of the fact that people are still wary of being 'deceived' by contemporary art and that they regard artists as no better than 'emperors parading in their new clothes':

> 'Eminence without merit' (*The Sunday Telegraph*). 'Tate trendies blow a raspberry' *(Eastern Daily Press),* and my favourite, 'For 1,000 years art has been one of our great civilising forces. Today, pickled sheep and soiled bed threaten to make barbarians of us all' (*The Daily Mail*) (Serota 2000).

Such distrust is fairly standard, although it's hard to tell whether it's the media that informs and sustains public opinion, or vice versa. Either way, there's no doubt that particular controversial works shown at the Tate are what people have come to associate with contemporary art. Indeed, unpublished research carried out for the *At Home with Art* project suggests that respondents specifically identified contemporary art with the Turner Prize, Damien Hirst, Tracey Emin, formaldehyde, unmade beds, the 'bricks' and 'crappy nappies'. Moreover, the majority of respondents participating in this research were alienated from contemporary art, fearful of being duped by it and, ultimately, 'exulted' in their rejection of it . Conceivably, all that distinguished the reception which greeted one of Carl Andre's *Equivalents* 25 years ago was that distrust of contemporary art used to be even more explicitly associated with the fact that it was being paid for out of the public purse (Iles 1987). It probably goes without saying that exhibitions of Old Masters are beyond such criticism. They continue to attract the largest audiences both wordwide and in the UK (*The Art Newspaper* 2001).

So, in a world in which hype combines with suspicion, what do we actually know about people's consumption of contemporary art in England? Is it really the case that as a nation we are 'mad' for it? This chapter examines the evidence. It comprises five sections which consider:

- The political context and policy background which is encouraging what Collings refers to as 'the new pro-art public' (2001b: 14)

- the size and the profile of the audience for contemporary art
- the robustness of the data
- the public's attitude to contemporary art
- some observations.

Political Context

The arts are for everyone. Things of quality must be available to the many, not just to the few (Smith 1998: 42).

In many respects, encouraging people to love art is a government project. According to Labour, one of the party's defining characteristics on coming to power in 1997 was its 'fundamental belief that the individual citizen achieves his or her true potential within the context of a strong society'. It regarded culture as central to this agenda, insisting that 'the arts are not optional extras for government; they are at the very centre of our mission' (Smith 1998: 42). There were four cardinal principles against which that commitment was given: that the arts should be for everyone; that they should be a part of our everyday lives; that cultural activity has an important contribution to make in working toward the government's goal of high and sustainable levels of employment; and that the arts should be made an integral part of our education service (Smith 1998: 22–7), ultimately providing a key to a rich life for individuals and the prosperity of the nation (DCMS/DfEE 2000: 3). While the Department for Culture, Media and Sport's (DCMS) agenda and some of the associated personnel have moved on since these statements were made, this kind of thinking officially still informs the Department's vision up to 2011 (DCMS 2001).

Given that it believes that 'the arts are a civilizing influence', the Labour government requires 'arts organisations to reach out into the communities around them' (Smith 2000: 14). Labour has introduced major changes in the management of the cultural infrastructure. Before the present government came to power, central government's attitude toward cultural policy was essentially distinguished by a policy vacuum, implied via the arm's-length principle and the working practices of such bodies as the Arts Council of England (ACE). However, in 1998 DCMS created a new and proactive role for itself in what it referred to as a 'new cultural framework' (DCMS 1998). This involved the Department's assuming 'a more strategic place in the complicated structures of cultural policy and funding' and formalizing the conditions of its relationship with its sponsored bodies and, ultimately, the whole of its funding stream. This centered on 'the delivery of appropriate outputs and benefits to the public' in relation to the delivery of the government's own objectives – the promotion of access and social inclusion, the

pursuit of excellence and innovation, the nurturing of educational opportunity and the fostering of the creative industries. Commitments to developing audiences for contemporary visual arts and increasing their understanding are, thus, fundamental to the Department's funding agreements with the Tate and the Arts Council.

The Tate, like all DCMS's other sponsored museums, is subject to the Department's desire to increase access. Following a review which began in the summer of 1997, DCMS devised access standards (DCMS 1999b), developed its own code of practice on access, and insisted on the production of access plans as a condition of grant funding (DCMS 1999b). It also promotes museums as 'centres for social change' (DCMS 2000a) and is encouraging their contribution to the learning society (DCMS/DfEE 2000). The Department has, of course, also pursued the principle of free admission to the museums it sponsors. It provided the Tate, for example, with an initial additional £5 million and thereafter £6 million per year to ensure free entry to Tate Modern (DCMS 2000b). At this time, entry to the national fine art museums tended to be free. And, although free admission to all the nationals was in prospect (it was introduced from 1 December 2001), the additional money to the Tate prompted accusations of favouritism toward the arts from the scientific community, who regarded the government's activities as not only polarizing the arts and sciences but ultimately prejudicing popular access to science. As the Director of the Science Museum put it:

> The public who enjoy places like this [the Science Museum] are being told they are second class citizens: if you want to enjoy science, you pay . . . Of course there has to be access to art. But science has to thrive, and it has to thrive in terms of popular access (Sir Neil Cossons cited in Radford 2000).

It remains to be seen whether free access to the nationals impacts on the audience numbers for the Tate and other fine art museums.

It might be considered that another example of the visual arts receiving 'preferential' treatment is the Baltic, a contemporary arts centre in Gateshead, due to open in 2002. This was the first Lottery project to be awarded revenue funding – £1.5 million per year plus guaranteed partnership funding for its first five years of operation.[2]

DCMS's rationalization of the arts funding system, as part of the New Cultural Framework, initially included the amalgamation of the Crafts Council into the Arts Council. The subsequent incorporation of the Regional Arts Boards (RABs) into the Council as well, means that the arts are more directly accountable to central government than ever before (DCMS 1998; ACE 2001a and 2001b).

Since 1998, ACE's objectives have conspicuously coincided with those of DCMS. The Council's present chairman admits that

Too often in the past, the arts have taken a patronising attitude to audiences. Too often artists and performers have continued to ply their trade to the same white, middle class audiences. In the back of their minds lurks the vague hope that one day enlightenment might descend semi-miraculously upon the rest , that the masses might one day get wise to their brilliance (Robinson 1998: 4).

And he expressly promised that the 'new Arts Council' would

. . . place its emphasis squarely on creating new audiences . . . Widening access to the arts and acting imaginatively to bring in and keep new audiences will be right at the core of everything we do at the Arts Council (Robinson 1998: 5).

ACE's proposals for a 'new single national body' are predicated on the assertion that the funding and support of the arts needs to satisfy, first and foremost, 'the public, as the ultimate beneficiary of its work' (ACE 2001b). In practice, the access strategy of ACE's Visual Arts Department currently focuses more on developing the infrastructure rather than audiences per se (ACE b undated).[3] Nevertheless, within the context of the arts funding framework, access to the visual arts should have directly been boosted by Lottery funding[4] and the New Audiences programme, in particular.[5]

The Audience for Contemporary Art

Despite these intentions to increase audiences for contemporary art, it is not clear what difference initiatives introduced by ACE or DCMS have made, or are making, to the national picture. Indeed, it could be argued that it's too soon to say how these initiatives are influencing the national picture.

While such Lottery schemes as *Arts for Everyone* and *Awards for All* may well have changed the profile of the visual arts, their greatest impact will have been to encourage greater participation at community level and among young people. Although participation is generally regarded as a step toward inspiring attendance at art events, levels of participation and attendance are currently often considered together (as in Jermyn et al. 2001 and ACE 2000a), or even mutually referred to as 'engagement' (Bridgwood and Skelton 2002). However, the two are nevertheless distinct. It is only attendances that are considered in the present chapter.

The evaluation of the Arts Council's New Audiences programme is due in 2003, but a report on its first year (Jermyn et al. 2000) did not identify the number of new audiences attracted.[6] Curiously, the form that the Arts Council designed for organisations to report on their New Audiences' projects contains no explicit references to new audiences (ACE a undated).

One strand of the New Audiences programme is *New Contexts*, which is intended to reach new audiences by placing arts events in non-traditional spaces such as nightclubs, club-like venues and festivals. However, an evaluation of the pilot found that *New Contexts'* audiences comprised people who were, in fact, more likely than the general public to participate frequently in arts-related events – with 83 per cent claiming to go to galleries/art exhibitions once a year or more (Jermyn 2000).

Individual initiatives aside, the standard data on the size of the national audience for the visual arts remain thin on the ground. A signal weakness of the sector is its inability to provide hard data to support claims as to the popularity of contemporary art. On the basis of the evidence presently available, we don't actually know how many people 'consume' the visual arts overall, whether there are more of them than there used to be, or if their profile has changed.

In addition to various pieces of ad hoc research, the Arts Council annually collects two sets of information about attendances to the visual arts:

- One comes from the Target Group Index (TGI), an omnibus survey of 24,000–26,000 adults in England, Scotland and Wales. This asks: 'about how often these days' respondents go to arts events; when they last went; and which arts activities they like to read about in the print media or watch on TV. The closest category TGI has to contemporary visual arts is 'art galleries and exhibitions'.
- The other collects audience/attendance figures from organizations which receive regular and fixed-term funding from the ACE and the RABs – the 'arts funding system'. These performance indicators cover England only. Precisely because these data exclude those galleries associated with the most high-profile Lottery projects – Tate Modern, New Art Gallery Walsall and The Lowry, all of which receive core revenue funding from other bodies – in theory, the ACE data should serve a barometer of what's going on on the ground.

At the time of writing (November 2001), the latest TGI data available was for 1999/2000, and they show 21.5 per cent of the adult population as attending arts galleries and exhibitions.[7] But a comparison of the figures collected over the years contains little to suggest that a larger percentage of the population are attending contemporary visual arts events than previously – even after over £182 million of arts Lottery funding alone had been ploughed into the sector.[8] In fact, the data (Table 2.1) show that between 1993/94 (the year before the advent of Lottery funding) and 1997/98, a higher percentage of the population said they were going to art galleries and exhibitions than in 1999/2000.

The most recent data that ACE and the RABs have gathered from their visual arts clients refer to 1999/2000.[9] These draw on a wide range of organizations dedicated to the visual arts, photography, architecture and crafts. The aggregated

Table 2.1 Percentage of the adult population who currently attend arts events

	% of the adult population
1989/90	21.2
1990/91	21.4
1991/92	21.1
1992/93	20.4
1993/94	21.6
1994/95	21.4
1995/96	21.8
1996/97	22.4
1997/98	22.3
1998/99	21.1
1999/2000	21.5

Source: TGI data, ACE (2000b: Table 6.1); Arts Council of Great Britain/England annual reports

'audience' for these organizations is 5.5 million (close to Tate Modern's reported attendances during its first year). But this figure collates the numbers of 'consumers' provided by bodies as varied as individual publications and publishers,[10] professional support organizations[11] and public art agencies[12] – all of which have different understandings of 'audiences' and 'attendances'. A constant sample of 21 galleries (excluding the Hayward) suggests that their total audience (actuals plus estimates) fell some 3 per cent between 1998/99 and 1999/2000.

Comparison of Visual Arts with Football Audiences

In making claims for the popularity of contemporary art, advocates have been known to assert that more people go to art galleries than to football matches (Riddell 2001). Not only is this curious, given that both contemporary art and football have been criticized as relatively elitist,[13] but it's unclear what such claims are based on or even what the comparison might prove. The Museums and Galleries Commission once boasted that 'more people go to museums each year than go to football matches and the theatre combined – some 74 million in 1990' (MGC 1992). But this particular claim makes no sense given that it rests on the Commission's misinterpretation of its own data – namely, that the 74 million refers to visitors, when in fact it refers to the number of visits made.

Comparisons between the data available on attendances at football matches and art galleries are difficult, in that it's impossible to relate like with like. The best that can be done is to consider the relative percentages of the adult population interested in the two activities and the respective sizes of their aggregate audiences.

– 17 –

- TGI data (Table 2.1) indicate that about 22 per cent of British adults attended 'art galleries and exhibitions' and that of those who don't go, just over 2 per cent watch coverage of art galleries and exhibitions on TV. (No data are available for radio coverage.) Data from the same source show that closer to around 36 per cent of adults resident in the UK attended live matches, watched matches on TV or listened to radio coverage (Mintel 2000b: 7).
- The 32 galleries that contributed to the ACE/RAB's aggregate visual arts attendances in 1999/2000 attracted 4.4 million reported visits plus a further 600,000 estimated visits. These probably account for the majority of attendances within the subsidized sector, with the exception of public art.[14] To construct a more accurate estimate of the size of the national audience for contemporary visual arts one would need to add attendances at those subsidized organizations which didn't make returns to the ACE, and those funded outside the arts funding system, as well as private-sector galleries.

No aggregate attendance figure is available for commercial galleries, and institutions tend not to disaggregate attendances for contemporary art. However, some figures for temporary exhibitions of contemporary art are available in addition to those provided by the ACE. *The Art Newspaper*'s annual attendance report for 2000 suggests a further 2.4 million.[15] Moreover in 2001, the contemporary art fair, Art 2001, attracted 40,000 visits. On the basis of the evidence available, there would have been a minimum of 7.5 million attendances at galleries and exhibitions of contemporary art in England in 2000.

The aggregate attendance at Carling Pemiership and the Nationwide divisions 1–3 matches for 1999/2000 is around 25 million.[16] Attendances at Premier League matches alone represent just under 50 per cent of this total.

Even allowing for the fact that the above estimate for visual arts is conservative and that it excludes the majority of public art projects, art comes out of the comparison badly – not least on the basis of potential capacity, cost and availability.

- The average capacity of football grounds diminished following the fire at Bradford City and the Hillsborough tragedy. This means that at top level, many clubs are operating at, or approaching, full capacity. While this only affects the top Premiership clubs, it has nevertheless restricted the market's development (Mintel 2000b). In contrast, many of our major galleries have recently had extensions funded by the Lottery in order to benefit everyone 'irrespective of income'.[17]

Although capacity is conventionally discussed in relation to the performing arts, there are no published estimates as to what full capacity for visual arts venues

throughout the country might be, nor any indications as to whether they are remotely approaching this. Tate Modern was exceptional in having to control access on a number of weekends in June and over one bank holiday in August 2000, shortly after opening. This was due to congestion in the galleries, which occurred when the overall totals for the day exceeded 35,000 and the number of visits per hour exceeded 6,000 (correspondence with Penny Hamilton and Nadine Thompson, Tate, 1.11.01).

- The majority of visual arts organizations are free to visit, whereas the average cost of attending Football League matches varies from about £15 for first division to £9 for third division (conversation with John Nagle, Football League, 7.11.01). Tickets for Premiership games can now exceed £40 per match, particularly among the London clubs and for European matches, which can be explained by demand exceeding supply, and the rise in footballers' wages (Mintel 2000b). In contrast, prices for other Football League matches have only risen with inflation.

 Fees paid to artists probably make little or no impact on most galleries' costs, particularly in the subsidized sector. The latest research available found that between 1993 and 1996 just 8 per cent of artists received a fee, and that in public-funded galleries the average was £143 (Shaw and Allen 1997).[18]

- Whereas most galleries are probably open at least 7 hours a day and 10 months of the year[19] and public art is, by definition, free and accessible around the clock – access to live football is more restricted. Premiere League teams play 38 matches per season (half at home, and half away) and Football League teams 46 matches, with matches lasting 90 minutes.[20]

Profile of the Audience for Contemporary Art

Despite being paid for by public money, the ACE's TGI data are copyright and – apart from the headline figures published in the Arts Council's annual report – cannot be reproduced. So, it's only possible to generalize about its findings.

In terms of the overall picture, the data reveal little that's surprising. People from social groups AB are the most likely to attend art galleries and exhibitions, as are the most highly educated (identified as being those with a terminal education age of 19 or over) and those from tranches of the population characterized as wealthy and prosperous.[21] Indeed, the TGI data confirm gallery-goers as typically having the same characteristics that were identified over 30 years ago as informing 'the love of art' (Bourdieu et al. 1991: 110).[22]

TGI also reveals that the majority of visual arts attenders also go to other kinds of arts event and that what they attend tends to have minority appeal – ballet,

contemporary dance, opera and classical music and jazz (all of which attract around 10 per cent of the population or less).

The variables by which ACE analyses the TGI data include gender, age and social group, education, annual household income, ACORN group (A Classification Of Residential Neighbourhoods – a system which classifies the population according to similar housing, demographic and socio-economic features), and readership of newspapers. These remain constant and are uninfluenced by research findings which suggest moving on from the standard orthodoxy of describing arts attenders in terms of their socio-economic standing and demographic character-istics. DiMaggio (1996), for example, has begged the question, what makes art-museum visitors different to other people?

> Art-museum visitors are more secular, trusting, politically liberal, racially tolerant and open to other cultures and lifestyles, and much more tolerant and interested in high culture than are comparable non-visitors. These differences represent a distinctly modern disposition, evincing first a faith in progress and scientific (and artistic) authority and, second, an open cosmopolitan orientation to both people and cultures (DiMaggio, 1996: 161).

The Robustness of the Data

Whatever the picture suggested by the above data, various caveats have to be applied to it.

Despite having been commissioned and analysed by the Arts Council for 15 years, anecdotal evidence suggests that TGI users[23] are critical of the reliability of respondents' accounts; question respondents' definitions of art galleries and exhibitions; and wonder why the Arts Council's published summary of results doesn't more fully exploit the data. Thus, despite DCMS and the Arts Council's professed concern to promote access to the arts, especially among people who are socially excluded, the published TGI analyses contain no time-series data on attendances by social grade or ACORN group – both of which it covers. Conse-quently, no shifts within the profile of gallery-goers, or groups moving from having been 'excluded' to 'belonging', are discernible. Moreover, although the arts funding system specifically supports contemporary visual arts practice, the TGI's classification 'art galleries and exhibitions' manifestly doesn't coincide with this. (It is likely to embrace historical fine art, design, schools, amateur, society and craft exhibitions.) Consequently, TGI data are of no value in identifying the audience for subsidized contemporary art – but then, they don't purport to. The percentage of the population consuming contemporary art will, inevitably, represent only a fraction of the picture presented.

Various caveats also have to be applied to the ACE/RAB performance-indicator figures. The figures reveal nothing about how many people constitute the audience for visual arts organizations – and whether this constituency includes a lot of people who 'consume' the visual arts infrequently or a smaller group who do so habitually. Nor do they reveal the extent to which the audience for subsidized contemporary arts comprises those professionally engaged in the visual arts. This group accounts for a sizeable percentage of attendances at the 'independents' and at private views, which often represent the largest concentration of numbers present in galleries at any one time.

Although the Arts Council asks organizations to distinguish between actual and estimated attendances, it's not clear how these are differentiated in practice. Visual arts' attendance figures (like many museums') are known to be unreliable, not least because admission tends to be free and there are no box office systems in place used to count audiences (Jermyn et al. 2000: 3) – a fact that mitigates against any detailed analysis of aggregate audience profiles. And, although the figures are scrutinized before inclusion, one difficulty of the ACE/RAB data is its inclusion of returns from several public art agencies (conversation with Paul Dwinfour, ACE, 1.11.01).

What distinguishes quantifying audiences for the visual arts from those for plays or concerts is the pedantic issue of whether people are actually looking at or contemplating the artworks on display or merely passing by. Nowhere is this question more apposite than in attempts to interrogate audiences for public art projects. This highlights the question of what meaning can be attached to audience numbers.

The vast majority of ACE capital lottery projects were required to make some kind of commitment to public art, a criterion which resulted in over £54.4 million worth of commissions. An evaluation of these public art projects found that only around half the projects surveyed were able to estimate the minimum and maximum numbers of people who would see or pass the given artwork in an average week. These suggested a potential audience in the region of 5.1 to 6.7 million people in any one week (Table 2.2) – numbers which are heavily skewed by two or three schemes which accounted for around 90 per cent of this total estimated audience (Annabel Jackson Associates 1999: 28). But, would every pedestrian, every driver and passenger passing through Trafalgar Square once or twice a day, for example, count as a member of the 'audience' for the public artworks installed on the fourth plinth over the past couple of years?

If quantitative data for the visual arts are problematic, so too are the qualitative data. On the one hand, attitudinal research about contemporary art is far less common – and is virtually non-existent at a national level; on the other, what research exists is less reliable because it draws on smaller sample sizes; and, responses may be ambiguous.[24] Moreover, there is no way of telling whether

Table 2.2 Audience numbers and people passing by public art works in an average week

Audience size band	Schemes with this minimum		Schemes with this maximum	
	Number	Audience	Number	Audience
Up to 100	14	936	4	190
101–1,000	51	29,281	43	28,000
1,001–10,000	39	146,130	56	250,715
10,001–100,000	7	338,423	12	526,423
Over 1000,000	2	4,620,000	3	5,920,000
All	113	5,134,770	118	6,725,328

Source: Annabel Jackson Associates, 1999: 28

research findings which pertain to particular projects are nationally applicable or reveal general truths.

The Publics' Attitude to Contemporary Art

Despite the political and bureaucratic will to increase attendances for the arts, virtually no research has been carried out in the UK which examines the nature of people's interest in or engagement with contemporary art. The last publicly available piece of research commissioned by the Arts Council that most closely matches this description was undertaken 10 years ago (Robb 1992). But given the sector's resistance to the notion that the number of attendances can be regarded as a measure of arts events' success (Jermyn et al. 2000), one might have imagined that there would be a greater visible investment in qualitative research.

The closest there is to a national survey about awareness of and attitudes toward contemporary art was carried out by the private sector. In 2000, Pizza Express commissioned research into attitudes to modern art[25] in anticipation of the launch of its Prospects 2001 Art Prize (QBO 2000). The prize is intended to make art more accessible (being linked to the displays in the company's restaurants) and to encourage emerging artists. The survey sample of 1,028 people were socio-economically representative of the UK adult population.[26] In general, the survey asked whether respondents liked modern art and, if not, why not; whether they had ever bought any, and if so why, and what they had paid for it. Responses were analysed according to such variables as gender, social group and whether or not respondents had visited galleries. Although the results were celebrated by Pizza Express (QBO 2001) it is actually unclear whether they reveal any changes in popular taste.

- Despite the current celebrity status of 'young British artists', respondents identified Damien Hirst as the tenth and Tracey Emin as the fifteenth most well-known artist of all time (QBO 2001).[27]
- Of respondents, 40 per cent claimed to visit galleries and said that they went at least once every six months. This figure contrasts with the TGI findings, which show 21.5 per cent of the population as having gone to art galleries and exhibitions in 1999/2000. This disparity may partly be accounted for by the fact that the Pizza Express sample contains a higher percentage of C1 and C2s and fewer DEs than the TGI sample, and that it comprises a smaller and conceivably less accurate sample.
- Across the sample as a whole, 38 per cent of respondents – 1 in 3 – claim to like modern art. Although the majority of ABs surveyed either don't like modern art or wouldn't commit themselves to expressing a preference (63 per cent), it was nevertheless still the case that people most likely to like modern art were those who visited galleries and who came from social groups A and B. The percentage of people who liked modern art and didn't visit galleries diminished through the social groups C1, C2, DE.
- The reasons people gave for not liking modern art were similar across all social groups, gallery visitors and non-visitors. In order of diminishing importance these were: 'I prefer old fashioned art' (40 per cent); 'I don't understand it' (28 per cent); 'It's a big con' (13 per cent); and 'It's too pretentious' (9 per cent). No reasons given (10 per cent).

Although there is nothing to suggest if, or how, gallery-going might influence people's taste, the survey revealed that gallery-going ABs were the most likely to have bought 'a piece of modern art' (23 per cent), as against only 6 per cent of non-gallery goers. The majority of purchases had cost up to £100 (67 per cent) – but, in grossing up, the survey estimates this market to be worth £774 million (QBO 2001). People's reasons for buying, in diminishing order of importance, had to do with liking 'the look of it' (75 per cent); 'because the colours went with my décor' (12 per cent); as 'a gift for someone else' (6 per cent); or, as an investment (5 per cent). ABs were the most likely to have bought it because it was created by someone they knew. But, beyond the 1 per cent of respondents who referred to the works they had bought as capturing the 'essence of the country' and representing 'a tranquil scene', none of the other, unprompted reasons people gave for their purchases pertained to its meaning or symbolic value. This either suggests that people regard art as primarily decorative, that they are reluctant to discuss their feelings about it, or that the survey methodology (telephone interviews) mitigated against it.

The Pizza Express research appears to confirm a relatively high level of interest in and awareness of modern art. It appears to lay the ghost of populist taste for

'pert pets and sultry sirens' (Dewhurst 2001) – personified by Tretchikoff's *Miss Wong* – and to contradict the findings of Komar and Melamid's mid-1990s survey of Americans' tastes in art.[28]

If, for the sake of argument, we accept that there has been 'an incredible shift in the attention that the media pay to visual art in this country . . . [and] a complete shift in audience attention too' (Craddock 2000: 130), what has happened? In what ways have people's 'consumption' and understanding of contemporary art changed? As the critic, Sacha Craddock asks: 'Is art easier to understand now? Have people become more sophisticated? Or, is it about something else?' (2000: 130).

The present Secretary of State for Culture, Media and Sport insists that access and excellence are not mutually exclusive (Jowell 2001). But, it may well be that the relationship between access and lifelong learning is more problematic. It has, for example, been suggested that the sheer number of people passing through Tate Modern, by definition, undermines the quality of visitors' experience.

> The quiet relationship between the artwork and individual is fast becoming replaced by 'been there', 'done that' and quickly grasping what the work is about. Controlling audience flow becomes the major factor with this new phenomenon (Craddock 2000:130).

While this implicitly begs questions about the ideal conditions in which to contemplate art, research undertaken for the Education and Interpretation Team at Tate Modern suggests that this view is rather too damning (Fisher 2001), and that visitors are interested in the displays and want to find out about them. Attitudinal research carried out among a cross-section of visitors (first-time and repeat visitors, and 'arts confident' and 'arts unconfident' visitors) focused on their use of the interpretation material provided (wall texts, captions, audiotours, etc). Because it is a new attraction, the gallery attracts a considerable proportion of first-time visitors, many of whom feel compelled to see around the whole building. Despite being on a visual high, fatigue inevitably sets in and such visitors are only able to take in a limited amount of information about individual works. But, as the proportion of repeat visitors increases, this is likely to change. It appears that the vast majority of people read some of the interpretative texts available, and while they don't necessarily have the time to take in large amounts of writing (and assume that the audiotour might 'slow them down and get in the way'), they nevertheless appreciate information provided in digestible chunks close by the artworks.

So, how far do these various pieces of research go to answering the question posed by the critic, Judith Bumpus, 'Is "difficult" art popular or not?' (2000). The phenomenon of what she refers to as 'difficult art pulling them in at Bankside',

'albeit served up in popularly palatable form', highlights the issue. Media coverage tends to focus on the apparent transformation of public taste. Millard (2001), for example, regards visual artists as 'tastemakers'. Collings merely refers to the public's shock of recognition rather than their considered appreciation:

> Twenty years ago an ordinary person might have wandered into an art gallery, seen some typed sheets of paper on the wall . . . they'd know it wasn't for them. Now they know different. Instead of going 'Uh?' the public can say, ' Oh look, it's a dead shark' . Or, 'Crikey! Obscenity? Our favourite – we see it on TV all the time! (2001b: 12).

While such stories assert changes in the public response to contemporary art, they tend to skirt around the degree to which the art world might, or might not, seriously wish to embrace the masses. There are those among the cognoscenti who contest the desirability of a shared culture (Brighton 1999a; 1999b), and those who aspire to preserving visual art's status as an elite form, in that while

> . . . the art of the past century lost touch with its popular audience . . . the conjunction of wealth and intellectual obscurity, once a deterrent, may now be an asset.

> Today, when nothing is a treat, art remains enticingly apart and special (Bumpus 2000).

Others simply denigrate the popularity of Tate Modern as synonymous with what they perceive as its vacuousness:

> It's a silly woolly, crowded, meaningless place, but I go there anyway; I suppose for the same reasons that everyone else does: it's friendly and free, it's part of modern trivia.

> . . . the whole operation is establishment instead of anti-establishment. The new giddy, amusing, slightly empty idea of art that the self-help warehouse shows of the 90s stood for, in a punky way, is now the official idea of art that Tate Modern stands for, in a dutiful way . . . it stands for playful empty ironic vacuity, hyper-professionalism, a sort of innocuous chumminess, pc values and slightly diluted sexy fizz (Collings 2001a: 25).

Close

The issue of what people take in, how they benefit from contemporary art, and the terms and nature of their engagement and identification with it are, arguably, central to the current political mission to increase learning and justifications for subsidy. These are the issues that tend to be overlooked by the art press. Whereas the tyranny of modernism formerly protected publicly funded artists from having any responsibilities to the public, it is now contended that

There can be no artistic independence – in the sense of adolescent irresponsibility – when the artist is paid by the State, any more than there is when he or she is financed by an aristocratic, religious or commercial patron. There is only a legitimate negotiation about values, duties, rights and benefits.

Uncomfortable as this might be . . . it is actually straightforward enough. More complex, and not much considered by society today, are the ethical responsibilities that artists have to the rest of humanity (Matarasso 2000: 70).

Moreover, it has been argued from within the world of the arts that the sector as a whole needs to assume greater responsibility:

The Turner Prize is justly celebrated for raising all sorts of questions in the public mind about art and its place in our lives. Unfortunately, however, the intellectual climate surrounding the fine arts is so vaporous and self-satisfied that few of these questions are ever actually addressed, let alone answered.

Why is it that that all of us here [at the Turner Prize] – presumably members of the arts community – probably know more about the currents of thought in contemporary science than those in contemporary art? Why have the sciences yielded some great explainers like Richard Dawkins and Stephen Gould, while the arts routinely produce some of the loosest thinking and worst writing known to history? . . .

. . . there could and should be a comprehensible public discussion about what art does for us, what is being learned from it, what it might enable us to do or think or feel that we couldn't before.

Most of the public criticism of the arts is really an attempt to ask exactly such questions, and, instead of priding ourselves on creating controversy by raising them, trying to answer a few might not be such a bad idea . . .

If we're going to expect people to help fund the arts, whether through taxation or lotteries, then surely we owe them an explanation of what *value* we think the arts might be to them (Eno, 1996: 258–9).

When, in the Dimbleby Lecture 2000, the Director of the Tate described his own experience of contemporary art, he also expressed his hopes that that it might provide others with 'insights that are no less profound than those gained from the experience of earlier art' (Serota 2000).

The Arts Council has begun to be concerned about evaluating art education projects (Woolf 1999), but very little – if anything – is known about the nature of the vast majority of people's encounters with contemporary visual art. These experiences are, for the most part, casual and relatively unmediated. But so long as the rhetoric of the Arts Council insists that that the public is central to its mission, its lack of interest in finding out about how audiences respond to and perceive contemporary art is anathema. As one of the Council's visual arts officers recently admitted, 'We have very little information on visual arts audiences . . . nothing that concentrates on contemporary visual arts. It's a big gap!' Perhaps now

would be a good time to start collecting data and analysing and acting on what is discovered.

Notes

For abbreviations used, see References, p. 30.

1. Tate Modern's need to ensure audiences may partly explain its programme of special exhibitions, 2002–03, which primarily comprise work by 'modern' rather than contemporary artists: Andy Warhol; Matisse/Picasso; Donald Judd; Eija-Liisa Ahtila; and Barnett Newman.

2. Although the Baltic still has to raise the balance of its £3 million per annum running costs after support from the ACE lottery and its other funding partners (www.balticmill.com/whatis/funding.html), these guarantees of revenue are presumably intended to save the centre from the fate that has met other Lottery-funded projects which had over-optimistic predictions of visitor numbers and which failed to generate sustainable incomes.

3. The key tasks being identified as to: secure, sustain and develop the visual arts infrastructure of key agencies and venues; develop a department-wide touring strategy; and develop a department-wide publishing and distribution strategy.

4. ACE's capital programme not only funded visual arts projects but required applicants to address 'the contribution of artists, craftspeople and film and video makers to their building projects', thereby extending the principles of 'percent for art' which had been introduced in the UK in the late 1980s. By the close of the original capital programme, over 2,000 projects had been funded on the basis of awards worth approximately £1 billion, excluding partnership funding which should have been characterized by some degree of artist involvement (Annabel Jackson Associates 1999).

5. The New Audiences Programme was established by the Secretary of State in April 1998, out of his desire for the arts to be a part of our everyday lives. 'I want to encourage cultural activity to come to the people, rather than always expecting the people to go to the activity' (Smith 1998: 44–5). New Audiences is intended to bring new audiences to the arts and take new art to audiences across the country. To date, the programme has received £20 million and runs through 2002, with a full programme evaluation due in 2003 (Jermyn et al. 2000; www.artscouncil.org.uk/arts/new audiences.html).

6. The number of attendances recorded cover different types of contact – performances, readings or exhibitions or involvement in participatory activities

such as workshops. Although a high proportion of the projects examined specifically targeted people who do not traditionally attend the arts, the report contains no information as to how many became arts attenders as a result. Nor is there any breakdown of attenders by art form.

7. A recent pilot study, undertaken by the Office for National Statistics on behalf of the Arts Council of England and which anticipated a full survey involving some 6,000 people in England, suggests 24 per cent of respondents had been to an art, photography or sculpture exhibition in the 12 months prior to interview (Jermyn et al. 2001). A further 16 per cent had been to video, multimedia or live/performance. This latter category of activity overlaps with the Arts Council's working definition of visual arts. Research carried out for Resource in November/December 1999 suggested that 28 per cent of the population had been to a museum/art gallery in the previous 12 months (MORI 2001: 5).

8. This figure is the total of arts Lottery funding from the Arts Councils of England, Scotland and Wales which has been identified as going to visual arts projects up to the end of 1998/99. It does not include partnership funding (Selwood 2001a: Table 31.2) and funding from the Millennium Commission, and the New Opportunities Fund.

9. The visual arts organizations covered – independent galleries; local authority-run museums and galleries; the Hayward Gallery; public art, photography and general developmental agencies/support organizations involved in promo-tional activity (Dwinfour et al. 2001). Given that several of these are primarily concerned with offering professional services (Acme Housing Association, *Art Monthly*, Arts Services Grants, National Artists Association, Public Arts Forum, Visual Arts and Galleries Association, etc.), references to this data set have been restricted to art galleries.

10. For example, *Arts Monthly, Frieze*, AN Publications, *Everything Magazine, Creative Camera, Portfolio Magazine* and the Crafts Council.

11. For example, the National Artists Association, ADAPT Trust, Engage, AXIS Visual Art Information Service, Art Services Grants, Acme Housing, Public Art Forum, Devon Guild of Craftsmen.

12. For example, Commissions East, Freeform, Grizedale Society, Public Art Development Trust, Public Art South West, Public Arts, Yorkshire Sculpture Park.

13. About one-third of men regard football as an expensive middle-class game (Mintel 2000b).

14. Respondents include the Hayward Gallery, MOMA, Arnolfini, the White-chapel Gallery and Ikon.

15. This includes contemporary exhibitions at the following galleries – not included in the ACE data: the Serpentine, the National Gallery, the Royal

Academy, the Royal College of Art, the National Portrait Gallery, the Tate, the Barbican, the Museum of London, the Whitworth, Dulwich Picture Gallery, the ICA, Camden Arts Centre and the Estorick Collection. The listing is not comprehensive.

16. Dobson and Goddard (2001) cite 25.4 million for 1999.

17. These were the government's requirements of Lottery funding as specified by the National Lottery Act, etc. 1993. For a history of the evolution of Lottery funding and its intentions see Selwood (2001b).

18. By the time Shaw and Allen's report was published (1997), Exhibition Payment Right had ceased to operate as a national scheme. The average payment was found to have been £154.

19. The Museums and Galleries Commission found that 62 per cent of museums were fully open to the public 10–12 months of the year (MGC 1999: Table 1.11). The generalization that galleries are probably open at least 10 months of the year allows for closure for the changeover of exhibitions.

20. No attempt to compare viewing figures for football and contemporary art on television has been made here because of the difficulties of comparing existing television figures for the former (Mintel 2000a) with figures for the latter which would need to be disaggregated from the figures for arts coverage in general.

21. According to ACORN these comprise wealthy achievers, suburban areas; prosperous pensioners, retirement areas; affluent executives, family areas; affluent urbanites, town and city areas; prosperous professionals, metropolitan areas; better-off executives, inner city areas.

22. Another piece of research commissioned by the ACE found that those attending exhibitions were most likely to be from professional or 'inter-mediate' groups (Jermyn et al. 2001).

23. The Arts Council of England has permission to make the data available to assist clients of the Arts Council of England, the Scottish Arts Council, the Arts Council of Wales and the RABs.

24. Such ambiguities are explored by Bridgwood and Skelton (2002).

25. The survey assumed that 'modern' was synonymous with 'contemporary' (conversation with Liz Faye, QBO).

26. A comparison of the distribution of this sample with that used by TGI, 1999/2000 (ACE 2000c) suggests some differences, not least that the TGI data is drawn from a substantially larger sample (around 24,000 adults) and from a smaller reference area (England, Scotland and Wales). The percentages of ABC1, C2s and DEs in the two samples differ.

27. The top ten includes Picasso (1), Monet, Rembrandt, Constable, Gains-borough, Turner, Cézanne, Hockney, Pisarro, Hirst (10) (QBO 2001).

28. In 1993, the artists Vitaly Komar and Alex Melamid received a $40,000 grant from the Nation Foundation to make a telephone survey of Americans' taste in art. They interpreted their survey results in the paintings, *America's Most Wanted* and *America's Least Wanted*. See Bird 2001: 114.

Acknowledgements

I should like to thank Liz Fay, Quintin Bell Organisation; Jane Burton and Gillian Wilson, Tate Modern; and Eileen Daley, Arts Council of England – all of whom made unpublished research available to me. Other data was provided by Alex Hinton, Business Design Centre and Nadine Thompson and Penny Hamilton, Tate. Paul Dwinfour, Arts Council of England, Pam Jarvis, Sussex Arts Marketing, and Russell Southwood commented on and corrected parts of this chapter in draft form. Holly Tebbutt, London Arts, and Adrienne Skelton, Arts Council of England brought me up to date with research on contemporary art audiences. I'm also grateful to librarians at Sport England and press officers at the Football League and the Premier League for their considerable patience in dealing with my enquiries.

References

Abbreviations

ACE	Arts Council of England
ACORN	A Classification of Residential Neighbourhoods
DCMS	Department for Culture, Media and Sport
DfEE	Department for Education and Employment
MGC	Museums & Galleries Commission
RAB	Regional Arts Board
TGI	Target Group Index

ACE a (undated) *New Audiences Programme*. Unpublished evaluation form.
ACE b (undated) *Visual Arts Plan, 2000–2002*. London: Arts Council of England. Unpublished.
ACE (2000a) *Public Attitudes to the Arts*. London: Arts Council of England.
ACE (2000b) *Artstat: Digest of Arts Statistics and Trends in the UK 1986/87– 1997/98*. London: Arts Council of England.
ACE (2000c) *Target Group Index 1999/2000. Summary of Results*. London: Arts Council of England. Unpublished.
ACE (2001a) *Prospectus for Change*. London: Arts Council of England.

ACE (2001b) *Working Together for the Arts. The Arts Council's Detailed Plan for Future Support of the Arts in England*. London: Arts Council of England.

Aidin, R. (2001) 'The man who made us love art', *Evening Standard Magazine*, 12 October: 16–18.

Annabel Jackson Associates (1999) *Evaluation of Public Art Projects Funded under the Lottery. Final Report to the Arts Council of England*. London: Arts Council of England.

The Art Newspaper (2001) 'World-wide exhibitions figures in 2000'. No 111, February: 20–3.

ArtsBusiness (2001) 'Tax changes set to benefit arts'. Issue 71, 28 March.

Bird Jr, W.L. (2001) *Paint by Numbers*. Washington DC: Smithsonian Institution, National Museum of American History.

Bourdieu, P., Darbel, A. with Schnapper, D. (1991) *The Love of Art: European Art Museums and their Public* (Trans. C. Beattie and N. Merriman from orig., 1969). London: Polity.

Bridgwood, A. and Skelton, A. (2002) 'The Arts in England: developing a survey of attendance, participation and attitudes', *Cultural Trends*, 40: 47–76.

Brighton, A. (1999a) 'Command Performance', *The Guardian*, 12 April: 13.

Brighton, A. (1999b) 'Who needs "art for everyone"?', *Tate*, Spring: 88.

Bumpus, J. (2000) 'Is "difficult" art popular or not?', *The Arts Newspaper.com* (www.theartnespaper.com/news/article.asp?idart=4054)

Collings, M. (2001a) *Art Crazy Nation: The post-'Blimy!' art world*. London: 21 Publishing Ltd.

Collings, M. (2001b) 'Art-Crazy London', *Evening Standard Magazine*, 12 October: 12–14.

Craddock, S. (2000) 'Arts between Politics and Glamour'. Extract from an article first published in *Tema Celeste* (English edition) 81, July–September, in M. Wallinger and M. Warnock (eds) (2000) *Art for All?* London: Peer, 300–1.

DCMS (1998) *A New Cultural Framework*. London: Department for Culture, Media and Sport.

DCMS (1999a) *Museums for the Many. Standards for Museums and Galleries to Use when Developing Access Policies*. London: Department for Culture, Media and Sport.

DCMS (1999b) *Efficiency and Effectiveness of Government Sponsored Museums and Galleries*. London: Department for Culture, Media and Sport.

DCMS (2000a) *Centres for Social Change: Museums, Galleries and Archives for All. Policy Guidance on Social Inclusion for DCMS Funded and Local Authority Museums, Galleries and Archives in England*. London: Department for Culture, Media and Sport.

DCMS (2000b) *Chris Smith Announces Free Access for Tate Modern. First New 'national' Gallery for 100 Years Will Have Free Admission for All*.

London: Department for Culture, Media and Sport. Press release 27/2000, 8 February.

DCMS/DfEE (2000) *The learning Power of Museums – A Vision for Museum Education*. London: Department for Culture, Media and Sport and Department for Education and Employment.

DCMS (2001) *Culture and Creativity. The Next Ten Years*. Green Paper. London: Department for Culture, Media and Sport.

Dewhurst, R.A. (2001) 'Pert Pets and Sultry Sirens', *The Exhibitionist: Art Galleries in the Region*, 13 July/September. Leeds: West Yorkshire Arts Marketing, 8–9.

DiMaggio, P. (1996) 'Are art-museums visitors different from other people? The relationship between attendance and social and political attitudes in the United States', *Poetics*, 24: 161–80.

Dobson, S. and Goddard, J. (2001) *The Economics of Football*. Cambridge: Cambridge University Press.

Dwinfour, P., Joy, A. and Jermyn, H. (2001) *A Statistical Survey of Regularly and Fixed Term Funded Organisations Based on Performance Indicators for 1999/2000*. London: ACE.

Eno, B. (1996) *A Year with Swollen Appendices*. London: Faber & Faber.

Fisher, S [for the Susie Fisher Group] (2000) *At Home with Art. How has the ACE, Tate, Homebase Initiative Succeeded with the Public*? Unpublished draft report for the Arts Council of England.

Fisher, S. [for the Susie Fisher Group] (2001) *How do Visitors Respond to Interpretation Techniques at Tate Modern? Qualitative Research*. Unpublished report for Tate Modern.

Foreign and Commonwealth Office (1998) *Panel 2000. Consultation Document*. London: Foreign and Commonwealth Office http://www.fco.gov.uk.

Iles, C. (1987) *Confrontations. The Role of Controversy in Art. New Work Newcastle '87 on Tour*. Newcastle: Tyne and Wear Museums Service.

Jermyn, H. (ed.) (2000) *Placing Art in New Contexts: A Summary of a Report to the Arts Council of England*. London: ACE.

Jermyn, H., Bedell, S. and Joy, A. (2000) *New Audiences Programme. Report on the First Year*, 1998–1999. London: ACE.

Jermyn, H., Skelton, A. and Bridgwood, A. (2001) *Arts in England: Attendance, Participation and Attitudes*. London: ACE.

Jowell, T. (2001) Unpublished keynote speech to the Museum Association Conference.

Leonard, M. (1997) *Britain TM: Renewing our Identity*. London: Demos.

Matarasso, F. (2000) 'Freedom's Shadow', in M. Wallinger and M. Warnock (eds) *Art for All?* London: Peer, 70.

MGC (1992) *Museums Matter*. London: Museums and Galleries Commission.

MGC (1999) *Museum Focus. Facts and Figures on Museums in the UK. Issue 2.* London: Museums and Galleries Commission.

Millard, R. (2001) *The Tastemakers. UK Art Now.* London: Thames and Hudson.

Mintel (2000a) *Sports Participation.* London: Mintel International Group Ltd.

Mintel (2000b) *Football Business. Leisure Intelligence.* London: Mintel International Group Ltd.

MORI (2001) *Visitors to Museums and Galleries in the UK.* London: Resource.

National Audit Office (2001) *Access to the Victoria and Albert Museum.* Report by the Comptroller and Auditor General. HC 238 Session 2000–2001. London: Stationery Office: 25–7.

QBO (2000) *Modern Art Survey.* Unpublished data.

QBO (2001) 'Home is where the art is, say Britons. Modern art goes mainstream as £774 million is spent on works for British walls'. Press release, March.

Radford, T. (2000) 'Scientists angered by "arts mafia" influence. "Two cultures" clash over cash for Tate but not for Science Museum'. *Guardian.* 6 March. www.guardian.co.uk/Archive/Article/0,4273,3970806,00.html

Riddell, M. (2001) 'Tate, our Tate. What need have we of a new Wembley when as a nation, we now prefer art to footer?', *Observer,* 6 May.

Robb, D. [for The Research Practice] (1992) *Results of Research into the Contemporary Visual Arts.* London: Arts Council of Great Britain. Mimeo.

Robinson, G. (1998) *An Arts Council of the Future.* The Arts Council of England Annual Lecture 1998. London: The Arts Council of England.

Selwood, S. (2001a) 'Profile of the Visual Arts' in S. Selwood (ed.) *The UK Cultural Sector: Profile and Policy Issues.* London: PSI, 391–401.

Selwood, S. (2001b) 'The National Lottery' in S. Selwood (ed.) *The UK Cultural Sector: Profile and Policy Issues.* London: PSI, 139–64.

Selwood, S. (ed.) (2001c) *The UK Cultural Sector: Profile and Policy Issues* London: PSI.

Serota, N. (2000) *Who's Afraid of Modern Art? The Dimbleby Lecture 2000.* http://www.bbc.co.uk/arts/news_comment/dimbleby.shtml

Shaw, P. and Allen, K. (1997) *Artists Rights Programme: A Review of Artists' Earnings for Exhibitions and Commissions.* London: National Artists' Association.

Smith, C. (1998) *Creative Britain.* London: Faber & Faber.

Smith, C. (2000) 'Government and the Arts'. Lecture at the RSA. London, 22 July 1999, in M. Wallinger and M. Warnock *Art for All?* London: Peer, 14–15.

Tate (2001) *Fact Sheet: Visitor Research.* Mimeo.

Wallinger, M. and Warnock, M. (eds) (2000) *Art for All? Their Policies and Our Culture.* London: Peer.

Woolf, F. (1999) *Partnerships for Learning: A Guide to Evaluating Arts Education Projects.* London; Arts Council of England and Cambridge: Eastern Arts Board on behalf of the Arts Funding System in England.

−3−

Domestic Disturbances: Challenging the Anti-domestic Modern
Christopher Reed

Although it is often taken for granted, the idea of domesticity is an invention of the modern age. The influential cultural historian and theorist Walter Benjamin pinpointed the early nineteenth century as when, 'for the first time . . . living space became distinguished from the space of work' (Benjamin 1973: 167 and 1999: 8). If we examine the elements that comprise our notions of domesticity – separation from the workplace, privacy, comfort, a familial focus – we find that each has been identified by historians as a defining feature of modernity. Domesticity, in short, is a specifically modern phenomenon, a product of the confluence of capitalist economics, breakthroughs in technology, and Enlightenment notions of individuality.

When we think of modern art and design, however, we do not think of domestic imagery or objects for the home, for in the arts the linkage of domesticity and modernism was overruled by another conceptual invention of the nineteenth century: the 'avant garde'. As this term derived from military strategy suggests, the avant-garde imagined itself away from home, fighting for glory on the battlefield of culture.[1] Therefore, although most modern makers of buildings, furniture, sculpture, and paintings supplied the rapidly expanding market for dwellings and their embellishment, these workers and these products were excluded from the ranks of the avant-garde. Drawing on the Odyssean trope that defines heroic mission against Penelope's domestic stasis, successive waves of the avant-garde presented themselves as transgressive, exciting, virile, and new, by contrast to an idea of 'home', which is framed by default as conventional, dull, feminine, and old-fashioned. In the eyes of the avant-garde, being undomestic came to serve as a guarantee of being art.

The tendency for avant-garde artists, designers, and critics to assert accomplishment through contrast with domesticity has characterized modernism at least since 1859, when Charles Baudelaire first published his famous essay, *The Painter of Modern Life*, which became a manifesto for Impressionism. Baudelaire celebrated the modernist painter as a *flâneur*, 'a man of the crowd', who curses the hours he must spend indoors, when he could be out recording 'the landscapes of the great

city' (Baudelaire 1964).[2] In line with this ideology, Impressionism, despite its many paintings with domestic subjects, is best known for images of landscapes and city streets, supposedly rendered on the spot by artists far from home and studio.[3] As Griselda Pollock has noted in reference to the art of women Impressionists, 'spaces of femininity' (which she catalogs as dining rooms, drawings rooms, bedrooms, balconies, terraces and private gardens – in short, the spaces of domesticity) were subordinated by the leading Impressionists to the public spaces of theatres, nightclubs, cafés, and brothels. Pollock argues that even when men turned to domestic subjects, their images 'are painted from a totally different perspective'. The men, she says, present the home as spectacle to be witnessed by an audience of outsiders, rather than 'with a sureness of knowledge of the daily routine and rituals' that characterizes the art of women Impressionists, for whom the domestic sphere was home turf (1988: 80, 81).[4]

When a subsequent generation of avant-garde artists challenged the fundamental assumptions of Impressionism with their Cubist abstractions, the only rule they left inviolate was the proscription against domesticity. For all the radicality of its abstraction, Picasso's famous *Demoiselles d'Avignon* is, like Degas's monotypes, set in a brothel, while his Cubist still-lifes and assemblages deploy a vocabulary of forms that insists on their setting outside the home: wine bottles and glasses are combined with newspapers, pipes, chair caning, and guitars to evoke the Baudelairean public spaces of bars and cafés as modernism's proper sphere.

Expressions of antipathy toward domesticity were not confined to painting, but characterize modernist architecture as well. The historic rise and fall of domestic values is the subject of architect Witold Rybczynski's book, *Home: A Short History of an Idea*. He traces the phenomenon of domesticity from roots in the Middle Ages, through a florescence in seventeenth-century Holland that lasted into the nineteenth century, and finally to a crisis at the dawn of the twentieth century when the 'distinctly unhomey' International Style aesthetic that critics compared to a 'cold storage warehouse cube' came to dominate the most prestigious ranks of architecture and design (1986: 187–8).

Rybczynski cites the Viennese architect Adolf Loos as a pioneer in the 'process of stripping away, which is so characteristic of modern interiors'. In a now-famous 1908 manifesto, Loos equated ornament with crime, asserting that the tendency to decorate manifested the same impulses as graffiti and tattooing, and that all were symptoms of degeneration inappropriate to a forward-looking modernism. In fact, despite their stripped-down exteriors, the insides of Loos's houses were often sumptuous displays of materials and craft. Nevertheless, recent feminist analysis has recognized in Loos's domestic interiors a dynamic analogous to that Pollock found in the interiors depicted by male Impressionists. Quoting Loos's assertion that the architect who is also an artist begins by sensing 'the effect that he wishes to exert upon the spectator . . . , homeyness if it is a residence', Beatriz Colomina

argues that for Loos domesticity was not lived but staged. And 'homeyness' was not necessarily the drama Loos believed houses should perform. His 1903 review of interior designs by a competing architect mocked their studied tastefulness by imagining them as settings for 'birth and death, the screams of pain for an aborted son, the death rattle of a dying mother, the last thoughts of a young woman who wishes to die . . .'. One of Loos's own domestic designs was a house he proposed for Josephine Baker in Paris, in which the dancer's residence was imagined as a kind of perpetual nightclub, where visitors arrived under a two-storey indoor pool lined with glass windows affording views of the swimmers. It was, Colomina notes, 'a house that excludes family life'.[5]

The anti-domestic tenor of avant-garde architecture is nowhere more evident than in the career of modernism's most influential architect, Le Corbusier. As important as his buildings were his writings, which first appeared in the 1920s in *L'Esprit Nouveau*, an avant-garde French journal of which he was an editor (and where Loos's 'Ornament and Crime' appeared in translation in 1920). Anthologized in 1923 and quickly translated under the title *Towards a New Architecture*, Le Corbusier's essays made him an authoritative spokesman for modernist design. In these texts, Le Corbusier inveighed against the 'sentimental hysteria' (245) surrounding the 'cult of the house' (18), and proclaimed his determination to create instead 'a machine for living in' (passim). In Le Corbusier's contest between house and machine, masculinity itself was at stake. He called for design practices to reflect what he saw as the spirit of modernity, a collaboration between men: the 'healthy and virile' engineers on one hand, and on the other the 'big business men, bankers, and merchants' for whom 'economic law reigns supreme, and mathematical exactness is joined to daring and imagination' (22). This vision excludes women, who are entirely written out of Le Corbusier's sketch of the pre industrial family, in which 'The father watched over his children in the cradle and later on in the workshop' (253). Women are present only by implication, for instance in Le Corbusier's association of modern houses with 'moth eaten boudoirs' (18) that threaten the virility of his heroes:

> One can see these same business men, bankers and merchants away from their businesses in their own homes, where everything seems to contradict their real existence – rooms too small, a conglomeration of useless and disparate objects . . . Our industrial friends seem sheepish and shrivelled like tigers in a cage. (Le Corbusier 1927: 210)

Le Corbusier's own house designs can be analysed as experiments in the subordination of feminized signifiers of domestic comfort (hearth and gable, for instance) to the look of the precisely tooled machine. (Figure 3.1) As Rybczynski points out, Le Corbusier's designs offered no actual mechanical or functional advantage over conventional builders of his day. In some ways, with their small kitchens up many flights of stairs and their sweeping surfaces of plate glass and

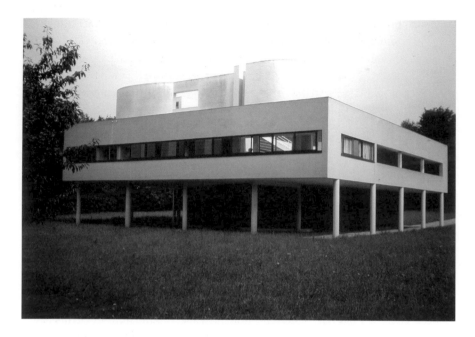

Figure 3.1 Le Corbusier, Villa Savoie (Photo: Sharon Haar).

white cement so difficult to keep clean, his houses are a practical step backwards. The innovative quality of Le Corbusier's designs takes place on the level of their style or visual sign system.

This strategy of guaranteeing the heroism of modernist design by suppressing associations with domesticity also structured defences of avant-garde art throughout the twentieth century. In 1904, Julius Meier-Graefe began his multi-volume study of the development of modern art by attributing the recent 'retrogression' of popular painting to a decline in church patronage and a concomitant rise in art made for houses, where the chief criterion of value is 'comfort'. 'In these days, the pure work of art has been brought into immediate contact with every-day life; an attempt has been made . . . to make it the medium of the aesthetic inspiration of the house', Meier-Graefe complained:

> Art under such conditions ceases to be divine; she is no longer the enchantress . . . but rather a gentle little housewife, who surrounds us with tender attentions, and eagerly produces the sort of things that will distract tired people after a day's work. (1968 [1908]: 2–3, 9–10)

Ten years later, Wyndham Lewis, the leader of London's Futurist-derived Vorticist movement, in an uncanny prediction of Le Corbusier's better-known

manifestos, promoted his art with appeals to the 'modern city man', who 'in his office . . . is probably a very fine fellow – very alert, combative, and capable of straight, hard thinking', but in his 'villa in the suburbs' is reduced to 'an invalid bag of mediocre nerves, a silly child'. 'The best type of artist', Lewis proclaimed, 'would rather give expression to the more energetic part of that City man's life – do pictures to put in his office, where he is most alive – than manufacture sentimental and lazy images . . . for his wretched vegetable home existence' (Lewis quoted in M.M.B. 1914). Concurrently in Russia, Alexander Rodchenko defended his 'non-objective painting' as 'the street itself, the squares, the towns and the whole world. The art of the future will not be the cozy decoration of family homes. It will be as indispensable as 48-storey skyscrapers, mighty bridges, wireless, aeronautics and submarines,' he proclaimed (quoted in Solomon-Godeau 1991: 35).

Though the Dada and Surrealist artists are often contrasted to the rationalist modernism of figures like Le Corbusier, their fascination with the uncanny – in German the *unheimlich* or 'unhomey' – allied them with their rivals in an antagonism toward the home. Dada and Surrealist art habitually appropriated the accoutrements of domesticity in ways that undermine connotations of homey comfort, while the theoreticians of these movements sustained the anti-domestic rhetoric of earlier modernists. Extending the Baudelairean restrictions on modernism's proper sphere, the Surrealist leader André Breton, for example, pronounced: 'The street is the only valid field of experience.' Even Surrealists had to live somewhere, of course, but they worked hard to subvert the domestic qualities of their dwellings, rendering them – at least in their own eyes – as unhouselike as possible. Their letters and memoirs delight in describing how a house occupied by André Thirion and his friends featured a tapering mirror that, they claimed, recreated the disorienting set of the film *The Cabinet of Dr. Caligari*. Breton's own house was described admiringly by Thirion, as 'like one big museum' – that is not like a house at all – in which 'every painting, every object sent out an exceptionally powerful emanation . . . which adhered to it like a shadow wherever it was put' (quoted in Haslam 1978: 115- 19, 170).

Perhaps the clearest demonstration of the Surrealists' investment in rhetorics (verbal and visual) of anti-domesticity is the project for an 'architecture of our time', published in their journal *Minotaure* in 1938 by the Chilean artist Matta. (Figure 3.2) Matta had studied architecture with Le Corbusier before turning to painting and joining the Surrealists. Now he proposed a dwelling in which the architectural signifiers of domesticity were replaced, not by symbols of the machine, but by such Surrealist elements as a 'staircase without banisters to master the void' and 'walls like damp sheets molding and molded by psychological fears'. These, along with supple 'pneumatic furniture', Matta described as an environment to recall the conditions of the womb. This claim might suggest a rehabilitation of

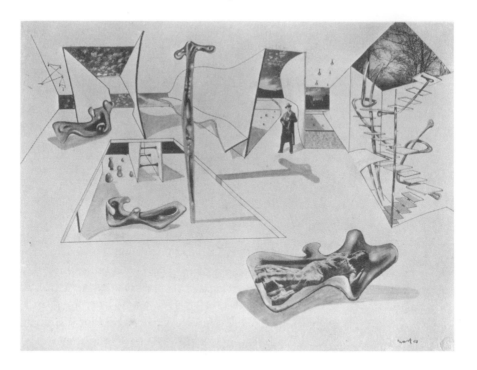

Figure 3.2 Matta Echaurren, drawing of Architecture du Temps from Minotaure 11, 1938.

the feminine, but the essay culminates by describing how, 'with tangled fingers like the clasped hands of a woman whose breasts have been hacked to shreds, one would feel the hardness and softness of the space . . . And we will ask our mothers to give birth to furniture with warm lips' (Echaurren 1938; on Matta, see Rubin 1968: 54). Once again claims to avant-garde status are asserted as fantasies of attack on what is perceived as the quintessence of bourgeois convention, the home, and with it the housekeeper, whose body is presented as interchangeable with the house, and thus a legitimate target of violence.

Ironically, given the anti-domestic attitudes of European modernists, when after the Second World War a new generation of American modernists sought to distinguish itself from its forefathers, what they condemned was the domesticity of modern European art. The critic Clement Greenberg asserted New York's primacy over Paris and London by evoking the American artist's 'shabby studio on the fifth floor of a cold-water, walk-up tenement', which he praised as 'more real' than the easy conviviality of older art centres (Greenberg 1986 [1948]: 194). Metaphorizing his ideal of artistic existence into an aesthetic standard, Greenberg coined the phrase 'homeless representation' in order to describe lingering figurative elements in the work of important contemporary artists (Greenberg 1993 [1962]: 124–5).

Similar assertions of the principle of anti-domesticity may be found in the manifestos of artists from the mid-century American avant-garde. The painter Robert Motherwell defended the vast size of Abstract Expressionist paintings with the explanation, 'The large format, at one blow, destroyed the century-long tendency of the French to domesticize modern painting, to make it intimate', characterizing this as 'a *heroic* impulse as compared with the intimacy of a French painting' (quoted in Kozloff 1965: 37 and in de Antonio and Tuchman 1984: 65). Adolph Gottlieb and Mark Rothko announced in the *New York Times* that their art 'must insult anyone who is spiritually attuned to interior decoration; pictures for the home; pictures for over the mantel' (Gottlieb and Rothko 1982 [1943]).

For both Greenberg and his contemporary Harold Rosenberg, the domestic was the antithesis of art. Imputations of domesticity could be inherently damning, as when Greenberg – perhaps prompting Motherwell's defensiveness over the domestic – attributed to some of his paintings an 'archness like that of the interior decorator who stakes everything on a happy placing', or when he dismissed de Chirico's late work with the phrase: 'It was not even easel painting; it was elementary interior decoration' (Greenberg 1986 [1947–8]: 242, 136). One of Greenberg's best-known essays defines the avant-garde through its opposition to 'kitsch', a term identified with the knick-knacks of middle-class home (1961 [1939]: 3–21, 154–7). In another important theoretical statement, sensationally titled 'The Crisis of the Easel Picture', Greenberg cited the 'fatal' influence of 'all-over' abstract art, which, because 'it comes very close to decoration – to the kind seen in wallpaper patterns that can be repeated indefinitely', now 'infects' painting as a whole (1961 [1948]: 155). For Greenberg, the only value of decoration was to destroy itself by becoming 'vehement', 'turbid', and 'violent'. Part of the 'mission' of modernist painting, he said, was 'to find ways of using the decorative against itself' (1961 [1958]: 200).[6] Likewise, Rosenberg argued that abstract 'action paintings' became simply 'apocalyptic wall paper' if, in his words, artists shirked 'the Open Road of risk that leads to the farther side of the object and the outer spaces of the consciousness' (Rosenberg 1960: 32–5). In this view, home is a place to leave behind when you start out to do something significant – hence Greenberg's anxiety to claim about the sedentary Cézanne, his 'was a more heroic artist's life than Gauguin's or Van Gogh's, for all its material case' (1961 [1951]: 58). This became the standard of modern art: a heroic odyssey on the high seas of consciousness, with no time to spare for the mundane details of home life and housekeeping.

It is a cliché of psychoanalysis that the repressed always returns. The return of a repressed domesticity is unwittingly signaled in Greenberg's description of 'decoration' as 'the specter that haunts modernist painting' (1961 [1958]: 200). This idea of a ghost from the past, repeatedly repressed but returning, offers a striking image of modernism's relation to the decorative and the domestic – related

terms that, as in Gottlieb and Rothko's manifesto, were merged in avant-garde indictments. The spectral power of the decorative derived from its importance in modernism's founding years, when Baudelaire's anti-domestic rhetoric was countered by artists and critics who identified modernism with decoration and the look of the bourgeois home. Pierre Bonnard, for instance, in 1891 proclaimed: 'Painting must above all be decorative', and he later recalled the turn of the century as a time when 'I personally envisaged a popular art that was of everyday application: engravings, fans, furniture, screens, etc' (quoted in Watkins 2001).

Bonnard's domestic emphasis was typical of his avant-garde contingent, the Nabis, a group whose art suggests the potential of a pro-domestic modernism. When Bonnard's colleague, the painter and critic Maurice Denis, celebrated the challenge to conventions of realism offered by Gauguin's painting, for instance, what he admired was its 'decorative deformations'. Like Loos, who was his contemporary, Denis linked decoration with primitive impulses, but for him this primitivism was laudatory. Denis praised Gauguin's self-conscious return to 'the first principles that he called *the eternal laws of Beauty*', citing the artist's claim to have 'retreated farther back than the horses of the Parthenon . . . to the "dada" of my childhood, my good old wooden rocking horse'. Emblematic of this return to basics, for Denis, was the impulse to embellish domestic space. About Gauguin Denis asserted:

> Here we are dealing with a decorator . . . ! He who at Pouldu decorated the hall of his inn as well as his gourd and clogs! He who, in Tahiti, despite anxieties, sickness, and misery, cared above all for the decoration of his hut. (1920 [1909]: 270–71 my trans.)[7]

Gauguin himself wrote: 'To think that I was born for applied art and that I have not been able to achieve it. Neither windows, nor furniture, nor ceramics, etc . . . there, in the end, are my aptitudes, far more than in painting strictly speaking' (Malingue 1946: 232 my trans.). Despite such counter-examples, however, the overall anti-domestic tenor of avant-garde art and its histories is evident both in Gauguin's expression of regret at the lack of opportunity for domestic design and in the history of his decorated door panels for the inn at Pouldu, which were subsequently cut out of the doors, framed, exhibited, reproduced, and analysed as easel paintings, while the room of which they were a part dropped almost entirely from the enormous literature on this artist. By the same token, the Nabis, who so admired Gauguin, have been marginalized in accounts of the French avant-garde.[8]

Even more than the French, the anglophone avant-garde is powerfully haunted by the spectre of domesticity. Both Aestheticism and the Arts and Crafts Movement, twin strands of the Victorian avant-garde, focused on the decorative arts, making the look of daily life their central concern. John Ruskin's influential essays, for instance, exhorted readers to 'look around this English room of yours, about

which you have been proud so often . . . Examine again all those accurate mouldings, and perfect polishings, and unerring adjustments of the seasoned wood and tempered steel.' Denouncing the mind-numbing labour behind such productions, Ruskin reproved his audience, saying, 'these perfectnesses are signs of a slavery in our England a thousand times more bitter and more degrading than that of the scourged African, or helot Greek'. Just as, for Ruskin, the look of the home was an index of the moral health of the nation, so too a reassertion of domestic values was the road to reform. He argued that virtue lay 'not [in] Rationalism and commercial competition', but in 'household wisdom' and 'the incidents of gentle actual life', which he saw enacted in 'primitive' Italian painters such as Giotto. 'If we do our duty', Ruskin exhorted his readers, we can 'enter upon a period of our world's history in which domestic life aided by the arts of peace will slowly, but at last entirely, supersede public life and the arts of war'.[9]

Ruskin's ideas were profoundly influential. His example was invoked and his words were echoed by Aesthetes and Arts and Crafts activists alike. Lecturing across America, Oscar Wilde cited his tutelage with Ruskin as he described the Aesthetic ideal with the Ruskinian injunction that 'in years to come there will be nothing in any man's house which has not given delight to its maker and does not give delight to its user' (Wilde 1969 [1908]: 270, 306–7). More than anyone else, however, it was William Morris, the pre-eminent Arts and Crafts entrepreneur, who embodied the domestic focus of English modernism. Abandoning a brief career as a painter, he founded the enormously influential guild that made simplified quasi-medieval furnishings and fabrics staples of 'artistic' home design by the turn of the century. At the same time, Morris's prolific writings kept Ruskin's domestic model of social reform constantly in the public eye. 'My extravagant hope is that people will some day learn something of art, and so long for more, and will find, as I have, that there is no getting it save by the general acknowledgement of the right of every man to have fit work to do in a beautiful home', Morris said (1914, 22: 86). This was the essence of the Arts and Crafts ideal, which made the home, and the arts associated with domesticity, a primary arena of engagement.

If such impulses toward a serious engagement with domesticity were repressed in the development of modernism, they returned with a vengeance during the seismic shifts in the practices of art and design signified by the term 'post-modernism'. Historians often begin discussions of postmodernism around 1960, with Pop Art's challenges to the authority of formalist criticism and abstract art. From Richard Hamilton's collage, *Just what is it that makes today's houses so different, so appealing?* (often cited as the first work of Pop Art), through the mechanical rendering of Patrick Caulfield's impersonal interiors or Andy Warhol's soup cans, to Roy Lichtenstein's ceramic dinnerware, Pop techniques and materials have long been recognized as undermining modernist beliefs in self-expressive

form and facture. Less often remarked, however, is the way Pop iconography repeatedly returns to domestic objects and interiors, redeeming the visual aspects of home life as worthy of attention.

At the same time, architects such as Robert Venturi, inspired, in his words, by 'the vivid lessons of Pop Art' to challenge 'the puritanically moral language of orthodox Modern architecture', produced the first examples of postmodern design. Venturi's 1962 house for his mother rejected the mechanical signifiers of modernist architecture by its exaggerated quotations of homey exterior elements. The now famous image of Vanna Venturi sitting on her stoop beneath the oversized split gable roof and gigantic chimney encapsulates Venturi's goal to 'create an almost symbolic image of a house' (Venturi 1977 [1968]: 104, 16, 118; see also Venturi 1992). (Figure 3.3)

Despite their attention to the visual aspects of home life, however, the embrace of domesticity in much Pop-era art and design was less than wholehearted. Often, the accoutrements of home life were presented with an ironic detachment, as if to defend artists and viewers from charges of too intimate an association with domesticity. It took ten years and frankly feminist artists, relatively impervious to modernism's anti-domestic machismo, to embrace the full emotional and aesthetic potential of the home. Feminist artists were far more willing to lavish time and

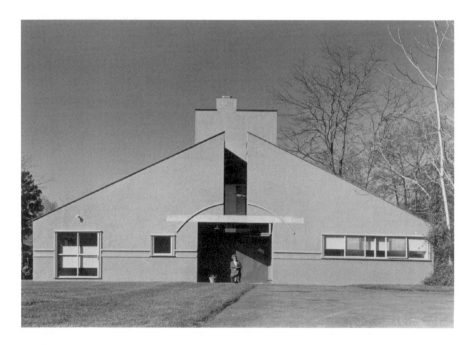

Figure 3.3 Venturi, Scott Brown & Associates, Vanna Venturi House, Chestnut Hill, Philadelphia, Pennsylvania,USA; (Photo: Rollin La France, 1964) (Photo copyright VSBA).

attention on projects that thematized the processes and passions of 'women's work' around the house. In Los Angeles in 1972, twenty-three women in Judy Chicago and Miriam Schapiro's *Feminist Art Program* at the California Institute of the Arts created *Womanhouse*, turning an abandoned house into a walk-in rumination on the condition of women's lives. According to Schapiro, their question was, 'What would art look like if made in the image of domesticity by a group of women artists'? Their answer included a 'Womb Room' encased in a web of crochet, a dining room with food rendered in fabrics, vinyl and petrified bread dough, a 'Nurturant Kitchen' where fleshly pink cabinets and appliances stood out against walls studded with breasts that echoed the forms of fried eggs stuck on the ceiling, a 'Fear Bathroom' where a bathing female figure made of sand dissolved in a tub, and a 'Menstruation Bathroom', where viewers peered through a veil of gauze to see, in its maker's words, 'under a shelf full of all the paraphernalia with which this culture "cleans up" menstruation was a garbage can filled with the unmistakable marks of our animality'.[10] In England from 1973 to 1979, Mary Kelly created her 135-piece, *Post-Partum Document*, exploring the reciprocal production of identity between mother and infant in dense psychoanalytic prose combined with the careful presentation of the most mundane artefacts of child rearing: scribbled drawings, baby clothes and blankets, and – most notoriously – fecal stains (Kelly 1983).

Art like this revealed the potential of domestic materials and imagery to convey the profound emotional and aesthetic experiences associated with home life. Looking back with eyes informed by such work, we may recognize in certain examples of Pop-era art the power of domestic objects to suggest deeply felt aspirations to particular forms of identity. The assemblages Daniel Spoerri called *tableaux-pièges* (picture traps), for example, when they were created around 1960, were seen as Dada-influenced essays in randomness, simply recording the accumulation of objects brought together through the course of his daily life on the surfaces of his room. Today, however, they seem redolent of the artist's aspirations to create an identity as a Parisian intellectual: the kind of person who would linger at home over dirty dishes (they would be cleared away in a café) discussing literature and poetry over wine, coffee, and cigarettes. The perceived randomness of Spoerri's accumulations is belied by his personal associations with certain of the objects. The book, for instance, in the Tate's tableau-piège is by Spoerri's Swiss countryman, the poet Robert Walser, and was a gift from his uncle; similar aspirations to identify with a history of Swiss artistic achievement are suggested in the dedication of a related *tableau-piège* to Alberto Giacometti, another Swiss artist.

One might compare Spoerri's deadpan presentation of a particular form of domesticity with the nearly-contemporary early films of Andy Warhol, another ambitious migrant to the urban avant-garde. Warhol's emphatically mundane

documentations in 1963–4 of his friends kissing, eating, sleeping, getting haircuts, having sex on his sofa, have been long celebrated for challenging the stylistic conventions of film-making, but can also be seen as testaments to the power of domestic activities to signify claims for identity.[11]

Such readings of the work of Warhol and Spoerri are enabled by the intervening work of artists openly committed to exploring the potential of domestic settings to convey richly textured images of identity. Nan Goldin, for instance, in the 1980s investigated her overlapping sexual and artistic subcultures in long series of photographs of people in their environments. Goldin documented ways of life far – even outrageously – beyond the norm. Countering clichés about how an undifferentiated 'we' live, Goldin insists on the specificity of her experience: 'I don't ever want to be susceptible to anyone else's version of my history' (Goldin 1989; see also 1993). Yet her attention to the iconography of daily life – wallpaper, bed linens, telephones, laundry, dirty dishes – results in the repeated juxtaposition of the strange with the familiar, suggesting a bond in our shared experiences of domesticity.

Similar juxtapositions of the strange and the familiar animate the work of Rachel Whiteread, who casts the spaces once occupied by domestic objects and settings: rooms, or most famously a whole house. Taking off from Pop precedents – Bruce Nauman in the mid-1960s cast the space under his chair and spaces under a shelf – Whiteread's far more committed exploration of such work has aroused serious debates about domestic life at the end of the twentieth century. Her monumental *House* of 1993 was widely seen as a commentary on gentrification and homelessness (Bradley 1996). More subtly, her smaller pieces arouse powerfully ambivalent emotions about domestic objects. A piece like *Untitled (Air Bed II)* (Figure 3.4) intrudes a homely object into the public space of the art gallery, while the nature of that object evokes both the transience of the overnight guest and the pathos of homelessness through allusions to the mattress lying on the street, either discarded when a household moves or functioning as a resting place for someone dispossessed of a home.

Such now-canonic works of postmodernism have used domestic elements to challenge modernist assumptions that meaning and beauty in art are guaranteed by the rejection of domesticity. These and allied projects, though they dared to depict domesticity, did not challenge conventional modes of avant-garde production (the one-off or limited edition object) and display (the museum or commercial gallery). Modernism's powerfully overdetermined equation of accomplishment with masculinity, dynamism, transgression, individualism, et cetera, continues to warn artists away from serious engagement with the economic and spatial conditions of middle-class domesticity, which remains pejoratively associated with femininity, stasis, conformity, and the collectivity of the family. It is the blithe indifference to this proscription that makes the *At Home with Art* initiative so radical.

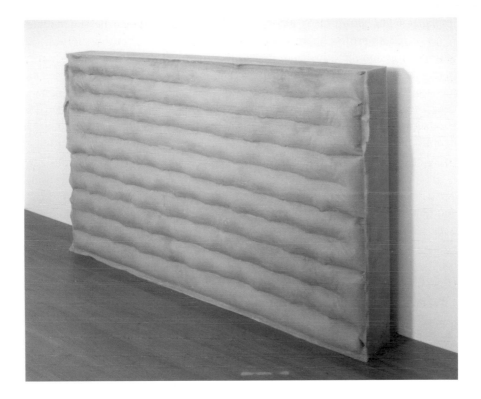

Figure 3.4 Rachel Whitcread, *Untitled (Air Bed II)*, 1992, Tate (TO6731).

Claims for radicality are easily tossed about in the arts, but few actually live up to the term's meaning of attending to root causes. Instead of beginning with conventional assumptions about the nature of the home, *At Home with Art* was truly radical in having the participating artists begin by interviewing families in one English town about their attitudes toward their domestic environs. Even this quick and unsystematic form of research immediately turned up challenges to the claims made by modernist theorists about domesticity. To return to the theorist with whom this chapter began, for instance, we find Walter Benjamin condemning domesticity as the physical manifestation of the bourgeois idea of the 'private citizen' and celebrating what he presented as its alternative: the high-tech look of the steel and glass houses designed by architects such as Le Corbusier. Benjamin (despite Le Corbusier's appeal for patrons among the 'big business men, bankers, and merchants') praised modernist architects for destroying the bourgeois individualism of conventional homes, where a fussier aesthetic enabled 'the resident's own traces' [*spur*] to mark every spot [*fleck*] so that: 'The interior was not only the private citizen's universe, it was also his casing.' Benjamin's choice of nouns here evokes the messy physicality of organs, tracks, and stains, an

implication that corrupts the catalogue of furnishings onto which, he said, middle-class residents project their identity: 'the knick-knacks on the shelves, the antimacassars on the armchairs, the filmy curtains at the windows, the screen before the fireplace'. In contrast to the bourgeois interior, Benjamin promoted the modernist 'glass houses' proposed by Le Corbusier and other modernist designers, because: 'Glass is such a hard and flat material that nothing settles on it . . . It is the enemy of possessions.' The new architects, then, 'will completely transform people' because 'they have made rooms in which it is difficult to leave a trace' (Benjamin 1973: 169; 1977, 2(1): 217–18, my trans.).[12]

Benjamin was wrong on several counts. Historically, the ease with which avant-garde 'glass-architecture' was absorbed by the upper bourgeoisie, both in high-end domestic design and in corporate office blocks, belied his expectations that glass walls heralded the more egalitarian age of an exemplary 'new poverty'. On the contrary, by the end of the twentieth century the concurrent stripping away of traditional signifiers of domesticity from modernist housing blocks (less glass than concrete) inspired by Le Corbusier's prototypes became one of the starkest signifiers of economic and social inequality. Benjamin's failures of prediction were premised in faulty analysis of the conditions of domesticity, as evidenced even in the brief extracts from interviews with the families involved in the *At Home with Art* project published in the catalogue to the exhibition. These interviews reveal the home as being, far from the inhabitant's snug 'casing', sites of complex negotiations between individual and family identity, between presence and absence, between here and away.

The failure of the home neatly to embody its inhabitants is clear in virtually every interview: 'None of our furniture is stuff I'd buy from choice.' 'Unless it's something I particularly dislike, I go along with Vanessa's judgement . . . It's a compromise.' 'I don't have much to do with what's displayed around the house.' 'The things in this house mostly reflect Paul's taste. He likes Victorian clutter . . . I've realized I don't like Victorian clutter . . . Very often your choice is limited by money.' 'Although we like a lot of the same things we see them differently.' 'You get things that are passed on from your family or whoever. You live with it and eventually you decide you don't really like it' (Painter 1999). All these comments reflect tensions of identification and alienation between people and their domestic decorations far more complex than Benjamin recognized. By the same token, many of the interviews revealed, at the core of the supposedly static and self-contained middle-class home, evidences of extra-vagance (in its literal sense of voyaging beyond the limits) and absence: emblems of immigration, images of absent family members and of former family homes, souvenirs of travel and of past stages in the inhabitants' lives.

All of the artists participating in *At Home with Art* have challenged the conventional avant-garde dismissal of the domestic as both site and subject for

significant art. Some of the strongest projects in the exhibition engaged directly what the interviews revealed as the real complexity and ambiguity in the relationship of inhabitants to their homes. Richard Deacon, for instance, began from the Mills family's love of souvenirs, objects that exceed Benjamin's emphasis on identity as bodily presence to suggest a more complex sense of self that willingly – even joyously – includes our association with things far away in time or place, things we also know others have a prior claim on. (My little statue of the Eiffel tower, for instance, associates me with the history of the public culture of Paris, even as I recognize that for some other people – Parisians – it represents home in a way it never will for me.) Deacon's intriguing small sculpture (Plate 12) is a souvenir of an event in which he claims no part (the conflagration of a car), though its visual aspect arouses his own childhood memories of maps, themselves guides to experiences outside the home. His sculpture also carries clear visual associations with Chinese characters, another association with the far-away. At play in this work, then, are tensions between self and other, here and away, private and public that are inherent in the common domestic element of the souvenir.

A similarly thoughtful engagement with the complexity of domestic experience is provided by Richard Wentworth's plates. (Plates 31/32) 'Plates operate in a complex world of manners, sharedness, separation – a public/private thing', the artist notes: 'The strangest thing about plates is that when you sit down to eat you get your own, but the moment you finish it's somebody else's.' This pithy observation undercuts Benjaminian assertions of an uncomplicated physical association of middle-class subjects with their possessions. The plates themselves, embellished with gilded reproductions of the fingerprints that are customarily expunged in the processes of manufacture, invoke the broader issues raised in the artist's statement as well as allied ideas about labour in the home: who touches dishes before they reach the table? who washes up? The connotations of gilding (precious materials, fine craft) invert Benjamin's pejorative rhetoric, now celebrating the traces of human physicality – often, in both manufacture and maintenance, women's physicality – embodied in the accoutrements of middle-class life and using these marks to explore how nominally private domestic life participates in such collective systems as labour and manners.

Starting with the presumption that houses and their furnishing are sites of important and complex experience, the *At Home With Art* project has provoked the creation of intelligent and often beautiful objects, and in the process challenged the art world's conventional structures of patronage, inspiration, manufacture, exhibition and ownership. The danger is that a project willing to flout so many avant-garde assumptions will – despite the art world's oft-proclaimed desire for radical transgression – simply exceed the capacity of critics, artists, curators and their institutions to engage it as 'art' at all. The hope is that by taking seriously the effects and implications of *At Home With Art* this book will help to sustain – and

perhaps even provoke more of – the kind of thoughtful attention to domesticity shown by the artists associated with this project.

Notes

This chapter is adapted from the author's *Not at Home: The Suppression of Domesticity in Modern Art and Architecture,* London and New York: Thames and Hudson, 1996.

1. Classic analyses of the avant-garde include Renato Poggioli (1962) and Peter Bürger (1984 [1974]). An excellent introduction is found in Linda Nochlin (1968).
2. On the *flâneur*, see Saisselin (1984) and Herbert (1988).
3. Careful analysis of Impressionist techniques casts doubt on the extent to which these paintings were actually made out of doors, as demonstrated by Robert Herbert (1979).
4. For an extended analysis of the staging of conflict in Impressionist – and Impressionist-inspired – domestic interiors by prominent male painters, see Susan Sidlauskas (2000).
5. Rybczynski 1986: 198–9; Loos 1970 [1908]: 19–24; Colomina 1992: 73–128.
6. On Greenberg and the decorative, see Kuspit (1979).
7. Denis's reference to Pouldu is to an ensemble of murals and painted decorations Gauguin and three colleagues made for an inn in Brittany in 1889.
8. The most detailed published analysis of this project appears in *Gauguin e i suoi amici pittori en Bretagna Valle d'Aosta* (1993), pp. 72–3. On the marginalization of the Nabis, see Watkins 2001, 23–6.
9. Ruskin 1905, *Stones of Venice*, Vol. 2, Chapter 6, Section 13 (Vol. 10, p. 192); *Mornings in Florence*, Chapter 2, Section 36 (Vol. 23, pp. 331–3); *Two Paths*, Lecture 3, Section 95 (Vol. 16, p. 342).
10. See Schapiro 1985; *Womanhouse* catalog 1972; Chicago 1975: 103–32. On *Womanhouse* and related projects, see Wilding 1977; see also both Wilding and Raven in Broude and Garrard 1994, 32–65.
11. On Warhol's films, see Koch 1985.
12. These two fragmentary essays overlap substantially, repeating many of the same phrases. Elsewhere, Benjamin praises Le Corbusier's architecture as marking 'the terminus of the mythological figuration "house"' (1999: 407).

References

Baudelaire, C. (1964) 'The painter of modern life', in *'The Painter of Modern Life' and Other Essays* (trans. J. Mayne). London, 1–18.

Benjamin, W. (1973) 'Louis-Philippe or the interior', in *Charles Baudelaire: A Lyric Poet in the Era of High Capitalism* (trans. Harry Zohn). London: NLB, 167–69.

Benjamin, W. (1977) 'Erfahrung and Armut', in R. Tiedemann and H. Schweppen-häuser (eds) *Gesammelte Schriften*. Frankfurt am Main: Suhrkamp Verlag, 213–18.

Benjamin, W. (1999) *The Arcades Project* (trans. H. Eiland and K. McLaughlin). Cambridge, Mass.: Harvard University Press.

Bradley, F. (ed.) (1996) *Rachel Whiteread: Shedding Life*. Tate Gallery Liverpool.

Broude, N. and Garrard, M.D. (eds) (1994) *The Power of Feminist Art: The American Movement of the 1970s, History and Impact*. New York: Abrams.

Bürger, P. (1984 [1974]) *The Theory of the Avant-garde* (trans. M. Shaw). Minneapolis: University of Minnesota Press.

Chicago, J. (1975) *Through the Flower: My Struggle as a Woman Artist*. Garden City, NY: Doubleday.

Colomina, B. (1992) 'The split wall: domestic voyeurism', *Sexuality and Space*. Princeton: Princeton University Press, 73–128.

de Antonio, E. and Tuchman, M. (1984) *Painters Painting: A Candid History of the Modern Art Scene*. New York: Abbeville Press.

Denis, M. (1920) 'De Gauguin et de Van Gogh au classicisme' (1909), *Théories, 1890–1910*. Paris: L. Rouart et J. Watelin, 262–78.

Echaurren, M. (1938) 'Mathématique sensible – architecture du temps', *Minotaure* 11, Spring, 43.

Gauguin e i suoi amici pittori en Bretagna Valle d'Aosta (1993) Centro St-Benin, Museo Archeologico Regionale.

Goldin, N. (1989) *The Ballad of Sexual Dependency*. ed. M. Heiferman, M. Holborn and S. Fletcher. New York: Aperture.

Goldin, N. (1993) *The Other Side*. ed. D. Armstrong and W. Keller. New York: Scalo.

Gottlieb, A. and Rothko, M. (1982) Letter to *The New York Times*, 1943, in E.H. Johnson (ed.) *American Artists on Art from 1940 to 1980*. New York: Harper and Row, 14.

Greenberg, C. (1961) *Art and Culture: Critical Essays*. Boston: Beacon.

Greenberg, C. (1986) *The Collected Essays and Criticism, Volume 2, Arrogant Purpose, 1945–49* (ed. J. O'Brian), Chicago: University of Chicago Press.

Greenberg, C. (1993) *The Collected Essays and Criticism, Volume 4, Modernism with a Vengeance, 1957–69* (ed. J. O'Brian), Chicago: University of Chicago Press.

Haslam, M. (1978) *The Real World of the Surrealists*. New York: Galley.

Herbert, R. (1979) 'Method and meaning in Monet', *Art in America*, September, 90–108.

Herbert, R.L. (1988) *Impressionism: Art, Leisure, and Parisian Society*. New Haven: Yale University Press.

Johnson, E.H. (1982) *American Artists on Art from 1940 to 1980*. New York: Harper and Row.

Kelly, M. (1983) *Post-partum Document*. London: Routledge & Kegan Paul.

Koch, S. (1985) *Stargazer: Andy Warhol's World and his Films*, 2nd edn. New York: Marion Boyars.

Kozloff, M. (1965) 'An interview with Robert Motherwell', *Artforum*, September, 33–37.

Kuspit, D.B. (1979) *Clement Greenberg: Art Critic*. Madison: University of Wisconsin Press.

Le Corbusier (1927) *Towards a New Architecture* (trans. F. Etchells). London: Architectural Press.

Loos, A. (1970 [1908]) 'Ornament and crime', in U. Conrads (ed.) *Programmes and Manifestos on 20th-century Architecture* (trans. M. Bullock). London: Lund Humphries, 19–24.

M.M.B. (1914) 'Rebel Art in Modern Life', *Daily News and Leader*, 7 April.

Malingue, M. (ed.) (1946) *Lettres de Gauguin à sa femme et à ses amis*. Paris: B. Grasset.

Meier-Graefe, J. (1968 [1908]) *Modern Art: Being a Contribution to a New System of Aesthetics* (trans. F. Simmonds and G.W. Chrystal). New York: Arno.

Morris, W. (1914) *Collected Works of William Morris*. M. Morris (ed) 24 vols London: Longmans Green.

Nochlin, L. (1968) 'The invention of the avant-garde, France, 1830–80', in T.B. Hess and J. Ashbury (eds) *Avant-garde Art*. London: Collier, 1–24.

Painter, C. (1999) *At Home With Art*. London: Hayward Gallery Publishing.

Poggioli, R. (1962) *The Theory of the Avant-garde* (trans. G. Fitzgerald). Cambridge, Mass.: Harvard University Press.

Pollock, G. (1988) 'Modernity and the spaces of femininity', *Vision and Difference: Femininity, Feminism and the Histories of Art*. London: Routledge, 50–90.

Raven, A. (1994) 'Womanhouse', in N. Broude and M.D. Garrard (eds) *The Power of Feminist Art: The American Movement of the 1970s, History and Impact*. New York: Abrams, 48–65.

Rosenberg, H. (1960) 'The American action painters', *The Tradition of the New*. Chicago: University of Chicago Press, 32–5.

Rubin, W. (1968) *Dada, Surrealism, and their Heritage*. New York: Museum of Modern Art.

Ruskin, J. *The Works of Ruskin.* E.T. Cook and A. Wedderburn, eds. 36 vols. London: George Allen, 1905.

Rybczynski, W. (1986) *Home: A Short History of an Idea.* New York: Viking.

Saisselin, R.G. (1984) *The Bourgeois and the Bibelot.* New Brunswick, NJ: Rutgers University Press.

Schapiro, M. (1985) *Femmages 1971–1985.* St Louis: Brentwood Gallery.

Sidlauskas, S. (2000) *Body, Place, and Self in Nineteenth-century Painting.* Cambridge: Cambridge University Press.

Solomon-Godeau, A. (1991) *Photography at the Dock: Essays on Photographic History, Institutions, Practices.* Minneapolis: University of Minnesota Press.

Venturi, R. (1977 [1968]) *Complexity and Contradiction in Architecture.* New York: Museum of Modern Art.

Venturi, R. (1992) *Mother's House: The Evolution of Vanna Venturi's House in Chestnut Hill.* New York: Rizzoli.

Watkins, N. (2001) 'The genesis of a decorative aesthetic', in G. Groom (ed.) *Beyond the Easel: Decorative Painting by Bonnard, Vuillard, Denis, and Roussel, 1890–1930.* New Haven: Yale University Press, 1–28.

Wilde, O. (1969 [1908]) *Miscellanies* (ed. R. Ross). London: Dawsons.

Womanhouse catalogue (1972). Valencia, CA: California Institute of the Arts.

Wilding, F. (1977) *By Our Own Hands: The Women Artists' Movement, Southern California, 1970–76.* Santa Monica, CA: Double X.

Wilding, F. (1994) 'The Feminist art programs at Fresno and CalArts', in N. Broude and M.D. Garrard (eds) *The Power of Feminist Art: The American Movement of the 1970s, History and Impact.* New York: Abrams, 32–47.

House-trained Objects: Notes Toward Writing an Alternative History of Modern Art
Tanya Harrod

To start with a truism: homes in Britain contain objects valued by their owners. Some of these objects will have been purchased, some may be gifts. Some may be defined as luxuries, others as necessities, but it is the interplay between these goods which is important and through which individuals display discrimination, responsibility and agency in their role as consumer-collectors (Miller 1997; Guerzoni and Troilo 1998). A proportion of this stuff will have been diverted from an original use and re-presented, in effect taking the form of a souvenir. Such objects are framed by what has been called the 'aesthetics of decontextualisation' (Appadurai 1986: 28) and might include horse brasses and toby jugs (mementoes of an indigenous past) as well as totemic objects like blown-glass gondolas signifying Venice or tribal rugs from Iran suggesting travel, embodying geographical as opposed to temporal distance (MacCannell 1999: 145–60; Barnett 1995: 17). These might be modestly priced – a glass knick-knack from Venice – or have great rarity value – a kelim rug with a romantically narrative provenance.

Especially valued contemporary objects in any one British home may include paintings, prints, kitchen equipment, sound systems and so on. In Britain especially there are likely to be 'craft' or applied art objects in many homes, made and designed by the same person and related to a family of objects made in the same material. As tracking the fortunes of the crafts and applied arts is one sub-text of this discussion, perhaps I should elaborate. There may be striking differentials in the material value of this category of handmade objects. Take for instance objects seen as part of the British studio pottery movement. This encompasses a broad band of creative activity and could include a humble hand-thrown mug costing as little as £5 or a Hans Coper pot which at auction might reach sums as high as £60,000. But, as is argued elsewhere in this volume, few British homes contain objects from the world of contemporary art, even if, paradoxically, many contemporary artists characteristically adapt or replicate 'homely' objects in their work.

Another truism: elite one-off works of contemporary art are not widely available and are extremely expensive. But there are imaginative schemes like The

Multiple Store set up in 1998 to produce limited editions of three-dimensional objects designed by leading sculptors (see Plate 39). Although these cost between £950 and £90, in the view of Sally Townsend, the project's organizer, they appeal primarily to a highly informed audience, only really making sense if the consumer has some knowledge of the contributing artists' wider careers.[1] We may regret this state of affairs and seek to redress it through projects that offer artworks on loan to members of the public or to institutions such as schools or hospitals. We might even argue that the absence of art in a broad sense from British homes is disputable. Mediated forms of art enter our homes indirectly in the form of cheap reproductions and posters and, rather differently, in the form of television programmes, CD covers, designer objects, clothes and graphics in magazines, all of which reflect the visual culture of our time. But these broad definitions do not obtain in what the American philosopher of art Arthur Danto has identified as the 'art-world' – a network of major collectors, dealers, museums, critics whose consensus defines what are accepted as appropriate art genres (Danto 1964: 571–84; Gell 1996).

This matter of appropriateness, a kind of modern version of mannerist decorum, is important because fine art is highly and effectively commoditized and to that end its boundaries are stringently policed by the art-world's gatekeepers. On the whole, artists themselves do not operate as gatekeepers. During the past one hundred years many of them have crossed boundaries frequently, either deliberately or innocently. More recently, however, they have taken on many of the activities of curators and critics and have tended to endorse subtle, equally exclusive, variants of this taxonomic process. Take, for instance Richard Wentworth's remarkable 1998 exhibition *Thinking Aloud* which was an extended meditation on the nature of objects. It was inclusive but also exclusive, including architectural plans, fine art, maps, plans, flags, signs, toys and traps but, for example, no objects of contemporary applied art (Wentworth 1998). This may signal that currently the applied arts or crafts occupy a difficult cultural position – not quite art objects but not innocent workaday objects either, ripe for discovery by an artist curator.

Some Boundaries

Most of us, for whatever reason, do not purchase works of contemporary art for our homes (although we may buy reproductions, craft and applied art). Our major museums and galleries have their own systems of separation. The premier site for viewing contemporary art in Britain, London's Tate Modern,[2] does not collect (and rarely displays) applied art, craft or design, even if made or designed by acknowledged fine artists. In fact the demanding experience of visiting Tate Modern, a

former power station reconfigured as a gallery of art, vividly underscores these divisions. Unlike the former Tate Gallery at Millbank (now Tate Britain), Tate Modern is the antithesis of a domestic space. Perhaps that is why its galleries are difficult places in which to view most art made before 1945.

Boundaries have to be drawn and, of course, London's Victoria and Albert Museum is where we expect to find twentieth- and twenty-first-century applied art and design intelligently presented. This is not particularly surprising or dismaying, but at times the exclusion distorts our perception of relatively recent historical moments. Curatorial taxonomies demonstrate that the museum of modern art necessarily has an ambivalent attitude to cultural history. Its purpose is partly to ring-fence and protect an activity called fine art – not to explain visual culture as a whole. It is a protectionist attitude that was also, and arguably remains, characteristic of the academic discipline called art history – particularly among the first scholars and curators who contributed to the construction of histories of the modern period.

Let us look at some examples. In 1997 the exhibition *Modern Art in Britain 1910–1914* held at the Barbican Art Gallery, London attempted to recreate the crucial series of exhibitions of modern European art in London just before the First World War. Roger Fry's assemblage of continental art staged at the Grafton Galleries in 1910–11 under the title *Manet and the Post-Impressionists* is generally thought to be of crucial importance in this context and, of course, included ceramics as well as paintings and sculpture. But the curator of the Barbican show did not retrieve the sizeable number of pots by figures like Henri Matisse, André Derain and Maurice de Vlaminck shown in 1910 nor were they mentioned in the catalogue essays (Plate 37). In effect, the curator failed to cultivate a period eye. Yet Fry's decision to include ceramics in 1910 was important, signalling that in the first decade of the twentieth-century making and decorating pots was one way of avoiding the potential academicism of easel painting (Gruetzner Robins 1997; Tillyard 1988: 127–8).

When it comes to monographic exhibitions the complexity of an artist's interests is almost invariably censored. The 1993 Tate Gallery exhibition on the work of Ben Nicholson (Lewison 1993) was something of a landmark in its inclusion of Nicholson's applied art in the form of textiles and painted boxes. But they really only appeared in an archival context and Barbara Hepworth's and Nicholson's shared intense involvement in the interiors which they created in the 1930s was therefore marginalized. Similarly the 1985 exhibition *St Ives 1939–64* (Tate Gallery 1985), which looked at the post-war artistic community in St Ives, included ceramics essentially as a footnote giving little idea of the fruitful interrelation of a range of applied arts and fine art in West Cornwall at that time.

Even when an artist's forays into the applied arts are allowed to become the focus of an exhibition, fine art curators have a way of missing the point. For

instance, the 1998 exhibition *Picasso: Painter and Sculptor in Clay* (Royal Academy of Arts, London) was limited to that artist's 'unique' work in fired clay. But Picasso's one-off pieces were only a small part of the story. He also produced ceramic editions and series in collaboration with the Madoura Pottery for reasons that were utopian – linked to his membership of the Communist Party – and specific to a time and a place – the south of France just after the Second World War (Silver 2000: 78–141; Harrod 1989).

We accept the kind of curatorial decisions I have outlined almost without a second thought. Clearly though, the relationship between craft, design, the fine arts and architecture needs to be addressed when writing the history of modern visual culture. Why do certain activities get ignored? Why have attitudes toward objects that appear intended for a domestic environment fluctuated so markedly in the past hundred and fifty years? After all, in the late nineteenth century and the early part of the twentieth century craft and applied art activity was seen as a way of expressing ambivalence toward bourgeois industrial society (Ogata 2001).

Craft, Art and Early Modernism

In 1905 the Arts and Crafts painter, designer and socialist Walter Crane published a collection of essays entitled *Ideals in Art* (1905). Trained as an illustrator, Crane sought a more democratic union of the arts and worked most fruitfully as a book illustrator and a designer of textiles, wallpapers, interiors and stained glass. He also created vivid graphic designs for the socialist cause (Smith and Hyde 1989: 108). We do not think of Crane as a radical artist in the context of early modernism – he belongs to an earlier period – but he inspired intelligent younger artists all over Europe by associating fine art with decline and decadence. In Crane's view what he called 'the art of portable picture painting' lacked serious contemporary links to architecture and a wider world (Tillyard 1988: 109). There was, however, an ambivalence about Crane's slighting references to art 'enclosed in gilt frames or supported on pedestals' (Crane 1888) because Crane worked hard as a painter and by the 1890s had a reputation as a fine artist in Germany.[3] And to an extent he was borrowing and updating ideas expressed by William Morris as early as the mid-1870s.

Morris's linking of art and politics and morality and his concern with a context for art was taken up by avant-garde thinkers all over Europe and North America and in the Far East, particularly Japan. Morris's political writing led serious young artists to think how their work was consumed and by whom. His imaginative valorization of design encouraged a new interest in the quotidian, the everyday, in 'things' at the expense of easel painting.

Not all early modern artists saw the activity of easel painting as so problematic that they considered its rejection. For Paul Cézanne the internal problems specific

to painting were complex and demanding enough to take up all his energies without experiments in the applied arts. But for other painters all over Europe one way of rejecting the skills taught by the academies of art through the systematic study of casts and copies was in self-taught experimentation in other media. In France this anti-academic approach was first pursued by Paul Gauguin and by the group that admired his work, the painters who called themselves Les Nabis, after the Hebrew word for prophet. Around the start of the 1890s in northern Europe new media and unfamiliar methods formed part of a strategy to alter the ways in which art was produced and consumed (Clark 1999: 55-137). The stylistic term *art nouveau* does not quite do justice to the diversity of experimentation, nor to the extension of these concerns into the twentieth-century.

For the young Pierre Bonnard, Les Nabis' experiments with painted screens and fans and with stained glass and enamels and ceramics were both emblematic and political of 'our generation (who) are always seeking links between art and life through the creation of objects of everyday use' (Musée Matisse 1996: 18). For the young Henri van der Velde anti-academicism took the form of flight in the winter of 1892 to the coastal town of Knokke-sur-Mer where he laboured over an appliqué hanging, *La Veillée des Anges* (Plate 38). This foray into female practice, achieved with the help of an aged aunt, was followed by his creation, with his wife Maria, of the house Bloemenwerf as '*une maison-manifeste*', a utopian dream-space and practical home (Van der Velde 1992: 191–2; Ogata 2001: 165–76).

These experiments in the applied arts were also inspired by another early modern trope – that familiar anti-modern nostalgia for archaic and non-European cultures. Anti-industrial yearnings were commonplace among European novelists, critics and artists from Rainer Maria Rilke (Parry 1997) to Walter Benjamin (Leslie 1998) to Le Corbusier. On his journey through East Europe in 1911 – an important journey of self-education – Edouard Jeanneret (he was to adopt the pseudonym Le Corbusier in 1920) was deeply moved by vernacular architecture and craft as he travelled toward Turkey. He bought quantities of peasant pots in the Balkans, as well as traditional rugs and embroideries, all of which were shipped back to Switzerland at great expense (Allen Brooks 1997: 263–300, 326). His *Voyage d'Orient* shaped his subsequent thinking.

Le Corbusier's frequently quoted identification of the home as a '*machine à habiter*' and his negative attitude towards female domestic taste obscures the complexity and poetry of his attitude to housing and toward interiors. The crucial model was vernacular and peasant domestic architecture. Thus art in the home would chiefly take the form of craft, in the form of vernacular pots (Figure 4.1) and Roumanian and Berber rugs. Then there were objects that he deemed beyond style, such as the archaic and non-European artefacts and sculptures shown in his studio in 1935 in the informal exhibition *Les arts dits primitives dans la Maison d'aujourd'hui*. Other admissible objects included mural paintings by himself and

Figure 4.1 Edouard Jeanneret with his favourite Serbian pot, August 1919 at the Villa Jeanneret-Perret. (Fonds Le Corbusier, Bibliothèque de la Ville). La Chaux-de-Fonds.

a handful of artists he respected, tapestries (christened *le mural du nomade*) and found objects (*objets à réaction poétique*) (Malécot and Saddy 1988).

Le Corbusier's discovery of vernacular ceramics in 1911 had been prefigured in 1908 by Adolf Loos who saw in the act of making a pot 'chance, passion, dreams and the mystery of creation' (Loos 1998). Their interest was shared by other artists and was part of a wider exploration of processes such as direct carving in stone and the creation of crude wood blocks to print paper or textiles. This was art for the home, both actual and potential. Intimacy was important, as was bohemianism. The two were braided in photographs taken in 1910–12 of the Expressionist Ernst Ludwig Kirkner's studio homes in Dresden and Berlin – cave-like interiors filled with African carvings and hung with Kirkner's hand-block-printed textiles (Rhodes 1996).

Ceramics: a Special Case?

In the case of ceramics made by (rather than collected by) artists in the early modern period, there was a disjunction between a desire to experiment and the

capacity of the art world to take in craft genres. Ceramics could synthesize painting and sculpture but this very hybridity proved problematic. Gauguin's ceramics in particular confused the boundaries between fine art and applied art. Mostly made between 1886 and 1895, they were not particularly well received and even today his ceramics still seem 'difficult' and adventurous with their odd inelegant conjoining of abstract vessels and realistic figures. Gauguin clearly hoped for an audience and was bitter about the way in which the public appeared to prefer safer kinds of experimentation in the pure forms of Auguste Delaherche's handsome neo-oriental pots.

The ceramics decorated by the painters known as Les Fauves around 1907 similarly tended to be little discussed either when they were exhibited or subsequently. They were made in most instances with the encouragement of the dealer Ambroise Vollard who suggested that his artists work with the self-taught tin-glaze potter André Metthey at his studio north of Paris in 1907(Musée Matisse 1996: 43–69). On one level, involvement in making or decorating ceramics alerted artists to deficiencies in industrial design. Gauguin had been particularly critical of the historicist production at Sèvres for instance – he called it 'the death of ceramics' (Musée Matisse 1996: 15). But an involvement with ceramics worked in other ways too. In the case of Matisse, in his early paintings he depicted little worlds of objects which deserve further investigation.

Ceramics and small sculptures made by his hand and the textiles, furniture and carpets that he collected animated his interior scenes, portraits and still lives. For instance, *The Red Studio* of 1911, *Girl with Green Eyes* of 1908 and his *Still Life on an Oriental Rug* of 1908 (see Plate 37) all include ceramics of the kind that he decorated in collaboration with André Metthey (Musée Matisse 1996: 86–7). At that early date Matisse was also depicting archetypal figures against empty flattened backgrounds, as in *La Danse* of 1909–10. In this context his ceramic experiments were important in a different way, for his painting on pots suggested a new kind of dancing figure inhabiting a new kind of space. Matisse was not the only artist to learn from his applied art experiments during this Fauve period. In a reverse process, André Derain combined the decoration of pots like *The Dancers* and *Three Seated Nudes* of 1907 with the making of woodcuts and direct carving. All these works in non-fine-art media allowed him to develop the kind of heightened colour and flattened space that he was pursuing in paintings like *The Dance* of 1906.

Apart from Gauguin none of these early modern painters left accounts of what ceramics meant to them and for each artist it seems likely that ceramics played a different role, ranging from spatial to colouristic experimentation. The best account of the possibilities of ceramics is provided by Pablo Picasso in a letter to the sculptor Henri Laurens. Picasso explained to Laurens in 1948 that while painting should create a sense of space he had found that by painting a ceramic form he

was able to create the multiplicity of flattened viewpoints which he demanded from sculpture (Kahnweiler 1957: 17–18). As Picasso's dealer Kahnweiler astutely observed, some of the paradoxes that Picasso had first explored in sculptures like the 1914 *Glass of Absinthe* series were further investigated in his post-war ceramics. But the possibilities were many and complex. With Picasso, as Kenneth Silver has pointed out, there was a romantic political dimension to his decision to make editions of ceramics. He liked the idea that 'anyone might buy them, use them, and maybe hang them on the wall like a souvenir' (Silver 2000: 141).

Writing Modernism

The desire of early modern artists to experiment and escape the stranglehold of easel painting and expensive sculptural processes like bronze casting by using a range of craft media deserves further exploration. We associate a move into the applied arts with the British Arts and Crafts Movement and with art nouveau but, as I have suggested, it had a more extended history than that. While we have histories of the role of the 'ready-made' as an avant-garde challenge to accepted art practice, the more complex, messier and less conceptually transparent world of the 'hand-made' remains under-documented (Richard Salmon/Kettle's Yard 1997: 24–44). In effect we can trace two early twentieth-century avant-garde histories: an institutionalized fine-art version, fully constructed by the 1950s, which continues to be policed predominantly by non-practitioners influenced by the art market, and the less manageable actuality of painters and sculptors with uneasy links with the crafts, design and architecture.

Wandering through London's Tate Modern or Tate Britain, we would not expect to find the sculptor Eduardo Paolozzi's wallpapers of the early 1950s nor his wallpaper, textile, tile and ceramic work undertaken in collaboration with the remarkable photo-collagist Nigel Henderson (Figure 4.2). We would be surprised to see the jewellery and silver-smithing work of the painter Alan Davie, likewise Henry Moore's cast concrete wall lights made speculatively in 1932 and his magnificent silk-screen wall hangings created in collaboration with Zika and Lida Ascher in 1948. These exclusionary policies often have gender implications, as with the absence of Margaret Traherne's splendid small stained-glass panels and Frances Richard's austere embroidered pictures (Plate 40). Both were just two among many women who trained as painters and who in the 1950s went into the applied arts because the area offered more opportunities for women (Harrod 1999: 245, 295, 324–5). All these objects of applied art have manifest links to concurrent developments in the fine-art world of the 1950s but they were made from inappropriate and highly specific materials – cloth, fired clay, glass. In some instances they were made by inappropriate people, by which I mean women. For

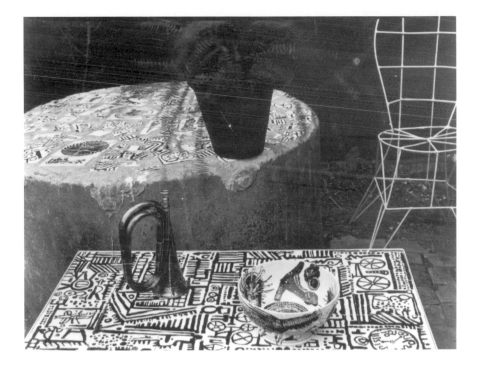

Figure 4.2 Nigel Henderson and Eduardo Paolozzi, tiled coffee table and bowl photographed at Thorpe-le-Soken, 1950s. Tate Gallery Archive.

instance Richards, the wife of the painter Ceri Richards, was operating in a male-dominated art world at that date. These objects were also, with few exceptions, manifestly made for the domestic environment.

We do not know much about this kind of work because, by contrast with the fine arts, the crafts in the twentieth century, in the form of a movement with roots in the nineteenth-century Arts and Crafts Movement, have had an uncertain complex identity and are under- or ineffectively commoditized. Craft practice requires an ethnography rather than an evolutionary history. Thus in the first part of the twentieth century, up to about 1939, craft could include blind ex-servicemen making nets just after the First World War at the philanthropic workshops set up by the charity St Dunstan's as well as Phyllis Barron's hand-block-printed textile entitled *Log* of 1915 inspired by Vorticist painting (see Plate 41). Any definition of craft could also take in lots of handwork in industry and surviving vernacular craft such as hurdle-making or basketry or the manufacture of turned and carved spoons – all examples of good design arrived at by non-design, by a tradition of making. After the Second World War, craft could take in an anarchist counter-culture in which the workshop confers freedom and autonomy from the system as

well as ceramics which conflated painterly mark-making and sculptural presence, sharing many of the tropes of fine art while operating on a domestic scale.

Only comparatively recently has it become apparent that twentieth-century modernism was far from monolithic and that, indeed, we need to recover some lost modernisms. Figures like Phyllis Barron, Margaret Traherne and Frances Richards suggest that crafts made by women and based on hand processes constitute one such lost modernism (Harrod 1999: 11, 116–18). The situation is complicated by the way that all the visual arts tended to be in constant interplay, making it inadvisable to write about painting without considering design or to discuss sculpture without reference to ceramics.

Thus the critic Herbert Read moved from admiring the studio pots of William Staite Murray in the late 1920s to dismissing handmade objects in favour of the perfection of cast ceramics by 1934. Similarly in the late 1920s and early 1930s the painter Paul Nash took an interest in a whole range of craftsmen and women – in potters like Bernard Leach and hand-block printers like Barron, Dorothy Larcher and Elspeth Little and saw them as the one group in Britain who could effectively furnish a modern interior. But in 1934 he founded Unit One. Its membership was limited to artists and architects and it was to be 'a practical unit in an industrial system' (Lewison 1993: 47). In effect, in about 1934 both fine art and the crafts were marginalized in favour of design and architecture by progressive thinkers attempting to respond to mass unemployment and slump and the flood of positive propaganda about the command economies of totalitarian regimes.

But the home, the domestic, still continued to be of interest to artists such as Paul Nash, Barbara Hepworth and Ben Nicholson and commentators such as Herbert Read. Problematically for the crafts, however, the home was to be furnished with a restricted mixture of advanced fine art, mass-produced goods and mostly non-European art and craft. These were the components of the classic progressive interior, good examples being Herbert Read's home in Hampstead in about 1933 (Figure 4.3) and another Hampstead dwelling, the architect Erno Goldfinger's house at 2,Willow Road (Naylor 1999). Their agenda would have found favour with figures abroad like Le Corbusier but, as we have seen, he carried on a far fuller Arts and Crafts tradition of integration, particularly in the fine detailing of his exteriors and interiors, and in his fondness for murals and tapestries as well as through his continuing interest in the vernacular, particularly in relation to building types and techniques.

If the situation was relatively fluid between the two world wars, after the Second World War figures in the art world began fully to articulate the belief that fine-art should be viewed apart from other visual disciplines and that a discipline like painting was inherently alienated from domestic space. Clement Greenberg, the paramount fine-art critic of the 1950s and 1960s, beautifully encapsulates the mood in his 1948 essay, 'The situation at the moment'. He dismisses the Paris art

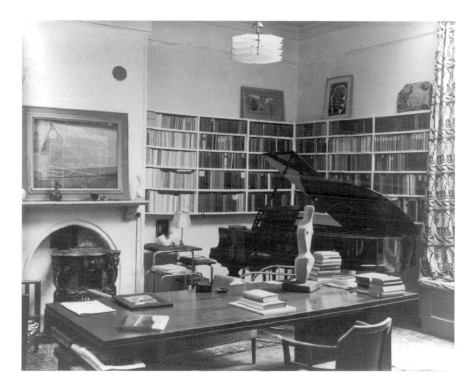

Figure 4.3 The interior of no 3, The Mall, Parkhill Road 1933. This was Herbert Read's home from 1933 until 1939. (Benedict Read.)

world – the talk, the cosy literary and art magazines – and goes on to say 'what is much more real at the moment is the shabby studio on the first floor of a cold-water, walk-up tenement on Hudson Street; the frantic scrabbling for money; the two or three fellow painters who admire your work; the neurosis of alienation that makes you such a difficult person to get along with . . .' The art produced in these difficult conditions would not, however, be for private ownership: 'abstract pictures rarely go with the furniture'. Such work needs space and therefore 'while the painter's relation to his art has become more private than ever before because of a shrinking appreciation on the public's part, the architectural and, presumably, social location for which he destines his product has become, in inverse ration, more public' (Greenberg 1986: 193–5).

Greenberg was commenting accurately on the conditions of painting production at that date but he was precisely wrong about the purity of the future consumption of such work. By the mid-1950s wealthy collectors drawn to the Abstract Expressionists had few problems integrating their work with the furniture. Despite their scale, they were paintings and could be hung on a wall. Paintings perform their task of wall decoration rather effortlessly, whether in an appropriate home or

in an art gallery. Of course, the home's potential as a dangerous place for fine art is recognized by the art world. Responsible galleries seek 'good' homes for works of contemporary art and can 'refuse to transact' (Douglas and Isherwood 2001: 100–4) if it seems likely that the artwork will not join an established collection. But complete control is impossible and notoriously, in Cecil Beaton's famous fashion shoot for *Vogue* Pollock's canvases (Pollock being the type of alienated artist Greenberg had in mind in his 1948 essay) were co-opted as an elegant backdrop to haute couture (Crow 1996: 39).

Awkward Customers

Greenberg's strictures were slow to take root in Europe. I have suggested that in the 1950s artists in Britain experimented with a range of craft media for domestic interiors. Sometimes the aim was to gain a steady income. In the case of women the world of applied art could offer more creative opportunities and greater acceptance. For an artist like the Danish Asger Jorn, Greenberg's exclusivity had little significance. In the early 1950s Jorn was briefly involved with a new design school modelled on Bauhaus lines, the Hochschule für Gestaltung at Ulm in West Germany. But he soon fell out with its director Max Bill. Jorn's response was to set up his own counter-cultural Mouvement International pour un Bauhaus Imaginiste. From 1953 he spent time in Albisola near Genoa where he and former COBRA group members made wild expressive ceramics that were subsequently shown at the Milan Triennale of 1954. In Milan he made his speech *Contre le Fonctionalisme* – a heart-felt plea for the inclusion of what he called the 'free artist' in the shaping of the post-war world. Jorn's ceramics were emblematic of that longing and their intense chaotic quality stood for everything which was lacking in the encroaching technocracy and warrior politics of the cold war (Harrod 2000: 13–14). The way in which Jorn exhibited ceramics in Albisola is of interest. They were shown informally in garden and house settings (see Figure 4.4). In 1955 he exhibited 500 plates decorated by schoolchildren (Koplos and Borka 1992; Atkins 1977; Jorn *c.*1954).

Jorn's activities had a good deal in common with a body of later work that mounted similar socio-political attacks, most specifically on the art market and on the primacy of painting and sculpture. But the joyful democratization characteristic of Jorn's work was absent – as was its domesticity and craftedness. One question that might be asked of the conceptual and experimental art of the 1960s and 1970s is 'where was it meant to go?' Jorn's work done in Albisola is still housed in his home – now a museum. But that kind of setting hardly seems appropriate for the conceptual art of the 1970s. The answer seems to be an archive, or at least a kind of site that is neither gallery nor home. Yet the facture of 1970s conceptual art

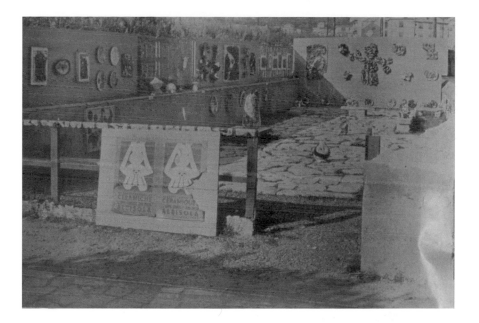

Figure 4.4 Outdoor exhibition of ceramics at Albisola in 1955 with a relief ceramic by Karel Appel on the back wall. Illustrated in Asger Jorn, Pour la Forme, L'Internationale Situationniste, Paris, c.1955.

employed a domesticity of process. As John Stezaker points out: 'Conceptual art opened up the use of non specialist processes of everyday life in the production of work (for me photography, collecting, captioning etc.) ... The work which I most value from this time (of mine and others) is the work which remains closest to the everyday procedures employed and to the confrontation with the everyday which these allow' (Philpot and Tarsia 2000: 153). Stezaker's investigations could in theory be done without a studio. The kitchen table would do. But even if everyday processes were employed it would be absurd to see domesticity in the art or to think much about the work being displayed in a domestic environment.

Perhaps the anti-domesticity of conceptualism explains why there was a craft revival in Britain from 1973, under the patronage of the government-funded Crafts Advisory Committee (later Crafts Council). Certainly unpurchasable fine art and the uniformity of product design created a space for complex referential objects. Most of the crafts of the 1970s and 1980s essentially drew on early modernism in painting and sculpture for inspiration. All the genres of craft were enlivened by this symbiotic relationship with twentieth-century fine art. Ceramics, in particular, functioned as affordable abstract sculpture for the home. But surprisingly, many of the tropes of art that we associate with the contemporary art of the last ten years or so – a fondness for creating ghostly doppelgänger of existing objects

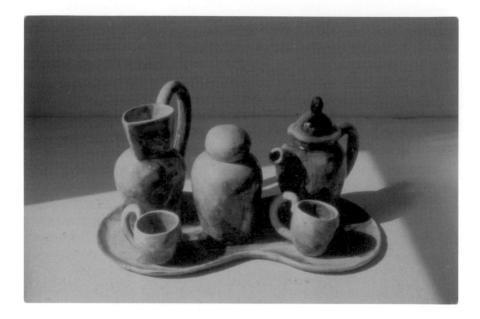

Figure 4.5 Andrew Lord, *Round Grey Shadow Coffee Set*, 1978, earthenware, Leeds Museums and Art Galleries.

(see Figure 4.5) for instance, or for using textiles to carry confessional communications – were already to be found in the more radical crafts of the 1970s (Harrod 1999: 369–410; Betterton 2000). 'Radical craft' – the phrase seems designed to raise a smile. But its existence deserves serious documentation.

The Situation at the Moment

If we look over the past century and a half, it is possible to discern an alternative history of the visual arts, one which is inclusive rather than exclusive and which honours the variousness of artists' approaches and which includes crafts and applied arts in the story. One way of noting this catholicity is to be attentive to the home and objects of domestic scale. As we have seen, this approach results in tales of the unexpected in which Le Corbusier emerges as a pottery enthusiast and Eduardo Paolozzi writes busily to the Council of Industrial Design with details of his wallpaper designs.[4]

If we pursue this alternative history up to the present, activities that seemed overlooked and marginal now appear to have taken centre stage. It would be hard to ignore the recent development of interest among fine artists in domestic objects, particularly in their oddness and instability. It is a tendency inspired by, as much

as anything, the cultural and theoretical studies taught in art schools that introduce students to sources as varied as Marx's haunting opening lines on 'The Fetishism of the Commodity and the Secret Thereof' in volume one of *Das Kapital*, Freud's 1919 essay on 'The Uncanny' and a powerful body of writing by figures as diverse as Mary Douglas, Alfred Gell and Susan Stewart. At the heart of much of this writing is an emphasis on consumption as a process through which individuals construct identities and in which objects, like people, have unstable and unpredictable careers. Artists reading these texts find oblique confirmation of their rejection of avant-garde notions of originality in favour of replicating, reconstituting and remaking everyday 'things'. This kind of activity, however, does not herald a situation in which the home becomes a site of experimental endeavour. Quite the reverse.

It is easy to be misled by the sheer quantity of curated shows that suggest an interest in the quotidian and the domestic and in craft processes. An exhibition curated in 1997 by Paul Heber-Percy entitled *Craft* set the tone by including a dreamlike series of objects, made by hand and with an air of utility – rag rugs by Ben Hall, Neil Cummings's laborious remake of the Rietveld Chair in veneer and cardboard (see Plate 43) Andy Voss's solid-wood replication of a radiator and Naomi Dines's neatly stitched leather *Stay* (Richard Salmon/Kettles Yard 1997). In 1999 Heber-Percy put together another show, *Furniture*, in which he sought 'to curate an exhibition whose appearance hovers ambiguously between furniture and sculpture'. He wanted to 'foreground this movement between familiarity and strangeness to make the gallery both domesticised and institutional' (Richard Salmon/John Hansard Gallery 1999).

These pioneering exhibitions were followed by many others which dealt with 'familiarity and strangeness' through an invocation of the domestic and craft. An incomplete selection would include *Perfidy: Surviving Modernism* (Kettle's Yard 2000), an exhibition engaging with 'the world of ordinary things' and site-specific to Le Corbusier's monastery Sainte Marie de la Tourette near Lyon; *DIY: variations on the theme of wallpaper* (The Gallery Channel 2000), in which nineteen artists were invited to approach 'the notion of "wallpaper" in the "domestic environment of a 1850s Grade II listed Victorian home'; *The (Ideal) Home Show* (Gimpel fils 2001), which attested 'to the importance of the things that surround us every day'; and Nina Pope's *A Public Auction of Private Art Works* (Pope 2001), which restaged an auction held in Kimbolton Castle, Cambridgeshire in 1949 by inviting artists to create objects inspired by items described in the sale catalogue.

Yet despite this focus on what a press release described as 'an explosion of domesticity in art' (Angel Row Gallery 2001), it would be innocent to suggest that many artists would want their work to be exhibited in an actual home. Indeed the everydayness (with a twist) of most of the work suggests that it would be lost in a cluttered 'real' home. This was made abundantly clear in the 2001 exhibition and project *Close Encounters of the Art Kind* (Painter 2001). Its curator, the artist Colin

Painter, recruited six sculptors and six North London households and over six months a work by each sculptor was rotated from home to home. This was a worthy project that appears to have brought pleasure to both householders and artists. But the photographic record of the project is revealing (see Plate 69); most of the sculptures are rendered virtually invisible by the home environment and are only properly recuperated in the exhibition at the Victoria and Albert Museum where they are displayed apart from the everyday objects that clutter most homes. The V&A exhibition also included three or four much loved objects from each household. These were shown in museum vitrines and ended up looking as odd and as challenging as the sculptors' contributions – a distinctly 'uncanny' outcome!

This is where we return to the applied arts and in particular to ceramics. I have suggested that ceramics are a 'special case', outlining instances when fine artists were particularly drawn to the genre. But now I want to focus on ceramics made by ceramicists – artists who devote themselves pretty exclusively to the medium of fired clay. I have already suggested that ceramics have a role as affordable abstract sculpture for the home. But ceramics are historically part of a rich tradition of ornament. In particular, the extraordinary plasticity of clay means that ceramics have re-represented all kinds of artifacts – from bronze statuettes to silverware. As a result ceramics have, over the centuries, carried all kinds of high and low art references into the domestic space. Although modernism in design narrowed the ornamental range of industrial ceramics, from the 1920s onward studio pottery was able to carry on this process of re-representation.

Currently, a few ceramicists, like their cousins in the fine-art world, are commenting on the world of things and on consumption itself. But the fact that ceramics have always been part of the domestic environment as part of a culture of display and collecting largely orchestrated by women raises an important question. Does an object's status as an artwork depend upon context? In the exhibition *ART/ARTIFACT* in New York in 1988 the curator Susan Vogel put a Zande hunting net, tightly rolled for transport, into a clean white art gallery space. A practical African object immediately began to look like a conceptual sculpture (Gell 1996). Very few 'homes', indeed only those configured to resemble galleries, could have worked that kind of transformation on the Zande net. In most domestic settings the bundled up net might have stood out, but a viewer would have been unlikely to freely associate it with a similar looking artwork. As we have established, few homes contain artworks. The net in a home would be more likely to spark off thoughts of practical objects – a tent for instance, or even a net!

Which brings me to the work of the ceramicist Richard Slee. Like the Zande net, his work looks well in art galleries. Slee's ceramics are sensitive to the whole range of ornamental objects that do 'memory work' for us – the horse brasses, Toby jugs and glass gondolas that I mentioned at the beginning of this chapter. To run through our original truisms: homes are full of practical things like tents, mixers,

and washing machines. They frequently lack artworks as defined by the art world. We expect instead to find a range of fairly assertive ornaments. Slee, by working from ornament to create ornament, is able to enter the home with ease. And without anyone much noticing, Slee manages to investigate big themes such as national identity, landscape, 1940s animated film, cheap British industrial pottery and icons of power and governance. So what have we got here? An object made of glazed fired clay, which, by virtue of its facture, material and its maker's background, generically does not quite fit into the art world. Or is this a house-trained art object? But here I rest my case because relations between art, craft and the home fluctuate and will continue to do so. Inscribed in this instability is an alternative history of modern art.

Notes

1. For more on The Multiple Store see www.multiplestore.org
2. I am focusing on London here; major galleries outside the metropolis include art, craft and design under one roof, but invariably in different areas of the museum/gallery.
3. My thanks to Alan Crawford for clarifying my thoughts on Crane.
4. See Paolozzi writing with efficient verve to Peter Hatch at the Council of Industrial Design on August 22, 1955. List 1, no 2, Nigel Henderson papers, Tate Gallery Archive.

References

Allen Brooks, H. (1997) *Le Corbusier's Formative Years*. Chicago: University of Chicago Press.

Angel Row Gallery (2001) 'House work: domestic spaces as sites for artists', press release. Nottingham: Angel Row Gallery.

Appadurai, A. (1986) 'Introduction: commodities and the politics of value', in A. Appadurai (ed.), *The Social Life of Things: Commodities in Cultural Perspective*. Cambridge: CUP.

Atkins, G. (1977) *Asger Jorn: The Crucial Years 1954–1964*. London: Lund Humphries.

Barnett, P. (1995) 'Rugs R Us(And Them): The Oriental Carpet as Sign and Text', *Third Text*, 30, Spring, 13–28.

Betterton, R. (2000) 'Undutiful daughters: avant-gardism and gendered consumption in recent British art', *Visual Culture in Britain*, 1(1), 13–29.

Clark, T.J. (1999) *Farewell to an Idea: Episodes from the History of Modernism.* New Haven: Yale University Press.

Crane, W. (1888) *Arts and Crafts Exhibition Society.* London.

Crane, W. (1905) *Ideals in Art: papers, theoretical, practical, critical.* London: Bell & Sons.

Crow, T. (1996) *Modern Art in the Common Culture.* New Haven: Yale University Press.

Danto, A. (1964) 'The Art-World', *Journal of Philosophy*, 61, 571–84.

Douglas, M. and Isherwood, B. (2001) *The World of Goods.* London: Routledge.

The Gallery Channel (2000) 'DIY – variations on the theme of wallpaper', press release. London: the Gallery Channel.

Gell, A. (1996) 'Vogel's net: traps as artworks and artworks as traps', *Journal of Material Culture*, 1 (1), March, 15–38.

Gimpel fils (2001) 'The (Ideal) Home Show', press release. London: Gimpel fils.

Greenberg, C. (1986) 'The situation at the moment', in J. O'Brian (ed.) *Clement Greenberg: The Collected Essays and Criticism – Arrogant Purpose 1945–1949*, Vol. 2, Chicago: University of Chicago Press.

Gruetzner Robins, A. (1997) *Modern Art in Britain 1910–1914.* London: Merrell Holberton/Barbican Art Gallery.

Guerzoni, G. and Troilo, G. (1998) 'Silk purses out of sows' ears: mass rarefication of consumption and the emerging consumer-collector', in M. Bianchi *The Active Consumer: Novelty and Surprise in Consumer Choice.* London: Routledge.

Harrod, T. (1989) 'Picasso's Ceramics', *Apollo*, May, 337–41, 372.

Harrod, T. (1999) *The Crafts in Britain in the Twentieth Century.* New Haven: Yale University Press.

Harrod, T. (2000) 'British Ceramics: a discussion document', in L. Seisboll (ed.), Britisk Keramik.2000.dk, Rhodos.

Jorn, A. (c.1954) *Pour la Forme: Ebauche d'une méthologie des arts.* Paris: Edité par l'Internationale Situationniste.

Kahnweiler, D.-H. (1957) *Picasso: Keramik Ceramic Céramique*, Hamburg: Facheltrager-Verlag.

Kettle's Yard (2000) *Perfidy: Surviving Modernism.* Cambridge: Kettle's Yard.

Koplos, J. and Borka, M. (1992) *The Unexpected: Artists' Ceramics in the 20th Century.* s' Hertogenbosch: Museum het Kruithuis.

Leslie, E. (1998) 'Walter Benjamin: Traces of Craft', *Journal of Design History*, 11(1), 5–13.

Lewison, J. (1993) *Ben Nicholson.* London: Tate Gallery.

Loos, A. (1998) 'Pottery', in A. Opel (ed.), *Adolf Loos, Ornament and Crime: Selected Essays.* California: Ariadne Press.

MacCannell, D. (1999) *The Tourist: a New Theory of the Leisure Class*. Berkeley: University of California Press.

Malécot, P. and Saddy, P. (1988) *Le Corbusier: le passé à réaction poétique*. Paris: Ministere de la culture et de la communication.

Miller, D. (1997) 'Consumption and its Consequences', in H. Mackay (ed.) *Consumption and Everyday Life*. London: Sage.

Musée Matisse (1996) *La Céramique Fauve: André Metthey et les peintres*. Paris: Réunion des Musées Nationaux.

Naylor, G. (1999) 'Modernism and Memory: Leaving Traces', in M. Kwint, C. Breward and J. Aynsley (eds) *Material Memories: Design and Evocation*. Oxford: Berg.

Ogata, A. (2001) 'Artisans and art nouveau in fin-de-siècle Belgium', in L. Jessup (ed.) *Antimodernism and Artistic Experience: Policing the Boundaries of Modernism*. Toronto: University of Toronto Press.

Painter, C. (2001) *Close Encounters of the Art Kind*. London: Victoria and Albert Museum.

Parry, I. (1997) 'Rilke and Things', in T. Harrod (ed.) *Obscure Objects of Desire: Reviewing the Crafts in the Twentieth Century*. London: Crafts Council.

Philpot, C. and Tarsia, A. (2000) *Live in Your Head: Concept and Experiment in Britain 1965–75*. London: Whitechapel Art Gallery.

Pope, N. (2001) *A Public Auction of Private Art Works*. Cambridge: Commissions East.

Read, H. (1934) *Unit One: The Modern Movement in English Architecture, Painting and Sculpture*. London: Cassell.

Rhodes, C. (1996) 'Through the looking-glass darkly: gendering the primitive and the significance of constructed space in the practice of the Brucke', in L. Durning and R. Wrigley (eds) *Gender and Architecture*. Chichester. John Wiley & Sons.

Richard Salmon/Kettle's Yard (1997) *Craft*. London: Richard Salmon.

Richard Salmon/John Hansard Gallery (1999) *Furniture*. London: Richard Salmon.

Silver, K. (2000) 'Pots, politics, paradise', *Art in America*, March, 78–141.

Smith, G. and Hyde, S. (1989) *Walter Crane 1845–1915: Artist, Designer and Socialist*. London: Lund Humphries/Whitworth Art Gallery, Manchester.

Tate Gallery (1985) *St Ives 1936–64: Twenty Five Years of Painting, Sculpture and Pottery*. London: Tate Gallery.

Tillyard, S. (1988) *The Impact of Modernism: Visual Arts in Edwardian England*. London: Routledge.

Van der Velde, H. (1992) *Récit de ma Vie 1863–1900*, Vol. 1, ed. Ann van Loo, Brussels: Versa/Flammarion.

Wentworth, R. (1998) *Thinking Aloud*. London: Hayward Gallery Publishing.

–5–

The Art of Home-making and the Design Industries
Tim Putnam

Assessing the relationship between contemporary art and the home brings together two histories: that of the domestic in art practice and that of art in home-making. As for the former, it is important to acknowledge that much of the subject matter of the fine arts through their history has been and remains domestic. Within this, polarizations have taken place between the norms which have arisen around certain artistic avant-gardes and those associated with domesticity. In one place, family hierarchy and parental authority has been contested, while in another the domestic is disdained as inconsequential in comparison with the public realm. This difference between the domestic as too much and too little reminds us that the position of home and family in the world has been subject to significant change. The bourgeois patriarchy against which Baudelaire's *flâneur* is juxtaposed is a world in which family strategies permeate the public as well as the private realm. The emergence of ways by which individuals from diverse backgrounds could establish careers in the arts itself points towards the ascendance of a more universal public space beyond society as an aggregation of families. For some time now, life in the advanced countries is no longer primarily organized by and through families, though kinship remains important. Science-based industry has transformed the house into a multiple terminal of public technical infrastructures and households into qualified supports of this apparatus both as producers and as consumers. The transparency of the house idealized in modernist architecture has come to be widely realized in home arrangement throughout the European culture area, with a corresponding transparency of the household in terms of macro scale forces. Hence the emergence of 'modern' has been paralleled by a redefinition and indeed reduction in the cultural centrality of the domestic, and it's not only artists who have registered this reduction.

As for the place of art in home-making, we must remember that professionally produced art and craft (or design and architecture) taken into the domestic context are intermediate goods which enter into the production, by home-makers, of an environment with a considered aesthetic. Accordingly, we will focus on transformations in the aesthetic orientations of home-makers as the place of home and

family has been redefined. Unevenness in diffusion of cultural change and in awareness of their aesthetic articulation has impeded the diffusion of contemporary art in domestic contexts at certain points in time. Certainly, the period of the spread of science-based industries of mass-production and diffusion has been associated with particular distortions in the organization of markets among the goods entering into home-making, affecting the diffusion of art. The intensive development and diffusion of the infrastructures supporting the conveniences of modern home comfort dominated both social and household investment for several decades of the twentieth century at the expense of both furnishing and the applied arts. Further, the universalizing ideologies associated with this diffusion and reinforced by its association with degrees of social democracy disrupted the existing relationships between both art and design and hierarchies of cultural consumption. The production and consumption of art and design appeared for a time to have been removed from the artisanal and become a cultural branch of mass-production industry.[1] However, rising incomes support discretionary consumption and as the modern-home wave of social capital infrastructure investment has been succeeded by intelligent networks, differentiating cultural content has re-emerged as a focus for both time and money investment. Further, the processes of product development and dissemination elaborated by the design industries through the modern and postmodern phases have played an unintended part in redefining the home-maker as a cultural creator. It thus appears that polarizations between contemporary art and the domestic may turn out to be limited oppositions constrained within particular cultural conjunctures – affected for example by the uneven spread of aesthetic movements or other structuring circumstances across artistic and home-owning practices.

Aesthetic Principles in Home-making

In what follows we will consider certain modes of configuring space operative in both home-making and fine-art practice. By exploring how aesthetic considerations were redefined in the home-making matrix through the period of transformations instanced above, we will gain a perspective on the terms of rapprochement for contemporary art and the home. The term aesthetic is used here in a double sense. On the one hand it refers to categories employed (with varying degrees of explicitness) in articulating and assessing creative practice in a particular cultural context. On the other it refers to a discourse which involves a degree of abstraction from – and therefore permits comparison between – these contexts. In this second sense, we can imagine an aesthetic domain as involving universalizable categories of judgement. Kant believed that standards of judgment comparable to those of pure and practical reason were implicit in discourses of taste. While this may seem

fanciful, the elaboration of a discourse of cultural choice which brings into relation commodity circulation, design innovation, individual mobility and formation is of pivotal importance. Equally, the realization of such a discourse depends on choice, mobility, commodification and value change in artefacts, in a history of design. Thus, as Bourdieu emphasizes in his critique of Kant, aesthetic discourse is not only part of a bourgeois age and consonant with a bourgeois world-view but characterizes practices which establish relations of power by abstracting both people and objects from immediate contexts – in contradistinction to the 'popular aesthetic' which, in making a virtue of its rootedness in particular social and material contexts, does not admit the possibility of aesthetic discourse in the full sense (Bourdieu 1984; Putnam 1995).

Thus the aesthetics of home-making not only articulate domestic life but define a place for the home – and through it, the household – in the world. The aesthetics of the home are inscribed in its inhabitants. This articulation involves discriminations of many kinds; for this discussion, we will focus on principles which relate the structure of the made and orders of perception, cognition and behaviour which turn up in the configuration of space for both activity and contemplation, that is, in domestic architecture, home arrangement and decoration.[2] These principles must be translatable both into modes of living – that is, the competence developed through routinized dispositions in and of lived space, and the knowledge embodied in the professional competence of architects, the design industries and the arts. Relations between the domains of home-making and the design industries may vary considerably: historically, those providing making services once largely followed 'traditional' patterns defined by modes of living. The elaboration of patterns and plans and the technologies of construction and equipment have acquired dynamics of their own and may be co-ordinated in production and marketing to the extent that whole 'lifestyle' environments may be offered. However, communication between clients and makers is still necessary in order that design elements can be revalidated in relation to modes of living (Putnam 1995).

Aesthetic principles such as those with which we are concerned help organize such communication. They must be adequate to a number of different kinds of requirement if their validity is to be sustained, and where supporting circumstances are no longer congruent, the referents of elements or the rules of their interrelation may be redefined (DeVilliers and Huet 1981). Within the last three hundred years two very different paradigms for the configuration of space have been evident across the profusion of styles of domestic architecture, home arrangement and decor seen in the European culture area. In the first, space is bounded, segmented, and graded. Activities are composed and balanced around a geometry of axes, permitting social and family relations to be mapped onto the human frame, and vice versa: a hierarchy of 'high' over 'low' is used to privilege the mental, the moral and the ancestral, a subordinate horizontal symmetry models conjugal

complementarity, while the social front turns its back on the 'services' on which the household depends. In the second, space is extensive, continuous and fluid. Containment and orientation is mutable, and horizontality, asymmetry and transparency accommodate multiple foci and changing patterns of activity. Openness and equivalence of treatment emphasize the interdependence of household activities. We will refer to the first pattern as 'classical' and the second as 'modernist'.

As formal systems, these are quite opposite: alternative and apparently mutually exclusive ways of constructing cultural possibilities. Beyond the articulation of space, they extend into the choice and disposition of objects, and the treatment of surfaces. Just as the modernist interior does not contain and orient persons, neither does it contain and orient collections of objects. Whereas 'classical' decoration grounds an enclosure, 'modernist' surface treatment qualifies enclosure, detaching places from each other. The paradigms have clear counterparts in the world of art. Their juxtaposition is well characterized by the distinction Rodchenko and his associates made between 'construction' and 'composition', in any medium. Significantly, in terms of our later discussion, Constructivist principles explicitly set out to provide for new modes of living with methods derived from what they understood as science-based methods of making (Hulten 1979: 250–72; Barris 1993).

The 'Classical' Paradigm

In domestic space, the formal characteristics of our paradigms are made homologous with dispositions of modes of living and particular ways of actualizing possibilities for producing elements of domestic material culture. The nature of the aesthetic must articulate the circumstances impinging on professional design and the production of houses with those impinging on the parameters of households. The classical paradigm characteristic of the first great period of commodified accommodation served to relate building technologies which were largely artisanal and additive, domestic services delivered by human labour, with or without tools, kinship structures becoming more collateral than dynastic in a society and economy permitting individual agency and mobility but organized predominantly through familial networks, alliances and patronage (Trumbach 1977; cf. Halttunen 1982, Putnam and Newton 1990, Putnam 1995). The constraints inherent in simple labour-intensive building and service technologies appeared natural at the time, and form was believed to derive principally from living modes. The most elaborated forms of knowing the world and the technologies depended from them were focused on recognizing: naming, describing and placing the given in a cultural order. Representation was not, therefore, a special preserve of the arts.

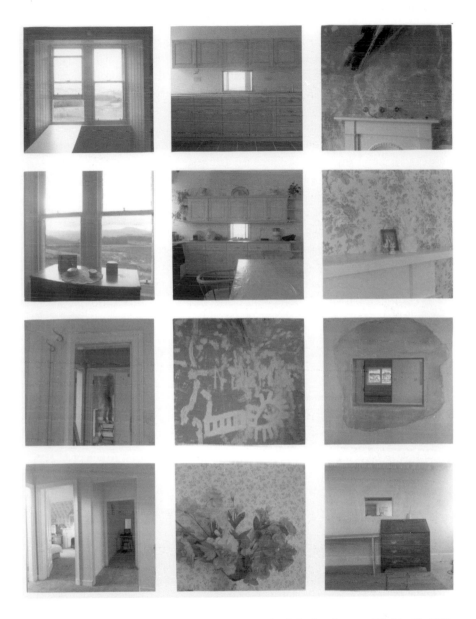

Figure 5.1 The interpenetration of 'classical' and 'modernist' values is exemplified in this 1990 study of home renovation by photographer Mary Cooper, commissioned for the Household Choices Project, Victoria and Albert Museum and Middlesex University, with the support of the Arts Council of Great Britain.

To the extent that the values of these parameters could be made homologous through alignment according to a set of principles, they formed a mutually reinforcing whole. What is now recognized as a paradigm was formed over time as a result of alignment of discrete orders of phenomena. The designation 'classical' refers most of all to a combination of anthropomorphism and axial geometry. But these formal properties only became important in orienting home-making as they were aligned with key features of modes of living and thus imbued with content. Pioneering demonstrations of these were made in Palladio's villas, where vertical hierarchy on the one hand and the vista on the other were mapped on to service and wider social relations. The planning of larger houses in early modern Europe shows a variety of experiments with composing elaborated social space in these terms. Urban contexts restricted the use of symmetry, as did the divergent requirements of spaces for elaborating public and private activities. In eighteenth-century England, internal stability and the emergence of collateral, couple- centred, family structures led to a fashion for diverting and varied spaces, for example in garden design, at the expense of the effect of domination; height became used more to conceal and reveal rather than impose. Relentlessly, great elaboration and part-industrialization of decorative art production added new discriminations to cultural capital while extending access to the existing.

While the great elaboration of domestic material culture thus took place in a dialogue between the arts and their greater patrons, the central features of the classical paradigm were shaped by those features which were most extensively adopted, as follows:

1. Where conditions permitted, the separation of key elements from the common room, first a parlour – at once householder bedchamber, storehouse of valuables and place of ceremonial reception, where possible placed to visibly balance (though seldom exactly equal) the principal room, a working kitchen placed behind, and sleeping for other (eventually all) household members placed above; thus the emergence of a central entry hall and eventually stairs, and/or corridors.
2. Most remarkably, visible evidence that houses address the public space, even where this was notional as in the country: orientation to the street or building-line identification of a public façade with a balanced, quasi-symmetrical and vertically hierarchical composition, employing simplified elements of polite architecture in e.g. doors and windows, plinths, soffits.[3]
3. Further, the articulation of decorative hierarchy within the house using similar elements and respecting the same principles: thus differences in the elaboration of joinery, wall treatment, styles of furnishing and object display were used to designate entries and principal rooms which were given over to reception.

Even in modest houses, the unity of classical composition was addressed by mutual reference between architectural decoration and the architectural language of principal furnishings. Chimneypieces were particularly important as architectural elements in orienting activity and contemplation. In the common room the hearth was the centre of many activities, literally the centre of the house. The differentiation of kitchen from the common room and refinements in hearth design may have distributed activities away from this hearth, but at the same time permitted the emergence of a more purely social and symbolic hearth in the principal room; the strong vertical emphasis of the chimney piece, with its dynastic associations, began to be balanced in the eighteenth century by the mantel shelf disposing objects, the collateral sociality of its horizontal plane often reinforced by a glass. As mobility declined in the later Victorian period, an overmantel fitting with a gridded *étagère* was added to the hearth to enhance its capacity to orient regard in a room more densely figured and populated with *bibelots*.[4] Victorian hall furniture articulated the same elements for similar purposes. As Ames has shown in respect of North American examples, symmetry around a vertical axis was particularly stressed as a representation of 'the house', i.e., the family (Ames 1984).

The 'Modernist' Paradigm

During the first half of the twentieth century, the classical paradigm was challenged and in some contexts supplanted by another with values to all its variables systematically opposite in a way which cannot be coincidental. In a discursively self-conscious way, 'modernist' space was defined in opposition to 'classical' space. It was a more abstract space in every way, dematerializing the apparent foundations of society to reveal principles from which new possibilities could be fashioned. Its accord with the depth of analysis in scientific understanding and the extensive, synthesizing dynamics of technology was appreciated by a wide circle of modernist protagonists beyond those associated with Constructivism and DeStijl, who championed it as such. If, as Buckminster Fuller observed, few of this modernist avant-garde understood enough about contemporary science and technology to make more than a gestural interpretation of it, their aesthetics had supports in the new material culture (Banham 1960: 329). Constructional techniques permitted, indeed encouraged, the making of extensive spaces with flexible partitions, with service and communication technology networks, revised locational priorities and activity configurations. The rationalized culture of modern science-based industry and its educational supports, mass communications and public administration, where people found their way through arrays of functions, could be aligned easily enough with this aesthetic. But what of the sphere of home and family?

We have argued that a paradigm for domestic spatial configuration must have not only formal coherence as an aesthetic, but be capable of being made adequate to the expression of predominant modes of making and of use – what we have called modes of living. As we have seen, this means not only the pattern of household routine activity but also of supports for contemplation, memory and social relations. Would adoption of an aesthetic which formally systematically inverts previous values imply a corresponding radical change in mode of life? The answer must be yes if the mapping of formal properties onto their referents remains the same. But if the terms of this mapping change such that a particular relation no longer signifies what it did, then not. And if a pattern of such change produces a more self-conscious awareness of one set of terms as a cultural order in its own right, as 'code', the nature of the homologies mapped through the aesthetic elements is shifted to another level and opposition to the previous relations of meaning is sublimated, allowing the presence together of formally opposing elements (Morley 1990).

This cultural logic is evident in the elaboration and adoption of the modernist paradigm for domestic space. The early architectural elaboration, if an exercise in visual polemic against the 'classical' unities of bourgeois propriety, quickly established a resonance with science-based industry in redefining the normal house as one built around new service infrastructures and appliance technologies. Thanks to a complex involvement of the state, the 'modern home' became universal in reality only a few decades after the prototypes. Infrastructure commitments, and especially public-housing investments, forced development in a direction and at a pace that would never have been brought about by market processes alone. Whereas emulation and 'trickle-down' effects were important in the emergence and diffusion of the classical model, the modern home was promulgated by a frontal assault of the domestic design industries (Putnam 1993, 1995).

The process of promoting the modern home placed firm bonds between the service technologies and domestic routines at the centre of domestic spatial orientation, cutting across the frontstage/backstage structure inherent in the status-oriented classical model. Public acceptance of visionary convenience and comfort was widespread and enthusiastic.[5] Industrially designed kitchens and bathrooms brought elements of the new aesthetic into most homes. Key relationships in the classical paradigm were also dissolved by changes in heating and lighting technologies which permitted a reconsideration of the function of rooms in everyday use. Spatial extensiveness thus began to acquire a practical meaning.

If comfort and convenience were the banners under which the modern home ideal first won acceptance, its aesthetic also acquired a wider resonance in modes of living. Already at the end of the nineteenth century, certain elite cultural groups had begun to advocate a simplification of domestic decor and openness in planning

on grounds of integrity, views which were to find an echo among those concerned with health and hygiene.[6] Interestingly, both views were strongly associated with the rapidly growing 'rational' professions working in the public and corporate organizations which by mid-century were to link polity, economy and society. Adherence to the modern paradigm has thus in a real sense been associated with the emergence of new modes of living in which individuals project themselves through a world at once more extensive in travel and communication, unified in organization, and objectified in knowledge; a world at once more present in the home and mediated in more elaborate ways (Putnam 1993; Halle 1993; Gullestad 1992).

While not everyone was equally enthusiastic to live in such a world, its gradual acceptance filled in the interpretation of the modernist domestic paradigm. Households have become smaller, as couples first demanded to live apart from their parents and as the number of single-person households has increased. Family networks and alliances have become more shaped by than shaping of life chances, and the value given key relationships partly in appreciation of their contingency can be seen in little clusters of 'snaps'. Where life was built of locally constructed relationships, neighbours may now seem strangers, and houses often turn their backs on the street (Halle 1993). A greater consistency in decorative treatment corresponds to more fluidity in the place of activities (and possible visitors) in the house. Such changes in modes of living are uneven in their spread and have taken more than a generation to emerge, but are now recognizable over the European culture area. In many respects, significant changes in the use of domestic space and the nature of home are continuing, for example in the personal space and social autonomy of resident youth and in the refocusing of attention in relation to personal and shared use of information and communication technologies.[7]

We have seen significant shifts in modes of living which are disruptive of the reinforcements in classical paradigm and accord better with the cultural logic of the modernist aesthetic. Further, these can be shown to be linked with the redefinition and realignment of aesthetic dispositions attached to the classical paradigm toward that of the modernist paradigm. Evidence of these is abundant even in the British case where, partly due to the high-percentage occupation of older housing stock, the adoption of the modernist paradigm has apparently been most qualified. Inter-war wallpaper catalogues show a lifting of figure from ground which breaks the grounded classical enclosure and 'floats' the wall; paint palettes through the same period show a progressive lightening; overmantels disappear and fire surrounds are lowered and reconfigured first as detached delineated construc-tions then, boxed in pastel tiles, dissolved into the room space. Displayed object counts in principal rooms plummet, and their arrangement becomes less sym-metrical. These trends were well underway before the war. In the 1950s, innumer-able examples of architectural ornamentation are boxed in, or ripped out. In the

1960s room boundaries begin to be 'knocked through' with a vengeance, and patio doors to the garden begin their inexorable proliferation.

Such changes do not realize Mies' Barcelona Pavilion, or the Wiessenhof Seidlung. Bearing that in mind, modernist architectural critics and subsequent historians have, with an enthusiast's short sight, chosen to suppose a British resistance to the modernist paradigm which longer-term evidence of cultural change does not support. Compared to the two or three centuries over which the classical paradigm was established as general cultural terms of reference, a couple of generations is not a long period for paradigm change to be established. What has been evident in the British case, as indeed elsewhere in the European culture area, is a willingness to combine and shift available elements.[8] While this may appear to design and architectural historians as 'eclecticism' or ignorance, it may also be evidence of confidence in moulding a mode of living, or cosmopolitan sophistication.

The Contemporary Matrix

Beyond differences of context, it is clear that in the domestic sphere the modernist spatial paradigm has not so much replaced the classical paradigm, against which it was defined, as come into a more or less easy coexistence with it. In a European survey of arrangement of the living room conducted in 1987, values associated with the two aesthetics register as discriminants in otherwise differing national contexts (Bonnes et al. 1987). In effect, they continue to signify as alternatives for domestic decor, confirming their formal coherence as sets of values. How these properties are mapped onto modes of living, however, may be more context-specific than aggregate survey results suggest, even though there were mildly significant positive correlations (in 1985–6) of modernist elements with relative education and affluence and negative ones with age. What appear formally to be the same elements may well not play equivalent roles in different contexts. We have also noted considerable evidence of selective adoption and interpenetration of these two sets of values. Evidently, many contemporary home-makers have taken on board the classical and the modernist paradigms as a matched set of codes and realize a balanced interpretation of their opposed values according to their living-mode priorities. Pratt's (small-scale qualitative) study in Vancouver found the 'pillars of society' implementing a restrained, simplified and lightened inter-pretation of the 'classical' paradigm in leafy suburbs while incomers and entrepre-neurs exhibited lavish idiosyncratic expressions of 'modernist' space in the dunes.[9]

Systematic coherence in phenomena which bridge home-making and everyday routine on the one hand and objectified discursive or material systems on the other require repeated adjustment to the mapping of referents. As the evolving ranges

of the design industries and modes of life grind against each other like glaciers, meanings are altered. What counts as 'modern' or 'high-quality' in a particular context is relative to what is available to those in that context, and may change as availability changes.[10] Similarly, to choose a wallpaper where figures float above a ground which is not anchored firmly in the bounded and graded space of the room is clearly an element of modernist paradigm and can be shown to be appreciated in terms relevant to its most often referenced values, e.g. openness, space, lightness, etc.[11] However, in terms of a full professional discursive specification of modernism, this might well signify as negative (and so observed many modernist critics) (Morley 1990). Therefore the aesthetic principles employed by home-makers can not simply be read off their object choice and arrangement. It is necessary to explore how home-makers deploy categories within their mode of living and determine the terms of the assimilation of discursive formulations or representations in the pragmatic judgements of domestic life routines.[12] Using cultural awareness to transform environments /emplacement may only involve placing one's life within a particular discursive space to a limited extent. The selective and partial adoption of professionally elaborated design elements into generic cultural paradigms and particular modes of living often confounds expectations in the design industries and leads to professional criticism of limited popular understanding or appreciation of the discourse.

If the terms of adoption arise within modes of living, the appropriation of professionally produced art, design and architecture is greatly affected by the organization of industry channels of dissemination. In the heyday of the classical paradigm the main sources for the acquisition of both furnishings or criteria for home arrangement were found in a familial and neighbourhood context which might therefore be justly termed traditional; advice literature or critical opinion recommending or cultivating a particular taste or the advertising of firms was ancillary to personal contact. Circles of advice including publication were also generally small, and shop or department store staff were often the only link to the design industries. That is not to say fashion or explicit discursive formations were not important, but that style in this sense was filtered strongly through particular social nests and thus became suffused with and read as character and status (Halttunen 1982). This was true at differing levels of household expenditure.

The era when the modernist paradigm emerged was the era of mass media and broadcasting and accordingly of impersonal context-independent discussion and circulation of advice. The content of the modernist address as well as its mode of communication was also universalist and therefore less imbued with particular readings of status; not infrequently, it was suffused with social democratic ideologies. Accordingly, despite the uniformity of address, it became possible to see and think outside the many limitations of local contexts and act in accordance with this wider circulation of information.

All industries found in this period that the relations of sale and of consumption were changing and that firms needed to project themselves in to this space, even in the making of machine tools. Design advice became more extensively and explicitly offered – this shift in the form and channels of mediation through the century perhaps changed the cultural significance of the design industries more than any changes in the design produced – affecting all sectors and also the design professions, as personal advice to clients was resituated within systematized advice (Putnam 1988). Interior-design advice for the home had become packaged to the extent that this work could no longer be sustained as a professional activity.[13] It become an adjunct of the integration of retailing with the domestic design industries, where the development and marketing of new co-ordinated ranges of designed goods became a major axis of growth.

This formalization of design advice in the marketing of goods for the home – a design education of the public beyond the wildest dreams of design critics – has redefined the terms of engagement between home-makers and professionals across the aesthetic paradigms with which we have been concerned. Because formalization was hitched to commoditization it favoured the piecemeal assimilation of discursive elements within householders' bricolage of the environments for playing out their life practices and strategies. The establishment of the classical paradigm also depended on the widespread adoption of formal elements of architecture, variously understood and interpreted. But this process was anticipated in the transmission of formal elements of modernism and increasingly pre-organized by the design industries in relation to speculative projections onto modes of life. The authoritative mode of address adopted by modernist advice in the early days of asserting its universality was soon displaced in advertising by an insinuating mode of address – and it was not only status that was again connoted but also categories ascribed to the subjectivity of the consumer, such as 'leisure' and 'pleasure', which transformed convenience from a quantitative to a qualitative mode.[14] Within this context, new modes of market segmentation were projected once the high tide of modern home infrastructure investment and its legitimating universalist discourse had passed.

By the mid-1980s many social scientists and cultural critics as well as those directing the design industries had become convinced that projective social identification through selective consumption of design for the home was a major phenomenon, especially in the British context where home ownership received both economic and ideological reinforcement. However, those who closely examined home-making decisions found more fundamental processes at work: first, investment in adapting and rearranging the dwelling to accommodate continuing change in living modes, where already altered relations between the genders and most importantly between the generations were presenting new aspects in relation to information and communication technologies; and second,

investments within widely varying terms of reference, to personalize domestic space – that is, to incorporate into its material culture more satisfying extensions of self, whether through representation or the alteration of spatial disposition or equipment. The processes through which design advice became packaged in the marketing of goods for the home played a key role in enhancing the sophistication of this personalizing capability, and thereby increased the possibility of the selective use of the principles of the classical and modernist paradigms by householders.

As many design firms found out to their cost in this period, the space for branded goods and packaged lifestyles in the home market was squeezed between drives present in differing ways in all contemporary modes of living.[15] The self-deception of many in the design industries at the outset of 'postmodern' developments was principally due to overlooking or underestimating the scope and fundamental character of the work undertaken by home-makers in achieving an aesthetic realization of evolving modes of living. Many never escaped self-satisfaction with their professional recognition and confidently extrapolated its aesthetic terms of reference beyond the niche metropolitan audiences which refer to this world, and others such as Habitat and Laura Ashley, which did succeed (in quite different ways) in offering ranges distinctive and flexibly assimilable enough to acquire a broad clientele for a time, struggled to renew their relevance. At the other extreme, firms risked many millions on the advice of consultants armed with impressively segmented surveys and success with brand development in other fields, but little understanding of design, cultural process or home-making. A common deception among design professionals in this period was to overlook the cumulative impact of the marketing strategies pursued by design industries on the consumer. The contemporary home-maker is constantly learning and is capable of matching all but the most dedicated professional in energy, commitment and discerning knowledge of their requirements. Everything which has been offered by the design industries has entered into this process of learning and is remarkably quickly absorbed, with unintended consequences for retailers in some cases.

Conclusion

From our discussion, there are a number of reasons for renewed optimism about the reception of contemporary art in the home. First, the European culture area has largely assimilated the cultural consequences of the massive structural changes associated with the emergence of the modernism which transformed both art and the domestic. Key elements of the modernist paradigm have been aligned with contemporary modes of living to the extent that it is now dominant in home arrangement and established alongside the classical paradigm as a generic cultural

resource. As this polarization is de-antagonized in vernacular practice and the functional adaptation of domestic space to living requirements is resolved, cultural aspects of personal extension into the living space will increase relatively in importance. The capacity of 'designer label' goods to fulfil expectations of this kind is quite limited; the space for original art production to enter the domestic sphere on an extensive scale is already increasing. Certainly, the taste for art is extending beyond a personalizing exercise of home-making discretion as previously understood and is included by many young individual home-makers as an essential component of establishing a home. This suggests that distinctive ways of materializing experience are increasingly being considered a kind of necessity.

Of course, neither contemporary art nor home-making will stand still, and their place in life activity as a whole will continue to be the subject of forces which are already evident and interact increasingly with evolving intelligent media and communication technologies. The modernist spatial paradigm involves a certain mutual adequation of an objectivized universal space, infinite and abstract, but by the same token objective and transparent, with a way of conceiving of personal choice and movement (actualized for example in the equal treatment of differing and moving points of view in the frame, and the absence of binding hierarchy or grading of space as impinging on the subject). As information and communication technologies extend the dimensionality of space beyond the visual and the present, beyond the moment, they will begin to bypass the transparency and undermine the self-evident centrality of this kind of space. Effective personal space for choice and consideration, let alone imagination, will become less tied to co-present physical surroundings, however extensive, with major consequences for the meaning of home, but more generally for the surface between subjectivation and available objectifications of space and of time (Dunne and Raby 2001).

These developments will offer new readings of the emergence of modernist universalism and the rupture between composition and construction which cut across both the arts and the making of the domestic. They will open new territory for both home-making and art practice.

Notes

1. However, in some European countries through the twentieth century the consumption of art has a considerably broader base than in others, reflecting an orientation among artistic producers as well as sellers to address a proportionately more inclusive public, as well as expectations among cultural consumers about the uses of art.

2. Our specific concern is with principles for organizing activity and representations in space in the sense studies by Tuan (1977) or Canter (1977) rather than to describe or attempt to account for the adoption of particular styles of arrangement and decoration as in histories of decoration or specific taste formation. In particular, we are interested in the relationship between that which is produced within the context of a professional discourse and those generic principles adopted (more or less explicitly) by home-makers sharing a culture. Such relations have been the subject of pioneering studies by Boudon (1969) for the modernist paradigm and Glassie (1975) for the classical paradigm.

3. Alfrey and Clark, (1994). This culture of public address was diffused along major axes from urban centres: e.g. in Britain, along major turnpikes in the late eighteenth and early nineteenth centuries.

4. An article by the author on mantelpieces in the British popular home is forthcoming in Ecker et al. 2002.

5. The opportunity to enjoy 'American-style' domestic appliances emerged as the most desired post-war change in the British home in Mass Observation's 1944 survey. In one of many stories of this type, when the residents of Glasgow's Gorbals slums were to be decanted into the brave new world of high-rise housing a decade later, they burned their old household goods in a street festival of passage and filled their new homes with modern furniture bought largely on credit. Personal communication from Elspeth King, Glasgow Museums Service.

6. Wright (1980). This may be instructively compared with Halttunen's (1982) study of the period of design purification which preceded the great Victorian elaboration of material culture.

7. These trends emerged strongly in a study co-directed by the author, *Household Choices*, involving an exhibition at the Victoria and Albert Museum and elsewhere, with the support of the Arts Council of Great Britain. See Putnam and Newton (1990).

8. Aspects of the modernist paradigm, such as 'open plan', window walls, galley kitchens and flat roofs had a very uneven reception when they first entered the housing stock, particularly when they were not chosen by householders. Gradually, through a series of experiments and adjustments, they have been adjusted and accommodated to varying degrees in living models (see Boudon 1969; Pratt 1981; Putnam and Newton 1990; Attfield 1999; Pennartz 1999).

9. See Pratt (1981). Considerable academic and commercial attention has been devoted to the matching of combinations of domestic design values with particular social groups, but less to the dynamics of processes which may bring them into relation. See, however, Warde (1997).

10. Morley (1990), for example, found that 'modern' was a positive value for those setting up home in South London after the Second World War, but that this principally signified what was newly available as distinct from that which was handed on. Similarly, associations of 'quality' with particular materials and signs of workmanship were redefined when industry restructuring removed these from popular British furniture.

11. Such changes may be seen in the wallpaper collection of the Silver Studio Archive, Museum of Domestic Architecture, Middlesex University.

12. Several avenues for research open up here. Pennartz (1999) and Putnam and Swales (1999) set out a phenomenology of householders' priorities and Shove (1999) examines interdependence of choices. Miller (1990) and Munro and Madigan (1999) draw attention to relations between household members. Bachelard (1964) and Marcus (1995) explore dimensions of subjectivity while Segalen and LeWita (1993) and Chevalier (1999) explore those of family trajectory.

13. See the study conducted by Hope James for the MSc Interior Architecture, Middlesex University 1989.

14. This development was well surveyed in Nicholas Barker's series for BBC2: *Washes Whiter.*

15. Author's interviews with and personal communications from design managers and marketing consultants of recognized sector-leading firms in home furnishing, 1986–92, for the Household Choices Project, Victoria and Albert Museum and Middlesex University, established that it was much easier to project and produce new styles and ranges on an expanded scale than it was to connect these with appropriate user contexts. Both the quality of knowledge of contexts and the effective use of it in professional design processes were found to be limited, as was the understanding of the reception of the firms' design and marketing output. Nearly all respondent firms faced severe economic difficulties in the survey period involving shortfalls in projected purchase.

References

Alfrey, J. and Clark, C. (1994) *Landscape of Industry: Patterns of Change in the Ironbridge Gorge.* London: Routledge.

Alfrey, J. and Putnam, T. (1992) *The Industrial Heritage: Managing Resources and Uses.* London: Routledge.

Ames, K. (1984) 'Meaning in Artefacts: Hall Furnishings in Victorian America', in T. Schlereth (ed.) *Material Culture Studies in America.* Nashville, Kentucky: American Association for State and Local History, 206–21.

Attfield, J. (1999) 'Bringing modernity home: open plan in the British domestic interior', in I. Cieraad (ed.) *At Home: An Anthropology of Domestic Space.* Syracuse: Syracuse University Press, 73–82.

Bachelard, G. (1964) *The Poetics of Space.* Boston: Beacon.

Banham, R. (1960) *Theory and Design in the First Machine Age.* London: Architectural Press.

Barris, R. (1993) 'Inga: A Constructivist Dilemma', *Journal of Design History,* 6(4), 263–82.

Bonnes, M., Giuliani, V., Amoni. F. and Bernard, Y. (1987) 'Cross-cultural Rules for the Optimisation of the Living Room', *Environment and Behaviour,* 19(2), 204–27.

Boudon, P. (1969) *Lived-in Architecture: Le Corbusier's Pessac Revisited.* London: Lund Humphries.

Bourdieu, P. (1984) *Distinction: a Social Critique of the Judgement of Taste.* London: Routledge & Kegan Paul.

Canter, D. (1977) *The Psychology of Place.* London: Architectural Press.

Chevalier, S. (1999) 'The French two-home project: materialization of family identity', in I. Cieraad (ed.) *At Home: an Anthropology of Domestic Space.* Syracuse: Syracuse University Press, 83–94.

Cieraad, I. (ed.) (1999) *At Home: an Anthropology of Domestic Space.* Syracuse: Syracuse University Press.

DeVilliers, C. and Huet, B. (1981) *Le Creusot: Naissance et Développement d'une Ville Industrielle 1782–1914.* Macon: Champ Vallon.

Dunne, A. and Raby, F. (2001) *Design Noir: The Secret Life of Electronic Objects.* Basel: Birkhauser.

Ecker,G., Breger,C. and Scholz, S. (eds) (2002) Dinge. Medien der Agneinung Aneignung – Grenzen der Verfügung Königstein: Ulrike Helmer Verlag.

Glassie, D. (1975) *Folk Housing in Middle Virginia: a Structural Analysis of Historic Artefacts.* Knoxville: University of Tennessee Press.

Gullestad, M. (1992) *The Art of Social Relations: Essays on Culture and Social Action.* Oslo: Scandinavian University Press.

Halle, D. (1993) *Inside Culture: Art and Class in the American Home.* Chicago: University of Chicago Press.

Halttunen, K. (1982) *Confidence Men and Painted Women.* Yale: Yale University Press.

Hulten, P. (ed.) (1979) *Paris–Moscou 1900–1930.* Paris: Centre Georges Pompidou.

Marcus, C. C. (1995) *House as a Mirror of Self.* Berkeley: Conari Press.

Mass Observation (1944) *Peoples' Homes.* London: Mass Observation.

Miller, D. (1990) 'Appropriating the State on the Council Estate', in T. Putnam and C. Newton (eds) *Household Choices.* London: Futures, 43–55.

Morley, C. (1990) 'Homemakers and design advice in the postwar period', in T. Putnam and C. Newton (eds) *Household Choices*, London: Futures, 89–97.

Munro, M. and Madigan, R. (1999) 'Negotiating space in the family home', in I. Cieraad (ed.) *At Home: an Anthropology of Domestic Space*. Syracuse: Syracuse University Press, 107–17.

Pennartz, P. (1999) in I. Cieraad (ed.) *At Home: an Anthropology of Domestic Space*. Syracuse: Syracuse University Press, 95–106.

Pratt, G. (1981) 'The house as and expression of social worlds', in J. Duncan (ed.) *Housing and Identity: Cross-Cultural Perspectives*. London: Croom Helm.

Putnam, T. (1988) 'The theory of machine design in the second Industrial Age', in *Journal of Design History*, 1(1) 25–34.

Putnam, T. (1993) 'Beyond the modern home,' in J. Bird et al. (eds) *Mapping the Futures: Local Cultures, Global Change*. London: Routledge, 150–65.

Putnam, T. (1995) 'Between taste and tradition: decorative order in the modern home', in *Journal of the John Rylands University Library of Manchester*, 77(1) 91–108.

Putnam, T. (1999) 'Post-modern home life', in I. Cieraad (ed.) *At Home: an Anthropology of Domestic Space*. Syracuse: Syracuse University Press, 144–54.

Putnam, T. and Newton, C. (eds) (1990) *Household Choices*. London: Futures.

Putnam, T. and Swales, V. (1999) 'Défaire et faire les habitudes dans le déménage-ment', in M.-P. Julien and J.-P. Warnier (eds) *Approches de la culture matérielle; corps à corps avec l'objet.* Paris: L'Harmattan, 119–34.

Segalen, M. and LeWita, B. (eds) (1993) *Chez-soi. Objets et décors: des créations. familiales?* Paris: Editions Autrement.

Shove, E. (1999) 'Constructing home, a crossroads of choices', in I. Cieraad, (ed.) *At Home: an Anthropology of Domestic Space*. Syracuse: Syracuse University Press, 130–43.

Silverstone, R. and Hirsch, E. (eds) (1992) *Consuming Technologies: Media and Information in Domestic Spaces.* London: Routledge.

Trumbach, R. (1977) *The Rise of the Egalitarian Family*. London: Academic Press

Tuan, Y. (1977) *Space and Place: the Perspective of Experience*. Minneapolis: University of Minnesota Press.

Warde, A. (1997) *Consumption, Food and Taste*. London, Sage.

Wright, G. (1980) *Moralism and the Model Home: Domestic Architecture and Cultural Conflict in Chicago, 1873–1913*. Chicago: University of Chicago Press.

What Would We Do Without It?
A Few Thoughts About Reproduction in
the History of Art

Anthony Hughes

The role that reproduction has played in the history of Western art since the Renaissance has been significant, even if it has often been only occasionally and imperfectly acknowledged. One reason for its neglect may be the common-sense perception that reproductions are by their very nature inferior products. Jonathan Richardson wrote of the hand-made facsimile that 'the ideas of better and worse are generally attached to the terms original and copy' and he added that, 'ordinarily the copy will fall short' (Richardson 1719). His sentiment has been endorsed ever since and strengthened, if anything, by the advent of photography. Historically, things have been less cut and dried than Richardson and his successors would perhaps have liked to acknowledge, but before exploring some of the complexities of the issue, the arguments in favour of Richardson's assertion require acknowledgment. In contemporary terms, the case may be set out simply and clearly.

Let us suppose that a successful art institution – the Royal Academy, say – were to advertise a blockbuster exhibition of world masterpieces, only to charge admission to several rooms full of framed prints. Visitors would undoubtedly feel cheated. However pleasant it might be to pass in a moment from Klimt's *The Kiss* to Monet's *Poppy Field*, the public could justifiably point out that the same experience may be had free by browsing in one of those shops that specializes in reproductions for the home. We would expect to pay an entrance fee only when offered a view of the real items themselves. They are unique; reproductions appear everywhere and can offer only second-class experiences.

Anyone professionally engaged with art can easily provide a long list of reasons why photographs ought to be regarded as poor substitutes for authentic objects. To take only the case of paintings for the moment, it is clear that, however careful the photographer and printer may have been, significant differences between original and reproduction subtly transform the viewer's experience of an image. Relationships between colour and tone are altered by the quality or type of paper on which a picture is printed, and by the scale of representation chosen. Alteration

of scale is more crucial than it seems, as our reactions to pictures that are larger than our own bodies is quite different to those that are significantly smaller, and even involves changes in physical behaviour – how far away we stand, whether we bend forward or backward when looking. Size also affects the kind of things we look for. Texture in reproduction is only present in unsatisfactory form: this applies not merely to the handling of paint on the surface, which may sometimes take the viewer's experience of a picture into the third dimension, but to the more elusive appearance given to an image by the medium and support – oil paint laid on wood or copper, for instance, tends to have greater 'brilliance' than oil paint on canvas because the weave of a textile provides a naturally light-absorbing surface. Photographs eliminate such effects. Experience teaches that many paintings are cropped to a greater or lesser extent when reproduced. Even when this is not the case, they are always torn from their surroundings. When reproductions are hung, intentionally unframed paintings may be framed, or the wrong kind of frame will substitute for an authentic one – painters like Klimt devised their own frames, and regarded them as integral to the picture. Images may be detached from their proper context. Michelangelo's *Erythrean Sybil* set in a discreetly distressed gold frame makes an independent item of a figure which belongs to the complex of the Sistine ceiling. And none of the points made so far addresses the complex issues of cultural context at all: Michelangelo's frescos are quite literally inseparable from the place in which they were painted, a consecrated space still used for its original purpose as the chapel of the papal palace.

The list – familiar to professionals – could be extended. Ironically it is itself a tribute to the ubiquity of reproduction in modern forms of art history, curatorship and commercial dealing. All these activities would be unrecognizable in the absence of the photographic print. Scholars need to remain alert to the possibility of being misled by photographs precisely because they use them constantly. If you are in the business of attributing pictures, to arguing historical cases about them, or providing information about them to the gallery-going public, it is unarguably preferable to use evidence taken directly from the objects themselves.

When we turn from the relatively small world of scholarship to review attitudes to reproduction among the general public, there appears to be a sharp division of opinion. On the one hand, there exists a majority who either casually accept, or positively enjoy, using posters, greeting cards, postcards and prints of old and modern masters as decorative items at home or in the workplace. On the other, is a minority opposed to hanging reproductions on walls. It would be interesting to know how the latter group was formed and constituted (if it is in fact a homogeneous group at all). Perhaps, as the French sociologist Pierre Bourdieu argued, cultural choices of this sort are a product of overlapping factors such as education, social class and profession (Bourdieu 1984), though certain tastes may be deliberately cultivated by socially aspiring individuals. My own impression is that,

while some hostility to the hanging of reproductions may be set down to snobbery pure and simple ('we' are not the sort of people who do that: the meanest original is always preferable), the situation may be more complicated than it at first seems, since many who are happy to decorate their walls with prints will admit that they would prefer to live with the original Bruegel, Van Gogh or Picasso, but that their income obviously prohibits such luxury. In other words, Richardson's notion of the superiority of original over copy often remains intact even when, practically, reproduction fits snugly into the domestic environment.

This attitude, after all fairly reasonable, is also several centuries old. E.H. Gombrich long ago pointed out that the self-denying prejudice against the photographic reproduction as a decoration for domestic spaces is fairly recent (Gombrich 1999). The home of his cultured parents in pre-First World War Vienna contained many examples of framed photographs chosen as reminders of the best art (Giotto and Michelangelo among them), far preferable, in his mother's view, to the mediocre contemporary originals that his parents might have been able to afford. Incidentally, the practice ran to three-dimensional art as well: Freud's Viennese study contained a collection of figurines reproducing ancient bronzes and terracotta statuettes.

It could be argued that a refusal to admit reproductions to the house or flat, whatever its origins, betrays an anxiety that seems social rather than rational or aesthetic, a defensive fear of being misunderstood as a person who can't appreciate the difference between an actual work of art and its copy. After all, those who oppose the use of reproductions as decoration often buy expensive art books containing coloured photographs of paintings which commit many of the standard sins: details may be presented as virtually independent pictures, whole images scaled up or down or inappropriately framed by print or by the white margins of the page. So why, as markers of taste, should reproductions be acceptable in books, but not on the wall? Is it because a plate in a book is somehow more 'honestly' presented than a framed print as it cannot pretend to be a real picture – only, so to say, a picture of one?

When not professionally motivated, anxiety about reproduction seems to mask another anxiety about what may be an appropriate response to art, as though to enjoy a reproduction were not merely to commit a social gaffe, but to reveal a lack of the right kind of sensibility. Perhaps there is yet a third layer of worry concerning what might be the 'correct' responses to art. If so, this is certainly misplaced.

Though not infinite, the range of responses to art works is unclassifiably large and may be quite idiosyncratic and unpredictable. If an image is associated with a personal history, it is even possible for a reproduction to take precedence over an original. An extreme example comes from my own experience. There hangs in my dining room a framed British Museum print of a Chinese painting (Plate 44). It

was given to me long ago in my adolescence by a friend's mother (coincidentally, a Viennese woman of Gombrich's own generation) and one dimension of its significance for me is that it is the first 'art' that I ever personally owned. It has come to stand too for the memory of the now dead woman herself. Quite apart from this melancholy association, it has always been a troubling picture, given to me only in part from a generous impulse. For the woman herself, it had become an unwanted reminder of a stillborn daughter, and she could not correct a perception she had suddenly had of one of the lotus blossoms as the image of a skull in profile. As she also cogently demonstrated how her misreading worked, it at once became, ineradicably, mine as well. Thus the reproduction – this, unique reproduction – in its simple wooden frame (altogether culturally and historically inappropriate to a Chinese silk scroll) is consequently overloaded with conflicting associations which dominate my reactions to it. I certainly wouldn't part with it even in exchange for the original.

My example may seem totally inappropriate to any discussion of the relative values or uses of originals and copies as it describes the mentality proper to a keepsake, a memento rather than to a work of art. It is a mentality that may charge any item with significance for anyone at any time. Art objects, by contrast, are supposed to have meaning for us because their worth is acknowledged by the whole culture, and does not reside merely in individual histories. While this is undeniable, I should like to suggest that my story of the reproduced Chinese scroll is rather more relevant than it may seem at first glance: that the place given to art within Western culture is a great deal more complex than the purist reaction towards reproduction would imply, and that the issues thrown up by reproduction itself allow us glimpses of that complexity. An art object, whether in two or three dimensions, is among other things a cultural memento, encapsulating a time or a place, or it may be an ideal or dream associated with particular societies and moments. Moreover, the values we attribute to such objects mirror our own collective preoccupations and dreams. Reproduction is part of the process whereby individual objects may achieve this special status: through reproduction and dissemination, images and things acquire a currency they would not otherwise have had. Sometimes, as we shall see, qualities that belong to the reproduction affect our perceptions and treatment of originals. Besides all this, objections to inappropriate framing or literal and cultural decontextualization may often be raised when we encounter an object in the real world as well as in its virtual counterpart. Before discussing these issues, however, we need to turn our attention initially away from painting, which gives a rather misleadingly tidy view of the whole matter of reproduction.

Sometime in the 1960s, the term 'multiple' became current to describe identical works of art produced in series, a move that was partly intended to challenge the

notion that art objects were rare, singular creations by ironically exploiting commercial methods of production. However, a sizeable portion of what we normally think of as art had been produced in multiple form for several hundred years before the twentieth century. There is no point in asking for the 'original' of a Dürer woodcut, engraving or etching (Figure 6.1) (Strauss 1977): each image printed from the matrix of block or plate has nominally equal status (nominally because in practice the metal plates from which engravings and etchings are pulled wear relatively quickly). Though Dürer's design was undoubtedly worked out in a series of drawings, and in all probability a master drawing was used to transfer it to the woodblock or plate, this template was probably destroyed in the making of the image and would not in any case have been considered more precious than any particular impression. In other words, the plate functioned in the same way as a photographic negative.

A printed picture, like Dürer's, seems to be no more than a commercially cheaper variant of the contemporary painted image, but there are differences. Early sixteenth-century paintings were for the most part 'bespoke', as Michael Baxandall put it (Baxandall 1972) – that is, they were produced for a particular client, perhaps for a particular setting: the imagery of non-religious works may often have been fully understood only by a small coterie surrounding the patron. Dürer's engravings of secular subjects were self-selected: they advertised his ingenuity and learning as well as what we would call his pictorial inventiveness. It is true that the subjects may reflect the sometimes esoteric interests of the circle surrounding his friend, the humanist Willibald Pirckheimer, in their home town of Nüremberg. However, these engravings were sold all over Europe and by the end of the century were celebrated collectors' items. In these circumstances, their 'meaning' could no longer be controlled by the small group in which they originated: rather, any purchaser would need to make his or her own sense of these fascinating though often puzzling pictures. Their value lay in the fact that they were examples of Dürer's art, guaranteed by the presence of the famous monogram which appeared on them.

This is a recognizable stage on the way to a modern view of the visual arts which celebrates individual achievement, but leaves interpretation of images open to different societies of viewers, who may bring to the task widely varied ranges of cultural equipment. This, not so very much later, became characteristic of the market for paintings, and is often associated with a vague feeling that it represents the culmination of a mysterious 'rise in status' of the artist. The role printmaking played in that process, however, has not always received the attention it deserves. That role was not played exclusively by the upmarket 'original' print of the kind represented by Dürer. It also involved the so-called 'reproductive' engravings that began to appear almost simultaneously. At this point, we may for the moment return to the example provided by the reproduction of paintings.

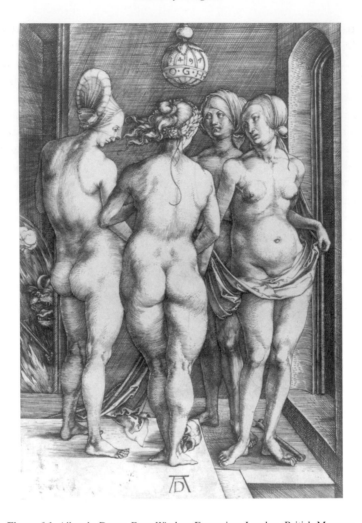

Figure 6.1 Albrecht Durer, *Four Witches*, Engraving, London, British Museum.

The representative figure here is Marcantonio Raimondi, a Bolognese print-maker whose early career, perhaps significantly, included a spell as a faker of Dürer woodcuts. By 1511, Marcantonio had moved to Rome where Raphael harnessed his talents as an engraver to produce a series of prints that subsequently became as famous as those made by their Northern European counterparts. Among them was an engraving showing the mythical summit of Parnassus where Apollo and the Muses are surrounded by celebrated poets. Marcantonio's caption (*Raphael pinxit in Vaticano*) seems to claim that his image (Figure 6.2) represents a fresco Raphael had painted in the Vatican. Occupying a lunette above the window embrasure of the so-called Stanza della Segnatura, Raphael's *Parnassus*

(Figure 6.3) was one of a series of paintings ordered between 1508 and 1512 by Pope Julius II to decorate what was probably a library: *Parnassus* represents one of the 'faculties', Poetry, into which books were at that time conventionally classified (the others, Jurisprudence, Philosophy and Theology all being present too) (Jones and Penny 1983).

The engraving does not effect a direct translation of the painting. Although it includes a naturalistically represented window with shutters, thus drawing attention to Raphael's ingenuity in fitting his allegory into such an awkward space, it seems to have been based on a discarded preliminary drawing, now lost, but given a new lease of life by Marcantonio's engraving (Shoemaker and Brown 1981). Modern observers especially, by means of photographic reproductions of both images, are currently in a position to admire Raphael's virtuosity as a designer able so prodigally to offer alternative solutions to the same problem, and this may have provided some of the original motivation for its issue. Many contemporary buyers, however, having no immediate access to the original, would do as Vasari apparently did: take Marcantonio's inscription at face value, assuming that what they held in their hand was a recognizable 'likeness' of the fresco (Vasari 1966–87).

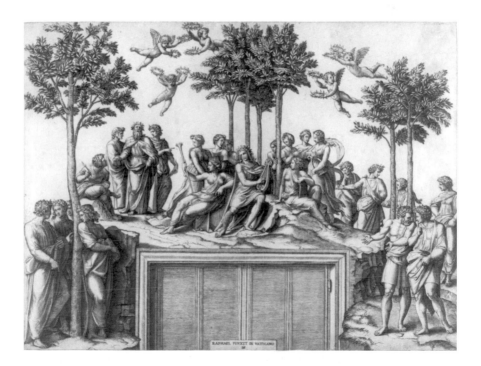

Figure 6.2 Marcantonio Raimondi, *Parnassus* (after Raphael), Engraving, London, British Museum.

However, in spite of its claim – and the seemingly scrupulous insertion of the window – Marcantonio's print actually decontextualizes the *Parnassus*, turning it into a picture independent of the symbolic scheme to which it originally belonged. It has become a representative of Raphael's art, and its significance is now generalized, cut loose from the specific meanings Julius II intended to incorporate into his chamber (Hughes 1988). The case is a significant one because the alternative presentation of an image devised for a specific setting was the result neither of accident nor of some maliciously exploitative decision, but a step deliberately taken by the painter and his engraver.

What was unusual, at this very early stage, was the claim that the print represented an actual work in a specific location. Discrepancies between original and copy were the norm, so much so that the very term 'reproductive engraving' which had been commonly given to this class of prints has been cogently challenged in recent years (Bury 1993; Landau and Parshall 1994). In general, the very earliest engravers played fast and loose with their sources, often combining motifs from paintings with invented landscapes or settings borrowed from other prints. In addition, free copying and piracy were commonplace when a particular figure or group proved saleable (some engravers apparently carelessly pirating their own works). No recognized system of copyright existed during this period apart from random 'privileges' that were occasionally sought from governments or rulers and, in any case, the early printmakers had no standard of fidelity to originals that we would find acceptable today. Yet the replication of these borrowings and transpositions worked powerfully to modify regional styles of painting, sculpture and architecture across the European continent (Wells-Cole, A. 1997). We can often follow a curious trail, the visual equivalent of Chinese whispers, showing how an invention replicated again and again was, bit by bit, incorporated into new contexts before losing all connection with the original work. As the industry of printmaking grew, so did an informal system of acknowledge-ment, the creation of the so-called 'address' that gradually became a standard feature of the reproductive print. At its most elaborate, the address was an inscription (or series of inscriptions) that gave the names of the designer of the original work, the engraver, and the printer/publisher, a division of labour that sometimes privileged the name of the designer (in our terms, the artist) as the brand that would sell an image, but gave the publisher most power since it was he who generally financed the venture and received the commercial reward. By the end of the sixteenth century, a genuine 'reproductive' printmaking flourished, publishing images of paintings and sculpture that were for the most part certainly more intimately known in printed form than the originals they represented.

William Ivins argued that these hand-crafted reproductions teemed with imperfections, not the least of which were the personal – or workshop – styles of engraving that set up an interference between the image and the viewer (Ivins

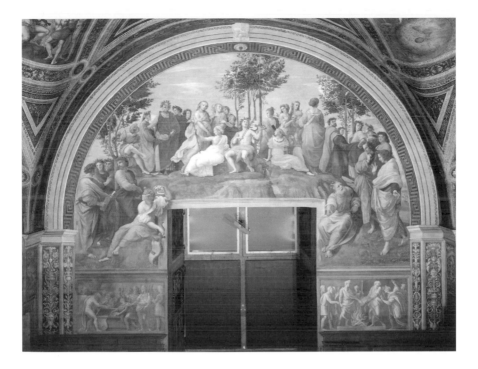

Figure 6.3 Raphael, *Parnassus* (1509–11), Fresco, Stanza della Segnatura, Vatican Palace, Rome.

1969). The point was well made, but Ivins went on to draw the false conclusion that photography had eliminated all misleading distractions from the truth of representation. However, there can be no absolute gold standard of visual good faith. Ivins claimed that the discrete marks that constitute a photographic print, being microscopic, belong to a realm 'below the threshold of vision', consequently, unlike the lines, hatchings and flecks that make up an engraving, they no longer interposed a veil between the beholder and the work itself. Nowadays, it is generally acknowledged that photography inescapably remains an interpretive medium. From lighting, selection of aperture and exposure time to the making of the print, everything the photographer does involves some crucial choice that will subtly influence the observer's response.

Older forms of reproduction often acknowledged the necessity for interpretive changes. When Rubens designed a version of his great altarpiece, *The Raising of the Cross*, he made of the painted triptych a unified picture, and changed the setting in order to accommodate the image, not only to its new wide format but to the tonal systems the engraved line was capable of forming. Two centuries later, Turner was just as exacting a taskmaster, altering detail and advising the engraver on tonal adjustments that would adequately suggest effects of colour in the

monochrome prints he produced after his paintings when he included a handful in his *Liber Studiorum* (Finberg 1924; Gage 1969).

In a past where travel was considerably more difficult and expensive than it is today, and when the international exhibition was a rarity, the reproductive print became the mainstay of scholars and critics, achieving practical priority over contact with originals. We should, I believe, assume that familiarity with printed reproductions bred an awareness of their strengths and weaknesses, just as familiarity with photographs does today, a familiarity so close that it only rarely provokes comment.

Two examples, widely separated in time and culture, may demonstrate the importance of the print. In 1672, the Italian Gian Pietro Bellori published a life of Rubens (Bellori 1976), many of whose paintings he could never see. For information on the great paintings for North European patrons, Bellori relied on prints that Rubens himself had issued. Over two centuries later, Jacob Burckhardt wrote his famous book, *Recollections of Rubens* (Burckhardt 1950) relying – as the title indicates – on memory of paintings once seen on his travels, but no doubt also supplementing reminiscences and notes by recourse to the photographs that had begun to appear by that time. What is interesting, however, is that as late as 1894, the year of the book's publication, Burckhardt could still respectably consult handmade prints after the pictures. On one occasion, his evocation of the *Pitti Palace Landscape with Ulysses and Nausicaa* slips from a direct description of the painting – which he knew well at first hand – to the engraving after it by Bolswert.

Burckhardt's manoeuvre is understandable because he grew up in a world where the print was not merely a 'faithful copy' but, in the best instances, a recreation of the picture in another medium. What applies to the Rubens and Turner prints also holds for the mezzotints, lithographs and other forms of reproduction that appeared from the eighteenth century onward, providing aide-mémoires for those who had in all probability seen the paintings only briefly, and completely representing them for those who could never hope to obtain a first-hand view. By the late nineteenth century, the print could provide the artist with more money than a commission. Lady Butler sold the copyright of her *Calling the Roll after an Engagement, Crimea* (usually simply named *The Roll Call*) for exactly ten times the fee she received from Charles Galloway who commissioned the painting itself (*Great Victorian Pictures* 1978). The engraved image was replaced by a photogravure issue in the 1890s and no doubt the whole run amply rewarded the Fine Art Society who had released both versions. It almost goes without saying that these reproductions today command considerable prices in their own right, at least in the specialist market for military pictures.

It is only a small step away from prints like these to the market in contemporary reproductions – though it is doubtful whether the popular imagery of David Shepherd, Beryl Cook and Jack Vettriano should be called reproductions in the

conventional sense. Though Vettriano's coloured pictures have an obvious origin in the painter's studio, probably few of the people who buy them consider that they are acquiring inferior versions. These are images made to be printed, multiples as self-sufficient in their own way as the engravings produced by Dürer and his contemporaries some five hundred years ago, though unlike those items, these may be bought in different sizes and in varied formats. This is not to say that a market exploitation of fine-art snobbery has not developed in relation to the works. For the reproductive media employed to produce them, the highest prices are commanded by limited-edition silk screen prints, and, while Vettriano's originals certainly now go for large sums at auction, it is reproduction that has established him as a successful artist, a progress the reverse of the one we are accustomed to think of as normal.

It is clear that, because Vettriano's pictures are almost exclusively known to the public through reproductions, many of the pleasures his paintings offer (the nostalgia evoked by the period costumes of the figures; the cinematic narratives they imply but never overtly spell out; the hinted eroticism) do not depend on close acquaintance with the oils. A long historical view, however, offers striking instances of similar phenomena. First of all, these 'literary' associations, once frowned upon by formalist art historians and critics, are to be found not merely in Victorian art but also in much 'old master' painting, most especially in seventeenth-century Dutch genre, some of it disseminated in printed form during the eighteenth and nineteenth centuries. It is enough to remember the tableaux vivants that Charlotte, the heroine of Goethe's *Elective Affinities*, stages on the basis of Terborch's so-called *Paternal Admonition*, as it was known to her through 'the famous engraving by Willie' (Goethe 1971). A partial parallel to the kind of print success Vettriano has had was enjoyed in eighteenth-century England by Hogarth, whose narratives like *Marriage à la Mode* offered the public a more rumbustious type of storytelling. This sequence, though based on a series of exquisite paintings, was for several centuries best known in engraved form (Bindman 1997).

Any account of the power of reproduction to shape the reception and history of art would ideally include some consideration too of the way in which damaged or lost works continued to make their presence felt. Perhaps the most spectacular case comprises the long history of Leonardo da Vinci's *Last Supper* and its effects not only on the making of other works, but also on the critical accounts of its qualities. Here, even first-hand acquaintance guaranteed nothing and had to be supplemented by the plethora of painted and printed versions that have been made across the centuries, themselves produced on the basis of more or less informed guesswork (*Leonardo e l'incisione* 1984).

As for works that have been altogether lost, they have sometimes been given a type of 'immortality' through reproduction – as some nineteenth-century writers

liked to phrase it (Bann 2000). These form instances not merely of the reversal of normal hierarchy, but also of reproductions that have by chance totally supplanted their originals. Art historians still exploit the (albeit unsatisfactory) drawings made for Cardinal Francesco Barberini of Pietro Cavallini's fourteenth-century frescos that once decorated the walls of the Roman basilica of San Paolo Fuori le Mura (White 1966). During the age of photography, such records became both more abundant and more trustworthy. One of the most striking instances is provided by the twentieth-century black and white photograph that is all that remains of Caravaggio's first version of the altarpiece for the Contarelli Chapel. This painting of the apostle Matthew, rejected by Caravaggio's patrons, was destroyed by Allied bombing during the Second World War. All arguments about the reasons why it should have been judged unsatisfactory must appeal to the photographic evidence (Cinotti 1983).

There are other cases too where both handmade and mechanical forms of reproduction leave behind traces of images that would otherwise have been obliterated. A curious byproduct of these technologies is their ability to record stages in the development of a work of art. Incomplete proof copies of Dürer engravings or Rembrandt etchings allow the observer vicariously to participate in the artist's progress as an image was gradually constructed or altered. Rembrandt especially exploited the ability to produce several versions of a single work as though, like Raphael earlier, but much more obviously and systematically, he were offering a demonstration of his virtuoso power to improvise a series of variations on a single theme. Once again, we may observe a continuity between past examples and the modern photographic print, which has an extensive ability to record what would otherwise have been lost. Though some of this material is the product of invasive methods such as X-rays or infra-red photography, both of which reveal part of what is hidden beneath the surface of finished paintings (or sculptures), the photograph can also keep a record of processes that give rise to what are virtually different works of art. Photographs of the stages that Matisse's painting *Nu rose* went through between May and September 1935 preserve not so much a line of development as the making of a series of separate pictures, discarded one after another. Similar ephemeral images are dramatically re-presented for the viewer of Georges Clouzot's *Le Mystère Picasso*, a filmed documentary of Picasso at work (or, it may be, at play).

There exists no more striking example of the preservation of lost art through reproduction than the sculpture of ancient Greece. A considerable portion of it was for many centuries known exclusively through so-called 'Roman' copies. Some scholars now think that their forebears may have overconfidently assumed that so many of the classical statues that fill our museums are direct replicas of the famous works mentioned by Pliny and Pausanius. But even taking into account that many might be variations on a canon of great statues, there remain many still that are

confidently presumed to be deliberate replicas (Marvin in Hughes and Ranfft 1997). It has not escaped attention, however, that this has given rise to a curious situation. Scholarly articles have been written on the careers of famous ancient sculptors; exhibitions have been organized on their oeuvres without there having been the remotest possibility of showing a single authentic work. A whole area of learning and sensibility has developed on the basis of a forest of reproductions whose fidelity cannot in principle be assessed with any certainty (Allington in Hughes and Ranfft 1997).

Nevertheless, the standing of ancient sculpture was so high from the Renaissance onward that these second-hand carvings were themselves replicated. When eighteenth-century English gentlemen made the Grand Tour, they brought back with them not only genuine antiques, but also replicas made to measure – either full-size marble copies or smaller works. Many sculptors carried such figurines of famous ancient pieces as a stock-in-trade. The fashion was to possess these items as a sign of taste, and it mattered very little if they were not genuine since it was important to advertise knowledge chiefly of the most excellent examples of classical art. Not everyone could own the *Borghese Warrior*, but the connoisseur and the gentleman could admire it in some form of replica (Haskell and Penny 1981). Such sculptures peopled the grander English country houses and their grounds in the past, and the modern garden centre has, to a certain extent, democratized this tradition.

The importance to European and American visual culture of these reproductions would be hard to exaggerate. Casts of them filled academies and art schools where students were trained to draw from them in order to inculcate a proper taste and, almost by osmosis, internalize the proportional systems of a range of what were believed to be the ideal human figure types. The discipline of drawing after the antique continued to be a mainstay of artists' training well after the advent of modernism, only being generally (though not completely) discarded, in Britain, during the 1960s. On the continent, and in many centres in the United States, the practice is still maintained.

The repertoire of admired statuary was enlarged during the Renaissance to include 'modern' works too. Francis I, the great French monarch of the sixteenth century, collected antiquities, and added to them casts of Michelangelo figures. Michelangelo's own countrymen began to produce not only full-scale copies and variants of his best-known statues, but reduced versions in terracotta and bronze, in effect canonizing the sculptor's works as classics, worthy to be admired and imitated alongside examples of antique art (Hughes in Hughes and Ranfft 1997). By the late nineteenth century, during which medieval and Northern art became admired, an eclectic series of cast facsimiles was put together in the Victoria and Albert Museum where they may be viewed today, a real three-dimensional equivalent of our hypothetical exhibition of printed reproductions.

It would be as easy to make a case against the integrity of these casts as we earlier made one against photographic versions of paintings. The exhibition of details in place of whole ensembles, the decontextualization of sculptures which were originally site-specific, the alteration of textures and colour (no marble resembles the distinctive surface of plaster, for example): all these are accusations that can be levelled at the permanent exhibition in the cast court. Certainly, any student of art history who based some theory on the evidence provided by these replicas alone would be asking for trouble. In a quite different sense, however, these objections would be beside the point. The cast court of the Victoria and Albert is a permanent reminder of an era that was relaxed about reproductions, seeing them as educational tools with both informative and enjoyable roles to play. Beyond its historical interest, however, it might also serve to recall the large part reproductive techniques have played in sculptural practice.

Like the pictorial arts, sculpture too has a long history of the manufacture of multiples. By far the most obvious reproductive medium is bronze, which first afforded opportunities for the goldsmiths and sculptors of the Renaissance to make small 'table sculptures' in series. Pirated copies were taken from the originals as after-moulds, and to these over the centuries, second- and third-generation casts were made. Strictly speaking, such items are not reproductions so much as opportunistic fakes, though perhaps the most interesting point about the distinction is that it is founded on the basis of the claims made for these copies rather than on any point of technique. Once again, 'honesty' seems to be at stake, though in a different, and far clearer, form than this first presented itself to us in relation to illustrations in printed books. The process of fakery of course continues today, when often the only perceptible difference between copies and originals is a miniscule distinction in size, imperceptible to the eye (the fakes being millimetres smaller).

During the sixteenth century, reduced reproductions had been made of Michelangelo's work, as we have seen. During the following centuries, reduced versions of monumental statues became common (Janson 1985). As interest grew in the processes of design, so bronze casts were often made from the small-scale clay or plaster models that are the sculptor's equivalent of the preliminary sketch. The reproduction of such fragile works in a durable form has not been without its ethical problems. Many works of this kind date from the early modern period when no copyright existed at all. Moreover, as Jennifer Montagu has pointed out, immediately post-Renaissance clients may have had a subtly different assessment of the respective roles of designer and founder, the bronze or silver worker who produced the statuette and from whose workshop the object actually issued (Montagu 1989).

Sculptural practice and the market for three-dimensional objects altered subtly but significantly during the dominance of the great Royal Academies of France

and England during the eighteenth and nineteenth centuries. Sculptors now began to exhibit plasters of forthcoming works, or even of statues and groups that had not been commissioned at all. The marbles or bronzes that would subsequently be made if the artist were successful were not necessarily manufactured by the sculptor, but by professionals. Stone carvers became the executives of these sculptor-designers, and the methods of reproducing marble carvings were now considerably enhanced by the introduction of pointing machines that made the transfer from clay or plaster to finished stone much easier and more accurate than before (Wittkower 1986) – sculptors in any age had rarely been bronze founders, of course, so there was no real change in the production process on that side; rather, stone-carving now became one reproductive medium among many – for what went hand in hand with this development was an expanded market for luxury goods offering opportunities for sculptors as designers of domestic ornament. The prominent academic sculptor Falconet probably offers the most famous example, being appointed Director of the Sculpture Studios at the Sèvres porcelain manufactory and himself providing many designs that were reproduced in different media. Some were exhibited at the Academy, and made in bronze, lead, biscuit and marble. It is symptomatic of this type of production that the Victoria and Albert marble can only be considered the 'probable' prototype shown in Paris in 1757 (Levitine 1972). If it was, it would itself have been preceded by a plaster or clay model. Showcase plasters exhibited at the annual salons cannot be considered the 'originals' any more than the copper plates or woodblocks from which prints were made.

Such a semi-industrialized working practice does not altogether fit with popular conceptions of art and artists, and from time to time the reproductive processes involved in sculpture have given rise to outrage. Scandals have been especially associated with the production and issue of bronzes from the studio of Rodin (Krauss 1985). As Rosalind Krauss has pointed out, reproduction lay at the heart of Rodin's working methods (Krauss 1977). The sculptor would fashion models in clay or plaster from which moulds were taken in order to create the saleable or usable object. Rodin himself frequently utilized the same figure for different purposes, turning it on its axis, combining it with other sculptures to form new groups, and scaling the work up or down as necessary. Single figures from an important monumental group like the *Burghers of Calais* were cast and sold as independent sculptures, the patination varied, though not in every case specified or even checked by the sculptor himself, who left much to the founder (Tancock 1976).

Of all the 'scandals' associated with Rodin's work, none generally causes more trouble than the issue of posthumous bronzes from the Musée Rodin. These works are perfectly legitimate 'Rodins' over which the museum has copyright: they are not regarded in any sense as reproductions. The undoubted legality of the procedure, however, has not prevented sometimes acrimonious debate from breaking out

between critics and art historians over the authenticity of such posthumous issues, and from time to time these arguments get an airing in newspapers. One recent article in *The Guardian* outlines the bafflement caused when the expectation that works of art should be unique and uniquely expressive of an individual sensibility is frustrated as it is whenever Rodin's practices come to public attention. Actually, Rodin's methods were not, and do not remain, at all unusual.

A subtler ethical question was raised by Robert Crum in relation to another group of posthumous works, however: the bronze versions of Degas's wax 'sculptures' (Crum 1995). In a strict sense, Crum argued that these are not 'sculptures' at all. Especially during the latter part of his life, Degas made wax models, most of them figure studies of dancers and women washing, often modelled to help him with already begun or projected paintings or pastels. These, he stated, were not to be regarded as 'sculptures' at all. After his death, casts were taken from what remained in his studio – extremely fragile models – in order to produce bronze editions of them. Examples may now be found in museums all over the world. Crum questioned the legitimacy of the practice for several reasons – Degas's hostility toward the 'permanent' and recognized medium of bronze which would turn these artefacts into publicly acceptable sculptures; the repairs that were silently carried out on the originals in order to take moulds from them; the facsimile of Degas's signature that forms an integral part of the works, and the misleading dates that appear on labels or in catalogues which suggest to the unwary that the bronzes were made during the artist's lifetime. Questions naturally arise concerning the authenticity of the chasing and patination of bronzes that could never have been presented to the artist even for approval.

Crum's criticism could be extended to many twentieth-century examples. Posthumous sculptures by Boccioni, Duchamp-Villon and Gonzales have all been issued in unauthorized media, and are commonly exhibited as 'original' works of art (in the limited sense that all multiples made from a single matrix may be regarded as 'originals') (Parigoris 1997). Yet if Crum and others are correct, perhaps we should view them as highly unusual forms of reproduction. It is even possible that it would be better to regard some as speculative 'completions' of works that remained mere potentialities in impermanent media.

The difficulty of deciding what word should be appropriately applied in such cases does not arise entirely from the fact that the instances are unusual ones. Differences between copies, facsimiles, and reproductions of a work of art can rarely be defined in narrowly technical terms alone. It is more fruitful to look at distinctions of this sort as products of social transactions. As we have seen already, when it is based on a known work, a fake may be understood as a kind of reproduction dishonestly presented. Once it is recognized that there exists a family of overlapping issues in connection with reproduction, its uses and effects, the discussion about originality and authenticity becomes less clear-cut than it often seems.

In a very broad sense, it could be said that much of what human beings make and do – including art – begins in mimicry. This would include the ambition a child might have today to become an artist by emulating someone or something seen, and we know that such ambitions do bear fruit in adult life. Following that stage, even radical types of art education involve students in a kind of initiation in the ways of thinking and behaving that are characteristic of those who wish to make art. Conceptual art itself works within a set of expectations and guidelines which, though they are not exactly rules, require the artist to pay close attention to predecessors and rivals, if only because no intervention, however novel, will be meaningful if it cannot in some generic sense be related to what has gone before. For the production of art, a type of resemblance is always essential.

I should not want to make more of this point in relation to the contemporary world, but in the long history of the visual arts, there is no doubt that education has traditionally involved rigorous imitative training. Long before the introduction of that engagement with antique sculpture that we have already encountered, apprentices were taught the rudiments of art by drawing and painting after the master's own works. One of Jonathan Richardson's anxieties about discrimination between original and copy concerned Renaissance studio facsimiles of drawings, facsimiles that were so close that there remains often some doubt today, in spite of a battery of scientific aids, in deciding which sheet of studies came first.

The purpose of this unremitting discipline was to enable apprentices to subdue their idiosyncratic hand to that of the master's, so learning to act as studio assistants capable of executing his designs on wall or panel with the maximum efficiency. Oddly, the system also required young painters setting up on their own to make their presence felt quickly by the cultivation of an original and identifiable manner, a stylistic brand that could distinguish their work from that of their forebears and contemporaries, and which they could teach to their pupils in turn. However, the ability to reproduce a work exactly remained highly prized. The number of 'studio replicas' that trouble art historians and museum curators the world over demonstrates more than anything the subtly different attitude toward the authority of the unique work that existed in the past, among both painters and sculptors on the one hand and their clients on the other. Vasari tells a story of the admiration which greeted Andrea del Sarto when he so perfectly fulfilled a commission to replicate Raphael's portrait of Leo X and his advisors that the two panels were indistinguishable (Vasari 1966–87).

Copying remained one of the standard activities of the art student or emerging artist. Degas famously spent much time in the Louvre drawing or painting after the accepted old masters. The activity is generally an attempt to learn with a view to mastering or reproducing this or that admired effect, but it may also be on occasion less instrumental: an analysis of the mentality of the artist or the profound structures of a painting. In that sense, it is more akin to learning a poem

or a piano sonata by heart. The two aims are not, in any case, incompatible with one another.

Other copies have functioned as critiques, or perhaps it would be better to say as a form of self-examination for strongly individual talents, who take what they want and reject or alter what does not suit them. Rubens, who produced striking versions of paintings by Titian and Caravaggio, and Van Gogh, who ingested Millet only to transform him completely, provide possibly the most famous examples (Jaffé 1989; Homberg 1996).

This is not exactly what we would call reproduction (though the difference might reside in the hand-crafted copy's lack of adaptability to commercial demands more than anything else), but it does modify the common notion of the supposedly necessary independence of each artist and work. In 'The work of art in the age of mechanical reproduction', probably the most celebrated piece of writing on photographic reproduction and its effects, Walter Benjamin argued that the ubiquity of reproduced images would eventually destroy the unique 'aura' of the work of art, removing its mystery from the masses, and so democratizing culture (Benjamin 1992). Though it could be argued that our culture has indeed become democratized and that reproduction has undoubtedly played a part in this process, nothing in the development of art and its exhibition within the last hundred years supports the contention that art has been demystified in the slightest degree. On the contrary, it is difficult to know why people should want to stand in front of the *Mona Lisa* if not to satisfy themselves that they have been in the actual presence of an accredited masterpiece only hitherto known virtually, in the form of reproduction. There is little else to be had from the experience: as everyone points out – you cannot see the thing properly through the thick glass that protects it. Much better to return to photographs for a clearer idea. Visitors to actual blockbuster exhibitions nowadays are apt to make similar complaints, though the obstacles in these may not be bullet-proof glass, but fellow viewers who make it impossible to catch more than fragmentary glimpses of the items on display. On the worst occasions, it may seem that all the most a dedicated visitor might be able to manage is a later scrutiny of the photographs in the catalogue, supplemented and informed by whatever has been gleaned from unsatisfactory glances at the works themselves. Far from diminishing the 'aura' of art objects (briefly, the fascination which issues from them as a consequence of 'their unique place in space and time'), the fame that photographic reproduction has lent them has only increased their power to attract.

Their attraction is rarely historical in the rather puritanical sense that professional historians like to cultivate. Indeed, there would be no need for any historical explanation of works of art if their meaning, and even their form, were transparently readable by every viewer. Historians, however rigorous their methods, are interpreters who find the past quite as difficult to access as do their (relatively

Plate 1 Angela Bulloch with Bob Russell, Engineering Manager, Granton Wragg Ltd. (*At Home With Art* project)

Plate 2 Angela Bulloch: developing prototypes. (*At Home With Art* project)

Plate 3 Angela Bulloch in the machine room, Granton Wragg Ltd, Sheffield. (*At Home With Art* project)

Plate 4 Angela Bulloch: *A 'B'*. (*At Home With Art* project)

Plate 5 Tony Cragg: initial plaster models for garden tools. (*At Home With Art* project)

Plate 6 Tony Cragg: computer-generated images of the garden fork, Delcam UK. (*At Home With Art* project)

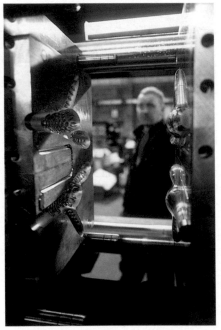

Plate 7 Tony Cragg: final prototypes, manufactured by Spear & Jackson, plc. (*At Home With Art* project)

Plate 8 Injection moulding tool made for Tony Cragg's garden fork. (*At Home With Art* project)

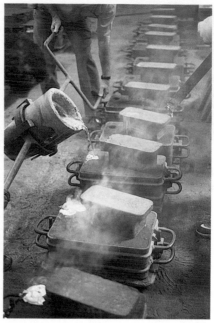

Plate 9 Richard Deacon arranging original 'found' aluminium fragments with 'Rob' Robinson, G.H. Plummer & Co. (*At Home With Art* project)

Plate 10 Richard Deacon: aluminium being poured into moulds, G.H. Plummer & Co foundry works. (*At Home With Art* project)

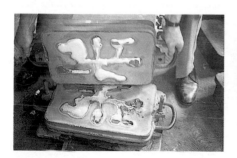

Plate 11 Richard Deacon: opening the mould. (*At Home With Art* project)

Plate 12 Richard Deacon: aluminium sculpture. (*At Home With Art* project)

Plate 13 Antony Gormley: variety of prototypes of pegs. (*At Home With Art* project)

Plate 14 Antony Gormley tests prototypes in his studio. (*At Home With Art* project)

Plate 16 Antony Gormley: peg. (*At Home With Art* project)

Plate 15 Bob Russell, Engineering Manager, Granton Wragg Ltd, tests the peg at the factory. (*At Home With Art* project)

Plate 17 Anish Kapoor: original model for lamp. (*At Home With Art* project)

Plate 18 Anish Kapoor with Mary van Hogermeer and Philip Lazell of the design department, Welwyn Lighting Company, test second generation prototypes in Kapoor's studio. (*At Home With Art* project)

Plate 19 Anish Kapoor: lamp in production at Welwyn Lighting Company. (*At Home With Art* project)

Plate 20 Anish Kapoor: lamp. (*At Home With Art* project)

Plate 21 Permindar Kaur with Tom Caveney, Managing Director, Stafford Rubber Company, Stafford. (*At Home With Art* project)

Plate 22 Permindar Kaur: stamping figures from foam sheeting, Stafford Rubber Co. (*At Home With Art* project)

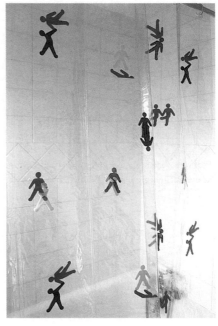

Plate 23 Permindar Kaur: detail, shower curtain. (*At Home With Art* project)

Plate 24 Permindar Kaur: shower curtain. (*At Home With Art* project)

Plate 25 David Mach: his original photograph (detail) of the beach at Fife. (*At Home With Art* project)

Plate 26 David Mach: early computer print-out for the beach towel. (*At Home With Art* project)

Plate 27 David Mach: final, simplified print-out for the beach towel. (*At Home With Art* project)

Plate 28 David Mach: beach towel. (*At Home With Art* project)

Plate 29 Richard Wentworth: found tiles with paw-print. (*At Home With Art* project)

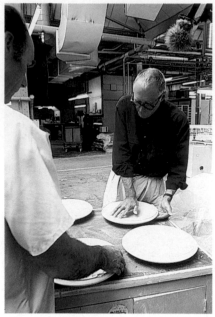

Plate 30 Richard Wentworth pressing fingerprints into a plate to make a mould, Royal Doulton Company, Stoke-On-Trent. (*At Home With Art* project)

Plate 31 Richard Wentworth: rear-view of the plate. (*At Home With Art* project)

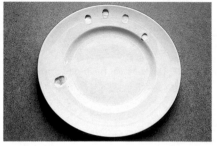

Plate 32 Richard Wentworth: plate. (*At Home With Art* project)

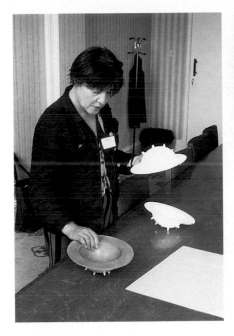

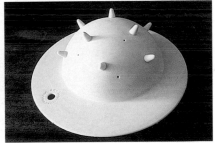

Plate 34 Alison Wilding: specially designed machine tool for making her ceramic sculpture, Royal Doulton Company, Stoke-on-Trent. (*At Home With Art* project)

Plate 33 Alison Wilding with original prototype (plastic and rubber) and first sculptures out of the kiln, Royal Doulton Company. (*At Home With Art* project)

Plate 35 Alison Wilding: adding the 'legs' by hand, Royal Doulton Company. (*At Home With Art* project)

Plate 36 Alison Wilding: ceramic sculpture (fine china). (*At Home With Art* project)

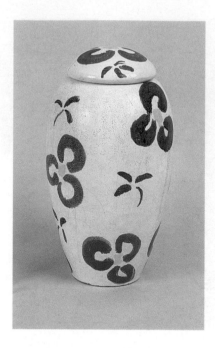

Plate 37 Henri Matisse, Pot with a cover, 1907, tin-glaze, Musee Matisse, Nice. This pot appears in the painting *Still Life on an Oriental Rug*, 1908, now in the Puskin Museum, Moscow.

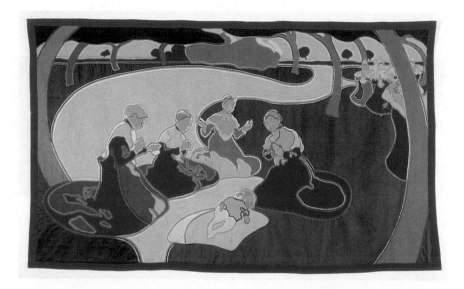

Plate 38 Henri van der Velde, *La Veillée des Anges*, 1893, appliqué wall-hanging of wool and silk, Museum Bellerive, Zurich.

Plate 39 Fiona Banner, *Table Stops*, 2000, glazed ceramic, edition of 100, A Multiple Store commission.

Plate 40 Frances Richards, *Hieratic Head*, 1950s, appliqué embroidery. Private collection.

Plate 41 Phyllis Barron, *Log*, 1915, hand-block printed textile, Crafts Study Centre, The Surrey Institute of Art and Design.

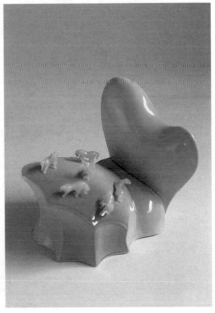

Plate 42 Richard Slee, *Field* 1998, mixed media.

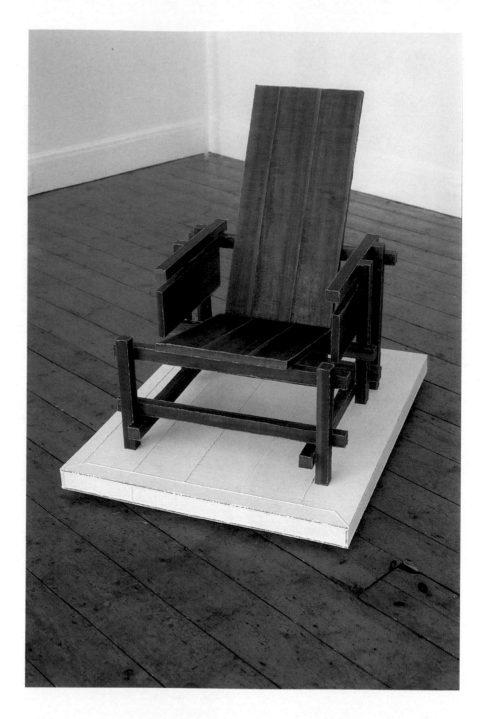

Plate 43 Neil Cummings, Rietveld: *Original Version Red and Blue Chair*, 1991, found veneer and cardboard.

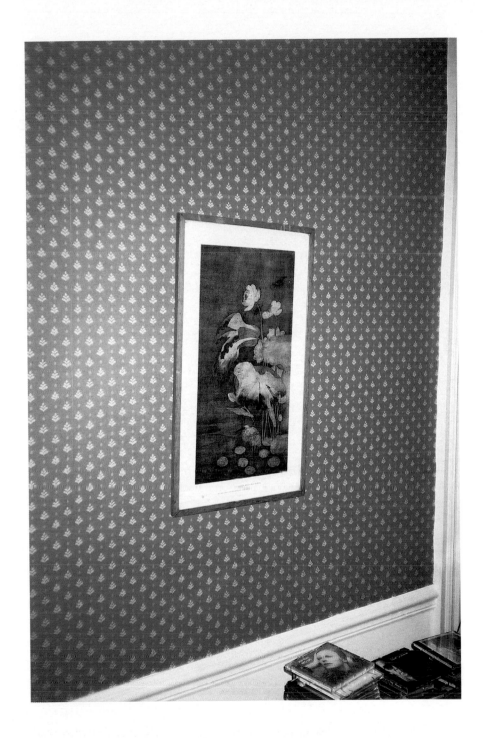

Plate 44 Anthony Hughes's dining room with print of Chinese painting.

Plate 45 Alison Wilding's ceramic sculpture on Matthew's sitting-room sideboard. (*At Home With Art* project)

Plate 46 Tony Cragg's garden trowel in Barbara's garden shed. (*At Home With Art* project)

Plate 47 Permindar Kaur's shower curtain in Daphne's bathroom. (*At Home With Art* project)

Plate 48 Antony Gormley's pegs on David's bedroom wall. (*At Home With Art* project)

Plate 49 Antony Gormley's pegs in Steve and Mary's home. (*At Home With Art* project)

Plate 50 Richard Deacon's metal sculpture on Bob's hearth. (*At Home With Art* project)

Plate 51 Alison Wilding's ceramic sculpture in Sarah's home. (*At Home With Art* project)

Plate 52 David Mach's beach towel now in use in Mara's bathroom. (*At Home With Art* project)

Plate 53 Richard Deacon's metal sculpture restored to Alice's toilet cistern. (*At Home With Art* project)

Plate 54 Tony Cragg's garden tools on Laura's kitchen wall. (*At Home With Art* project)

Plate 55 Angela Bulloch's sound sculpture on Andrew's wall. (*At Home With Art* project)

Plate 56 Tony Cragg's garden tools in Tim and Pam's garden. (*At Home With Art* project)

Plate 57 Angela Bulloch's sound sculpture on George's study wall. (*At Home With Art* project)

Plate 58 Alison Wilding's ceramic sculpture in Tom and Jean's home. (*At Home With Art* project)

Plate 59 Anish Kapoor's lamp on Sylvia's floor. (*At Home With Art* project)

Plate 60 Anish Kapoor's lamp on Ted's floor. (*At Home With Art* project)

Plate 61 Richard Wentworth's plate with jam tarts in Lucy's kitchen. (*At Home With Art* project)

Plate 62 Tony Cragg's garden trowel and fork in Jenny's flower pot. (*At Home With Art* project)

Plate 63 Richard Deacon, *Where is Man, Where is Death?* 2001, Sited at PSI Institute for Art and Urban Resources, New York. (Photo: the artist)

Plate 64 Richard Deacon, *Where is Man, Where is Death?* 2001, Sited at PSI Institute for Art and Urban Resources, New York. (Photo: the artist)

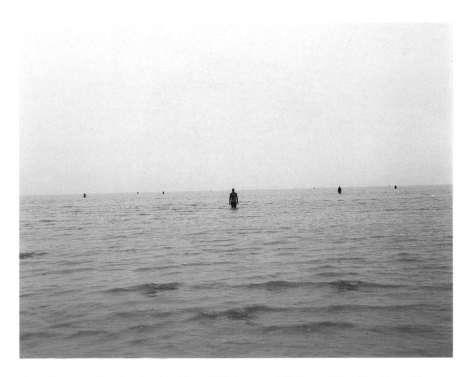

Plate 65 Antony Gormley, *Another Place*, 1997 Cast iron, 100 figures 189 ∞ 53 ∞ 29 cm (Photo: Helmut Kunde, Kiel)

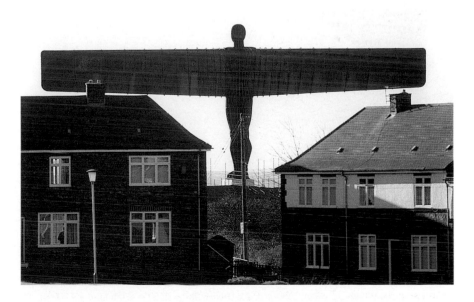

Plate 66 Antony Gormley, *The Angel of the North*, (Photo: North News and Pictures)

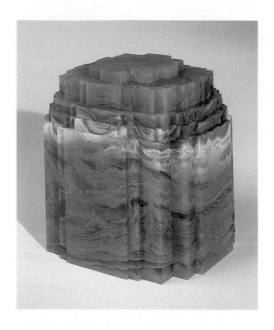

Plate 67 Alison Wilding, *Rising*, 2001. Cast pigmented acrylic. Edition of 35. 165 ∞ 160 ∞ 132 mm. Commissioned by The Multiple Store, London.

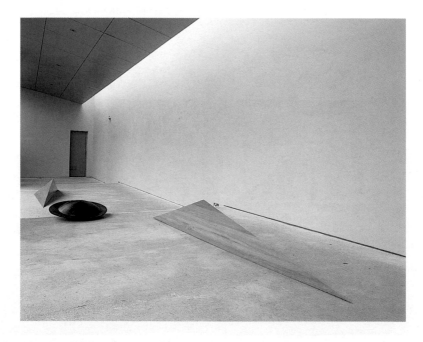

Plate 68 Alison Wilding, *Current*, 2000. Oak and copper. 380 ∞ 2550 ∞ 430 mm (oak), 200 ∞ 670 ∞ 630 mm (copper). Size variable with installation.

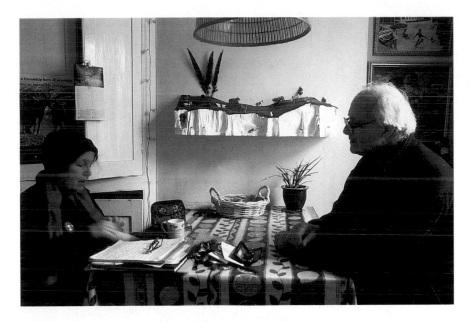

Plate 69 Tania Kovats' *The White Cliffs of Dover* in Maggie and Sylvester's home. (*Close Encounters of the Art Kind* project)

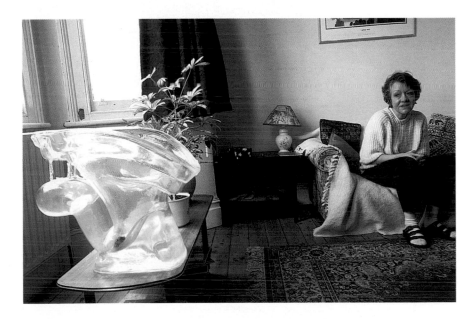

Plate 70 Sarah Lucas' *The Old In Out (Saggy Version)* in Sandra's home. (*Close Encounters of the Art Kind* project)

Plate 71 Langlands & Bell's *www*. in Mari and Michael's home. (*Close Encounters of the Art Kind* project)

Plate 72 Keir Smith's *Fragments from the Origin of the Crown* in Lynn's home. (*Close Encounters of the Art Kind* project)

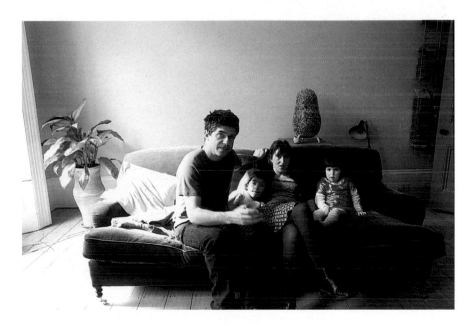

Plate 73 Bill Woodrow's *Fingerswarm* in Beeban and Spencer's home. (*Close Encounters of the Art Kind* project)

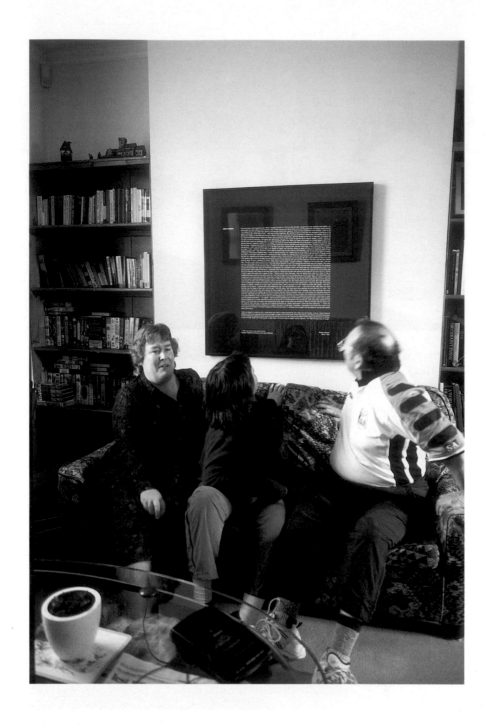

Plate 74 Richard Wilson's *GMS Frieden* in Gareth, Olwyn and Rhiannon's home. (*Close Encounters of the Art Kind* project)

few) readers and students. The phenomenon of 'decontextualization' that I have mentioned from time to time is not an effect of reproduction alone. Paintings, statues – most objects in any museum – are already, by virtue of their exhibition in these curious spaces, isolated from their original contexts and divorced at least in part from their first functions. Shifts in mentality perform their work of transformation as well as physical shifts in space. It is a kind of hubris to imagine that, even after absorbing the best scholarship on sixteenth-century Rome, we can gaze up at the Sistine ceiling – still relatively well-preserved, still in situ – as though we are sharing in totality the first impression of its commissioner, Pope Julius II.

In some respects, however, we can, without any false pride, claim to know it better than he could possibly have imagined. The reason is that we have so many photographs of its surface. Details almost impossible to discern from the floor, including the artist's brushstrokes, have been documented for us with a clarity and precision without precedent, and the same is true of so many monuments normally beyond the reach of our close inspection. The intrusive power of the photographic lens brings about its own cultural distortions. We were never meant to see so much, but then we were never meant to have access to preliminary drawings, crude sketches, private letters and the other remains, visual and literary that Michelangelo (or any other comparable historical figure) has left behind. Our reactions to art – the kinds of experience we have in direct or indirect relation to it – are thankfully hard to police.

In any case, art historians like me should reflect from time to time on the power that reproduction has to alter our view of the past. Our notion of what an artist's career 'looks like' is deeply affected by the ability to gather together whatever work survives in photographic form. Reproductive imagery was and remains crucial to the notion of an artist's œuvre, the body of work that may be collected and arranged by theme or in chronological order. Even today, it is evident that, once sold, an artist's works are scattered. In earlier ages, paintings or sculptures tailor-made for individual, often inaccessible, spaces could be quickly lost to sight. Ever since the publication of Vasari's *Lives*, biographical accounts invited readers to imagine the sequence of pictures, buildings and statues made by this or that hero and contemplate, at least mentally, the individual character of his or her art. Language, however, is a hopelessly imprecise medium in which to represent even the simplest of visual effects, and unless Vasari's readers had access to one or two examples of a painter's work or, more likely, could consult engravings and woodcuts after their imagery, the imaginative effort involved was difficult, if not quite impossible. Difficulties were compounded especially when the author's own memories or notes had become confused, as happened on occasion to Vasari himself, when he had to describe, without the support of reproductive engravings, imagery he had not seen for many years.

We should admit dangers too. I have a suspicion that the retroactive effect reproduction has on the viewing of the actual work will be criticized in the future. Anyone who expects old master paintings uniformly to exhibit the luminosity that slides lend to their reproductions in a darkened room will experience disappointment in a gallery, and it could be argued that the sense of let-down has not been confined to a historically naive section of the population. The fashion for cleaning paintings and then spotlighting them in exhibitions so that their surfaces acquire something akin to the sheen of a glossy printed page is becoming more, rather than less, common. Certainly, the present rage to clean was not caused by attractive reproduction alone, but it has played a definite role in educating public taste to accept the often surprising brilliance of 'restored' artefacts.

Like many phenomena, reproduction is in itself neither good nor bad, but a 'thing indifferent' ethically activated only in use. Perhaps to end, however, I should attempt its praise, if only ironically. After all, it could be said that, as the owner of my printed image of the Chinese *Lotus, White Heron and Kingfishers*, I get a great deal: namely, a real sense of the original's qualities without any of its drawbacks. I need never decide how best to conserve the painting itself, whether to attempt restoration, and whether or not it would be feasible to insure the thing against possible damage, destruction or burglary. Now that we all have experienced the convenience of reproduction, what would we do without it?

References

Allington, E. (1997) 'Venus a Go Go, To Go', in A. Hughes and E. Ranfft, *Sculpture and its Reproductions*. London: Reaktion.

Bann, S. (2000) 'Ingres in Reproduction', *Art History* 23, 706–25.

Baxandall, M. (1972) *Painting and Experience in Fifteenth-century Italy*. Oxford, Oxford University Press.

Beck, H. (1973) *Victorian Engravings*. London: Victoria and Albert Museum.

Bellori, G.P. (1976) *Le vite de' pittori, scultori e architetti moderni* (ed. E. Borea, intro. G. Previtali). Turin: G. Einaudi.

Benjamin, W. (1992) 'The work of art in the age of mechanical reproduction', in H. Arendt (ed., intro) *Illuminations*. London: Jonathan Cape.

Bindman, D. (1997) *Hogarth and his Times: Serious Comedy*. London: British Museum.

Bourdieu, P. (1984) *Distinction: a Social Critique of the Judgement of Taste* (trans. R. Nice). London: Routledge & Kegan Paul.

Burckhardt, J. (1950) *Recollections of Rubens* (ed. and intro. H. Gerson; trans. M. Hottinger). London: Phaidon.

Bury, M. (1993) 'On some engravings by Giorgio Ghisis commonly called reproductive', *Print Quarterly,* 10, 4–19.

Cinotti, M. (1983) *Michelangelo Merisi detto il Caravaggio: tutte le opere*; with a critical essay by A. Dell'Acqua. Bergamo: Poligrafiche Bolis.

Clayton, T. (1997) *The English Print 1688–1802*, New Haven and London: Yale University Press for the Paul Mellon Center for Studies in British Art.

Crum, R. (1995) 'Degas Bronzes?', *Art Journal,* LIV/I (Spring), 93–8. (exhibition review)

Finberg, A.J. (1924) *The History of Turner's Liber Studiorum. With a New Catalogue Raisonné*. London: Ernest Benn.

Gage, J. (1969) *Colour in Turner: Poetry and Truth*, London: Studio Vista.

Goethe, J.W. von (1971) *Elective Affinities* (trans. and intro. R.J. Hollingdale). Harmondsworth: Penguin.

Gombrich, E.H. (1999) 'Pictures for the Home', in E.H. Gombrich *The Uses of Images*. London: Phaidon.

Great Victorian Pictures: their Path to Fame (1978) Arts Council Travelling Exhibition.

Haskell, F. and Penny, N. (1981) *Taste and the Antique: the Lure of Classical Sculpture 1500–1900*. New Haven and London: Yale University Press.

Homberg, C. (1996) *The Copy Turns Original: Vincent van Gogh and a New Approach to Traditional Art Practice*. Amsterdam and Philadelphia: John Benjamins.

Hughes, A. (1988) 'What's the Trouble with the Farnese Gallery? An Experiment in Reading Pictures', *Art History,* 11, 335–48.

Hughes, A (1997) 'Authority, Authenticity and Aura: Walter Benjamin and the Case of Michelangelo', in A. Hughes and E. Ranfft, *Sculpture and its Reproductions*. London: Reaktion.

Hughes, A. and Ranfft, E. (1997) *Sculpture and its Reproductions*. London: Reaktion.

Ivins, W.J. (1969), *Prints and Visual Communication*. Cambridge, Mass. and London: MIT Press.

Jacobowitz, E.S. and Stepanek, S.L. (1983) *The Prints of Lucas van Leyden and his Contemporaries*. Washington, DC: National Gallery of Art.

Jaffé, M. (1989) *Rubens*: catalogo completo. Milan: Rizzoli.

Janson, H.W. (1985) *Nineteenth Century French Sculpture*. London: Thames and Hudson.

Jones, R. and Penny, N. (1983) *Raphael*. New Haven and London: Yale University Press.

Krauss, R. (1977) *Passages in Modern Sculpture*. Cambridge, Mass. and London: MIT Press.

Krauss, R. (1985) 'Sincerely Yours', in R. Krauss, *The Originality of the Avant-garde and Other Modernist Myths*. Cambridge Mass. and London: MIT Press.

Landau, D. and Parshall, P. (1994) *The Renaissance Print 1470–1550*. New Haven and London: Yale University Press.

Leithe-Jasper (1986) *Renaissance Master Bronzes from the Collections of the Kunsthistorisches Museum, Vienna*. Washington: Scala Books in association with Smithsonian Travelling Exhibition Service.

Leonardo e l'incisione: stampe derivate da Leonardo e Bramante dal XV al XIX secolo (1984) (ed. C. Alberici, schede di M. Chirico De Biasi). Milan: Electa.

Levitine, G. (1972) *The Sculpture of Falconet*. Greenwich, Conn: New York Graphic Society.

Marvin, M. (1997) 'Roman sculptural reproductions or polykleitos: the sequel', in A. Hughes and E. Ranfft *Sculpture and its Reproductions*. London: Reaktion.

Montagu, J. (1963) *Bronzes*. London: Weidenfeld and Nicolson.

Montagu, J. (1985) *Alessandro Algardi*. New Haven and London: Yale University Press.

Montagu, J. (1989) *Roman Baroque Sculpture: the Industry of Art*. New Haven and London: Yale University Press.

Parigoris, A. (1997) 'Truth to material: bronze, on the reproducibility of truth', in A. Hughes and E. Ranfft *Sculpture and its Reproductions*. London: Reaktion.

Richardson, J. (1719) *Two Discourses: I. An Essay on the Whole Art of Criticism as it Relates to Painting, Shewing how to Judge I. Of the Goodness of a Picture; II. Of the Hand of the Master; and II. Whether 'tis an Original, or a Copy . . .* London: W. Churchill at the Black Swan.

Shoemaker, I.H. and Brown, E. (1981) *The Engravings of Marcantonio Raimondi*. Lawrence, KS: University of Kansas Press.

Strauss, W.L. (1977) *The Intaglio Prints of Albrecht Dürer: Engravings, Etchings and Drypoints*. New York: Kennedy Galleries.

Tancock, J.L. (1976) *The Sculpture of Auguste Rodin*. Philadelphia: Philadelphia Museum of Art.

Vasari, G. (1966–1987), *Le vite de' più eccelenti pittori, scultori e architettori nelle redazioni del 1550 e 1568* (ed. R. Bettarini; with a commentary by P. Barocchi). Florence: Sansoni.

Wells-Cole, A. (1997) *Art and Decoration in Elizabethan and Jacobean England: the Influence of Continental Prints, 1558–1625*. New Haven: Yale University Press, for the Paul Mellon Center for Studies in British Art.

White, J. (1966) *Art and Architecture in Italy 1250–1400*. Harmondsworth: Penguin.

Wittkower, R. (1986) *Sculpture, Processes and Principles*. Harmondsworth: Penguin.

−7−

Accommodating
Daniel Miller

Introduction

This chapter is intended to survey one particular approach to the relationship between the home interior and the people who dwell within the home. The approach is ethnographic and associated largely, but not entirely, with the discipline of anthropology and, in particular, with material culture studies. I am not particularly concerned with objects of art or design but recognize that in some general sense the arrangements of the home interior and the placements of objects within the home represent one of the main arenas though which we all perforce engage in a constant project that might be termed design or even an aesthetic practice.

It is always something of a treat for an author if some felicitous pun happens to capture many of the points and qualities that he or she wants to express. In this case I will admit to some delight in considering the title of this chapter. The word 'accommodating' does a great deal of work for me by virtue of the semantic spread that it seems to have developed over time. On the one hand it speaks to the need we all have to find accommodation in the sense of a place to live, and accommodation can cover many such spaces from the homes we might own to temporary rented forms such as 'student accommodation'. Secondly, it may also involve a process of accommodating in the sense of an appropriation of the home by its inhabitants or indeed of the inhabitants by the home. Less obvious but central to this discussion is that this second meaning is reciprocal. It may imply our changing of a home to suit ourselves, but it can also imply the need to change ourselves in order to suit our accommodation. Thirdly, the term 'accommodating' expresses a sense of willing, of benign agreement to compromise on behalf of the other, which I will suggest often represents the spirit, or will, within which accommodation is achieved. By considering our relationship to the home through the term 'accommodating' we face the home not as a thing but as a process. Being accommodating and being accommodated is something we are constantly engaged with and this seems to me appropriate for the purposes of this volume. How accommodation becomes accommodating is the central question in this chapter.

I certainly do not claim that anthropology and material culture studies are the only disciplines to be concerned with this relationship of a place to persons; indeed, anthropologists rarely represent the applied side to this activity, which is given over to architects and more especially to interior designers. Other disciplines ranging from history through design, cultural studies and sociology all have a stake here. There is considerable overlap between them. Many of the most influential historical writings on this topic – ranging from one of the ancestral classics, Freyre's (1986) analysis of the great house and the slave quarters in Brazilian history, through to Braudel (1981) and the Annales school's work on the house in medieval Europe – were influenced by trends in anthropology. In turn, and again in Europe, a recent series of works on what are called 'house societies' that link kinship studies to the study of the home have been influenced by the work of historians on the house as a dynastic institution (Carsten and Hugh-Jones 1995).

My only concern with this issue derives from a rather different and more contemporary issue, that of consumption. For some time now I have been trying to demonstrate through ethnography how consumption needs to be understood not just as the purchase of items, but as the longer-term process by which we appropriate these objects and use them to in turn develop or change our lives. From this perspective, consumption applies not only to objects obtained from the market but also from the state, which is why my first research on this topic was on how people changed the kitchens they received as part of their living in state housing. But consumption is bound to the home by much more than a concern with the consumption of homes. The home has become the primary sphere in which most consumption takes place, whether this is of the media as received through television and the internet, or of a range of goods from pharmaceuticals to hi-fi. The home is where consumption happens, and any investigation of consumption as such as a longer-term process has to be contextualized in the study of accommodation itself. The point is equally evident if we consider the ambiguity of common terms such as the 'domestic' or the 'household'. What do these terms imply? Are they spatial units, as in that which takes place within doors as against out of doors? Are they social units concerned with aspects of gender relations, or kinship? Are they processes rather than units concerned with a kind of centripetal orientation of the world back to the private sphere? My point is that these meanings are inseparable.

Accommodating the Home

These issues point to a general concern with the home. What may be more particular to the concern of anthropology is the emphasis on social relations that are brought out by this interest in accommodating as both process and place –

balanced by the concern within material culture for the reciprocal agency of the material culture of the home in accommodating to its inhabitants. For this purpose I want to concentrate on a much shorter and more limited set of studies that have taken place within the last seventeen years. It is something of a cliché to argue that the first such study was the best, but I find myself helplessly drawn to this conclusion, although I will argue that the most recent studies of this subject have added many particular perspectives that complement and add to earlier work. To make these points I will concentrate on what I take to be the first and, for now, the last words on this topic of the ethnographic analysis of accommodating.

What I take to be the exemplary starting point for such studies was the volume, recently reissued but first published in 1984, of *Kitchen Table Society* by Marianne Gullestad, and what I want to emphasize is, paradoxically, the degree to which this was not a study of the home interior per se. Indeed, what made this such an important work when it first came out was, rather, that it was in many respects a conventional ethnography – though of the type of population that, on the whole, had not been the subject of conventional ethnographies. The topic was working-class women in the town of Bergen on the West coast of Norway. What made this special was that there was nothing special about these people. They were not being studied because they were a problem that academics were supposed to shed light on, such as drug-takers or the unemployed. They represented the neglected topic of the merely ordinary. What makes this conventional, I would say classic, as ethnography is the unremarked focus on what might be called the totality of their lives. The book takes its scope from the obvious experiential sense that these women had of their own lives that everything they did came together because it related to them. Their activity as workers in employment, as housewives, as parents or lovers are all integrated in their experience. Ethnography with its commitment to a holistic approach is intended to reflect that sense of totality.

As a result, much of the book is about these women's work, how they deal with the state and with the market, their husbands and their children. But as Norwegians they happen to particularly exacerbate certain tendencies that are characteristic of contemporary secular modernity, the condition that most academics and many populations inhabit today. They live in a world that centres on the private domain, behind the closed doors of the family house. While we may well be more integrated with global economics and politics than the population of any previous period, a good deal of this happens in our living rooms. This integration and exposure occurs through encounters mediated by television and the internet which is where every day we feel so close we can almost rub noses with the politicians and the celebrities we know about in common.

As it happens, if we are turning our attention to the private sphere, what better place to be working than a society that was renowned for its attachment to that very sphere? Norway would be alongside Japan as among the first nations one

would think of as regions where the privacy of the individual household is at a premium. If the private life of Norwegians could be excavated there was hope that this could be done almost anywhere. By the same token it is women who are clearly the gender that have in so many societies been allocated responsibilities that we associate with the domestic sphere. The neglect of women, their labour and their lives more generally, becomes here central to our failure to understand the nature of our own societies as a whole. This requires not only an understanding of the neglected topic of what women actually do, but a concern with the problem of what has generated the relationships and practice of gender more generally. In addition, in many societies that regard themselves as modern, it is the working class that are regarded as the ordinary, the quotidian. So, as a place to start an anthropology of the private home, the topic of working-class housewives in Norway seems to have been a particularly appropriate beginning.

I have no reason to think that Gullestad was particularly influenced by material culture studies or even its elder cousin (that has thrived in Norway), the study of Ethnology, with its fascination with topics such as hunters' knives or fishing vessels. Rather it is the centrality of the home itself which, as a good anthropologist, she came to acknowledge and give attention to both in this book and in a subsequent article on the art of home decoration (1992). In a way I would argue that it is particularly important that home decoration came to be regarded as a central part of the lives of people for someone for whom this was not an intended topic. This seems a far more convincing argument for its importance than merely a new development in, say, furnishing studies or design history. Indeed there is an underlying issue here, which is that ethnography itself had previously tended to flourish in social settings which are relatively public and accessible. The challenge faced by Gullestad and those of us who have followed her was to penetrate behind the closed doors of highly private societies to work in the place of privacy itself, something that most disciplines that rely on questionnaires and focus groups fail to attempt, let alone achieve.

What role then does home decoration have for these women in Gullestad's account? The title of her book, *Kitchen-Table Society,* indicates its prominence. These are women whose closest relations are often with other housewives and the common activity of reciprocal visiting and chatting around the kitchen table. This chat is itself of major importance, since one of the core characteristics of modern society, by which term I allude to the decline of religion and other forms of legitimation for customary behaviour, is the search for normativity. That is, our concerns and often our anxieties revolve around the basic decision as to just what is the right and appropriate thing to do and say. For these women it is the constant referring back to each other's behaviour that determines which act of adultery was beyond the pale and which group of bosses or students should be pilloried and reviled. From the point of view of social science, of course, this striving for the

normative, for a moral consensus, has been central to academic discussion from Durkheim through to Weber. Most of the major early theorists of the social sciences wanted to understand how a society that had lost its traditional structures of legitimation managed still to develop moral and social norms that people could adhere to.

So a *Kitchen-Table Society* is one in which society creates one of its most important instruments for reproducing itself around the kitchen table. Most ethnographies might have drawn attention to this without much thought for the kitchen table itself, but Gullestad is aware that the frame within which the overt activity takes place, as in most frames for behaviour, becomes essential to the possibility of the behaviour and its direction. Kitchen-table societies require the right kitchen. This group of women have to feel that their ability to potentially achieve consensus, to trust each other's opinions and secrets, depends on a recognition that each is 'one of us'. Norway is a particularly egalitarian society, and being one of us means that the kitchen must reflect a careful balance. There are two crimes to be avoided: on the one hand, that of letting oneself go, of failing to keep up a common standard that can be instantly seen in the care and attention given to furnishing and its maintenance and cleanliness; and on the other hand, that of being seen as the kind of person who has social ambitions that would lead to a distance between that individual and her peers, something which may be betrayed in the purchases she has made or the place she accords certain decorative objects in her home. It is the details – the 'nice' wallpaper, the old kerosene lamp now used for decoration, the Italian reproduction of a crying boy and the dark brown tables that tells visitors this is a friendly, we might appropriately say also 'homely', couple: a couple who subsequently, as fashions change, keep up with the times but don't try to be any kind of vanguard (1992: 73–5) Renovation itself becomes a way by which people keep in a kind of tandem with each other.

This careful balance that creates the appropriate frame for social interaction applies as much to the activity of keeping home as to the overall appearance. In order not to 'let go' and betray the sense of respectability that they share, an individual must constantly clean, tidy and dust. But it is recognized that this is the means to social intercourse not its replacement. So persons who continue to engage in such activities, who carry on dusting and cleaning when visitors are present, are said to 'have dust on their brains' and could be rebuked on these grounds. So in *Kitchen-Table Society* we see the activity of home-decoration as a kind of core to living in the modern world. By decorating the home appropriately and maintaining it to the right degree, individuals create a material frame within which they can socialize. This socialization is the basis for normativity – that is, deciding the moral parameters by which they will determine their own behaviour and judge others. In turn this behaviour is the way they determine their relationship to the world of employment, family and that which links them to the country and the

world at large. This makes this book a particularly good starting point for a study of accommodating, since it brings out the network of links that make the study of home interiors significant and that can easily be lost or forgotten if we start to focus too narrowly on this activity in itself and in effect fetishize the furnishing.

The very factors that made *Kitchen-Table Society* the ideal starting point for such investigations also implicate its limitations. The Norwegians are in certain respects an extreme example. This intensely private egalitarian home-focused society is one in which home decoration can be viewed as the essence of norma-tivity and normativity as the basis for the reproduction of society. It is certainly not the only such case. McCracken's (1989) study of Canadian homes with its central notion of 'homeyness' had a similar such focus, in which the primary concern is to make visitors feel 'at home' as quickly and as easily as possible. This was, incidentally, important since it also spoke of a refutation of one of the colloquial assumptions about the relationship between home decoration and society more generally asserted in the expression 'keeping up with the Joneses' which focused on emulation and competition.

Normativity is, however, only one aspect of this wider relationship and even in Norwegian society it may mask many underlying contradictions and subtleties. It was the feeling, inspired by Gullestad, that the Norwegian example was particu-larly important and that this particular aspect of her work was worth focusing upon in greater details that leads us from this first study to the most recent. Pauline Garvey (2001) has taken up this challenge and turned this general hunch into findings that build on, but also deepen, Gullestad's original work. Garvey carried out her research in the town of Skien which, even more than Bergen, is thought of by Norwegians as both essentially working-class and also quotidian. The kind of place that no one would think of studying because of its very ordinariness. Unlike Gullestad she made the activity of home decoration central to her work. At this level of detail the issue of normativity is both affirmed and also deconstructed. To be normative brings out all sorts of tensions between individuals and their families, between both individual and household and society more generally. There are also tensions between the inevitable differences between people of varying income and background and the emphasis on sameness and equality. By focusing upon home decoration these subtleties and contradictions can be investigated in their own right.

For example, Garvey's work shows that the simple notion of individuals expressing themselves in their decoration of the home is just that – simple. Once we start to consider what we mean by an individual we realize that we see ourselves both in terms of a longer narrative of the self, that which relates backward to our childhood and forward to our future, but also a sense of the multiplicity of persons we might be, or in different contexts are. We also see the many other paths we might have chosen and short-term aspects of our lives that

might not fit the longer trajectory. If we then turn to the matter of expressing ourselves in our homes, these tensions of the short term and long term find resonance in different ways in which this relationship to the home develops. We have the longer-term narrative of the houses we have lived with, a topic Lofgren (1994) analysed in relation to Swedish households where he links individuals' biographies to the history of their homes and home interiors. But we also have the short-term sense that before we make firm decisions, we are trying out possibilities that don't want to be overly constrained by some sense of a long-term trail that we follow like a train on its tracks. These considerations led Garvey to examine the way women may every now and again move things around the room, not creating a new decor exactly or a refurbishment but merely making sure that things are not in a 'rut', that they are subject to experiment and alteration that might then lead to a major change but, often as not, get put back the way they were before within quite a short time. By viewing this in terms of the larger contradictions of the relationship of the self to its own narrative, what might be thought of as about the most trivial activity – hardly worth considering even as an aspect of home decoration – becomes quite a profound aspect of home decoration as a whole.

The results of Garvey's research have been published as part of my book *Home Possessions* (Miller 2001), which consists entirely of fieldwork by my own PhD students and entirely devoted to this topic of the home and its material culture. As it happens, however, this book appeared at the same time as a series of others that brought to the era of their publication a kind of efflorescence in the study of this particular topic. If to Miller 2001 one adds earlier work such as Attfield and Kirkham (1989), Putnam and Newton (1990), Segalen and Le Wita (1993), and especially the flood of edited collections all from 1999 – Birdwell-Pheasant and Lawrence Zúñiga, Brydon and Floyd, Chapman and Hockey, and Cieraad – as well as Buchli's important monograph of that same year, then one can see a quite extraordinary rise of interest in this topic. Much of this literature is devoted to studies based on design history and more general histories of the recent past which are intended to document not just the trajectories that lead to the dominant forms of housing and house furnishing that we find today but also to relate this to the more general history of domesticity and the particular associations we see today between the domestic and gender (for example de Mare 1999, but see also Davidoff and Hall 1987, Frykman and Löfgren 1987, De Grazia and Furlough 1996). These selections have their own emphases, with Birdwell-Pheasant and Lawrence-Zúñiga (1999) often linking historical materials with comparative ethnography and Chapman and Hockey (1999) having a more sociological and policy-orientated interest.

Out of the wide range of issues that are covered by this recent abundance of material, I want to return to my declared initial focus which is the study of accommodating as revealed by studies with a material culture focus and as

revealed through ethnography in particular. As already noted with respect to Garvey's contribution, the more recent works have tended to build upon Gullestad and add to that initial work particular emphases that were missing in the original. Garvey is not alone in focusing upon the dynamics of the home, which is obviously important if we are thinking in terms of accommodating as a constant and reciprocal process. Several of the other discussions in Miller (2001) are directly complementary to Garvey in that they cover the various registers of mobility that situate the transient moving around of furnishing that she documents. For example, Clarke (2001) demonstrates that the more substantial refurbishment of homes will bear on different issues since it relates to a different temporality, one that is expected to last several years rather than a few days. She also helps us to bury a simplistic notion of 'keeping up with the Joneses' by her emphasis on a much more complex relationship between aspiration and people's sense of their current position. Her fieldwork in North London shows how often people have very little contact with any actual 'Joneses' as neighbours and instead use home decoration itself as a means to project ideas and ideals as to who they could be or become. As such her commentary is close to a number of those in the collection by Chapman and Hockey (1999), which is also devoted to the way in which actual homes relate to a sense of 'ideal homes'. These range from immigrants' aspirations toward assimilation, through aspirations of a single woman toward an ideal partner, or aspirations for the future of one's children. As such the home becomes not an expression of other people's 'gaze', but rather an interiorized and more controlled replacement of those absent others. It becomes in and of itself the effective 'other' against which one judges oneself.

Marcoux (2001) explores a generally neglected aspect of the relationship between people and their possessions: the process of divestment. He shows that this is just as important as refurbishment and moving furnishing around when it comes to the reciprocal realignment of persons and places that I am calling accommodating. When we move house we are forced to confront our possessions through explicit decisions as to what to keep and what to throw away. Marcoux demonstrates this is also taken as an opportunity to reconfigure both the repair and rewriting of the narratives of own personal biography and also the way relationships to others have formed part of this biography. This is because the objects of the home are the mementoes and reminders of the past and so the decision to discard some and retain others becomes the active management of one's own externalized memory. Finally, in terms of this dynamic approach to these relationships, Petridou (2001) focuses on groups who bring actual objects such as food from their countries of origin to, as it were, bridge a gap in the possibility of accommodating when the objects around them cannot provide the sense of authenticity they crave in their immediate environment.

Between them these contributions create a register of temporality from the frequency of moving furniture around to the much rarer refurbishment or moving house. It is also possible to develop a ritual around such re-establishment of the explicit and self-conscious relationship we have to our home possessions, and in many regions the festival of Christmas has become important in that regard. This was very evident in my own ethnographic researches in Trinidad (Miller 1993) where each year the taken-for-granted acceptance of the positioning of things around the home is challenged by the insistence that Christmas cleaning requires more or less every object to be taken out of the home and then replaced after cleaning. Furthermore the festival becomes oriented to this activity. Most Christmas purchases are not made as gifts for other people but are objects intended for the home interior. Also even if they were purchased at some other time of the year they are stored until Christmas Eve at which time they are taken out and displayed for the first time.

This is a ritual in which the activity of home decoration is turned into one act within a much longer performance. The reordering of the home is ritually closed at the end of Christmas Eve with the rehanging of the curtains at each of the windows, or better still the hanging of newly purchased curtains. From Christmas Day the newly reborn home becomes the basis for rituals of feeding and drinking that are successively directed to the immediate family and then to neighbours, work colleagues and as many others as possible to make the whole festival a kind of centripetal movement that has the whole population giving homage to the home interior itself as the inner shrine of domestic values and life. This becomes increasingly clear when contrasted with Carnival – the other major festival of Trinidad which has exactly the opposite orientation to the street, the exterior and the centrifugal process of drawing people from their homes to the public domain.

In most cases what are expressed in the relationships between people and homes are not so much individuals and their possessions as whole households or families and their configuration of relationships to each other and to details of their home decorations. In a series of papers, recent ethnographies have explored this aspect of the process of accommodating whereby what we observe is the simultaneous building of homes and relationships. For example Tan (2001) has followed up some earlier work by Bloch (1995), which argued that in some societies the construction of the home is understood as both a reflection of and a medium for the construction of a marriage. Both are seen to begin as relatively insecure and fragile structures that gradually acquire solidity and foundations. The increasingly 'concrete' house and marriage thereby become the solid basis for the core task of reproduction. Sometimes this has to be worked on despite disadvantageous situations. Drazin (2001) working in Romania found that the warmth of family-building inside the home based mainly on an aesthetic of wood has to be seen also

as a direct aesthetic negation of the grey and crumbling concrete of Soviet system blocks.

What emerges from such work is a process of accommodation that refers back to but expands on earlier research. Indeed with reference to Gullestad's work what we can now see is the way that both the sense people have of the normative and the sense they have of the state of their relationships may be much more fraught and contradictory when we delve deeper into the interior. Sometimes it is the actual state of homes that is entirely different from that which is assumed to be normative. This possibility is evident in the title of Daniels's commentary (2001) on 'The "untidy" house in Japan'. She exposes the way an Orientalizing ideology made the house a foundation for similar assumptions about the aesthetic harmony of 'tidy' Japanese domestic relations. This leads to an ethnographic encounter in which she can reaffirm the close relationship between domestic interior arrangements and social relationships, but this time through the way they are being contested. In most the normative is expressed through a taken-for-granted order or aesthetic which may not at first be apparent. In these researches by Tan, Drazin and Daniels we have taken the dialectic of homes and households to its conclusion. It is the constant reciprocity between the relationship among the people who dwell in the home and their relationship to the home itself which best expresses the idea of accommodating.

Accommodating to the Home

I suggested at the beginning of this chapter that accommodation has to be understood as a reciprocal process, which not only involves making the home suitable for the relationships we have with ourselves and with other people, but also adapting ourselves to the needs and sensibility of the house as a material object. To be convincing, this aspect of the process of accommodating has to overcome what might be called our 'common-sense' resistance to the idea of objects in and of themselves possessing agency. We have little problem imagining people adapting their surroundings to express themselves, even where, as we have just seen, this is not just a simple idea of their own biography. Expressing themselves is found rather to include a complex array including their sense of their personal biography, their aspirations for who they might be, their short-term experiments with other possibilities and so forth. But all of this implies a world of things that can be endlessly manipulated to fit with an individual's requirements for self-expression. This would be misleading, since in fact all the papers mentioned are equally concerned with the way in which people experience their inability to change the field of things they are surrounded with and the need, in turn, to adapt themselves to their accommodations. This is most evident in the case

of Marcoux, where the requirement is to adapt to a new home. Miller (2001) and Hecht (2001) take up this problem of reciprocity rather more explicitly in related discussions that focus on the agency possessed by homes and possessions. If the house is accepted as something that reflects the long term or a set of historical processes, then any present occupant has to contend not only with the agency of the previous occupants but also with the house itself as an agent. As Birdwell-Pheasant and Lawrence-Zúñiga note (1999: 9), the degree to which the house becomes taken for granted accentuates rather than detracts from this effect.

Miller (2001) contends that there are times when we do indeed objectify our sense of the house possessing agency. This can be found in the traditional figure of the ghost within the haunted house. This act of projection anthropomorphizes our sense that the house may actually be a good deal older and have developed more 'personality' than its mere occupants. Typically these are homes with a considerable history and ancient lineage. As such the mere inhabitants of any particular time are a much more transient presence than the home itself. By anthropomorphizing this distinction between our own transience and the longevity of the house, by having the inhabitants haunted by an ancient ghost, we in effect come to acknowledge this history of the house and its consequences for the present. The ghost of a haunted house is, in effect, the original 'estate agency'.

Even if we live in much less imposing and haunting homes, we may find for example that the house has a fine-arts and crafts aesthetic with many original features that intimidate us and make us feel anything we might do by way of decoration would fail to live up to that taste already expressed by the house itself. Given the current fashion for doing up 'one's' homes according to what is viewed as the authentic period style, many of us find ourselves immersed in books about 'Edwardian Homes' or searching the auction houses for Georgian ornaments to a degree that we may well feel tyrannized by the desire for authenticity. An unemployed man living on a council estate and lacking confidence in having any relationship to what he regards as the essentially female activity of home decoration may be living with bright painted walls that he utterly detests but although physically he could transform the flat into something more bearable he simply doesn't have the emotional and personal resources to do anything but suffer the taste of the previous occupant that he abhors. This too is a kind of haunting in which the agency of the house is not just felt but actively oppresses its occupants.

In a more positive light, Hecht (2001) presents us with an individual who has become increasingly conscious of what homes have done to her. Having come to terms with the successive homes she has lived in as central to the development of her own identity, her present house is almost as much a museum as is the actual museum where she works as a volunteer. She now gives up her life to her respect for this agency of homes and uses the museum to teach the younger generation

about the meaning of historical artefacts as possessions that have created her and her generation.

Conclusions

I have concentrated on the work of anthropology and those material culture studies that employ ethnography as their primary tool, mainly in order to remain complementary rather than repetitive of other studies in this book. I fully recognize the overlap between my concerns and studies in, say, the history of design such as Attfield (2000), both in terms of the issues being investigated and the kinds of material used. Such historical work often provides important historical backdrops for making sense of contemporary arrays of objects. Indeed the boundaries are quite porous. My own first attempt to investigate the process of accommodating through the study of how people on a government council estate altered the kitchens they had originally been provided with could not be said to constitute a proper ethnography (Miller 1988). Similarly figures such as Bourdieu (1970) have fluctuated between work on the order of the home among the Kabyle, which were ethnographically based, to more survey-based materials which were the foundation for his work on taste (1984) and have in turn attracted critical analysis through more recent studies of features of home interiors such as Halle's (1993) study of the patterns of paintings hung on the walls of US homes – a topic close to the heart of this collection.

To illustrate this point further, the work of Chevalier exemplifies the potential for combining historical and ethnographic work, possibly facilitated by the degree to which France has a particularly rich tradition in the historical study of the domestic sphere and indeed of the family more generally. For quite some time, studies in France have included historians such as le Roy Ladurie who have managed to construct creditable ethnographic studies of the past based on the minutiae retrieved from particular genres of archive, complemented by some of the important historical work on the family being associated with anthropologists such as Segalan.

Chevalier's own work (1998, 1999) begins with ethnographic material within a comparative anthropological perspective. This is derived from carrying out fieldwork on the home interior in France and then replicating her work with an additional study in Britain. What emerged from this were the advantages of being able to systematically delineate the differences in the contemporary relationship to the home in these two countries. This in turn raised questions that could best be answered through reference to historical studies. For example, the English passion for their gardens as the area for the transformation of nature is paralleled best by the French relationship to cuisine. To understand this and, for example, the

different role played by heavy furniture that is inherited through the generations in France, we have to understand the distinctiveness of England from most of Europe in not having a tradition of a second home in the countryside. This in turn has to be understood with reference to a different history of the peasantry, and quite possibly different traditions of both inheritance and, more generally, of individualism. Equally, there is a vast literature on home ownership that provides an essential context to all this work. But it is fair to say that what tends to be missing from the literature on home ownership is the portrait of the more intimate relationship of people and their home possessions provided by work such as Chevalier's (see Attfield 2000: 187).

In focusing on the more ethnographic aspects of accommodating, these studies reveal anthropologists rising to the challenge of an ethnography of the private sphere – that is, spending time within and documenting the details of ordinary homes and households even in such intensely private societies as Norway and Japan. This returns us to the work of Gullestad, where it was not any particular need to be concerned with the home interior and the details of decoration that led to her research on home interiors, but the realization that this is central to the whole array of issues that concern us about modern life. Many of these stem from the original Durkheimian desire to find the sources of normativity and morality when older forms of legitimation have gone. To which we may add more recent concerns with how people integrate their sense of the local and the global when the images of the world are mainly experienced in the privacy of their living room. The point that emerged from all of these studies is that home decoration is not a passive backdrop to such issues, it is often the medium through which households attempt to work out their resolution of such contradictions. Through the process of reciprocal accommodating they strive to find, not always successfully, a representation of the world they can literally live with and that assists rather than constrains their construction of relationships with each other and with the outside world.

This is hardly the first time an academic has viewed the relationship to the home and its interior as profound or as having major philosophical consequences. The phrase 'being at home in the world' has been a central tenet of philosophy from Hegel and before, and writers such as Heidegger made such concerns central to their quest for fundamental issues of ontology. But personally I have little interest in or sympathy with such attempts to project onto actual people and actual homes what might be called the 'needs of philosophers' to ground their conundrums in what can become universalistic and often glib conjectures as to what this relationship must thereby be. Accommodating as it has been addressed in this chapter is certainly a philosophical problem, but I simply prefer the way philosophy is 'done' by anthropology to that of philosophy. I think we can put a great deal more store by ethnographic enquiries that acknowledge the general issues at stake in thinking

about accommodating as this process of reconciliation with the world, but which demonstrate that the way such problems are experienced, the way the home and its decoration is used to express and ameliorate the contradictions of experience, are very particular to time and place. So that if this chapter can suggest one final meaning to the term 'accommodating', it is the need for us all to accommodate our academic interests and presuppositions to the diversity of these relationships as we encounter them.

References

Attfield, J. (2000) *Wild Things: the Material Culture of Everyday Life*. Oxford: Berg.

Attfield, J. and Kirkham, P. (1989) *A View From the Interior: Feminism, Women and Design History*. London: Women's Press.

Auslander, L. (1996) *Taste and Power*. Berkeley: University of California Press.

Birdwell-Pheasant, D. and Lawrence-Zúñiga. D. (eds) (1999) *House Life*. Oxford: Berg.

Bloch, M. (1995) 'The resurrection of the house amongst the Zafimaniry of Madagascar', in J. Carsten and S. Hugh-Jones (eds) *About the House*. Cambridge: Cambridge University Press.

Bourdieu, P. (1990 [1970]) 'The Kabyle house or the world reversed', in *The Logic of Practice*. Cambridge: Polity.

Bourdieu, P. (1984) *Distinction: A Social Critique of the Judgement of Taste*. London: Routledge & Kegan Paul.

Braudel, F. (1981) *The Structures of Everyday Life*. London: Collins.

Brydon, I. and Floyd, J. (1999) *Domestic Space: Reading the Interior in Nineteenth Century Britain and America*. Manchester: Manchester University Press.

Buchli, V. (1999) *An Archaeology of Socialism*. Oxford: Berg.

Carsten, J. and Hugh-Jones, S. (eds) (1995) *About the House: Levi-Strauss and Beyond*. Cambridge: Cambridge University Press.

Chapman, T. and Hockey, J. (eds) (1999) *Ideal Homes?* London: Routledge.

Chevalier, S. (1998) 'From woollen carpet to grass carpet', in D. Miller (ed.) *Material Cultures. Why some Things Matter*. London: UCL Press.

Chevalier, S. (1999) 'The French two-home project: materialization of family identity', in I. Cieraad (ed.) *At Home: An Anthropology of Domestic Space*. Syracuse: Syracuse University Press, 83–94.

Cieraad. I. (ed.) 1999. *At Home: An Anthropology of Domestic Space*. Syracuse: Syracuse University Press.

Clarke, A. (2001) 'The aesthetics of social aspiration', in D. Miller (ed.) *Home Possessions*. Oxford: Berg, 23–45.

Daniels, I. (2001) 'The "untidy" house in Japan', in D. Miller (ed.) *Home Possessions*. Oxford: Berg, 201–29.

Davidoff, L. and Hall, C. (1987) *Family Fortunes: Men and Women of the English Middle-Class 1780–1850*. London: Hutchinson.

De Grazia, V. with Furlough, E. (eds) (1996) *The Sex of Things*. Berkeley: University of California Press.

de Mare, H. (1999) 'Domesticity in dispute: a reconsideration of sources', in I. Cieraad (ed.) *At Home: An Anthropology of Domestic Space*. Syracuse: Syracuse University Press.

Drazin, A. (2001) 'A man *will* get furnished: wood and domesticity in urban Romania', in D. Miller (ed.) *Home Possessions*. Oxford: Berg, 173–99.

Freyre, G. (1986) *The Masters and the Slaves*. Berkeley: University of California Press.

Frykman. J. and Löfgren, O. (1987) *Culture Builders: A Historical Anthropology of Middle-Class Life*. New Brunswick: Rutgers University Press.

Garvey, P. (2001) 'Organised disorder: moving furniture in Norwegian homes', in D. Miller (ed.) *Home Possessions*. Oxford: Berg, 47–68.

Gullestad, M. (1984) *Kitchen Table Society: A Case Study of the Family Life and Friendships of Young Working-Class Mothers in Urban Norway*. Oslo: Universitetsforlaget.

Gullestad, M. (1992) *The Art of Social Relations: Essays on Culture, Social Action and Everyday Life in Modern Norway*. Oslo: Scandinavian University Press.

Halle, D. (1993) *Inside Culture: Art and Class in the American Home*. Chicago: University of Chicago Press.

Hecht, A. (2001) 'Home sweet home: tangible memories of an uprooted childhood', in D. Miller (ed.) *Home Possessions*. Oxford: Berg, 123–45.

Lotgren, O. (1994) 'Consuming interests', in J. Friedman (ed.) *Consumption and Identity*. Chur: Harwood Academic Press.

Marcoux, J.-S. (2001) 'The refurbishment of memory', in D. Miller (ed.) *Home Possessions*. Oxford: Berg, 69–86.

McCracken, G. (1989) '"Homeyness": a cultural account of one constellation of consumer goods and meanings', in E. Hirschman (ed.) *Interpretive Consumer Research*. Provo, UT: Association for Consumer Research.

Miller, D. (1988) 'Appropriating the state on the council estate', *Man*, 23: 353–72.

Miller, D. (1993) 'Christmas against materialism in Trinidad', in D. Miller (ed.) *Unwrapping Christmas*. Oxford: Oxford University Press, 134–53.

Miller, D. (2001) 'Possessions', in D. Miller (ed.) *Home Possessions*. Oxford: Berg, 107–21.

Miller, D. (ed.) (2001) *Home Possessions*. Oxford: Berg.

Petridou, E. (2001) 'The taste of home', in D. Miller (ed.) *Home Possessions*. Oxford: Berg, 87–104.

Putnam, T. and Newton, C. (eds) (1990) *Household Choices*. London: Middlesex Polytechnic and Futures Publications.

Segalen M. and Le Wita B. (eds) (1993) *Chez Soi – Objets et décors: des créations familiales*. Autrement collection, Mutations series.

Tan C.-K. (2001) 'Building conjugal relations: the devotion to home amongst the Paiwan of Taiwan', in D. Miller (ed.) *Home Possessions*. Oxford: Berg, 149–72.

–8–

Taste Wars and Design Dilemmas: Aesthetic Practice in the Home
Alison J. Clarke

Numerous studies have identified the importance of the household and social relations in the construction of taste (Putnam and Newton 1990, Attfield and Kirkham 1989, Gullestad 1992). Similarly, Bourdieu's sociological work *Distinction* fully established that choices among everyday objects involve aesthetic evaluations as aggregate class-specific expressions of taste (Bourdieu 1984). Using research taken from an ethnographic study of household consumption, this chapter reveals the actual processes through which taste is formed. Through observing the acquisition of an IKEA fitted-kitchen or a leopard-print patterned teapot, we see people negotiating and refusing aspects of potential relationships through taste. In this sense subjects and objects are not related merely by acts of representation, as though distinctions in goods just reflect distinctions between persons, but rather they work as a process of mutual objectification. Furthermore, the objects and images utilized in the contestation of relationships take on agencies of their own (Latour 1992). Rather than seeing them merely as markers of identity or reflections of aggregate values such as class, gender and ethnicity, homes and possessions are seen here as active agents in the construction of taste and social relations.

The consumption (acquisition and display) of art, design and artefacts in the domestic context is bound by complex webs of aesthetic discourse that are not merely representative of given dispositions (social class, gender, etc.). Unlike Bourdieu's study, this ethnographic insight into contemporary homes shows taste in action as it shifts to constitute particular forms of relations. Similarly, social relations are observed changing in response to particular manifestations of taste. The ethnographic examples used in the latter part of this chapter will focus on the dilemmas of comparatively art-and-design-conscious households to show why the material evidence of choice (objects, interiors, etc.) generates so much anxiety. For even when individuals possess formal aesthetic knowledge, they must ultimately place their taste within the context of an immediate and intimate network of social relations with potentially hazardous consequences.

This chapter is an attempt to address the nature of the aesthetic by examining the process of aesthetic judgement within three contexts from which it is all too

commonly excluded: first by undertaking an analysis of aesthetics as applied to everyday objects rather than works of art, second by understanding aesthetics as a social process rather than merely an encounter between an art work and an individual, and third by considering not only the relationship between the persons involved but also the relationship between the objects involved.

The evidence is drawn from an ethnography of household consumption carried out in a single street (and some adjacent roads) in North London over a three-year period (1995–1998).[1] The names of informants, areas and streets involved in the study have been changed so as to preserve anonymity. The very nature of ethnographic inquiry means that one is not studying specifically class or taste as discrete categories, but rather the intricacies, social relations and activities of often unconnected households. The intended study was not, then, of aesthetic processes but of the nature of provisioning.

The main street in the study, Jay Road, was selected because it lacked any outstanding features and defied any one definition, in terms of class or ethnic make-up, as a neighbourhood. One side of Jay Road is occupied mostly by a 1960s council estate (still predominantly tenant-occupied), the other side by owner-occupied and rented maisonettes and houses. Adjacent streets are comprised of larger Edwardian and Victorian family homes many of which are more recently occupied by middle-class inhabitants keen to take advantage of the lower than average price, in comparison to immediate surrounding areas, of such properties. In terms of ethnicity the study includes inhabitants of Greek Cypriot, West Indian, Southern Irish, Asian, Korean, Jewish and South American descent. In short the street is typical of North London in being cosmopolitan but manifestly ordinary. Although preliminary interviews were conducted with more than 150 households, 76 households formed the core of the ethnography.

One of the research techniques used in the study was to ask people to relay stories about how objects in the home were obtained and came to be in the place they now occupy. These 'biographies' and narratives provided detailed insight into how people came to own certain goods, but also highlighted subsequent issues over how these goods were consumed in the longer term. As with many material-culture studies, this topic was often more revealing about the relationships between members of the household than a study that asked directly about such social relations. At the same time this method proved highly revealing about the place of aesthetic judgements in the process of purchase and consumption. This chapter begins, then, with examples that used this method of object biography (Hoskins 1998; Appadurai 1986) and then goes on to consider a specific case study of neighbours on the street.

Aesthetic Encounters in North London Living Rooms

Decorative choices, it has been well established, are most commonly made within the context of the domestic (Clarke 2001; Halle 1993; Chevalier 1998). As a preliminary aspect of the ethnography, the 'object biography' approach established a kind of informal inventory of objects according to the narratives of different members within the household. Considering the following excerpts from a discussion with Judith, a middle-aged divorcee living in a council flat on Jay Road, we are able to see how an informal inventory of her possessions is cast directly in the context of her relationships. This set of quotations is indicative of the kinds of response people typically make to an enquiry regarding the reasons and histories surrounding the presence of particular objects:

> I had to have a teapot but I don't use it. My mother gave it to me, because when she comes over she likes what she calls a proper cup of tea. This was sort of our joke. (Figure 8.1)

> Well my painting [of a seascape], that was done by my father and I wouldn't part from that for all the tea in China, it's been everywhere with me since I was 21. (Figure 8.2)

> My children bought me that [floral china ornament] last Christmas because I left that space there available in case one [of them] bought a Christmas present for me. (Figure 8.3)

Most of Judith's selections involve a relationship between herself and some other person, usually a member of her family. Typically informants' 'inventories' would also include a scattering of objects that resulted from a simple personal choice. In this particular case such objects included a collection of china, the picture of the squirrel Judith finds restful, and some of her reproduction furniture. However, even though the last quotation clearly reveals the involvement of Judith's individual presence, it is clearly mediated by the preference of others.

Although these short quotations substantiate an argument that most decorative selections involve a relationship, they cannot reveal the subtleties of such relationships. It is worth exploring specific relationships in more detail, in this case Judith's relationship to her son who is still living at home with her. Judith's flat is exceptional in that although set within an extremely dull, standardized and neglected block of state housing, it stands out as a clear expression of aesthetic transformation. Even from the outside, the front door and ornamentation tells passers-by that this is a household that has been consciously engaged in a continual act of appropriation from the state. Plant hangers, mock-Tudor door hinges and elaborate black heavy doorknockers contrast sharply with the uniform dull green doors of the surrounding neighbours. The entrance hall, panelled from floor to

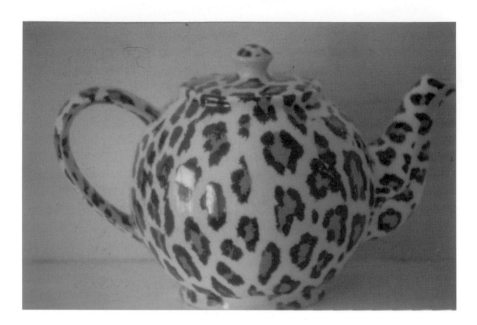

Figure 8.1 Teapot.

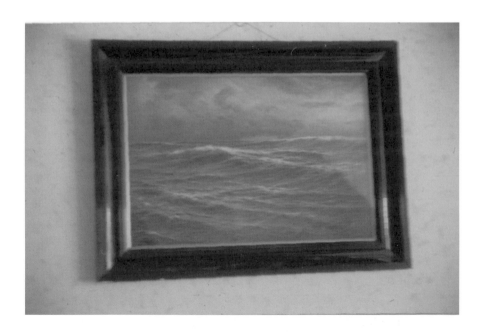

Figure 8.2 Seascape.

Figure 8.3 Floral China Ornament.

ceiling in dark varnished wood to match a stunning parquet floor, creates an impressive spatial transformation. When inside, it is impossible to separate the aesthetic decoration from the multitude of actual physical changes in the layout of the rooms.

Judith is quite explicit about this schema being an expression of the relationship between herself ('I was on a pink and grey theme at the time and that's what we went for') and her son. Her son, a professional builder, carries out all the structural changes in the flat transforming the space to make it utterly unrecognizable from the inside as one of the standardized council flats. Walls have been removed and ceilings lowered. Judith and her son have readily flouted regulations prohibiting the structural alterations of flats. The mother-son relationship is clarified as one moves through the range of their interactions. In acquiring furniture they pride themselves on their unity ('99 per cent of the time we agree'). On the other hand there are areas of acquisition in which the mother seems to take pride in the degree of their difference in order to assert her respect for her son's individuality: 'when it comes to buying anything for John I have to usually ask his friends, he's very particular in his choice of clothes, rather than I go out and buy something for a man. Obviously John is in the age group where the type of clothes that he likes are totally different from my taste. You know, I'm old-fashioned'.

The relationship to the son therefore comprises in equal measure a sense of identity and one of contrast; in both cases the mother shows considerable sensitivity and the son reciprocates in turn. Judith's close relationship with her son is contrasted with what she describes as her 'wasted years' bringing up her older daughters where she feels, due to the stress of work, she did not spend enough 'quality time' with them when they were growing up. In particular, she regrets not going on regular shopping visits with them or swapping mother and daughter tips on dressing. So the bland introductory statement that a choice involves a relationship should evoke the extraordinary complexity that can be excavated from the investigation of almost any actual family relationship. There is no reason to assume that everyday relationships encountered ethnographically are any less complex or contradictory than those represented in fiction; and this becomes most clearly visible through the negotiation of aesthetics and taste.

Judith's aesthetic, as expressed in the design and objects of her living room, is a combination of many factors. She is herself confident and experienced in matters of taste and in some cases she finds she does indeed 'know what she likes'. But even the objects she views as strong personal statements are integrated into an order of other objects that gain a patina of affinity because of how long she has owned them, or from whom she obtained them, or which particular gift relationship they expressed at a given time. These objects, once acquired, have implications for other or subsequent purchases. There is not even a desire for some free aesthetic choice here. Rather, Judith is concerned to match any new item to the order of things, which already embodies in its selection the history of previous relationships.

One cannot separate out here the implication of the materiality of things and the significance of relationships. In Judith's comment about leaving a space in case she was bought a Christmas present, we can see that she is working through a sense of the constraints of space, and of aesthetic order, in the hope that the received gift will be compatible within a previously constituted array of objects. She is equally showing her sensitivity to the obligations members of kin have to her. After a lifetime in this practice of the social construction of taste, she finds the isolation of individual preference wearing. She notes that she tries to bring along her ex-husband when she goes shopping, notwithstanding the fact that he actually hates shopping, because as she puts it 'well I suppose he's company more than anything else, but if you are buying any large article, I think its nice to have a second opinion'. She does not see this as a lack of self-reliance but, rather, as a positive appreciation of the sociality of choice.

Judith probably does not know that much about high art, and she probably desires neither this nor an overly independent sense of taste. Rather, she desires above all a sociality which is best affirmed by the interdependence of her taste, a

factor which is constantly objectified in the materiality of the living room and its decorative forms.

The example of Judith and her son's taste reveals the aesthetic construction of the home as a gradual and on-going process (see also Clarke 2001), formed through the integral relation of decorative choices and given relationships (past and present). However, it is in cases where a sudden rupture in this process takes place that the social nature of taste is brought most sharply into relief.

Mrs Holloway (Mrs H.), a seventy-year-old woman who has inhabited her three-bedroom semi-detached house on Jay Road since its completion in the late 1940s, has been mourning the death of her spouse of fifty years. After the recent passing of her husband, Mrs H. now shares the home with her 32-year-old daughter Ginny. In the hallway stands an oak veneered sideboard that Mrs H. bought from a local furnishing showroom with her husband when they first moved into the house. Through recalling the aesthetic choices made in moving into their first home it seems quite literally yesterday, for Mrs H., that she chose the wallpaper and matching carpet by looking at colour and fabric swatches at the kitchen table with her husband:

> We wanted good furniture – you know, the sort that would last a life time – heavy and good – and the carpet had lovely flecks that picked out the greys and reds of the wallpaper – we really loved it. I remember walking into this room [the front sitting room] with Arthur and us barely being able to contain our excitement – it looked so lovely.

Despite Mrs H.'s fond and vivid memories of her household's furnishings and interior design, in the course of the ethnography, she was in the process of eradicating all evidence of the material world she had shared with her recently deceased husband. Arthur had died suddenly and tragically in the marital home that Mrs. H. had previously anticipated sharing with him in his retirement. She was particularly bitter that his death had come only weeks after carrying out his final duties for the civil service and that, having worked hard all of his life, he was denied the pleasure of enjoying the benefits of a home and a fully paid mortgage.

Although still suffering from the loss of her husband, Mrs. H. had spent recent weeks desperately searching local furniture showrooms for a replacement set of sofa and armchairs which she considered of equal quality and aesthetic merit to those originally chosen with her husband in the late 1940s. However, despite failing to find adequate replacements she still insisted that the items of her early marital life be removed from the house and, in consultation with her daughter Ginny, she had begun to create a new interior scheme with stripped floors and modern fittings.

Together they perused contemporary interior design magazines finding just the right style for their new home. In several months the only household feature fully tied to the memory of her husband would be Drum the dog, named after her husband's favourite tobacco. Mrs Holloway and her daughter went through a similar process to that of the newly married couple that first inhabited the house in the late 1940s. But rather than swapping opinions with a new husband, Mrs. H. now considered issues of taste and aesthetics, through the swapping of opinions and ideas for new pictures and ornaments, with her daughter. Through this process both occupants create a style that constitutes 'their' taste and the house itself takes on a new relationship to its inhabitants.

Mrs Holloway is worried that her daughter Ginny, a single woman in her 30s, who works as a florist, will never marry as she only 'ever gets to work with gay men'. Although Mrs. H. is glad her daughter works with men who have 'good taste', she laments that they will only ever be 'just friends' with her daughter and that Ginny needs to be self-reliant. The house then takes on a new role – both mother and daughter are conscious that this decorative scheme may outlive the remaining parent and become the sole domain of the daughter; certain chosen objects, such as china and linens from the original wedding list used to set up home in the 1940s, are reappropriated into the new aesthetics of the house. For the house has become agent of both of their pasts and futures.

The preceding example lends a somewhat idyllic sense of taste as an expressive practice within sociality whereas in most cases it is exemplified by tension and a strong sense of ambivalence. Miriam and her husband Ivan, for example, live in a three-bedroom house adjacent to Jay Road with objects neither of them would admit to liking. Miriam is a solicitor in her early forties whose husband accuses her of having the same naive 'pre-Raphaelite' taste she displayed as a student when he first met her. Ivan is a freelance illustrator of Eastern European origin who specializes in 'dark' depictions for fantasy and science fiction publications. As the couple have such opposing tastes in art and aesthetics they have numerous pictures leaning against the skirting boards, which have yet to make it to the picture rail of their living room (see Figure 8.4). The objects they do have decorating their home (including modern glassware, ceramics and a textile hanging) are tolerated because they have been given as gifts or bought as travel souvenirs: criteria which circumvent the need for an overtly aesthetic justification. Although they might by all conventional accounts be described as 'happily married', in Miriam and Ivan's case their shared taste works as an absence rather than a presence, in which objects and images entering the home are rendered instantly problematic. After twenty years of marriage they are resigned to this aesthetic 'stalemate' and use it in the ordering of new objects and images which enter their home.

Figure 8.4 Pictures against wall.

While Miriam and Ivan's situation may appear extreme, conflict and tension over decorative choice is of course a typical feature of domestic relationships, though this is more usually confined to specific objects or images. Bill and Pam, who share a rented maisonette on Jay Road, regularly argue over the presence of a dining table and matching bentwood chairs (Figure 8.5), positioned in their living room bay window. Bill salvaged this set of furniture from a relationship with a previous 'live-in' girlfriend. Despite Pam's protests, Bill refuses to 'throw them out' stating triumphantly 'it's the only thing I ever got out of that relationship'. Similarly, Pam refuses to get rid of a Mickey and Minnie Mouse plastic ornament proudly displayed on the top of a shelving unit, that she received from friends in Taiwan. (Figure 8.6). Despite Bill's protestations over its 'bad taste', Pam insists that it reminds her of the fun times and friendships she had as a single woman prior to her cohabitation with Bill. However, there are other objects, such as a spiral chrome fruit bowl purchased from the Guggenheim Museum in New York, over which they proudly come together as a couple, telling friends and guests how they came across it in the gift shop and 'just couldn't resist it'.

Homes, Objects and Neighbours as Agents

People, then, to put it rather crudely, have active and ongoing relationships with their possessions and, in turn, their possessions operate as agents within them-

Figure 8.5 Dining Table and Chairs.

Figure 8.6 Minnie and Mickey Mouse revolving ornament.

selves, as illustrated in the next case study of neighbours Chris and Joy, and Eric and Jane. Unusually for Jay Road, these informants not only visit each other's homes regularly, but they share a history in that Eric and Chris went to art college together in the late 1970s. Although they were not particularly close friends during that period, they shared an allegiance with left-wing political groups and were involved in a radical busking group, known as the 'Moaning Minnies', which specialized in performing anti-consumerist songs. They took part in anti-apartheid and anti-capitalist demonstrations together and studied documentary photography and fine art. As well as having shared histories, Chris and Eric share a similar taste in late Victorian houses. Their newly purchased houses are mirror images of each other designed to the exact same room dimensions and original details and are separated only by a few hundred yards on the same street adjacent to Jay Road.

Now in his late thirties, Chris is the first within this peer group to take on a full-time job and buy a house with his wife Joy. Eric followed suit several months later and purchased a house on the same street with his girlfriend Jane. Chris and Joy moved from a low-rent flat, in a state of major disrepair, to a house kept in near immaculate order by its previous owner and decorated in a style that could be broadly described as contemporary and simple. This transition from low-rent urban flat furnished with discarded and second-hand goods has marked a broader life change and suddenly opened up ambiguities in the relationship between Chris and his wife Joy which, expressed as cultural and personal 'values', have been focused on the acquisition and maintenance of certain types of goods and their aesthetics.

Joy originates from Indonesia and has what she describes as 'a non-Western taste' and sensibility. She jokes, for example, that Westerners spend an enormous time caring for their objects and houses while they are quite willing to put their elderly relatives in nursing homes, rather than look after them themselves. She also has strong views about credit and was brought up to never desire what she could not immediately afford or acquire. As Chris and Joy have not yet decided how long they will remain in Britain, or indeed if they will move permanently to Indonesia, so far their home-making has been orchestrated around a notion of transience. Consequently, the furniture salvaged from skips to furnish their previous low-rent flat perfectly suited a shared aesthetic constructed around Joy's thrifty anti-materialism and the anti-consumerist politics of Chris' art-student days melded with a shared notion of transience. Their kitchen was furnished with objects borrowed from friends or obtained from car-boot sales, and everything from lampshades to bedspreads were purchased from charity shops or jumble sales.

In the move to their new home, however, Chris has discarded some items, such as battered saucepans and soiled arm chairs, in preference for a taste more in keeping with the style of the new house. For the first time in their eight-year marriage the couple have acquired brand new household items, as Chris in particular has begun to mark his new-found acceptance of stability and domesticity

through the coherence of a contemporary design style. Despite an arguably functional requirement for certain items of furniture, such as a kitchen table and a refrigerator, Joy intermittently opposes purchasing decisions by taking on a role as the thrifty money manager. In contrast, Chris describes himself self-mockingly as a 'born again consumer'. This is not to suggest that one of the partners is predisposed to functional economic decisions and the other to aesthetic decisions; rather, that each object acquired for the house is undergoing a series of fluid taste processes in which such dualisms operate simultaneously.

Having never formally shopped together for their home, Chris and Joy's mutual taste is on a par with that of a newly courting couple's (Miller 1998) in the sense that it is largely uncharted and, despite their previous approaches to 'materialism', open-ended. They have, for example, never purchased an item from a formal retail store such as Habitat or IKEA, and in the course of moving into a new house have to negotiate their relationship, shifting values and new taste as well as finding themselves 'learning' new consumer skills and knowledges. In many instances the necessity to negotiate 'their' taste is alleviated by the prior decisions of the previous occupant: an IKEA fitted kitchen is already installed and, despite Chris's antipathy toward globalized superstores, this comes as a happy relief.

Unlike previous informants mentioned so far, Chris and Joy only have an 'anti-taste' through which to frame potential purchases. Even a simple household white good, then, can pose a dilemma as to its appropriateness when neither individual is willing to take responsibility for the choice of type and style. In the case of selecting a refrigerator, which even Joy grudgingly admits the household needs, the couple reluctantly strive to formulate an aesthetic and functional criterion through which to make their shared choice. After a several-week delay in making a decision (Chris initially decides he wants a silver metallic mid-range priced model and Joy finds nothing to suit her taste or price range), the couple find a damaged white fridge/freezer made by a known brand in the 'bargain basement' of a high-street electrical shop. Despite the overt consumerism of their purchase, Chris and Joy feel vindicated in that they are paying only two-thirds of the manufacturer's recommended price. As they cannot reach a shared aesthetic around refrigerators, the house and its previous owner's decorative scheme is incorporated as a third party in their relationship as both partners agree that the new item 'best suits the style of the kitchen'. In the course of the ethnography it is the house and its preordained style, rather than the taste of the couple, which develops as the consistent means by which purchases are framed and justified. For example, the contentious selection of a half-price beech and laminate folding table is made solely on the premise of its ideal relation to the decor of the kitchen.

For the house, then, acts as an agent both in pacifying contentions and amplifying them. This is not only enacted in a conceptual sense, but also in a literal sense whereby objects are taken on loan from stores to be 'tried out' in the setting

of the house. For several weeks Joy and Chris could not agree on appropriate chairs to best match their 'bargain' kitchen table. Despite using utilitarian guidelines, such as comfort, height and durability, to make their choice the couple failed to reach a harmonious solution. In taking a range of single chairs home, posing them beside the table and against the backdrop of their kitchen decor and inviting their neighbours Eric and Jane to comment, the couple eventually came to a decision.

Even in the absence of the couple's contra-dynamic, the house acts as a stimulus and legitimization for certain types of choices. Chris, despite (or indeed because of) his anti-consumerist past has, since purchasing his house and furnishings, become increasingly savvy in his understanding of brands. During an extended absence of his wife from the household, as she visited relatives in her native Indonesia, Chris requested a housewarming present from his parents of a Krups electric coffee grinder. This particular brand matched perfectly the streamlined weighing scales incorporated already into the fitted kitchen installed by the previous owner. Furthermore, as a gift the expensive Krups appliance circumvented the need to justify his unmediated choice (see Figure 8.7).

Similarly, in Chris's absence Joy would re-apply a range of novelty fridge magnets, sent as gifts from friends in Indonesia, to the front of the refrigerator as a challenge to Chris's sought-after modern and clean aesthetic. In this way, the fridge became a focal point of the kitchen and a parody of the couple's style battle

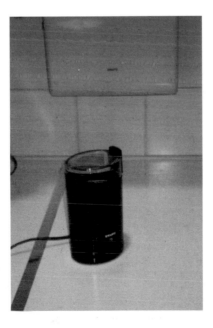

Figure 8.7 Krups Coffee Grinder.

as Joy periodically moved the kitsch items back to a prominent and provocative position.

The contentiousness of items such as the refrigerator is better understood if we consider the relationships between, not just Chris, Joy and their house, but of Chris and Joy and their neighbours' house. For Chris, in particular, the DIY and decorative schemes of his friend and neighbour Eric offered a direct point of comparison to his own aesthetic choices and vice versa.

While Chris's home had been entirely modernized by its previous owner, Eric's house (identical in proportions and lay-out) required complete refurbishment. Previously a family home owned by a 70-year-old Jamaican grandmother, the decor of the house (unlike that of Chris') could not easily be appropriated into the age and social group in which Chris and Eric were in the process of positioning themselves. While certain types of late 1960s wallpaper could lend themselves to a retro-irony indicative of a self-consciously 'designed' style promoted by contemporary magazines such as *Wallpaper*, the extreme brightness and wear of the interior design decided Eric to completely 'gut the place' and make it more in keeping with the simple style of Chris's home.

The process of making-home then, was not only shared with their respective partners. In fact, through a series of reciprocal exchanges, including the lending of tools and the swapping of DIY tips, the principal relationship in terms of taste and its negotiation resided with Chris and Eric (see Miller 1998 re gender relations and DIY).

Objects such as the fridge or a Habitat table, as well as the house, became sites of direct comparison. While Eric's refrigerator also featured kitsch magnets, unlike those placed provocatively on the fridge by Joy, Eric's were self-consciously kitsch juxtaposed as they were with knick-knacks displayed on the top of the appliance in the manner of an art school 'collecting for inspiration' project. Unlike Chris, Eric had inherited his kitchen table from a great-uncle, and had it sanded and refinished.

Acting as the initiator (being the first of the friends to 'settle down' and choose to buy in that particular location), Chris felt that he was disadvantaged in the sense that Eric always managed to benefit from his risks and hindsight. While Chris himself stumbled to find the most appropriate kitchen table in the context of an entirely new set of life circumstances, Eric sat back, took note and then positioned himself accordingly. Notably, the semi-amicable conflict between Eric and Chris manifested itself directly in the style decisions each made, and compared, over his house and its contents. Both friends had also been brought together by their endless reading of IKEA and Habitat catalogues and joked to themselves about how their agit-prop days had been replaced by cappuccino-fired shopping sprees.

While Chris tried to circumvent full-price branded goods through the acquisition of bargains and sale items, Eric maintained an ethical superiority, for example,

by buying appliances refurbished by a charity intended to help homeless teenagers. These individual gestures were consistently mediated through certain class dispositions rooted in the friends' histories as students. Whereas Eric studied fine art, Chris studied a more vocational degree in documentary photography. Whereas Eric was set to eventually inherit a substantial amount of property, Chris was entirely dependent on his monthly salary; in this way the project of home-ownership also took on different meanings.

Conclusion

It is a well-established point that choices among everyday objects involve aesthetic evaluations as expressions of taste, an idea fully established by Bourdieu in his well-known book *Distinction* (Bourdieu 1984). It is hoped that the above snapshots have shown that the process is most commonly dependent upon the immediate social relations of the persons undertaking this act of choice, and most importantly that the relationship between the objects themselves – the houses and possessions – have a major role to play in our understanding of aesthetics as a form of practice. In observing these choices we can watch people coming together in their taste, defining their differences through taste, negotiating and refusing aspects of a potential relationship through taste. Both subject and object are the consequences of relationships to other subjects and objects and these in turn have consequences for others.

Many people today may feel that they are relatively knowledgeable about the formal aesthetic values ascribed to art. Many more have other equivalent specialist knowledges, around areas of design, style and fashion, which can be equally scholarly and esoteric. Clearly, such knowledges are obtained through an individual's education and socialization into collective values. Yet, despite this, in the daily world of practical aesthetics where most aesthetic judgements become matters of taste, this knowledge, whether gained formally or informally, often proves an insufficient guide. In daily life the assertion of an aesthetic judgement is not simply that of the autonomous agent but most commonly part of a social context in which the expression of aesthetics is intended to be part of relationships. These may be relationships with others who are present, others held in mind, or those more complex internalized constructions of other subjects which psycho-analysts have called 'internal objects' to whom we relate our judgements. In this context, the lack of predictive ability with respect to the sense of the other and their aesthetic assessment makes it difficult to know what the effect of the opinion will be.

Whether it is walking out of a film or choosing a set of chairs, each individual is often left hoping that his or her companion will be the first to express an aesthetic

evaluation. This is not necessarily an expression of deferment where a dominated partner waits to be informed by a dominant partner. Rather, the individual may remain uncertain as to his or her own preferences, simply because of being aware of several possibilities. It is only when the implication of the preference for the relationships becomes clear that the individual knows for him- or herself what the preference actually was. This is because it is the consequences of the act that may determine what the act should have been. The phrase 'do we like this?' may have more experiential validity than the question 'do I like this?'; or alternatively, an individual may only realize how much he or she likes something when it transpires that the individual's child or partner does not.

This implies that the aesthetic judgement is itself the creature of social rather than merely individual agency. Without the security in our sense of the other with whom the relationship exists, we find that we constantly do not know ourselves what our aesthetic opinion actually is. Our opinion is a partially formed set of possibilities that is only concretized as clear preference through its relationship to other such opinions during its formation. To that extent the question of aesthetics may shed light onto an existential problem of modernity – the sense of uncertainty about the location of the self. This uncertainty rests in the larger problem posed by a dialectic of objectification in which the subject is itself constituted by the cultural forms in which it recognizes itself, which therefore makes the very materiality and history of the objects in question an active player in this process. There is a burgeoning literature on 'reflexive modernity' (e.g. Beck, Giddens and Lash 1994), but this tends to assume an individual wrestling with his or her own angst in the face of perceived risks. This is the problem of constructing a consistent auto-biography that can be found in some of Giddens's (1991) work on self-reflexivity. Even where there is a clear concern with mediation in such studies (e.g. Lash and Urry 1994: 48), these mediations tend to be institutional – as in the industries of cultural and fashion production – rather than social. It becomes very difficult to discern within that literature something approximating the ethnographic focus upon the sociality of the domestic.

Bourdieu is properly credited with establishing the academic refutation of this idea that taste as a form of aesthetic preference is merely an idiosyncratic individual choice. In *Distinction*, Bourdieu clearly demonstrated an overall relationship between individual taste and the workings of class in French society. The implications (which one could also have drawn from marketing research) is that taste is a much more predictable and contextualized phenomenon than most people had wished to acknowledge.

There may, however, be a complementary role between the sociological determination of this point and the anthropological. Bourdieu's *Distinction* continues the more sociological branch of his many research studies, being based on statistical readings of questionnaire data. In that respect it is quite different from

his more anthropological forms of inquiry as carried out among the Kabyle. If it constitutes a critique of the colloquial idea that 'it's all a question of individual taste' then that criticism is founded on the evidence that the individual may be relatively predictable when given the proper sociological description of his or her social position. This is confirmed in Bourdieu's more recent work on art where, for example, he claims that it is 'the history of social space as a whole, which determines tastes by the intermediacy of the properties inscribed in a position, and notably through the social conditionings associated with particular material conditions of existence and a particular rank in the social structure' (1996: 256).

This certainly constitutes a situating of art choice within the social space. Nevertheless the actual act of claiming an aesthetic preference remains throughout the work of *Distinction*, an entirely individualized activity. That is to say, Bourdieu is creating maps of social space based on the statistical manipulation of data based entirely on the statements of individual preferences. Bourdieu's method, so far from challenging this trait, actually concretizes this individualism by using a technique based on asking individuals to make choices in relation to questionnaires. It is clear that if aesthetic preferences were other than an individual encounter it would be impossible to discern this on the basis of such a methodology, since the method itself precludes any social contextualization for the stating of aesthetic preferences. Bourdieu's sociology fixes the individual as an aggregate within a social field. If this model of aesthetics is going to be challenged then this is most likely to come about as a result of ethnographic work where aesthetic choice is understood as a practice that can be studied directly in the contexts within which it is taking place (see Clarke and Miller 2002). It is also likely to move out of the art gallery to the place where most aesthetic judgements are made by most people, namely the field of shopping and the dressing and decorating of persons and homes. Similarly, while there is research (see Halle 1993) which is highly critical of Bourdieu's analysis of the domestic selection of art, it gives little attention to the social dynamics of that selection other than in aggregate terms.

The point made by the evidence of this chapter is not simply that aesthetic judgements are founded in social relations, but that the actual process of aesthetic adjudication is most commonly a social rather than an individual process. Aesthetic and social relations are both created in the same act of objectification. This extends Bourdieu's achievement in determining the social contextualizing of aesthetic choice. His sociological perspective where individuals are defined in relation to aggregate social fields is fleshed out by an anthropological involvement in the dynamic creation of the individual within a network of intimate social relations.

The second point made by this chapter is that it is not just the relations between persons as a field of practice that is crucial to understanding aesthetic acts, but also the relations between the objects themselves. The key aesthetic unit is rarely a single object any more than it is a single person. Mostly it is the 'wardrobe' or the

'room' within which a whole configuration of objects is found that together constitutes a relationship to taste as a social phenomenon. As McCracken (1988: 118–29) argued in his discussion of the 'Diderot Effect', it is most often the consequences of one choice for subsequent choices that renders a single choice most significant. So we found earlier in the chapter, for example, that Judith had already prefigured an empty space in the decorative order of her living room to add an anticipated gift from her children. This 'space' related both to her ongoing gift relations with her children but was also inseparable from a whole decorative scheme constituting her history of taste. Similarly, Chris and Joy are seen to use the agency of their house as a neutralized but active point of reference to counter an otherwise fraught aesthetic relationship, typified more by disjuncture rather than by a 'coming together', between the couple.

The point may be considered in relation to a more traditional anthropological investigation of material culture. In chapter three of his book *Signs of Recognition,* Keane (1997) has undertaken an examination of material culture in contemporary Ankalang, on the Indonesian island of Sumba. He notes that objects have a plurality of attributes which may or may not be significant for a specific occasion. They may be related back to their origin in trade, or in labour, or they may imply permanence or impermanence. Other potential attributes may include their value as cash, their past history of transaction and many other historical and material facets of their existence as objects. The object itself does not prioritize the relevance of its various attributes. One of the effects of formalization in exchange, therefore, is to mark out and limit those attributes which should be pertinent to that particular exchange.

Keane rejects the idea that this simply manifests the desire to unambiguously reflect the intentions and agency of any one individual. Instead, he argues that formal exchange focuses upon the event itself whose consequences transcend the intentions of individual participants and may end up expressing conflict and revealing aspects of both the relationships and the objects involved that participants would not have chosen to bring to light. The very durability and facticity of material culture means that objects may transcend the desire to control them; as, for example, when an object is torn or dropped and people read major consequences into those events, or the receiver of a gift highlights an attribute of the object which was not particularly that which the giver had intended to draw attention to. The implication of Keane's discussion is that objects are not merely the passive vehicle of communicative or semiotic intention, since their very materiality may act to create unintentional consequences to which agents have to respond.

The tensions revealed by Keane in his case may be greatly exacerbated when we turn to modern consumer culture. In a world where aesthetics gains the temporality of fashion, we are even less in control of our objects as forms of expression. For example, unless we are prepared to 're-do' our kitchen every year,

we are faced with the implications of a rustic pine kitchen, for example, existing beyond the aesthetic relation intended when it was originally built. All we can do is let the new visitor know that this is not the style we would have chosen if we were re-doing the kitchen today. Similarly, the day after we have paid full price for a new sofa, we discover to our horror that the furniture is being heavily publicized as a 'sale item' and, worse still, it is then seen being bought by someone whose judgement we detest! All such experiences problematize any previous confidence we might have had in feeling that we know what we like, which is also a sense that we know the aesthetic value that an object should have.

Many of the examples presented in this chapter demonstrate the anxiety that objects, as the material evidence of one's choice, raise for the person making that choice. In some cases it is the order of the goods themselves that is used by the subject to resolve this anxiety. In the new order established by a house as agent, a particular attribute of style is allowed to transcend the aesthetic concern with any individual object in favour of an array of goods based around an overarching principle. In effect, it is the order of things, here manifest in the decoration of a previous owner, that is used to resolve the problems constituted by the disorder of persons. Our increasing uncertainty as to what we 'should' like is resolved in making an individual purchase largely a small adjustment to a much larger package of related things: for example, a wardrobe or the home interior. In a sense it is easier if we let the objects choose each other. The situation may not be so different in the fine arts, where in the lack of any overarching aesthetic set of criteria that was a presumption of older art movements but has been largely eliminated within contemporary arts, we find instead that art works tend rather to be treated within genres such as performance art, conceptual art, etc. that provide an objectified context within which new ideas may be fitted as more or less original contributions. This is because in art worlds, even more than in decorative worlds, we may have reached the point where an abundance of knowledge about art has led to more, rather than less, uncertainty as to what we *should* like.

Aesthetics is rarely some naked Kantian encounter between a bounded individual and 'a work of art'. Both subject and object are the consequences of relationships to other subjects and objects, and in turn have consequences for these others. Indeed as in most ethnographic material culture studies we quickly come down to the level of observing complex forms of projection and introjection that form the mechanisms by which aesthetic preference comes to be enacted. The most significant conclusion from such studies is precisely their ability to dissolve away a dualistic conceptualization of subjects and objects. This is the reason why most people who may know a lot about art find in practice they are rarely at all sure about what it is they like.

Alison J. Clarke

Acknowledgements

A version of this chapter, devised in conjunction with Daniel Miller, was first presented as a paper at the ICA, May 1999, as part of the *Stealing Beauty* design exhibition round-table discussion. I would like to thank Theodore Zeldin for his thoughtful comments on the paper at that meeting.

Note

1. The preliminary stage of the research was constructed as a joint ethnography with Professor Daniel Miller, Department of Anthropology, University College London. Miller studied formal modes of acquisition (such as supermarket shopping) as part of a broader ESRC study (Miller, Holbrook Jackson, Thrift, et al. 1998; Miller 1998), whereas my extended research concerned the 'alternative' means by which households acquired goods (e.g. gift-giving, second-hand, home-made, catalogues, etc.) (see Clarke 1997; 2000; 2001; Clarke and Miller 2002).

References

Appadurai, A. (ed.) (1986) *The Social Life of Things.* Cambridge: Cambridge University Press.

Attfield, J. and Kirkham, P. (eds) (1989) *A View from the Interior.* London: The Women's Press.

Beck, U., Giddens, A. and Lash, S. (1994) *Reflexive Modernisation.* Cambridge: Polity.

Bourdieu, P. (1984) *Distinction.* London: Routledge.

Bourdieu, P. (1996) *The Rules of Art.* Cambridge: Polity.

Chevalier, S. (1998) 'From woollen carpet to grass carpet: bridging house and garden in an English suburb', in D. Miller (ed.) *Material Cultures.* London: UCL Press.

Clarke, A. (1997) 'Window shopping at home: classifieds, catalogues and new consumer skills', in D. Miller (ed.) *Material Cultures.* London: UCL Press.

Clarke, A. (1999) *Tupperware: The Promise of Plastic in 1950s America.* Washington DC: Smithsonian Institution Press.

Clarke, A. (2000) '"Mother Swapping": the Trafficking of Nearly New Children's Wear', in *Commercial Cultures: Economies, Practices, Spaces.* P. Jackson, M. Lowe, D. Miller and F. Mort (eds) Oxford: Berg.

Clarke, A. (2001) 'The Aesthetics of Social Aspiration', in D. Miller (ed.) *Home Possessions: Material Culture in the Home.* Oxford: Berg.

Clarke, A. and Miller, D. (2002) 'Fashion and Anxiety', *Fashion Theory*, 6/2: 191–214.

Giddens, A. (1991) *Modernity and Self-Identity.* Cambridge: Polity.

Gullestad, M. (1992) *The Art of Social Relations.* Oslo: Scandinavian University Press.

Halle, D. (1993) *Inside Culture.* Chicago: University of Chicago Press.

Hoskins, J. (1998) *Biographical Objects.* London: Routledge.

Keane, W. (1997) *Signs of Recognition.* Berkeley: University of California Press.

Lash, S. and Urry, J. (1994) *Economies of Signs and Space.* London: Sage.

Latour, B. (1992) 'Where are the missing masses? A Sociology of a few mundane artefacts', W.E. Bijker and J. Law (eds) *Shaping Technology/Building Society.* Cambridge, Mass.: MIT Press.

McCracken, G. (1988) *Culture and Consumption.* Bloomington: Indiana University Press.

Miller, D. (1988) 'Appropriation of the state on the council estate', *Man*, 23: 353–72.

Miller, D. (1998) *A Theory of Shopping.* Cambridge: Polity.

Miller, D., Holbrook, B., Jackson, P. and Thrift, N. (eds) (1998) *Shopping, Place and Identity.* London: Routledge.

Putnam, T. and Newton, C. (eds) (1990) *Household Choices.* London: Futures.

–9–

What Happened At Home With Art: Tracing the Experience of Consumers

Rebecca Leach

Introduction

This chapter is based on eighteen in-depth interviews with people who purchased one or more items from the *At Home With Art* (AHWA) range in Homebase. (See the summary of the AHWA project on pages 7–9 and Plates 1–36). The interviews were conducted between March and September 2001 in London and three cities in the Midlands, North-west and North-east.[1] Respondents were recruited to offer a balance of age, gender, region and item purchased. Names of all respondents have been changed. Some of the real domestic contexts of the pieces sold at Homebase are explored and a snapshot is offered of how these objects have been accommodated (and accommodated to). It is not my intention to claim generalizable findings about the purchasers – the research was qualitative and very small-scale – but to give a rich illustration of some of the accommodations that are made with things and the webs of meaning that transform them from things into belongings.

It is people's experiences and interpretations that make ordinary things extraordinary, and not the other way around: it is not for art to enrich people's lives since lives are already rich. Where the AHWA project has been most successful – in terms of these respondents – is where it has chimed in with their existing values, often in unspoken ways, and given a fraction more confidence with creative decision-making. The findings indicate the embedded nature of things and cultural objects in people's lives: things in homes cannot be separated easily from families, financial circumstances, individual and broader senses of taste, cultural ideas and myths about how homes should be. There is one instance, discussed below, in which the AHWA objects are taken into the home in an explicitly aesthetically discriminating manner – as art objects carefully chosen because of their place in the art world. Such respondents treat their homes almost entirely as galleries, curating the space and carefully managing its displaying qualities. For most respondents, however, the judgements are made more haphazardly, reflecting the multiple demands that homes place on us.

In the first part of this chapter, I take up Painter's idea of 'contagion' as he deploys it in the catalogue to the AHWA exhibition (Painter 1999: 7) and explore what it might mean, a compelling idea in our appreciation of objects. It is richly suggestive of a key dynamic in domestic taste – the idea that things simply speak to people without mediation. In the empirical discussion that follows, this theme is problematized. This unspoken dynamic is at work, but such a process is neither fully transparent nor opaque. There are discourses and languages of home that are learnt, yet they are often experienced as immediate and unmediated by people: it is a fundamental mechanism of consumer success that objects appear to have objective qualities (Miller 1987). As the large edifice of work on consumer objects tells us, this process is dialectical: examined at different moments, it can be both structural and phenomenal (see for example Appadurai 1986; Douglas 1991; Douglas and Isherwood 1978; Willis 1990). What I am concerned with here is the experiential side of this dialectic: the significances determined by respondents as they include AHWA pieces in their lives. Cummings nicely describes this inter-action as 'curating ourselves into being' (1997: 16) – this idea is fundamental to this chapter, reliant on a material culture that extends well beyond the gallery and the university. In discussing curation and accommodation, there are themes: functionality and inevitability, negotiation and singularity, transformation and obstinacy in the objects.

Giving House-room to Contagion

In his introduction to the AHWA catalogue, Painter reminds us of the dualism between art world values and the domestic world that excludes contemporary art from homes: 'To say "I wouldn't hang that on my living room wall" is thought to exemplify philistinism, a lack of regard for the intrinsic characteristics of the work as "art"'(1999: 6). He argues that 'familiarity' and 'contagion' rather than 'educa-tion' or 'knowledge' should be the emphasis if contemporary art is to enter more lives. He examples gardening or football, 'Both require knowledge but it begins at home – with family and friends – not seeming like knowledge at all' (ibid.: 7). So was AHWA contagious, and have people begun to feel at home with (this) art?

What does contagion mean? Painter seems to imply a kind of social contagion – bits of information passed on in familial settings. We also have to evaluate this project in terms of incremental adjustments to the visual culture of home, interior decor, degrees of engagement with and response to artistic practice. In this respect, its micro-impact mirrors the minutiae in the 'project of home' for most people. A rollercoaster of emotional and symbolic attachment, perhaps tinged with violence or the desperate need to escape, perhaps with sentimental longing for the past, home is experienced with an eye on temporality. You might well feel at home now

that you've discovered your style – as some respondents indicate – or because you've only just got somewhere you consider home, or feel not at home because you'll never be as comfortable as in your early childhood. You might well have things in your house you'd never have considered 10 years ago or have thrown away the thing that would 'make' your house today – if only you'd remembered the vicissitudes of fashion. However comforting it is to sink into whatever physical and social environment we call home in the immediate now, we all remake it: fiddle, adjust and reinterpret. The achingly smart and rich might well get someone else to do it for them every few years, but even they will have a stashed closet of past or future dreams. This project's impact is, like much art, incremental and ripe for contagion – once you put the idea out there, it multiplies where it can.

Here, the objects have – in some cases – worked through a stealthy visual and domestic culture, transferring ideas between the object and the home, incrementally adjusting the vision and interpretation of their owners. They have rubbed off tiny bits of themselves onto other objects (and people) and this process has worked in reverse: connections are made in the stories that are told that – perhaps had not been noticed before they were asked to reflect but – on reflection, become significant biographies. The germs that then attach to other things multiply, for some as part of an ecosystem of visual and material themes that start from self, family and home and spread out to say 'here I am'. Contagion and ecosystem are good metaphors for how these things happen in homes: they do compete for survival against wallpaper, collections, mess, hoarding tendencies, children and animals; they do have relationships with furniture and knick-knacks that are more than their parts; they do have environmental and personal impacts that are unknown and evolving.

For some, this germ of contagion is a controlled experiment, a Darwinian natural selection – the best, latest example of a Thing that is fittest for purpose: the design purists in particular (discussed below) represent this. For others, though, contagion is by way of a primordial soup: inevitable and excessive random variation, Things multiplying and falling in love with or threatening a war with other stuff. The hoarders and collectors, gripped by the physical inevitability of their stuff, chucked the Things in to see what happened. My co-researcher Shaku Lalvani said of one interviewee 'it is as if the things in her house have mated and produced the towel'. For these respondents texture is not only important (many of the purist minimalists find importance in texture) but abundant and rampant. The thing/home relation is still contagious whether you hold the things at arm's length and weigh them up with a glossy interiors or art magazine at your side, or whether you chuck them in and let them fight it out with the cat, the mucky old sofa you can't afford to replace and your embarrassing collection of random crockery.

The objects transformed into belongings once at home become part of an ordering system: belongings are one point on a continuum of objects in a

classificatory scheme that marks out treasured things, decorative things, art-world objects and so on. Where people place these objects, what they do with them and what they say about them tells us much about people's own classificatory schemes and meaning systems. However, it is important to recognize that this 'placement' that happens at the everyday level is not free of the baggage of social structure and symbolic system. Of particular importance in this case is the legacy of symbolic expectation and practical constraint that are attached to the idea of house and home.

There is a long history of meanings for display in homes which impact upon what gets allowed in and where it is put or what is done with it once it arrives. It is impossible to discuss this project without reflecting on this, although the broader debates are reflected elsewhere in this volume. Some of these constraints are related to the material realities of housing in Britain: the majority of us live in urban or suburban houses, separate from work and educational spaces, cohabiting with family members or partners. Within that framework, however, symbolic classifications further mark out the territory of home. There has been extensive debate on the mythological and idealized nature of the home (see for example Rybczynski 1988; Chapman and Hockey 1999). Such debate clearly identifies home as an ambiguous and multivalent idea which performs roles of privacy, security, entrapment, comfort, boredom, isolation, mythic idealization of the past, rural fantasy, the site for self-expression, the site for family cohesion, family conflict and violence, the place of 'feminine arts' and women's primary oppression. There can be little doubt that the home has a highly salient symbolic status and the dominant mythic reality of British life is partially centred on ideas of home. Yet at the same time, home is the site and source of the familiar – the material reality of home blends into its sense as the everyday lifeworld.

When people live in or create ideas of home anew, they are inevitably informed by this mythic history – either using its motifs or actively rejecting or modifying them. Such a history, then, is hard to escape and is embedded in our presumptions about what goes where, what is not done and what it all means. Even when there is a wholesale rejection of some of the more obvious fashions of bourgeois homemaking that dominated mid-twentieth-century Britain, the remnants of the discourse still remain. This legacy is vital in understanding the impact of this project, since it partially explains some of the hurdles that have to be climbed to get contemporary art out of galleries and public sites and into other less spectacular settings.

Who is At Home with Art?

There is evidence (albeit descriptive) of some incremental degrees of influence that this project contributes to but is not the sole cause of. It is more that it responds

to something already there: a series of desires people did not know they had until they discovered them. The two key findings that I am most persuaded by are the contextual and changing nature of material practices in the home, and the way this project appealed to a scale and tactility that seems to have been much appreciated. Before I discuss these, however, it is worth asking what relationship these respondents might have developed to more direct interpretations of contemporary art.

Many respondents discuss their sense of certainly having moved toward modernism in taste – for art and for home decor. Some directly talk about TV programmes, Habitat and IKEA, shifting fashions in interiors as factors influencing this change. But many don't – and discuss it in terms of their own transitions: getting older and wanting less clutter as they downsize; getting busier; children growing up; having more money to spend; or simply wanting to see more space. And some discuss contemporary art – influenced particularly by the opening of Tate Modern (and although many had not visited, they knew they wanted to or knew about it) and the relatively high latter-day publicity of BritArt and the Turner Prize. They don't categorically say they have been influenced to think about contemporary art by this project. But then they wouldn't, any more than an art critic or art historian would be able to admit to having Eames chairs because of magazines such as *Wallpaper* or *Elle Decoration*. Cultural influence just does not work like that.

Although many of the respondents were gallery-attenders, their relationship with art and contemporary art in particular was complicated. It was important to all respondents to tell some stories about their own history or values in relation to the art world. Although most had little background in art or art history, most had an interest. This ranged from an ex-student of fine art, now teaching sculpture; an architect; people whose partners or family members were designers, photographers or architects; people whose family produced or studied art; and people who produced art and craft themselves. A number of respondents referred to the buying process in terms of support for the artists or at least of buying to support the idea of the whole project. This was sometimes presented as supporting struggling or up-and-coming artists, which in one sense might be considered a failure of the project to educate people about the artists themselves. However, I don't think it has to be viewed in these terms as this support had an important status for these respondents. It was a small myth of patronage and ownership – people conceiving of themselves as collectors, the sort of people who own art – and in terms of what gets the pieces across the threshold, this should not be underestimated. Interestingly, not only did most respondents not know who the artists were, they didn't care very much. There was a very slight hint of perhaps watching out for their name in future, but not significantly. By contrast, it was those well-versed in art-world terminology who spoke most of 'my little Antony Gormley' or 'miniature

Richard Deacon' – particularly the former art student who had various things signed and packed away. On the one hand, this is obvious – arts followers would know their names and follow their work. But the fact that most respondents dealt with the objects in relation to their thingliness and their contextualization in their homes, and that the arts followers dropped hints about future value, indicated a pleasing inversion – even if ironic on the part of the art-literate – of the intrinsic value/commercialism divide.

Some respondents had read the catalogue or seen the TV programme about the AHWA project, but most interpreted and used the pieces in their own way. One of the nice things is the ways people pick up something of the artists' apparent intentions, even when they are not aware of prior comments and processes.

Colin Painter: Part of Cragg's reasoning was . . . droll and sound. He always loses his garden tools – so why not make tools that you can leave in the earth when you finish working? (Painter 1999: 17)

Tony Cragg: It is a modernist cliché that art has to be challenging or disturbing. That is not the point. Art is experiential. Art offers new experiences that give us a bigger, better framework of references and, at the end of it, makes us happier in our lives and therefore fitter to survive. (Painter 1999: 20)

Barbara: . . .well, we were in Homebase looking around different things and Mike [laughing] picked this up and said 'now you're not likely to lose this on the allotment' – because, to be quite honest, I've lost two or three at least; you know, on the allotment its easy to put them down when you're reading and you forget, you don't see them in the distance . . . but this, it shows up! [Laughs] From a distance – doesn't it? So that was why . . . And erm we've got a number of friends who've got allotments around us and they all said the same thing, you know, that they'd never seen those before and it was the same idea as I had, that you wouldn't lose them. But I did think I ought to keep washing it so that it wouldn't go . . . dirty grey like it is. But they're very good, very strong. Oh I have left it in the ground. Sometimes we go for three or four hours and you know it's like a garden and you wander around don't you, see some weeds or you do a bit of work on a certain patch and move on and as I say I can always see where it is. Whereas the other small ones they just go into the ground or behind a bush . . . a currant bush or something and . . . [trowel] (Plate 46)

It is hard to quantify it on the basis of this very small-scale research but one of the crucial things in this project has been the ability to touch the pieces. A number of respondents were the sort who get into trouble in galleries for touching things,

or who claim everything in the house should be handled, however precious. Handling the objects before buying them, being able to rearrange them and relocate them, even vicariously ('it could go there; but I haven't tried it yet') is a kind of curatorship that might be the thing that eases the gap between difficult abstraction and comfort. The touchability and scale of these objects is a winning success: not only do they fit in the home, they fit in the hand. It isn't an easy relation: kids fiddling with the ceramic sculpture, how to wash or display the plate. Will the light get broken? Will the trowel get dirty? Does the sound sculpture work? What if I have to cover up the pegs with coats? Does the metal sculpture look better this or that way up? I'll stroke the towel but I'm not going to use it on the beach, the shower curtain stiffly sticks out but at least it doesn't cling . . . But this tension and accommodation provides a nice contrast to the idea of art as a visual and intellectual reverie – at home, you might just sit and look and think; but then you might move it and fiddle around with it; and at other times, usurped by some other interest, it will fade into the furniture and familiarity, only brought to life again for ritual celebrations.

Alison Wilding: I don't think I've ever made something which can be used and displayed in so many different ways. Usually my work has a definite orientation. The nature of the project has brought this about. I like to think that my work rewards attention over time and has several layers to penetrate. This possibility is particularly strong in the home where people can live with the work (Painter 1999: 62).

Matthew: It does get moved around to different angles sometimes but that sort of shows its shape . . . to best effect. I'm not sure it's ever been the other way up completely – flat, like a hat . . . the word that springs to mind is like a colander really . . . but I mean it's a bit like the millennium dome in retrospect . . . but I suppose you'd think of it as a sort of bowl really. I've never actually done it but I suppose you could . . . well, maybe you wouldn't . . . I can't imagine doing it but you might want to put pot-pourri in it. But not really – I don't think it's a pot-pourri sort of thing! I'd imagine it would be nice hung on the wall because its got that hole and it sort of begs to be hung on the wall. Possibly yeah, the thing that worries me is what to hang it on the wall with because you need something that's not going to chip it or crack it or . . . I mean one of the images that sticks in your mind with this, when there's multiples of them . . . I think there was a picture in a home magazine when it was launched . . . an enormous array of them. Anything in that sort of volume is quite awe inspiring really. But you wouldn't be able to do that in your own house unless you had a really big space . . . It's even – I'm not sure where it has gone – there was a bit of paper with a rainbow on it that the girls had

done for something else [a local fair] – a rainbow from Noah's Ark got put inside the bowl . . . I think I prefer it plain! I think if you had enough of them you could try painting them different colours [ceramic sculpture]. (Plate 45).

Some respondents have a particularly rich tactile life, not only clear about their need to touch but also able to classify their horror at certain kinds of surfaces:

Lucy: I think I'm quite an earthy person, quite a sensual person so they're often things that are nice to touch as well . . . So my Buddha is very shiny and just is tactile. I suppose I like the feel of things, I like to . . .

. . . and I have things that I particularly don't like the feel of as well. This is probably going to sound bizarre but I have problem with things like card tables, the baize . . . I cannot bear that, or anything like that . . . peach skins. But then I do like things that often feel . . . cool actually, cool to touch.

I have written about this phenomenological love/hate relationship with objects elsewhere (Leach 1998) but here it is important just to say that we need to begin, however difficult for critics and sociologists, to understand the material unspoken relationships with things to really understand what people might learn – or catch, in the contagious sense above – from art. Where they can touch it, perhaps they fear it less. Where they can domesticate it and curate it in their own way, they have a chance to defend it in ways that would not be possible in a gallery. The key example of this is the way AHWA pieces fulfilled a very traditional domestic role: as conversation pieces. Categorically unlike interior design (upon which commentary is a serious faux pas and threat), these objects invited comment and respondents encouraged it. The incorporation of these things into the home lends itself to new boundaries being drawn around person and objects (Belk 1995; Douglas 1991; McCracken 1990) – investing it with their own personhood, their own bit of art needed defence against family dissenters, thereby strengthening the relationship with it.

Perhaps the most interesting transformations were for those who knew nothing about the project before this research began. Two very interesting respondents had bought the AHWA products knowing nothing more than the fact that they liked them. They had not been aware at all of the project because the products were remaindered on sale and because they had not seen any of the display information, nor had the items been sold with their packaging (which included an information leaflet). Both, however, admitted that it might have been available but they might have missed it. They had not even remotely imagined the pieces to be art but were delighted to find them part of this project when they were recruited for this

research. It transpired that both women had a well-established sense of their material culture or even what they called an 'artistic temperament'. Both were heavily engaged in home craft activities and had tried a variety of activities such as needlework, crocheting and knitting. Both homes reflected this with a rich variety of detail and colour: Daphne's glass collection like an Impressionist painting on her window sill; Barbara's attention to detail in changing her silk flowers as they came into 'season'.

They were both retired administrators, although Daphne, retired on health grounds, hoped to return to work. Barbara [trowel] (Plate 46) was married to a photographer; Daphne [shower curtain] (Plate 47) was divorced from an architect. Both humorously described their own negotiations with their aesthetically single-minded husbands in order to let in the chaotic scramble of crafty and pretty details to their homes. While both husbands seemed to be described as traditionalists, they were pared-down, almost modernist traditionalists, preferring white walls and wooden floors. Now divorced, Daphne had let her own style run riot, although this was tempered by a wistful recollection of her financially solvent married life compared with her economic hardship now that she was on disability benefits. On the one hand she remembered the smart pared-down house of her marriage with fondness, yet on the other she relished some of the chaotic making-do of her current situation (struggling a little, about to sell up and move somewhere smaller closer to her sister). This making-do meant in fact that her things, especially purchases, meant much more to her: economy generated a sense of true desires for things that were hard-won. Making-do is a nice metaphor for Daphne in other ways: she was waiting for her son to move on, waiting to get back to work, waiting to move house, waiting to start her next craft project.

For these two women, the research process confirmed their instincts about the objects as something quite special: a shower curtain that had, to her relatives, confirmed her as childish and quirky, was vindicated as a purchase; a garden trowel, the talk of the allotment as a potential sex-toy, was even more a conversation piece as well as being tremendously useful. Moreover, the making and making-do that these women have achieved – both working while taking full responsibility for homes and families, including foster children in Daphne's case – remind us of the tensions between 'keeping busy', homemaking and housework that many women face. The somewhat funny and frivolous purchases of the trowel and shower curtain – while both fully in use – are a damned good joke in this context. These two examples are so nice because they demonstrate how particular objects can intervene and stand out because of the social role they play. Daphne's attachment to her things was a relentless claim to identity, this research a vindication of her individuality. She expressed an interest in taking a degree in textiles as a mature student – nobody could claim that AHWA was causal in this move, but if it infected her further with the desire, all to the good.

A separate case reminds us of the transformations objects undergo in the battleground of domestic relationships. David, an architect, plainly links his own taste to his vocation such that it dominated his visual and material understanding: 'I think architecture school has quite a powerful effect on you. It does change your perception of space and buildings and objects an awful lot and you're much more critical'. He was quite strident in his personal model of good taste yet had a number of interactions which required negotiation with significant others. Defending himself against his mother's taste and her view of his tastes as a passing phase, unwanted presents were packed away, sold at car-boot sales or argued over. David demonstrates considerable disattachment to certain objects that he does not value, for example a canteen of inherited cutlery which he would rather sell but his mother wants him to keep. Although he values them in monetary terms, any sentimental or aesthetic value is absent. There is a pattern here that emerges with other respondents: an aesthetic certainty which is very inclusive and exclusive, almost rigid in its absolutism. However, this ideal-type aesthetic scheme is, perhaps fortunately, modified by domestic circumstances in many cases: while David would prefer purist control over his environment, his partner – with quite different tastes – would not allow it (Plate 48).

> *David*: . . .I bought three and then Jo used 2 to hang the wooden table top on the wall. I bought the other two to make back up the original three which I'm not quite sure what I'm going to do with yet but I've still got them. We've got two on the wall, which are supporting this Malawian table top which is about half a metre diameter . . . And we've got three left.

When David bought 3 pegs, he knew how they would be hung with an architect's precision: '. . . in a row, horizontally . . . about 300 mm apart'. He had envisaged them in a number of places, perhaps to the left of the window in their front room which the main door opened straight on to and which was to be used as a dining room. He had fully intended to use them as coathooks, although he thought them a little expensive for the purpose. He also recognized an ambivalence in imagining such a cleanly presented arrangement and then messing it up with coats, especially as he liked to be neat and tidy.

However, his plans were changed when his partner put two of them up in the bedroom to prop up a round Malawian table top. This was not his decision and he felt strongly enough to go back to Homebase to buy 2 more pegs to complete the set of 3. Although he conceded that in the end he felt this arrangement worked quite well, there was some ambivalence and it was clear that the purchase, placement and modification of material objects was present in the negotiation of his relationship with his partner, as indeed it is with many people. The tension between the couple's taste and their claims for independence in choice, purchase

and placement are evident in David's account. This is instructive, since it reminds us that setting up home with a partner can be a challenging material process in which partners use the material environment to stake out relative power and control. The pegs here transform into a compromise, an accommodation of the other, although the decision to use them for this purpose, without his knowledge, seemed in his account almost like a challenge, a territorial claim.

David comes round to the arrangement – unsure at first about the scale of the table top with the pegs, he gets used to it (though he still buys two more – a return challenge perhaps?). Steve and Mary (Plate 49) on the other hand, older and perhaps longer established in their relationship, had tastes that were convergent:

Mary: Cos we had wanted something to put Jackson on hadn't we?

Steve: Yes, it's to do with that difficult picture, pictures that shape don't hang on a string very well, they tend to flop off the wall so we had it screwed to the wall and didn't like the look of that. I had the things already and then the penny dropped.

It is interesting then, in such different circumstances and neither recalling reading the catalogue, that both pairs chose to use the pegs as props for art or decorative things, much as Gormley suggested in relation to the household he visited in:

Antony Gormley: Their flat was full of things hanging on walls that might not have been thought of as belonging on walls – a leather bag from Morocco or a piece of embroidered clothing from Baluchistan – relating to experiences in their lives. In the end I made this thing that supports that desire to hang things on the wall. I've reinvented a nail . . . My nail, or peg, . . . act(s) as a support for the isolation of objects which could then be looked at in a different way. (Painter 1999: 31)

It is not only the physical and symbolic legacy of home that needs engaging with: the social relations within and without the home affect fundamentally the objects and visual cultures within them. Homes are territories for family battle-grounds, not least for space and control over objects. Matthew was not just railing against style tyrannies but negotiating the complexities of two daughters, a textile-designer wife, a number of guinea pigs and stick insects and an evaporating budget. Matthew would have preferred 'minimalist' but family prevented it and the whole family were touchingly attached to the paper rainbow their elder daughter had placed in the bowl, even though he would have preferred it without. In this light, the 'extravagance' of his purchase of the ceramic sculpture was all the more significant: an expensive contemplative piece, heavily invested with unmet ideals, yet modified into sentimentality by the domestic setting. Most say

publicly that they agree, yet many compromise for the sake of their partner and children: thus material family histories are made. David acquiesced to the Malawian table top but was put out to find the pegs had been used without his consent; Sarah came to terms with her husband's golf-course photos and being so in charge of her environment, she didn't allow it to matter that he hated her ceramic sculpture; Daphne, now divorced, could have almost whatever she wanted, but could not fully shake off her abundant past. These negotiations are a crucial factor in understanding the object world of the home.

Curating Homes 1: Custodians of Housing Style

While family negotiation is crucial, there are wider discourses of homeliness that both limit and demand certain symbolic practices in certain types of homes. It turns residents almost into museum curators, custodians of heritage rather than radical gallery installers. This operates on three levels: first the constraints imposed by the physical buildings and organization of space – the majority of British housing conforms to similar styles and patterns, dominated by vernacular Victorian, Edwardian and Georgian architecture and patterns. Modern housing constitutes less than a tenth of housing stock in Britain (Brindley 1999: 35) and the majority of that is council housing. The characterful and desirable Victorian ideal, reinvented in 1980s Britain, remains a powerful influence partly because of its spatial organization (front room, back room, kitchen) and partly because of the dominance of Victorian ideas of homeliness in British culture (Hepworth 1999).

The tyranny of character is evident in some stories that are told by respondents: because character refers to the limited number of referents outlined above, people are reluctant to break away from it. This, allied with the concern for having things that 'go' with the style of the house and with each other, is part of the history of the bourgeois home that retains an influence on people's choices. The consequence of this is that choices of objects for the home become part of a decorating scheme that seeks to preserve the character of the house. This leads to a kind of curation, more museum than gallery curation, custodianship of things that are 'in keeping' with the house – often with an eye on resale value. AHWA offered a challenge to this ethic, although some respondents had not fully managed to break away from this tyranny of Victorian character. Having moved to a newer house, this woman found herself liberated:

> Lucy: I really thought this would not be the sort of house I would ever want to live in because it's kind of modern. We lived in a big Victorian place and I come from the countryside in big old houses, but actually I do like this because it's like a blank piece of paper, so you could actually do much more modern and contemporary things with it. Which you could never have done in our old place

which was Victorian and you just . . . I felt very constrained by a particular style whereas here, you can actually do what you like which is great, we like that. (Plate 61)

The limits placed on choice are not necessarily undesirable: as Oliver et al point out in their seminal book on suburbia (1994 [1981]), giving people what they want is not always a bad thing, and we ought not to succumb to the snobbery of assuming that if only they knew better they'd want the same as 'us'. Bentley in Oliver et al. (1994 [1981]) reminds us of some of the rules that the British house came to expect, crystallized in mid century suburban design but having a much wider impact. The functional separation of rooms, a hangover from Victorian ideas of a family sitting room and dining room, with a separate parlour for 'best', leads to clear ideas about what goes where. These ideas are still with us, however dated they seem and however modified by multipurpose living spaces. One woman in our study has her old furniture in the 'kids' living room; another stores away her best things for ritual celebrations.

Further constraints are offered by the ability to display objects in the average British house. Put simply, there are not many opportunities and with limiting requirements on scale. Oliver et al. (1994 [1981]) discuss the hearth, mantel and bay window as classic sites for display – natural plinths, they are often designed and used as focal points for decorative things: you might add the sideboard and a variety of walls and tables. Some people have dressers and display cabinets: for three women in our study the dresser was an aspirational item that they had either used or wanted to use; for three separate respondents in our study – self-described as 'arty' types – the glass vitrine, either made or salvaged, was the preferred display method. It was rare for people to stand or lay cherished/decorative things on the floor. There were some exceptions: two women, both collectors, used the floor as display areas. Both seemed to make the space more gallery-like: one shone a special light on her instruments in the corner; the other laid out her collection around the perimeter against gallery-standard decor of stripped wooden floors and white walls. The lamp was the exception to the AHWA objects which were generally not placed on the floor, and in one case a bounded floor (in the form of the hearth) was deemed suitable for the metal sculpture (Plate 50). The lamp in particular shows up the combination of domestic and art-world expectations in this placement: on the floor it fits the living room model of floor or standard lamp; yet it was also placed – in both cases – in corners, isolated from other things, better to appreciate its form (Plates 59/60).

For those reasonably well-versed in visual culture, buying from AHWA was a confirmation of the refreshing approach of this project and reflects a sort of relief that such things should be available. This is highly evident in one man's account of what is available in home cultures, dragged down by mediocrity. This medi-

ocrity operates on a continuum – incorporating household objects as well as architecture and design:

> *Matthew*: . . . I bought that picture because I wanted to support the artist. I thought, you know, everyone's buying other stuff. And I thought, here's Sainsbury's, a commercial enterprise, supporting something artistic or whatever . . . But you want to say, yes, there are people out here that are interested and don't just want rubbish all the time, cheapened things.
>
> . . . you know, people who normally have got good taste bring out the most appalling Eternal Beau dishes – nothing personal! – the sort of wheat-coloured pots . . .
>
> . . . this house is a mock-Tudor design and given the chance I'd rather have had a brand new one that wasn't mock-anything. I think that epitomizes the general availability of domestic products – there's so much mock-this and mock-that, it's all in the Tudor style or the Mexican style . . . I just wish there was something available that wasn't Eternal Beau! Why do we have to have pretend things? It really does bug me . . . (ceramic sculpture)

AHWA stood – for Matthew at least – as an escape into something liberating, a visual culture to take him away (just a little) from domestic chaos.

Curating Homes 2: Home as Gallery

In contrast to the somewhat chaotic curation of home described above, there is another register of curation, somewhere between managing a gallery and a galley. In such stories, the chosen objects have special status within a home which is designed and arranged with much consideration and deliberation. In fact, in some cases, it is as if this arrangement of home is itself the priority, not children, nor relationship nor anything socially domestic. The home-making and preserving is carefully managed and policed, and objects are thus allowed to be properly revered. This reverie is visual: placed appropriately as in a gallery space, without distraction – in fact the design of the home is often chosen to support this curatorial activity. Plain white walls, plain wooden floors, absence of knick-knacks and clutter predominate.

There is a connection – as you might expect – between this sort of home-making and concern for knowledge and provenance of the objects staged. In such homes, objects are mostly bought because they fit in to the scheme of taste alongside other valued objects – names are important and things that don't fit are deliberately excluded or at least packed away. Yet in such cases, objects are talked about with art-worldly confidence: that things 'work' in certain places, that

materials have particular qualities, that certain producers and artists can be defined and understood. This is significant because while on the one hand such homes appear almost gratingly staged, on the other the protagonists retain a belief in their own ability to choose pieces because of the qualities of the piece rather than some abstract symbolic fashion. Whether this is affected more or less consciously does not matter: the idea that the piece speaks directly for itself allows the illusion of a free choice.

For some respondents, this process is less curatorial, more design-orientated, relating to product design and architectural design in particular. This is the galley mentality as opposed to gallery mentality: the beautiful, superbly functional kitchen implement stands as the key motif here.

The AHWA objects for respondents in this mode fitted in to a clearly defined category of good design. For one such respondent it is particularly absolute. Brought up in an architect's household, always kept very tidy, when she tells of longing for something pink and plastic one wonders what desirous dangers pink plastic might hold for her. Self-confessedly conservative, she discusses at length how she always 'knows what she likes'. This is an interesting way of putting it and she says it over and over as if in fact, she is reminding herself that she knows (Plate 51).

Sarah: I was just very comfortable with it . . . it was part of what I surround myself with now. I also have . . . I'm quite lucky, I suppose, I don't know, when I see something I know whether I like it or not . . . when I see something I know whether it's me or not. And I knew – when I saw that – I just knew that I liked it. I mean I didn't for instance like the gardening fork and trowel. I thought the idea was great you know stick them in your garden and leave them there but that whole ethic isn't really me – I don't like leaving things there and I didn't like those. I didn't like the beach towel particularly. Because I thought maybe that was where they were beginning to sell out a bit. But maybe that's because when I see something I like I know I like it. And I don't . . . and I'm very sure about that, I don't have to be persuaded into something so when I have chosen something I don't worry about it from then on. I don't keep coming back and thinking now 'do I like that?' because I know I do.

I like really well-designed kitchen utensils, I like well-designed knives. I don't have stuff on show and then have a load of tat in the cupboard that . . . I like to use . . . I like things that work well.

If you've got to make dinner for 5 people, 365 nights of the year, you might as well do it with something that's nice to use and nice to look at. And I do work pretty much full-time, not completely full-time and I've got a very very busy life and I like to do things well, I like . . . I enjoy cooking, I like to have a nice

knife, I do bone chicken, I do do stuff that requires good utensils, I don't buy ready meals and shove them in the oven. You know I cook on an Aga because I like it, I love it, I've always wanted one . . . I knit. If I knit a jumper for my sister's kids – mine are too big to do anything for – I'll use expensive wool because I want to use . . . if I'm going to be spending that amount of time doing the knitting I want to be using a wool that feels nice when you're doing it.

I think people ought to pay for design, for well-designed items. And I think that I will pay £30 for a corkscrew if it works and won't pay £30 for an Alessi corkscrew that doesn't work. You know I don't like to buy things because they look designer, if their function doesn't . . . I suppose it's one thing I've just bought is that I do absolutely love and it's a fantastic potato peeler, which I saw in a magazine as being . . . And I actually went all the way to Harvey Nichols to buy it . . . And you can imagine it . . . it cost me about 25 quid to buy it and it's brilliant! I love to use it, every time I peel potatoes with it I think it's great, it's a really nice thing to use! (ceramic sculpture)

As with a number of respondents, there is a reliance on the idea of design which allows Sarah's aesthetic choices to 'hang' together. 'Function', as well as labels, serve to deal with any potential anxiety over taste, allowing the design-conscious to know what they like without ambiguity. In this case, it is interesting because the ceramic sculpture does not have an obvious function – Sarah infers it from her own aesthetic concerns. She would not dream of having a toy box in the living room and, although she changes things frequently, Sarah's visual culture is quite calculated and maintains an absolutist version of taste that relies on the apparently intrinsic qualities of good, beautiful design.

Moreover, as well as 'knowing what she likes', another key feature in her visual culture is the constant moving and rearranging of things. As for many respondents who do this it indicates a creative responsiveness. Yet at the same time there's a kind of anger or at least rootlessness in it and indeed in the ownership and use of the objects themselves: 'if you have to cook dinner for 5 people 365 nights of the year, you might as well have things that feel good while you're doing it'. In this case, there was a sense of the respondent really not feeling at home with things, but if she stuck to a code, it might be a little more comfortable. Decorative rearranging in this case did not seem like idle pleasure but fidgeting, like having a stone in your shoe, almost a physical anxiety for all the claims of 'knowing' what you like.

Functionality operates on other levels also. At least one respondent, Steve, uses the terms 'use value' and 'exchange value' to discuss his ambivalence about the pegs – not having much money, beautiful objects are legitimate consumerism if they're also useful. With them propping up a reproduction of a Jackson Pollock painting (see Plate 49), he says that he no longer thinks of the pegs as special –

they're just things now, although he has kept one in the box, which still has 'exchange value potentially'. This is quite significant as it shows up the sometimes contradictory meanings that objects hold for people: while valuing the pegs because they do a job and are beautiful, Steve keeps the box for their future value on the market, just in case. It also shows us the complex ways objects become accommodated – on the surface they have habituated to the house and just blended into the background yet in fact all the pegs are rendered special in different ways: one is saved with its packaging for posterity; the other two are revered nails (as Gormley suggested – see p.163).

This is not uncommon and even people who have them carefully and artistically on display sometimes keep the box. Some claim that 'oh yes they've still got the box somewhere', often because they might need to put it back in if they decorate or move – a casual, offhand and cool denial of acquisitive tendencies. And others are excited and amused by this, self-conscious but slightly thrilled at entering this game: an art collector, stimulated by reminders on the *Antiques Roadshow* that provenance matters and that the immaculate item in the box, with the bag and receipt, might be more valuable in years to come. One woman in our interviews, Jenny, had bought virtually everything in the series and had more than one of some: 2 lights, 12 coatpegs, 1 ceramic sculpture, 1 sound sculpture, fork and trowel (Plate 62), two metal sculptures, sound sculpture, a towel and 12 plates, though she'd like another 8 'so they can be used at a dinner party'! This has a number of implications: keeping the box is a nice human reminder of our acquisitiveness; buying the full set has some other connotations including stories of collecting discussed below and indeed the domestic symbolic nexus as discussed above. After all, the garden tools might be considered incomplete without each other and as for the plate, one is for sweet things or celebrations, or more problematically, to put on the wall like your granny did; 6 or even 12 count as a dinner service and make it quite a different thing.

The collector mentality is often divided up (Pearce 1995) into those who collect randomly, picking up curios that entice the eye or hand (much like Lucy and Laura below) or those who collect rationally, filling up the space with categories and aiming for completion: either the best and latest, as in the case of Sarah or having the 'full set' as in the case of Jenny. This is an extension of functionality as the mediating principle that gets things through the front door: even if it doesn't actually get used, the veneer of rationality counters the sense of reckless consumption. Recklessness, humour and abundance, however, for another group of respondents form the threshold mediator. Humour is a key principle in mediating the move of these pieces from an imaginary gallery into homes. In fact in the more accidental cases, it is that which gains the pieces entry. For Barbara, the trowel enters stealthily and hilariously and although she hadn't conceived of it as art, it was clearly an object to be discussed:

Barbara: Mike picked it up and said 'now you're not likely to lose this on the allotment!' – because to be honest, I've lost two or three at least; you know, on the allotment it's easy to put them down when you're reading and you forget, you don't see them in the distance. But this – it shows up, from a distance, doesn't it? [laughs][trowel]

Humourous functionality wins Barbara and Mike over: they weren't looking for a trowel but when they saw this one on sale they could not resist. This interview is a joy: Barbara and Mike spend most of it looking at me with incredulity and laughing at my questions because, although they laugh at it with their friends and joke about whether it might be a sex toy, they simply think of it as a trowel for their allotment and little else. Humour and fortunate functionality won them over.

Cragg's garden implements – more than the other items – provoked most discussion (coming a close second were the pegs, partly because people liked them and partly because Antony Gormley was one of the few artists they'd heard of or seen work by). The garden tools are loved, hated or laughed at/with and little in between. All but one respondent either used them as garden tools or intended to use them, as well as sticking them in the ground for functional or sculptural purposes. The exception hung them on the wall. The people who had bought other pieces often mentioned them as incomprehensible or even offensive, ridiculous and – crucially – they perceived them as unusable, something owners reject. The combination of humour and usefulness gave them an easy passage into some homes, although those who perceived them primarily as sculpture were concerned about their whiteness getting dirty and might just leave them on display in the house. Barbara on the other hand was concerned with what I would think about her trowel, normally hung up in the shed when not stuck in the ground as she worked and covered in mud. Overall, these qualities – functionality and humour – have worked well in this project as important mediators in the anxiety-provoking process of purchases; they are the persuasion factor that repels a surfeit of doubt that an art object alone might induce.

Transforming Meanings and Accommodating Art

Respondents expressing doubt over the purchase of the object contrasts with the stories of what happens when they become belongings – things 'accommodated to' within homes. This process is the most intriguing since it is the dynamic that most challenges the art-world's hold on the value of things – if and when people reuse things and reconstruct meaning, hierarchies of value become insignificant.

Richard Deacon: The souvenir is an interesting class of object. It contains memories or associations but it doesn't necessarily resemble them. It's a

reminder rather than a representation. I found a burnt-out car in a wood. It was a shocking experience because it was a pleasant piece of woodland and a very violent act had taken place. (Painter 1999: 25)

Bob: Well, on top of the Malvern hills there used to be a little café, and we always used to walk to the top . . . It's just a shed really, an old quarry shed that had been converted into a café in the 1930s and when my sons were small we used to go up there, walk up and the café was the destination. And then I think in the late 80s or early 90s it burnt down and they never replaced the café, they just cleared the site so the terrace and everything was still there. And we went up there and although it had been cleared and grass had kind of grown over it, there was still this little bit of melted lead that I think one of my sons picked up and we brought it home to my mother's. And it was only . . . it was years later, well last year, when I saw this, that it reminded me of that piece of lead . . . but a different version.

One respondent, Bob (see Plate 50) reminds us of the transformation that purchase affords the consumer of the mass-produced artwork – it is not unique until you take it home:

Bob: In the store, it's in a box, and there's lots of others in there, I mean it's not sort of unique is it? There's lots more of them. I think when you've taken it out of that context, you've brought it home, it's on its own then and it's . . . I think you can appreciate it more for what it is. I accept it's mass-produced to an extent, or it's limited or whatever, that didn't really come into it, I think it's just that when it's on its own, you know you can pick it up, you can think about it, you can analyse it, you can ignore it and it's . . .

This is the move that makes the object thrilling, a work of art: once home, it does not matter if 3,000 other people have them, it has become owned and contextualized. Much as consumerism in general requires this switch to be made for objects to be added to a catalogue of identity-markers, to become absorbed from a mass object into a 'me' object, the metal sculpture described here is appreciated in its originality only once in its unique setting of home. For some respondents, especially those least involved with different art worlds and their hierarchies of value and interpretation, a very familiar scale of meanings comes into play. These, at face value, are meanings borrowed from consumer-centred models of self-identity and difference. As with many choices in matters of taste, the desire – even if unsubstantiated – to be different or to have 'quirky' things is strong. These two words became a short-hand for purchasers in their explanations and justifications. Often such claims were made as a challenge to the imagined interpretations of others close to them, either to say how different they are from an old self or to confirm their status as different from other members of their circle or family.

In this scale of meaning, the originality of a work of art is crucial but it is interesting how this has been modified to adapt itself to modern consumer culture. It is not originality in the sense of an original production, nor a limited edition reproduction. But nor is it originality in the Baudrillardian (Poster1988) sense of a hyperreal interpretation of meaning – it is not about irony or an original interpretation as has been discussed endlessly in postmodern interpretations of culture. This originality is much more mundane and sociological in the sense that if it feels original, then that is what matters. This absorption of a sense of personalization and difference in one's home is crucial in most transfers of mass-produced items from fashion into identity and the move is very simple. People claim a thing for their own, they tell others about it and the others either confirm their membership of a group of like minds, or they establish the continued sense of extra-ordinariness.

Bob is equally eloquent about his own found-objects: he was reminded of a piece of lead which he found with his children at the site of a burnt-out café on the top of a hill where they used to walk. His mother has it at her house but it remained his, along with pieces of wood collected on the beach, an old Minton tile and a screenprint from an organization he used to work for which is interest-ingly reminiscent in design of the Deacon sculpture. The screenprint was also found, in a drawer when the organization closed down. Such findings, he said, would be valued more highly than contemporary art because of the discovery and uniqueness of the experience.

Bob particularly liked the non-functionality of the piece. This is someone happy with the ambiguous character of such objects and his interview shows that the qualities he admires in this piece are partly based on his grasp of and delight in the process (a man-made thing destroyed and re-made) but also upon its unspeak-able qualities. The passage above shows this: hanging 'it's. . .' at the end of descriptions, showing the something else that he can't quite vocalize. This object, perhaps more than all the others, is most mute although some perceive it, perhaps from the discussion in the catalogue, as a trivet. Its thingliness wins over this man, not least because he particularly appreciates such things.

The combination is a winning one for him: a thing found in the woods, like his own lump of molten metal, texturally thingly; and a thing he made unique by finding it among all the others and rescuing it from the mass into the singular home space. This extra layer of confidence he already possesses to make his own ready-mades from souvenirs is validated by the discovery of AHWA. He explicitly says this when asked by the interviewer. There you have it: no need for hordes tramping past singular masterpieces; instead an audience of one (well, four in his family plus a few friends) for an object rescued from the horde.

Once the object is found or rescued, however, it continues to live – and not always comfortably. Alice's metal sculpture (Plate 53), so proudly displayed on

the toilet cistern, had to be packed away once its additional meanings began to reveal themselves to her. The metal sculpture's mute qualities began speaking through her son:

> *Alice*: And about 6 months ago . . . something about it caused me a problem, and I couldn't work out what it was. And my son came round one day and being a man he was standing facing it . . . And he said 'Why have you got a representation of the swastika on the cistern?' And I said 'it's not a swastika' and he said 'Look at it'. And it was, it was close, he was right and then I couldn't have it there. So I moved it. I know exactly where it is but I haven't put it back . . . It's sitting in another room. I haven't got round to seeing it differently yet. And I didn't see it when I bought it. You know to me, it had all kinds of different things in it . . . I guess in my peripheral vision I'd seen what he was seeing but . . .

Alice has just about accommodated to this new meaning, although she is waiting for it to speak again. At the moment it is out of the public eye, in her study where she knows it will be reinterpreted. Where at first it joked, for the men visiting her toilet to smile at, now it broods a little. Lucy likewise broods over her plate, packed away with her other best things, 'it needs to come out' she says but she's uncomfortable about how to display it. These stories – of objects having a power over the space – link to another key theme: the idea of the inevitability of certain things, only evident once they've arrived.

Inevitability

Some respondents speak of 'not being able to help themselves' – they have to have particular objects. Sometimes the connection to the object was not very well articulated, although often this silent speech is instructive. The objects' hidden, opaque, material or mysterious qualities become important in such stories and the tales are told as if some unspoken communication is going on between the thing and the 'real' self.

A couple of respondents couldn't help themselves but buy things they loved, even when poor. In fact, the less money they had, the more they felt the impulse to buy things they loved rather than needed. Not shopaholics, it was more about surrounding yourself with wonderful things to remind you of life and to reward the struggle: harder to purchase = greater symbolic reward.

Laura, trained as a sculptor, had to fight back the stuff, although it seemed to be her boyfriend who did most of the battling. Not only she but one-half of her whole family were junk-monkeys, pressing things on each other, never throwing away bits of machinery and metal that might come in handy or be fixable. As an

artist, she had an excuse for keeping things, modifying found objects being the main practice in her art. Yet the moral weight of all the stuff was overwhelming in the interview: boxes stored in garages, cupboards filled with broken hi-fis and 4 or 5 kettles, grandparents' farm with scrap-metal piles in the yard. She had two crispy squashed frogs that she'd found on a roadside and a spare washing machine defunct in the back garden. It was all from her dad's side she said. And her mum, long separated from the dad and the family, would sell anything, dispose of things easily to make a bit of money. Us/them: we have stuff/they sell it. The stuff comes from somewhere (stories of belonging(s), gifts, inheritance, sentimental value show us this) and is then used to mark out and reinterpret relationships. Hoarding and collecting have a strong moral and relational weight, an underbelly (of other people's ghosts still clinging to the stuff) that is difficult to escape.

She had been tempted to use the tools in the garden but they remained on the wall because she wanted them to stay shiny . . . art works rather than tools (Plate 54). She is contemplating moving them from the kitchen to the bathroom 'because they'll work very well there'. This is a crucial phrase for people who place items, especially art pieces, or pieces that could be considered art, within the context of their home. It is as if the home has become – not a gallery, curated carefully, the background a blank canvas better to show off the pieces, as with some other respondents – but the source almost for a site-specific sculpture. The idea of the Tony Cragg tools 'working very well against yellow' in the bathroom or kitchen almost devolves responsibility from the person and places it onto the house and the objects.

It is as if the setting and object partly bypass the will. Laura's house was full of things she couldn't help but have, not least because as well as her own hoarding instincts, she had to deal with the sculptures and components that belonged to her partner – when I attended to interview her, the living room was dominated by a large scientific installation with a metal stand, large glass flask and various pipes. Things were everywhere – pipes, glass things, lumps of wood. There was no mess here; it was just that their house was dominated by stuff, run by it. Yet, despite this rule by matter, Laura's own material ordering process was evident with innocent harmonies between her choices of favourite objects and the garden implements: dried puffer fish, cacti and the tools were discussed at quite separate points in the interview and she seemed genuinely surprised when I pointed out the physical relationships between these objects: bulbous, spiky/perforated and a little problematic (the cacti caught on the net curtains in the kitchen, the puffer fish were an endangered species and she really didn't want to dirty the tools). It is as if she 'spoke' directly to the stuff without mediation.

Mara exercised a similar kind of 'material determinism' in which the objects have an inexorable effect upon her life. Her language is vivid and fruity, rich and tactile and there is a clear sense of her material connection with things. In

particular, she discusses colour with a kind of inevitability, as if colours just have to be together or apart, and as if once you have a piece, others inevitably follow (Plate 52). This is engaging and confident. Co-ordination here is more than matching, it is a law of nature that she taps into. She herself is 'brown' as she puts it and the beach towel looks good against her skin.

Her Verner Panton chair 'was responsible for everything' as she put it. There's a sense of epiphany in her acquisition of this orange plastic wonder since it creates her and her home from then on. There is a rollercoaster of things that 'go' with the chair. She had seen it in an exhibition and then her husband had bought one for her from a second-hand shop '. . . and that was it, all this stuff started coming'. She describes the chair as her child, and what is particularly poignant is that she is trying to get pregnant and even considering IVF treatment: her creative courses, furniture, art and house purchases are later described as substitutes for children. She also has some Panton hangings: removing the staples from them '. . . was like removing it from my body'. Her tactile appreciation of things is evidenced in her adjectives: crushy, crusty . . . She prefers the 'soft luxurious side, the velour track suit side' of the towel, she 'caressed it in the shop'.

'It took me quite a while to find my style, . . . I've had a good few tries'. This statement sums up her comfort in having found herself in these objects. But having waited all these years, again she is waiting: until the IVF is paid for, they can't finish the bathroom, where the chair and the towel will go. It is Mara's things that 'seem to have mated to make this towel': orange, pink, yellow, plastic, fur and shiny – this is the most obvious sensual relation to objects of all the respondents, although many of the women do talk about texture and touching things in this way. In these respondents, compulsive collectors and hoarders, the AHWA objects fight for space, yet they make complete sense in a sensate way. One wonders where they will stop unlike some of the more measured collectors for whom the transformations that occur while things are accommodated are paced and careful, for the compulsives the things may need rehousing . . .

Conclusion

I have presented different interpretations of how things come to be curated and accommodated in homes. These processes demonstrate differing degrees of confidence, comfort, involvement, conflict and influence from wider discourses. The experiences of respondents show that rich visual cultures, embedded in social experience and structure, exist within home settings.

Art should perhaps work to challenge perceptions and open up thinking. The domestic – typically – is conceived of as a place and a mythology which closes down thinking, the backstage zone which supports the 'outside' work of thinking

and doing (of course it is conceived differently for men and women). Comfort produces *ennui* and *stasis* (Teyssot 1996); danger produces change and thrill. This is at the heart of the antithesis between home and art; between comfort and gallery . . . The mistake, then, is to allow the myth of home to continue, as if it really is static. Our own thinking – and the artworld's – is closed if we allow ourselves to believe homes are conservative, stifled, soft and suffocating.

The myth of home beautifully mirrors the myth of art practice: homes containing stultifying history, parental and patriarchal power and the *ennui* of ageing and ticking carriage clocks. Yet who believes the myths of great *auteurs*, producing works of art from grand traditions out of the air? Sculpture, for those who know and do it, is mostly about practice, making-do, working the materials round an idea, failing and trying again. It is not that it is the same as interior design: trying a colour next to your sofa, not liking it and repainting; but it is similar in its modest humanism: getting pleasure in arranging things and finding small epiphanic thoughts in the middle of it – 'oh yes, that works!'

Yet if these processes (home-making and art-making) are more or less angst-ridden, more or less qualified by knowledge systems and expertise, more or less visible and conscious, more or less validated by others, they are essentially the same. Playing to different audiences, the creative work of home speaks in the same register as contemporary art. It is just that both sides, each knowledgeable of its own territory and fearful of the other's, don't want to believe it. Contemporary art and the home *are* diametrically opposed, and it might well be that protagonists of each stand laughing at and mocking the other side. They can each say with confidence 'I wouldn't allow *that* house-room'. Home, by virtue of its mythical solidity and stultification, appears to be closing down the creative imagination involved in appreciating and indeed making art. But scratch a person interested in wallpaper and *Changing Rooms* and you will find an artist. We invisibilize work and practice and mistakes and training in artists as in most professions: those who appear born *auteurs* are of course made themselves but they and we sometimes forget this. This is quite a simple argument: value and meaning exist on a continuum. At one level, the art-world, they are propped up by institutional structures and intellectual investments; at the other, they are consumed and re-interpreted by practices of everyday life. Somewhere in between are discourses of taste, consumer fashion and art practice which mediate. Yet the processes of judgement are fundamentally the same: as Cummings reminds us, 'careful attention to material practices has made it possible to question lazy distinctions between art and tool, good and bad or priceless and rubbish' (1997: 13, 16). Contagious contact between categories is a welcome antidote to absolutism.

Note

1. The research was funded by the Arts Council England's New Audiences
 Programme and conducted by the Susie Fisher Group in collaboration with
 myself.

Table 9.1. Summary of respondents and interview details

Details and pseudonym	Main purchase discussed [interviewer]	Location/purpose	Other purchases. Previously aware of artist Y/N
David (and Jo) 25–44 Professional	Pegs 3+2 [RL]	2 in bedroom, supporting wooden table top	3 still in box, intended for front room Y
Steve (and Mary) 25–44 Retired public sector	Pegs x 3 [RL]	2 in sitting room propping up repro of Pollock painting; 1 in box	Also trowel and fork, boxed/in flowerpot with lights in Y
Barbara (and Mike) 65+ Retired admin.	Trowel [RL]	In shed in allotment	N
Jenny 45–64 Cultural industries professional	Trowel and fork [CP]	Packed away but to go in flowerpots outside?	Bought everything else but shower curtain, including 2 lights, 2 'trivets', 12 pegs, 12 plates Y
Laura 16–24 Education	Trowel and fork [RL]	On wall in kitchen near door	Also metal sculpture on staircase shelf; towel in bathroom Y
Tim and Pam 65+ Retired Couple	Trowel and fork [SL]	In flowerbeds in garden	Y
Bob	Metal sculpture [SL]	On hearth in main sitting room	N
Alice	Metal sculpture [SL]	Put away in study but had been on toilet cistern in bathroom	N

Table 9.1. (Continued)

Details and pseudonym	Main purchase discussed [interviewer]	Location/purpose	Other purchases. Previously aware of artist Y/N
Andrew 25–44 GP	Sound sculpture [SL]	On wall between windows in sitting room	N
George 45–64 Education	Sound sculpture [CP]	On wall near door in study	N
Matthew 25–44 Technical	Ceramic sculpture [RL]	On sideboard in quiet sitting room	N
Tom and Jean Couple 25–44 Sales	Ceramic sculpture [SL]	On table in sitting room	Y
Sarah 25–44 Director	Ceramic sculpture [SL]	On top of bookcase in informal sitting room	Also pegs for kid's coats in porch and plate kept among other plates N
Daphne 45–64 Retired administrator	Shower curtain [RL]	Around shower in bathroom	N
Sylvia 25–44 Local authority	Lamp [SL]	On floor in corner of sitting room	N
Ted 25–44 Education	Lamp [CP]	In corner on floor of sitting room	Y
Lucy 25–44 Nursing	Plate [SL]	In box waiting to come out but unsure how to display; occasionally used only for sweet things	Also bought plate as gift for mum Y
Mara 25–44 HR	Towel [CP]	Packed away waiting for bathroom to be finished	N

Acknowledgements

I would like to thank Shaku Lalvani, Claire Panter and Susie Fisher of the Susie Fisher Group who contributed extensively to the ideas within this chapter. The Susie Fisher group was contracted by the Arts Council of England's *New Audiences* Programme to evaluate the AHWA project. Shaku Lalvani authored the interim analysis based on interviews conducted by Shaku, Claire and myself, and some of Shaku's findings are reworked here. The research was conducted with the aim of evaluating the AHWA project and to provide an academic interpretation of the findings: the latter was my remit and any misinterpretations or errors in this chapter are mine alone. Anne Painter supplied the photographs that help to convey some of the texture of people's lives.

References

Appadurai, A. (1986) *The Social Life of Things.* Cambridge: Cambridge University Press.

Bachelard, G. (1994) *The Poetics of Space.* Boston, Mass.: Beacon.

Barker, N. and Parr, M. (1992) *Signs of the Times.* Manchester: Cornerhouse.

Bayley, P. (1991) *Taste.* London: Faber & Faber.

Belk, R. (1995) *Collecting in a Consumer Society.* London: Routledge.

Bourdieu, P. (1984) *Distinction.* London: Routledge & Kegan Paul.

Brindley, T. (1999) 'The modern house in England: an architecture of exclusion', in T. Chapman and J. Hockey (eds) *Ideal Homes? Social Change and Domestic Life.* London: Routledge, 30–40.

Chapman, T and Hockey, J. (1999) *Ideal Homes? Social Change & Domestic Life,* London: Routledge.

Csikzentmihalyi, M. and Rochberg-Halton, E. (1981) *The Meaning of Things.* Cambridge: Cambridge University Press.

Cummings, N. (1997) 'Everything', in *Curating: The Contemporary Art Museum and Beyond.* A. Harding (ed.) *Art & Design.* 12 (1/2), 12–17.

Douglas, M. and Isherwood, B. (1978) *The World of Goods.* Harmondsworth: Penguin.

Douglas, M. (1991) 'The Idea of Home', *Social Research,* 58 (1), 287–308.

Hepworth, M. (1999) 'Privacy, security and respectability: the ideal Victorian home', in T. Chapman and J. Hockey (eds) *Ideal Homes? Social Change & Domestic Life.* London: Routledge, 17–29.

Leach, R. (1998) 'Embodiment and Consumption: Revisiting Merleau-Ponty' in I.Taylor (ed.) *Conceptualising Consumption.* Institute for Social Research Working Paper. Salford University

McCracken, G. (1990) *Culture and Consumption.* Bloomington: Indiana University Press.

Miller, D. (1987) *Material Culture and Mass Consumption.* Oxford: Blackwell.

Oliver, P., Davis, I., and Bentley, I., (eds) (1994 [1981]) *Dunroamin: the Suburban Semi and its Enemies.* London: Pimlico.

Painter, C. (1998) *The Uses of an Artist.* Ipswich: Ipswich Borough Council.

Painter, C. (1999) *At Home with Art.* London: Hayward Gallery Publishing.

Pearce, S. (1995) *On Collecting.* London: Routledge.

Poster, M. (1988) *Jean Baudrillard: Selected Writings.* Cambridge: Polity.

Putnam, T. and Newton, C. (1990) *Household Choices.* Middlesex: Futures.

Rybczynski, W. (1988) *Home: A Short History of An Idea.* London: Heinemann.

Samuel, R. and Thompson, P. (1990) *The Myths We Live By.* London: Routledge.

Saunders, P. (1989) 'The Meaning of Home in Contemporary English Culture', *Housing Studies,* 4(3), 177–92.

Silverstone, R. (1997) *Visions of Suburbia.* London: Routledge.

Teyssot, G. (1996) 'Boredom and Bedroom: the Suppression of the Habitual', *Assemblage,* 30. 44–61

Willis, P. (1990) *Common Culture.* Milton Keynes: Open University Press.

−10−

Mass-production, Distribution and Destination
Richard Deacon, Antony Gormley and Alison Wilding

Retrospective thoughts from three artists who participated in the *At Home With Art* project. (See pages 7–9 for a summary of the project)

The following texts are edited transcripts based upon conversations with Colin Painter.

Richard Deacon

The problem with multiple art works is often the distribution system – not the work. I participated in the *At Home With Art* project because I was interested in an unlimited edition distributed properly through a system that reached a large public. The project was a way of putting things in different places – reaching audiences that you wouldn't otherwise reach. Most artists are interested in that.

I think there is an audience and a market for art works outside of the gallery system and outside of a limited-edition market, which is specialized in order to sustain its economy. The limited number is a kind of guarantee of value. (Though even unlimited prints appreciate I've got Peter Blake's *Babe Rainbow* that was distributed through the newspapers and that has appreciated.) There is a market beyond the art market but it is very difficult to tap into. If you're a small gallery distributing large numbers is very problematic so that's why you need another system. Think of the garden gnome market – why not sculpture? People are seriously interested in having things to put in their gardens. If you were to do that, a distribution system like Homebase would be the one you would look for. I guess the same applies to souvenirs, and the piece I made for the *At Home With Art* project relates to that category of objects.

I thought Homebase should have followed it up with a second range. If you are committed to a product that's what you do. You produce the first range and then you follow it up and start to bring your buying public along with you. Homebase got a lot out of the project in terms of publicity and you could say that they let the artists down by not following through.

It's interesting that, since the project, B&Q have sponsored the Michael Andrews exhibition at Tate Britain and brought out a range of paints in collaboration with the Tate. The Tate has a brand to sell. Artists do to some extent but it's not quite as clear.

I didn't make a household functional object because that's not what I do (see Plate 12). I'm an artist so I'm good at making art. If you're making things for a mass market there's no reason why you shouldn't make the thing you're best at doing, rather than treating yourself as a brand and making something you're not really great at doing. One of the reasons I was invited to participate was name recognition. What I do is known. Equally, the reason why some people might be interested in buying something – or even looking at something – of mine has to do with a kind of name recognition. What I was interested in was trying to make something which had an equivalence with other things that I might produce – limited editions or unique objects – something that was in the same playing field.

I don't see the production of mass-produced works as undermining the status of one-off works. Apart from anything else my major works are far too complicated to be produced on a mass scale, although there is overlap.

I did consider things that might fit in a home – fireguards, ceramic fake fires, pressed-tin wall coverings, for instance. I think it really didn't become clear until the process went on that the problem of making a small sculpture was actually much more interesting than the problem of trying to find a functional object that I could adapt or modify or, even, design. I'm not a designer. It had to do with wanting to say that a work of art could be something that could be distributed in this way and that art wasn't defined by its limitedness or by the context in which it was distributed.

Most people who go to see my work in galleries are not potential customers. They go there for a particular kind of experience. The *At Home With Art* project was an opportunity to explore the possibility of making that experience more widely available. It would be ideologically very difficult to restrict access to that kind of experience. I'm not a missionary. I don't have a message. I have certain kinds of fascinations, concerns, compulsions and abilities – but in order to finish the process of making something I think you have to show it. I don't think the thing is ever finished if it's made and then hidden. The fact of a work being seen is part of its process. It's part of the function of being an artist to show work.

Of course, there are practical problems with fragile objects in robust situations and there is a difference between a football crowd and a museum crowd. There is a trade- off between access and wear and tear. For example, in France in the 1980s the Fonds Régionaux d'Art Contemporain (FRACS) under Jacques Lange became heavily decentralized. Money was pushed out to the provinces. FRACS became quite heavy collectors. Some of those FRACS took their mandate to make the works available to people in their regions very seriously and toured works

continuously to every village and town – every possible venue. From personal experience I know that there were, from time to time, problems of wear and tear in the work as a result of working the collection so hard. By contrast some of the FRACS chose to fulfil their mandate by building a prestigious display base, and works that were restricted to museum display in those regions didn't have anything like the same kind of problem.

Neither the museum display nor the nomadic showing seems to me to be an abuse of the objects. I don't particularly like repairing works but I recognize that can be what happens. But this is offset by the larger number of people who see it. It's much better that people see things. I'd rather have my work out there in the world than hidden in my store. It means that people are looking at it. As an artist I think it's a ridiculous thing to do to make work and keep it secret. Its being visible is part of the project.

It doesn't worry me what meanings or uses people attach to my work as a consequence of buying it from Homebase. I was aware when I agreed to participate in the project that to step outside the usual art-world 'white box' gallery context was to take other risks. You risk loss of meaning, loss of specialness. People go to galleries because they look for meanings. I don't think they're looking for particular meanings, but looking for meanings is an important part of the gallery-going experience. Outside of that context it's less clear – but, equally, homes have meanings. Outside the 'white box', intentionality is less clear. Without framing devices you're putting more responsibility on your audience to provide the framing devices through which the work will be given meaning. But I'm relaxed about the potential consequences of that.

The ways in which work is experienced and understood is always contingent on many factors. A long time ago, when I was a student at St Martins in the 70s, I remember using the analogy of a football team or a rock band which starts off playing with friends in the garage or on the local recreation ground with two or three supporters turning up. Gradually the band or the team becomes more successful, the number of supporters increases, the venues change and each time there's a match or a performance it's complete in itself. But the experience of the audience varies considerably from those who are there for the first time to those who have been there all their lives. The meaning of the performance varies according to individual experience and I think the same is true of art works. I suppose history shakes it down somewhat so that if we go and look at Masaccio in the National Gallery we're all relatively ignorant of the means of production. The work is heavily decontextualized for anyone looking at it today. But we still engage with it as meaningful.

Art is not entirely a product of autobiography, though that has a role to play, and it's not necessarily a product of context though that has a role to play. I have just made a work in New York (Plates 63, 64) and that has changed because being

in New York post-September 11th 2001 is very different from being there pre-September 11th. The meaning of the work has changed significantly.

It is also difficult to generalize about the meanings underlying one's works. Generalizations are not very productive. Particularities are more fruitful. Things work from the particular to the general rather than from the general to the particular. I'm suspicious of artists who universalize the motives underlying their work, whereas an artist who makes a work about putting a shoe on is potentially producing something that has much more capacity to touch interesting areas of universal experience.

The artist and the audience are tied together. Both have responsibilities. It's not just that I do something for them but they do something for me. It's all part of the same thing. We all have a shared responsibility. The shared responsibility is to let it happen; to allow material artefacts to behave as if they were animate; to allow the possibility that the bits of colour or pieces of matter are imbued with qualities that are like consciousness. There is a sense in which the object is between me and the audience and we both assume that the inanimate matter is behaving as though it was conscious or animate in some way.

The work I produced for *At Home With Art* was the first cast I'd ever made. There's a certain irony in the fact that I'm someone who uses mass-production techniques in a lot of my work, including mass-produced components from time to time and industrial processes – yet I was slightly surprised that I ended up making a cast object. I started off with five ideas for sculptures that I might make and it was the demands of mass-production that determined the ultimate choice. We spent a lot of time refining the piece and I was very happy with the process. It would have been very nice if the top surface had been a self-formed meniscus curve. But I understood the problematics of that and am comfortable with the result.

The project might have influenced my thinking in that I'm now trying to make some jewellery. I'm working with a small production company in the USA that works in the area between small limited editions and mass-production, editions of 500 or so. One of the pieces I am working on uses a similar element to the *At Home With Art* piece – a blob or drip. I'm interested in a wearable object because it's free of gravity. The work for *At Home with Art* is also non-located – there's no top or bottom surface, no up or down to it.

Anthony Gormley

I saw the *At Home With Art* project as a bridge between the anthropology of everyday life and industrial methods and economics in the making and distribution of things, in the making of 'reality'.

There is a desire to collect in the British psyche and the home is the burrow in which this desire is expressed – where the net curtain and the shag pile reigns supreme. Every time one crosses the threshold into domestic life one is in fear of what one is going to meet – sights, smells, sounds . . . In Britain, behind a political notion of individual freedom resides, also, a kind of protectionism of the zone of the personal: in the damp atmosphere all sorts of things grow. There is a lurking fear of what things one might find in somebody's bathroom cupboard.

But I don't have any reservations about entering this terrain. In broad terms, that's where art belongs. Art belongs in life. We've come to an acceptance that art aspires to the condition of the museum, but that's a failure because museums were originally conceived to contain objects that had had a life but are then preserved as specimens. They are recontextualized within a historic framework, in order to have another intellectual life. It seems to me that the art of our time should not short-circuit its own right to participate in life by aspiring immediately to the conserved and conservationist environment of the museum where everything is prescribed, and certainly mediated, by the notion that you're going to have an art experience. I am interested in the question of whether or not art that's made today can survive in the intimate, domestic eco-niche of the twenty-first century home.

The greatest compliment that can be paid to me and my work is that somebody is prepared to live with it. The condition to which I would like my work to aspire is that a person, or a family, or a larger group of people are prepared not only to buy the work but actually share their lives with it, on the understanding that there is some benefit from that sharing. I would put this higher than the aspiration to be collected by an institution because I think, in the end, that is where the art is tested. Does it contribute, does it allow thought and feelings that would not otherwise arise, does it change the quality of life in that place?

It is interesting that in the *At Home With Art* project six of us made functional objects (see Plates 1–36). I'm not really sure why I made a functional object. Perhaps I wanted to accept the condition of pragmatism or practicality as part of the brief. I didn't feel able to make a sculpture. But I did feel very comfortable with what happened and how it turned out and I know that I wouldn't if I'd made a little body form – I don't really know why. I didn't start with the thought that, 'I can't make a sculpture'. It was just that, in the process of thinking about it, it just seemed like the best thing to do – to make something that belonged in the domestic because it had a job to do rather than was going to be a self-consciously aesthetic thing.

My work is quite painful; it's not necessarily going to give pleasure. I think disturbance, cutting through the fabric of comfort that surrounds us, is important. That is what art has to do today. Art has this potential: to allow repressed things to be revealed. That is maybe another argument for art existing outside in the

elements because it's not conditioned by architectural context or its functionality whether it's a home, a bank or a museum (Plate 65). No art worth its salt is celebratory in exclusivity. I would say that there is very little art of value today that takes the Matisse position (art as an easy chair for the tired business man) if the Matisse position isn't already a misunderstood stereotype.[1]

But I think the situation of the artist is changing. We're becoming integrated in a way that was never possible before in spite of the pain. More and more people want to be involved in the way that artists think and what they're thinking about; they value it. Things are really shifting. The contribution of art is already being integrated.

One factor that influenced my decision to make a functional object rather than a sculpture was quality in the process of mass-production. I just know that, in terms of the quality control on the peg, it was very difficult to maintain the things that became very important. How many passes of the cutting tool should there be across the end face; what depth should those cuts be . . . ? And that's with a very simple object. The idea of making an unlimited edition of a sculpture with the same degree of quality is quite daunting. But that is a practical kind of *caveat*.

I am actually in the middle of the protracted process of trying to make a small model of *The Angel of the North* which needed to be completely remade because they couldn't make the ribs on that scale. That's going to be an unlimited edition and I'm still very worried about it. It is a reduction of something that already exists, a souvenir. I hope it's going to work as an object in its own right. I'm worried that they're not going to make it well enough – because it is important that it's going to sell at a price that will be affordable by everyone. I want it to be inexpensive but I want it to be well made. There are real tensions there – which I think we resolved in the peg. The peg was a way of being modest in ambition. (Although not particularly modest because, on one level, I was trying to make a classic.) On one level I was redesigning a nail and on another trying to make something that performed a function elegantly enough to justify its existence. The pegs look quite nice with nothing on them but they are quite adaptable functionally – as a coat hook or whatever. They have a sort of invitation to them: 'Put something on me. Hang something on me'. It tickles me that they can be just an interruption to the wall surface or they can have a coat on them and disappear but still function – still be there.

In the case of the peg I was able to originate the object in relation to the potential in the mass-production process. This was not possible with the miniature *Angel of the North* where I am attempting to find a process capable of reproducing, in miniature, something which already exists (Plate 66).

So quality-control is a significant factor in my unease about the mass-production of sculpture. But I make editions already – usually editions of five – like *Together and Apart* (Figure 10.1) and I haven't got any problem with that. So I

have to ask myself what the difference is between making five of something and making indefinite numbers?

It is an interesting fact that in many senses having more than one of something is an advantage to both the object and its understanding by the world. The fact that the versions of Brancusi's *Maiastra* (Figure 10.2) can be in more than one

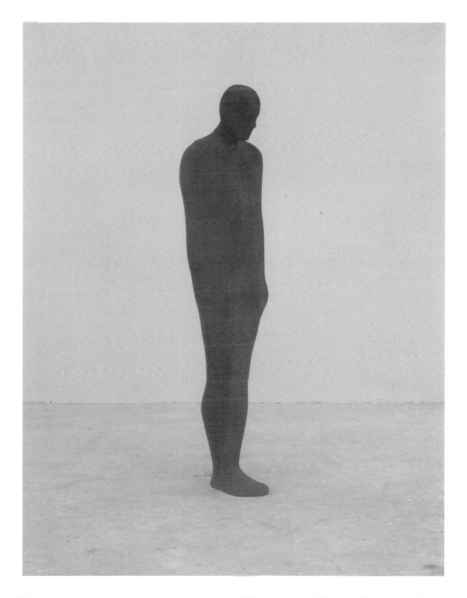

Figure 10.1 Antony Gormley, *Together and Apart*, 1998 Cast iron, 189 × 48 × 28 cm An edition of five plus three artist's proofs. (Photo. Stephen White, London).

place at the same time and be contextualized differently, but also be considered as unique and remarkable objects, can help the understanding of the work – or a work's ability to generate meaning.

But a literally unlimited edition – a total infection – obviously takes away from a work's particularity. I wonder if it is a justifiable dilution. I'm atavistic enough to think that sculpture is about concentration rather than dispersion.

It is interesting, Walter de Maria gets a 30 cm long bit of stainless steel and calls it a 'high energy bar' and releases it as an edition of twenty or so and it worries me that it wouldn't be a high-energy bar if it was a thousand. Is that totally irrational?

If art was so commonplace that it was the equivalent of conversation it wouldn't be valuable. It is concentration with synthesis, to do with trying to make an absolute. We all know that we live provisionally in a provisional world in which everything is changing; everything is subject to the unknown, and we try – out of a vessel which is always leaking, always disappearing – to make sense, structure, form, meaning. If art was, 'Watch my lips, hear my voice, this is what I'm saying. This is the truth', art would be revealed truth and a form of religion. Art is different. It is an attempt to synthesize, concentrate and isolate experience in an object. *But* artists admit their own inadequacies, the particularity of their viewpoint and that they are not aware of everything that's going into this thing but are engrossed in the process. The gift is to get the viewer in the same place as the artist in relation to this object as a potential container for thoughts, feelings, life process. It's not like any other form of communication. We're not communicating information even though the object is a fact. What we're trying to do is to create a condition in which thoughts and feelings can arise. I'm very aware that I might not be in touch with a lot of the stuff that might be contained, condensed and crystalized within a work. But the process might have some effect on other people's experience. They may be able to tell me something valuable that, in my concern with the making of the work, I didn't know about at all. I don't think that is a betrayal of my responsibility as an artist. I think it's an admission of the fact that art, when it's working best, touches on things that only art can do; the reasons for its making are things that can't be expressed in any other way. You can't judge the quality of the communication that transpires through art by information theory – 'Did you receive me?' 'Are you receiving me?'

I haven't got a final word on this because it is a radical move to make an unlimited dispersion of a work. If you want the work to be a part of life and you want it out there, why not? Maybe I just haven't found the right work to do it with yet.

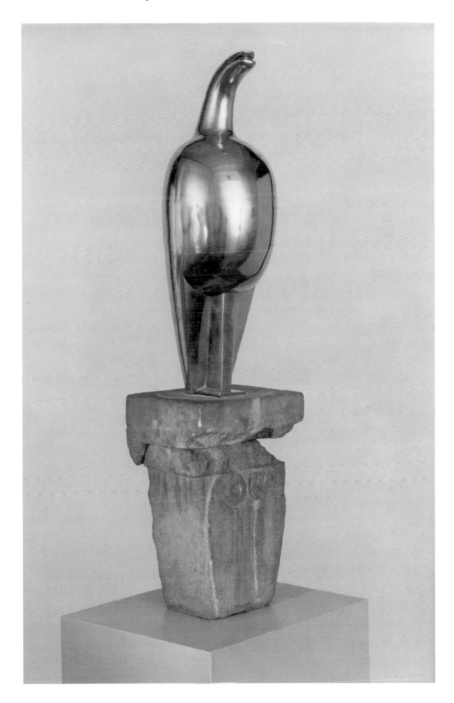

Figure 10.2 Constantin Brancusi, *Maiastra*, 1911 Bronze and stone. 905 × 171 × 178mm
(Tate Modern).

Note

1. 'What I dream of is an art of balance, of purity and serenity, devoid of troubling or depressing subject matter, an art which could be for every mental worker, for the business man as well as the man of letters, for example, a soothing, calming influence on the mind, something like a good armchair which provides relaxation from physical fatigue.' Henri Matisse (1908) 'Notes of a painter', *La Grande Revue*, 25 December, quoted in J. Flam (ed.) (1988) *Matisse, A retrospective*. New York: Hugh Lauter Levin.

Alison Wilding

There seemed to be some inconsistency of presentation of the objects in Homebase stores. My own experience was that the objects were actually hard to find in the stores I visited. I don't know why that was or what went wrong. Anyway, I understand that all the objects have now been sold – which was helped by the fact that Homebase put them on 'special offer' toward the end. It's good to know that so many of my works are now out there in people's homes. I'd be very interested to know where they ended up and how they're being used.

Recently I've made a work for the Multiple Store (see Plate 67) and it made me realize what a different situation that is. It's very unlikely that anyone who doesn't already know about the Multiple Store will access it even though it's on a website and has plans to widen its market beyond the 'art market'. What was particularly good about having work in Homebase was that people didn't have to have prior knowledge of the project to encounter the work. Though my personal experience in trying to access the objects in Homebase was frustrating, the larger situation was that people could stumble across the objects even without looking for them. With limited-edition multiples you are still operating within the limited range of the art world. Having the work in Homebase took it well beyond that context. I would like more people to experience my work. I like the idea of getting my work into new places and markets. It's not that I want to turn my back on the art world but I like the idea of being inclusive. I don't see any conflict between my work and position as a sculptor, showing one-off pieces in galleries, and the possibility of making mass-produced work for a wider market.

I think artists are less and less interested in showing in white-cube galleries. They are increasingly interested in how things are in the world outside the gallery. I would like more people to experience my work. The art world is very enclosed, although probably more people know about it now because it has become a celebrity game. I'm not sure if that means that more people are buying contemporary art. It would be good if it was as easy to buy a piece of work from an artist as

it is to buy a nice cup. It doesn't have to be a lesser piece of work just because there are more of them but it's important that the work is not compromised in the process. There is a gulf between the *At Home With Art* project and everything else that I've done. I'm aware that I work in a very small, esoteric, rarified space. This project was the antithesis of that. But there was no fundamental difference in the actual process and integrity of making the work. As it turned out the piece led subsequently to other related work, some of which I am very pleased with (Plate 68).

In having to make something to take its place in the home I found the brief was actually too open. Maybe it should have started in Homebase — seeing what they already stocked in the store and working from there. I wasn't sure of the relevance of starting by visiting a particular home, although it became clearer later that it had a lot of relevance to the work I ultimately produced. At first I went through a prolonged period of uncertainty in trying to come up with a viable idea. I worked through a range of possibilities. A lot of them were connected with things I'd already done in some form. But I never really like redoing anything and, in the end, the piece I made was totally new (Plates 33–36). As I said in the catalogue to the exhibition, once I gave up thinking about it too much and began to work with materials, things developed quickly. It transpired that my visit to the Sivalingham's home fed into the work significantly. Siva worked at British Aerospace at the cutting edge of research into the application of metals. At the same time the family made offerings to their Gods within a Hindu tradition. That seemed to me to be an extraordinary juxtaposition and one which had a strong effect on the piece I ultimately made . That is to say that it affected my thinking during the time spent exploring my ideas. I don't think you get a sense of that juxtaposition from the object.

While, like other artists, I have a small accumulation of art in my home, I don't consider myself 'a collector' of art. I like strange objects. Things you can move around, carry with you, put in your pocket. I have a stone-age axe head, an iron meteorite and a fossil from a river bed. I suppose they are things from other worlds: things out of context, out of our time, beyond our immediate understanding. They're like keys to a different place and time. Sometimes they're shut away and sometimes they come out. I suppose that's what people do with the art they buy. They don't always have it on show.

Because of the focus on the home – and perhaps because of the character of Homebase stores – the project raised questions about distinctions between functional and non-functional objects. The grey area between functional objects and fine art is endlessly fascinating. The object I made for the *At Home With Art* project was non- functional. It was sculpture. Yet the pre-publicity and the media response characterized the object as a bowl. It didn't occur to me that people would put things in it like fruit or eggs and use it as a bowl. Why would you want to put

anything in it? My mother has filled my piece with pot-pourri. I don't like that. Furthermore, I'd like to take all the other clutter around it away so that it can be seen properly. Although I'm not a control freak, I am only too aware, as an artist, of not having any control once things go into the world.

The difficulty is to show work outside the gallery and retain some sort of control. The context can change physically and the installation can be different to what is intended by the artist. I suppose I make a distinction between small objects that I might make for mass-production – in the knowledge that they will be used in ways that are outside my control – and the larger works that I make. This distinction is not in the nature of the process of conception or production but in my attitude to what happens to them subsequently. I mind less with the Homebase object because that's part of the deal – though I dislike some of the things that might happen to even that object, like my mother's pot-pourri for example – but for anything on a larger scale it would be too stressful.

Also it's very unusual for my work to be a single unitary object. It does happen sometimes but it's unusual. Most often my works have more than one component and these are critically related to each other physically and visually (Plate 68). So, as soon as you have a situation where the owner has to make a decision about how a thing is set up, there are many compromises. I've seen sometimes how people use my objects and I don't like it. This problem would be magnified if I mass-produced or, even, editioned such works. Yesterday, for example, I went to a sculpture park where I'm going to make a piece of work to be sited. Some of the terrain there is quite overgrown. I wanted to minimize the possibility of events outside my control influencing the context of the work. In the end I found a space that I know won't change and where nothing else can be placed. I don't want the work to be close to anyone else's because then it begins to look like something else.

There are limitations in what you could make through mass-production. Scale is limited, for example. It is most viable for small objects. I can't conceive of the larger objects I make being mass-produced. My immediate thought is that that would be a bad idea. I'm not sure why.

I have not been interested in making editions of my larger works. Why would I want to make editions? I have enough problems selling one. With my sculpture there is a great deal of hands-on work on it of a kind that would be very difficult to replicate consistently on a large scale. Everything has some sort of intervention on it that would be extremely difficult to convert into a repeatable form.

There's something about mass-production that lends itself to immaculacy and a fine total finish. I would be interested in trying to achieve a quality of immediacy. I think it might be interesting to do something that wasn't so hard-edged. If I were to make something for mass-production again I would want it to relate closely to other work that I was doing at the time. How I would proceed would depend on

my current preoccupations. The piece I made for the Multiple Store was related to other things that I was making. It was very like one of the etchings that I did in Madrid although I didn't realize it at the time.

I don't feel that there is any danger that mass-production might result in too much of my work being out there – overexposure. Even if one in five people owned a piece by me, what they did with it would be very private. People will always give things meanings because they feel compelled to do so – and I'm happy with that. I suppose I'm relaxed about the ways in which people interpret my work but not the ways in which they display or use it physically. Of course the two are closely connected.

–11–

Images, Contemporary Art and the Home
Colin Painter

Introduction

This chapter discusses the home as the site, for most people in Britain, of their primary engagement with images and as a neglected focus for the wider dissemination of contemporary art. There, as children, we acquire values and tastes. There, as adults, we continue to understand and define ourselves, largely through the deployment of visual objects. The existence of a plurality of image- using cultures in Britain is noted and the professional culture of contemporary art is discussed as part of this diverse context. Ways in which images are used in homes are discussed and compared to dominant values in the contemporary art world. It is suggested that the work of contemporary artists could have wider effect if artists, critics, and curators were to respond more actively to uses for images manifested in the home. Finally, there is a consideration of what might be involved in achieving this.

Art and the Uses of Images

In discussing contemporary art in relation to the domestic, the term 'art' brings complications. Although we commonly refer to all such things as paintings and sculptures as 'art', we also use the term to refer to special artefacts. In the latter sense, some paintings and sculptures have been given the status of art and some have not. 'Art' is what particular groups and societies decide it is. In Britain today we tend to delegate this decision to professional specialists. What counts as art can be different in different societies and can change for particular societies over time. The term 'art' is, therefore, distinctly different from such terms as 'painting' or 'sculpture' which refer to specific activities and all the objects that result from those activities.

In this sense, 'art' is not an attribute of a painting but of the way people relate to it – give it meaning, value and importance; how they *use* it. To speak of the *uses* of images is helpful here because it is non-evaluative and inclusive. It can apply to situations where images are not being used as art as well as those where they are – to ordinary daily situations as well as elevated aesthetic ones. (Brunius

1963: 124) In galleries, images are clearly used as art. In domestic life, they are sometimes used as art but they are also used in a variety of other ways, some of which have little to do with art as currently understood. Images can be used as wedding gifts, as souvenirs, as furniture. The same image can combine all these uses *and,* in the same home, be used as a work of art. 'Art' can be said to exist in a particular way (or group of ways) of relating to, or using, images – among many other ways of using them. In the variety of uses to which images are put, they fulfil a variety of needs – aesthetic, social, religious, commemorative – and reward associated modes of attention.

The general term 'images' is helpful because it, too, is non-evaluative and facilitates discussion of artefacts which do not have the status of art along with those that have. With some allowances, it is also capable of covering a range of formats – paintings, sculptures and photographs for example – and that is how it will usually be deployed here. It also readily covers video, film and others but this chapter is principally concerned with images which have a degree of permanent presence in the home.

The Power of Images

Images have effect. In addition to being of aesthetic significance, they offer select-ive accounts of and/or metaphors for human experience, imaginings, ideas and beliefs. However approximate communication might be – and interactions with particular spectators within particular contexts are crucial – images can offer propositions about what it is to be human in the world among other humans, including inner states and feelings as well as observations of the external world. Our experiences of images influence our thoughts, feelings and perceptions. They are an important part of the ways in which we develop ideas of who we are, our relationships with others and the world around us. We understand ourselves, and the realities we occupy, through descriptions – including images – that we make and share (Williams 1980). What images we live with is, therefore, a consequential matter.

This power is not confined to images deemed to be 'art'. All images have effect. To wish to widen the availability of the work of artists of the contemporary art world is not to presume to know what is good for others or to wish that everyone should live with 'art'. It certainly is to wish to participate, with some uncertainty, in an active cultural exchange. The esteem in which particular images are held is not only inevitably, but beneficially, the subject of debate. That debate is as important as the images that generate it – debate about what particular images achieve and how; a debate which should centre on efficacy in relation to specific uses, fulfilment of specific needs, rather than on general notions of taste. It is a debate which extends beyond images to life as lived; a debate in which the

contemporary art world takes little part beyond its own cultural boundaries. As for 'art', this is a slippery concept with many negative effects which we might be better off without. My interest is in the kind of work that the image-makers we call 'contemporary artists' *do*. Whether or not it continues to go by the title 'art' is immaterial. I want to legitimize, for this kind of work, wider uses than those currently associated with 'art'.

Contemporary Art

> I need art like I need God. And it's actually in that order . . . Art isn't a game for me. (Tracey Emin 2000: 102)

By contemporary art I mean the kind of images identified as the art of our time by the scholarly and pedagogic world of art and its institutions; taught in the fine-art departments of our art schools; supported by the Arts Councils and their related institutions, associated with the Turner Prize; included in the more recent elements of the Tate Modern collection.

It is these *kinds* of image, in their considerable variety, that I want to see participate more widely, rather than any particular catalogue of works. These kinds of image are produced, discussed, and made public by a fast-moving professional culture which I will refer to as 'the contemporary art world' – impossible to delineate with precision – full of diversity and contradictions, but nonetheless real. It is a culture which celebrates the knowledge that perception of both images and the world is itself creative, interactive and interpretative: a self-conscious culture, aware of its past, experimental and critically rigorous. It is the site of an informed debate, through images as well as words, about the effects of images. Perhaps most importantly, it is a world in which, among most artists, knowledge of the potentialities of images is held with a greater sense of responsibility than elsewhere.

This description of the contemporary art world is in stark contrast to that perpetuated by media hype which often characterizes it as irresponsible and sensationalist. These characterizations may, at times, be accurate but the larger truth is that at its centre is a community of informed and serious artists who, sometimes through humour, are conscientiously exploring matters of consequence through the making of images. There will be exceptions to most generalizations made in this chapter . . .

Contemporary Art and Other Image-production and Marketing

The nature of images in homes is related to what is available in the market place. Contemporary art is a small part of a universe of images providing for the needs

of British people in their homes. It is worth briefly noting some characteristics of this universe. Contemporary art is not the only kind of 'art' being produced in Britain (Brighton and Morris 1977). There is also a 'traditionalist art world' which in its period forms is close to the antique trade, handled along with jewellery, silver, ceramics and furniture. Living artists produce work of a traditionalist nature evidenced by privately funded institutions like the Federation of British Artists and its sub-groups – the Royal Society of Marine Artists, the Royal Society of Portrait Painters, and the Society of Wildlife Artists, for example. In its current forms, traditionalist art is handled by a range of commercial galleries which often announce themselves as dealing in 'contemporary art'. This is legitimate because the work is both contemporary and used as 'art', but it is not accorded high status in the contemporary-art world as defined here. It is excluded from the history of current art as it is being written in scholarly institutions. It rarely receives critical attention in the national media. Although contemporary and traditionalist art share a largely common heritage in the mainstream history of art (at least before 'modernism'), it tends to be perceived differently in relation to the priorities of each.

Outside these worlds of 'art' the making and marketing of images is less well mapped. The Fine Art Trade Guild announces itself as 'the trade association for the art and framing industry' which, within considerable diversity, deals in both originals and reproductions – limited editions as well as unlimited runs. The extent to which 'art' is emphasized varies. The nature of the images handled is extremely uneven. Much of it is consistent with traditionalist art but it includes images of a graphic and illustrative emphasis: some are virtually 'cartoons'. These coexist with reproductions of selected old masters and, occasionally, images from modernist art. The style of selling is much as in any other shop.

The art and framing industry is difficult to distinguish decisively from an extensive array of image-production, and marketing which gives little emphasis to notions of art. It cannot be described as a coherent entity and there is little published discussion of it. It includes both originals and reproductions and, in its heterogeneity, selected reproductions of recognized works of art. It often combines images with functional purposes – clocks, table-mats, teapot stands, calendars and other domestic objects, for example.

The places in which the images are sold reflect the primary uses to which they will be put in the style of presentation and the other goods with which they are made available – art galleries, gift shops, souvenir shops, furniture shops, garden centres . . . Images are used in home decoration schemes and are, therefore, sometimes sold in the same places as decorating materials. They are available from mail-order catalogues, market stalls, charity shops, fair grounds . . . (Figures 11.1a–p)

a

b

Figure 11.1 a–p Range of retail outlets for images.

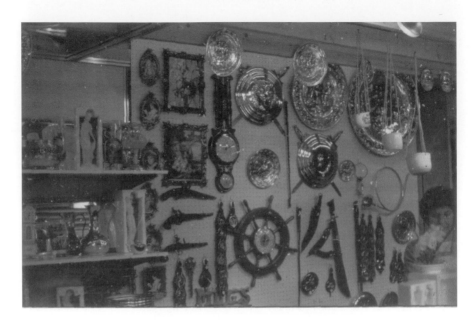

c

d

Figure 11.1 (Continued)

e

f

Figure 11.1 (Continued)

g

h

Figure 11.1 (Continued)

i

j

Figure 11.1 (Continued)

k

l

Figure 11.1 (Continued)

m

n

Figure 11.1 (Continued)

o

p

Figure 11.1 (Continued)

Contemporary Art and Publics

Despite the reported success, in terms of attendances, of galleries from Tate Modern to Walsall and wide media coverage for such events as the annual Turner Prize, there is still some way to go if contemporary art is to find a meaningful place in the lives of the majority of people in Britain. Flip commentary, presumably intended positively, often seems designed to ridicule. ('. . . it's friendly and free, it's part of modern trivia.' is how Matthew Collings describes Tate Modern (2001: 25). The celebrity enjoyed by a few artists, usually rooted in some perceived 'sensation', does little to enrich engagement with their work or make it any more influential in people's lives.

The crossing of cultural boundaries associated with 'postmodernism' has affected the public environment (via architecture and public art for example) but, otherwise, it remains largely confined within the practice and discourse of specialists. It has not crossed real cultural boundaries – entering other people's ways of life. To do so it will be necessary to connect with the priorities of those across the borders. This demands more than the appropriation of superficial appearances. It involves reciprocal processes, participation, integration and negotiation within the terrain of the uses that people currently have for images.

The reduction of contemporary art to triviality, and the occasional sensation, is strangely counter-productive and contradictory in a nation that puts significant public resources into its development. Art education is part of the state general education system, fine art has a place at every level in our universities and colleges, and public subsidy plays a major part in the support of contemporary art activities and galleries. Yet there is a lack of meaningful connection between the values and priorities of the contemporary-art world and those of the wider public which contributes to it through various forms of taxation. This is sometimes put down to shortcomings in the public – lack of understanding or 'an endemic resistance to the "new" in British culture, particularly in the visual arts', as Virginia Button puts it in her book *The Turner Prize* (Button 1999: 15). However, when – through specially devised projects – people not familiar with contemporary art, have the opportunity to live with it for some time among their own possessions, the evidence is that they are able to adjust to it in perceptive and personal ways that accord with their own priorities – even though, because of the more usual absence of contemporary art, some of the visual juxtapositions created might be somewhat incongruous. The project entitled *Close Encounters of the Art Kind* facilitated such situations when six sculptors made works available to be rotated from home to home round six homes. Each household lived with each sculpture for a month, siting it as they wished. Their perceptions of the experience were documented (Painter 2001) (Figures 11.2–11.7; also Plates 69–74).

Figure 11.2 Tania Kovats, *The White Cliffs of Dover*, 2000. Acrylic compound and flocking. 100cm × 26cm × 27cm .

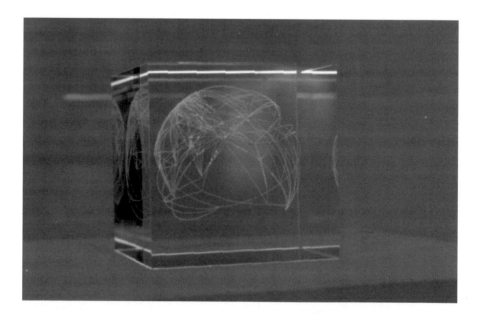

Figure 11.3 Langlands & Bell, *www.* 2000. Laser etched crystal glass. 10cm × 10cm × 10cm (Courtesy, The Multiple Store, London).

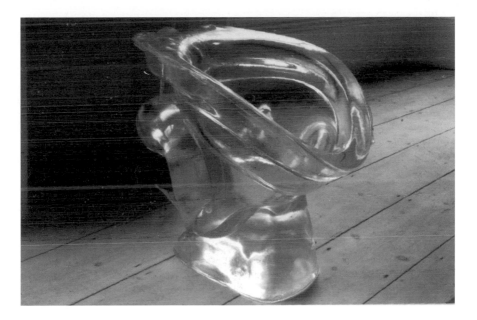

Figure 11.4 Sarah Lucas, *The Old In Out (Saggy Version)*, 1998 Cast Polyurethane 41.3cm ×
50.8cm × 36.8cm (Courtesy, Sadie Coles HQ, London).

Figure 11.5 Keir Smith, *Fragments from the Origin of the Crown*, 2000 Bronze 110cm ×
75cm × 45cm.

Figure 11.6 Richard Wilson, *GMS Frieden*, 2000 Photo inkjet print, wooden frame and glass 95cm × 95cm × 5cm.

Figure 11.7 Bill Woodrow, *Fingerswarm* 2000 Bronze, gold leaf 58cm × 35cm × 31cm.

Though contemporary art is largely absent, people in Britain demonstrate needs for images in their homes. They have real uses for them in their lives and can be thoughtful and articulate about them. Furthermore, while many surround themselves with 'traditionalist' images, many have a desire for the new, unusual, humorous and ingenious. This is apparent in the diversity of objects and images available on the general market. Much of this imagery might be derided – perhaps labelled 'kitsch' (Greenberg 1964) – but the issue here is not whether it is 'good art' but what roles it is performing, what interests it manifests and fulfils. The question is, can the work of contemporary artists participate more widely in the fulfilment, as well as the definition, of these roles and interests?

It is sometimes said that what we need to support artists graduating from art schools is a variety of private patrons in sufficient numbers to offer a variety of opportunities – thus providing financial support and contributing to artistic freedom (Daley 1998: 18). But that is exactly what we already have. People spend significant sums of money on images for their homes and gardens. They do so for a range of reasons and in accordance with a range of tastes. But the artists of the contemporary-art world tend to compete within a tiny sector – clearly too small to support them all – while ignoring a wider and more varied range of patrons. The postmodern era seems to allow everything, yet despite this apparent tolerance, reasons for valuing images in the home continue to be marginalized – and, along with them, ways into people's lives.

Ingredients of this marginalization will be discussed later here, but it is important to establish early on that artists addressing the home as subject matter, which is common, or as temporary site for installations, does not take contemporary art any closer to becoming part of domestic life. What is being discussed here is the possibility of participating in the life of the home, connecting with the needs people have there. This includes being made readily available and reconsidering existing assumptions and practices in ways that might affect the nature of some of the work produced. The continuing importance of work of a nature and scale that has nothing to do with the domestic environment is not in question.

The Power of Images in Homes

Our first encounters with images are not in museums or art galleries. The world becomes charged with meanings and values in our homes, through our interactions with families, friends and the communities in which we grow. Images that have some constant presence – in frames, on functional objects, on fabrics or wallpapers – are an integral part of the total environment in which feelings and identity take shape. We interact with them, project into them, daydream with them. They become part of the templates through which we are nurtured to view the world.

Figure 11.8 Andrew Smith (left) and his brother at home with Constable's *Cornfield*.

The Cornfield has hung in my parents' house – where I still live – for as long as I can remember. Some of my earliest memories are wondering where on earth it was and who is in the picture. My father is a farmer and the farm is bordered by a river which has a raised embankment around part, a dense wooded patch on the other side, vehicle tracks and wooden gates leading to cornfields. Probably aged between four and six, I became more familiar with our own land and wondered whether this was a picture of some of it. Could it have been my elder brother who was drinking from the river? He told me it was, and I was too young to know any better. I wanted to know who the dog was, too. In short, every separate item in the picture could be related to an image from my own life: the dog, elder boy, river, trees, gate, field, farmer, sheep, even Egglescliffe Parish Church: my curiosity was always aroused by how each fitted into place and I always wanted to go to the place where the picture was painted from to see all these things together. At that age, my imagination was more vivid and memory more vague than now. But in a few years I learnt that it was not a photo but a painting and it was somewhere I had never been to. Nowadays it is the familiarity of the painting that endears it to me the most.

Andrew Smith, Process Engineer (Painter 1996).

Some of us become accustomed to seeing images around us as art. Some of us come to think of art as existing elsewhere. Either way, this is not experienced as 'learning', 'education' or the acquisition of 'knowledge'. It happens through familiarization, contagion, and socialization. Attitudes to images – ways of

attending to them – are first shaped at the same table as preferences for foods. That is not to say that they cannot, or should not, be changed. Whether we adopt or rebel against our early experiences of home, they are formative.

When we become householders, the images and objects we gather in our homes play their parts in our continuing definition of ourselves, our ways of life and our beliefs (see Csikszentmihalyi and Rochberg-Halton 1981). They identify us with some and mark us off from others.

Artists who want their work to have effect could not aspire to a more influential context. Yet, works by artists of the contemporary-art world find their ways into few such places.

The Uses of Images in Homes

Most of us are not used to analysing our relationships with the images in our homes – and this includes homes containing contemporary art. When we bring to consciousness reasons for the presence of particular images, we describe combinations of roles and meanings many of which are inseparable from our lives, relationships and rites of passage. The images that surround us are rarely a 'collection' that we went out purposefully to buy. They have accumulated, largely through interactions with other people, over time. Some may be there out of a sense of obligation. There are ways of using images that are widely shared – though present in different combinations and with differing degrees of priority. What is of central significance to this discussion is the extent to which these are problematized in the contemporary art world. They are briefly noted here to be revisited later for discussion in relation to dominant contemporary art values.

Images. Depictions

To anyone not immersed in contemporary-art-world attitudes it would seem superfluous to say that images are often valued for the things depicted in them – people, places, activities, events. Depictions provide a way in which we can have the things we feel good about around us. They can represent the known or evoke imaginary worlds. Sometimes the focus on what is depicted is so powerful that talk about the picture does not register that the discussion is about a made image at all. It is as though what is depicted is actually present.

Images: Home Decoration

Images are used as part of the decoration of homes. While this can be described as a matter of 'style', that concept can have inappropriately superficial connotations.

Creating a visual environment that corresponds to our sense of who we are, or might like to be – and within which many of the most of the important events of our lives are enacted – is a consequential process.

Images: Beliefs

Beliefs and commitments are declared in images in homes. In some cases this is clear in what is depicted – overtly religious imagery, for example, and beliefs related to interpersonal relationships, loyalties and responsibilities. In other cases beliefs and ideas are embodied symbolically beyond their surface content – concerns with 'nature' in a landscape image, for example, which can be closely connected with conservationism or national identity. Beliefs are also embodied in the visual conventions deployed in images, in their relationship to notions of 'reality', for example. All of this is related to our sense of who we are in the world.

Images: Interpersonal Relationships

It is a commonplace that images are to be looked at. But they also have other functions. The ways in which they are obtained, received, inherited can be crucial to their meanings, inseparable from births, deaths, anniversaries, holidays, birthdays, retirements. They can confirm relationships. When combined with the distinctive events of particular lives their potential meanings are infinite. Like a book, an image can be a gift or mark an event independently of its appearance or content. This does not mean that *any* image would adequately perform these roles for particular people. Nor do these meanings preclude other potentialities that an image might possess.

Images: Works of Art

While the above uses for images are widespread, though with different emphases in particular contexts, the use of images as 'art' is less universal. The social distribution of the use of images as art is discussed briefly below. First, we can note some salient characteristics of this way of relating to images.

As works of art, objects have a public significance beyond the home. They are part of history and tradition as documented by scholars. When relating to works of art we can draw upon established knowledge and an associated language. To own them is to participate in the definition of high culture.

To consider objects and images as art is to prioritize their characteristics as made artefacts – who made them, where, when and in what medium. These are more fundamental to the identity of an image 'as art' than what is depicted, even

though what is depicted might be the primary reason for the image's existence. Similarly, the facture of an image is more important to its identity as art than other roles it might be playing – in decorative schemes for example. To relate to images as art is to be aware of distinctions between originals and reproductions. Generally, originals have higher status. Distinctions between limited-edition reproductions and unlimited editions are known. Limited editions have higher status. Notions of art include valuing uniqueness. For some, works of art have a financial value as investments.

Images: Combinations of Roles

It cannot be overemphasized that in all domestic contexts – including those containing contemporary art – images do not have single identities. They have combinations of roles. A single image in a given home can combine being a part of the decor, a confirmation of religious beliefs, a reminder of a place, a wedding present and a work of art. It is in this coexistence of roles, involving our capacity to shift modes of attention and perception, that art can be part of life.

Art, its Presences and Absences

Both theoretical (see, for example, Walker 1983; Braden 1978) and empirical studies in various countries (for example Bourdieu 1984; Dimaggio and Useem 1978, 1982) have connected higher levels of education and socio-economic circumstances with involvement in art. My own work in Britain confirms a broad association of middle-class status with objects being thought of as 'art' in the home. It began in the 1980s with fieldwork in Newcastle upon Tyne (see Painter 1980, 1982, 1986) which randomly sampled four categories of housing – from rented council properties to the most expensive end of the private property market (see Figures 11.9 a–d). That study confined itself to all objects hanging on walls in the 'public' spaces of homes – halls, living rooms, dining rooms, by whatever local title. This was a qualitative study with relatively small samples – a total of fifty-nine homes across the four samples. Within each home an informal interview approach was used to explore such themes as how objects were acquired and what roles and meanings they had for their owners. Whether or not they were thought of as art was central, as were concepts of art, absent or present.

An additional comparative sample (eleven homes) using identical methods, was taken of members of the local 'fine-art community'. This was operationalized by using the members of the Northern Arts Visual Arts Panel of the day. This gave an important measure of assurance that the sample had validity in the eyes of the professional community itself (Becker 1982).

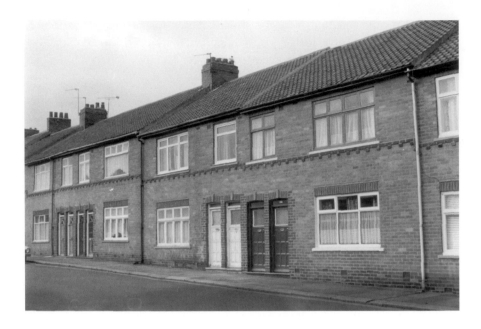

a

b

Figure 11.9 a–d 4 Categories of housing in the Newcastle-Upon-Tyne field-work.

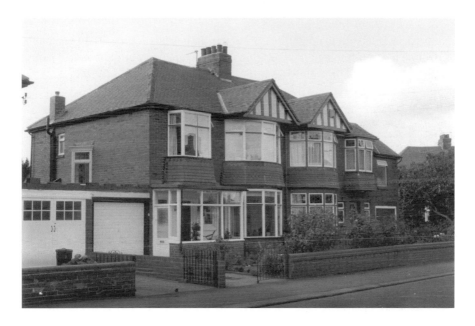

c

d

Figure 11.9 a–d (Continued)

My subsequent investigations (see Painter 1996, 1998, 1999, 2001) have explored, and elaborated upon, findings of that early study more widely geographically and have culminated in exhibitions of a documentary and polemical nature in fine-art venues. The following brief discussion is informed by this range of work. The generalizations involved inevitably exaggerate commonalities and differences. They should not be taken to imply a simplistic notion of social-class divisions or of homogeneities within particular groups.

An Initial Distinction: Functional and Non-functional

We commonly distinguish between art objects and other types of object on the basis that art objects have no function beyond their visual significances. This is reflected in distinctions between fine-art and applied art, fine art and craft, etc. To look at homes from a fine-art perspective tends to be to look for pictures and sculptures. However, in many homes there is no sharp distinction between these and functional objects which often carry images. Also, many apparently functional objects are not genuinely performing a function or are not present to perform the function for which they were designed, for example antique objects such as bed warmers and weapons. There are also many not seriously designed, or present, to primarily perform the functions to which they allude. They are often dominated by images – picture mirrors, imitation weapons, inexpensive thermometers mounted on plaques, clocks 'lost' in imagery, etc. (see Figures 11.10 a–d). These prompt the title of 'pseudo-functional' objects. Their presence seems to be more about their visual characteristics than the effectiveness of their utilitarian functions.

While not all functional objects are performing a real function, not all non-functional objects are pictures or sculptures – sprays of dried flowers or stuffed animals for example.

An attempt at an all-embracing categorization of objects hanging on walls therefore might be

Non-functional Objects
Images (with no other functions including low reliefs/sculptures)
Other non-functional objects

Functional Objects
Genuinely functional
Pseudo-functional

In terms of the above categories, my observations are that, in middle-class homes, the large majority of objects on walls are images and the small minority of functional objects are genuinely functional. By contrast, the walls of working-class

Figure 11.10a Imitation crossed swords and shield.

Figure 11.10b Souvenir thermometer.

Figure 11.10c Clock picture/picture clock.

Figure 11.10d Clock picture/picture clock.

homes tend to have a large proportion of functional objects and, of these, a majority are classifiable as pseudo-functional. Distinctions between the functional and non-functional associated with art are not considered important.

The impact of images and objects in homes is related to their size, prominence and location within specific spaces. This is accompanied by varying levels of prestige attached by particular householders to particular spaces in the home. These factors are often related to gender roles. In middle-class homes men are more likely to see themselves as collectors or connoisseurs taking responsibility for images in prestigious spaces. In working-class homes – generally smaller and with fewer rooms – women more often take responsibility for the visual surroundings. Such decision-making processes involved in determining the visual character of a home are full of complexity (see for example Painter 1986, Miller 2001).

Presences of Art

While the domestic use of images and objects as art is associated with middle-class life this has to be qualified in relation to contemporary art which, my observations

indicate, is present in relatively few homes. Art in the homes of the larger middle class is characteristically traditionalist in nature. Walls carry original paintings, limited-edition prints and limited-edition reproductions; landscapes, seascapes, equestrian pictures, still lives . . . There is a concern with the accurate representation of what is considered 'common sense reality'. In more wealthy homes reproductions which are not signed limited editions are relatively rare or, at least, tend to be small and in low-prestige areas of the home. The possibility of having the same image as others is not welcomed. It seems that the homes of the less wealthy middle class are more likely to have reproductions of 'old masters' on the walls and originals by lesser-known artists – perhaps by friends and work colleagues. These differences appear to be associated with relative lack of finances and, perhaps, a less certain hold on the 'cultural model', rather than with significantly different aspirations.

In the Newcastle survey, contemporary art was confined to the homes of the fine-art sample, a finding which has been confirmed by subsequent observations. Contemporary art tends to be present in the homes of relatively few people – a sub-group of the middle class (Halle 1993: 164). Householders frequently have higher education in fine-art or related subjects, and/or occupations in some way connected to the world of contemporary art, the arts and related media. This group is characterized by members of the fine-art community itself – artists, teachers, critics, dealers, arts administrators . . . To feel at home with contemporary art seems to go with being socially close to it.

While valuing contemporary art includes the same concern with the facture of images applicable to traditionalism, it adds notions of experiment, inquiry, the embodiment of individual – and new – experiences and observations. This is prioritized over the representation of 'common sense' reality. Critically, it involves an interest in the formal qualities of images as distinct from what they might depict.

The division between traditionalist fine art and contemporary fine art is the source of much confusion in discussions of art audiences in which the term 'fine art', or simply 'art', is used without further qualification. It explains the often overlooked contradiction in the facts that art is popular with the middle class on the one hand, but that graduating fine-art students cannot find patrons for their work on the other.

Absences of Art

In working-class homes possessions are often not thought of as art at all. Indeed, many objects can be interpreted as shaped by a desire to avoid confusion with art. Many are functional and the majority of these pseudo-functional. The frequent combination of apparent utility with image resists conventional categorization (see

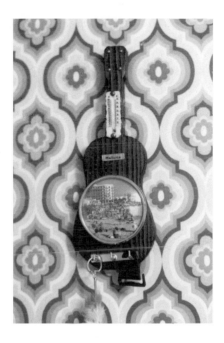

Figure 11.11 Guitar/thermometer/picture/key rack/souvenir.

Figure 11.11). The multi-faceted character of such objects rewards a preoccupation with fun, a pleasure in perceived unusualness. It is the *point* of such objects. The balance in the relationship between functional and utilitarian dimensions is crucial to both the humour and the flouting of convention. The choice of materials and imagery add to this.

Inherent in the denial that objects are part of the world of art is the denial that they have any significance beyond their immediate context. It can be interpreted as an active (though unarticulated) abstention. It is possible to detect a similar cultural ploy to Dada's 'anti-art' in many of the 'pseudo-functional' objects. Interestingly, there are also parallels in contemporary art in the work of such artists as Sarah Lucas and Hadrian Pigott (see Figure 11.12) but the ironies involved are those of art and the jokes are likely to be missed outside that world. At the same time, received notions of art as 'special' seem to be contradicted so that the objects are thought outrageous.

Where the uses of images exclude art, other meanings are prioritized. Images and objects often stand first for people, events and relationships. The use of words explicitly stating moral commitments in conjunction with images is frequent. (The low relief in Figure 11.13 also demonstrates an interesting incorporation of 'high-art' imagery.) Giving and receiving images as gifts is more common than in middle-class homes where fear of offending someone else's taste is greater. What

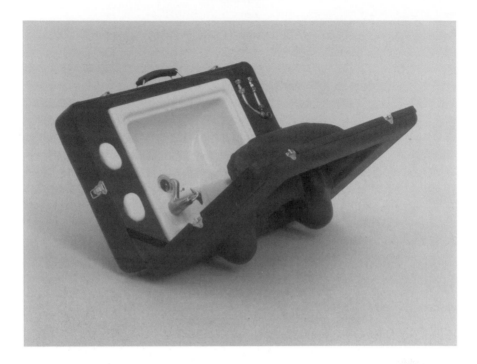

Figure 11.12 Hadrian Pigott, *Instrument of Hygiene (case 1)* , 1994 Fibre glass, leatherette covering, velvet lining, wash basin fittings 90cm × 50cm × 43cm (Saatchi Gallery) (Photo: Anthony Oliver).

is depicted tends to be more important than who made images or the qualities of their facture in terms of conventional media. Wide differences in stylistic conventions can, therefore, be tolerated, even celebrated. Concern with the ways things are made finds expression in a pleasure in things being 'different' – 'unusual'. (This is interestingly related to the priority given to 'originality' and 'the new' in the contemporary-art world and largely absent from middle-class homes.) Within great diversity, imagery from the world of art – old masters – can be present in reproduced forms, but rarely attended to as art or valued for their significances as art which might be unknown to the household. There is a high proportion of imaginary subjects in images. This culture of images is distinctive, even in its diversity, and is difficult to explain in terms of limited finances.

Absences of Contemporary Art

In the majority of both middle- and working-class homes there tends to be a shared dislike for, and suspicion of, contemporary art which offends notions of common sense and skill. The ultimate 'authority' of commentators and critics is accepted,

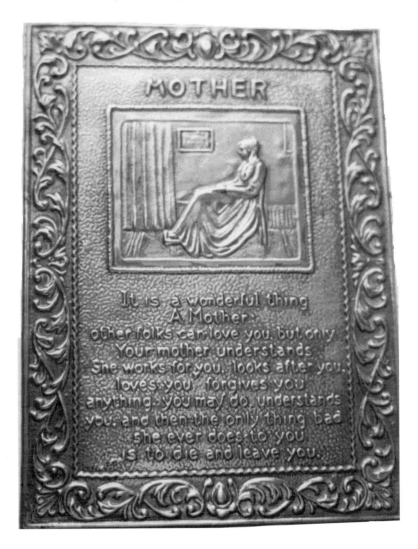

Figure 11.13 Brass low relief with poem.

but art is associated with beauty, specialness and skill which are perceived to be missing from contemporary art. Significantly, people not usually interested in contemporary art can be stirred to anger about it. Because art is associated with knowledge, with notions of good taste, discernment and 'cultivation', to delegate to experts the definition of today's art is implicitly to accept limitations in one's own taste and knowledge. Indignation is easily aroused when acquiescence appears to be ridiculed by apparently outrageous acts in the contemporary-art world which defy 'common sense'.

Implications

It must be stressed again that there is no intention to suggest that contemporary art should be limited in any way to the domestic sphere. Nor is there any suggestion that artists should be making objects that imitate those currently existing in people's homes. The questions are, can existing values and practices be extended to contribute to the fulfilment and definition of the needs for images that people manifest in their domestic lives? What steps might be necessary, and would they have such an adverse effect that they would be unacceptable? These questions are as much for the attention of curators, critics and other 'gatekeepers' as they are for artists. Reaching homes clearly has a lot to do with the nature of images, it also involves how they are made available to the public. This latter has two facets: the ways in which work is discussed and defined, and the ways in which it is made available for purchase. Both these are inseparable from the uses envisaged for images. In many respects, therefore, implications for contemporary art might be said to centre on how it is disseminated, rather than on the nature of the images themselves. However, this separation is unreal and it should be noted that existing factors associated with dissemination and marketing already impact upon the nature of imagery in the contemporary-art world.

Artists are not solely following their individual natures as creative beings (Wolff 1982). This is clear historically as evidenced by various forms of artist/patron/ client relationship (Baxendall 1980). Without historical distance today's constraints may not be so visible but they are real. The particular characteristics of the 'white box' art gallery, the demands of dealers and the processes by which artists can achieve exhibitions or commissions involve expectations which are directly related to the visual character of the work. There are the selective priorities of curators and critics as well as the peer-group pressures of other artists. Some constraints are simply financial and practical – the limitations of time, materials, the size of studio spaces and available transport. The choices facing artists, in terms of media, technologies and visual languages, are not entirely invented by them. They work within traditions. Traditions have shaped present options.

The real question for artists is not whether to accept external constraints, but which constraints to accept.

Toward Domestic Uses for Contemporary Art

There are a number of interconnected factors militating against contemporary art reaching more homes. They are so interdependent that it is difficult to isolate them in order to address them sequentially.

There is the prevailing rhetoric defining contemporary art as 'challenge' and 'disturbance'. There is the lingering negative attitude toward the domestic as a

potential site for art which is inseparable from negative attitudes toward most of the uses to which images are put there. There are widespread reservations about reproductions and mass-production which would help make work widely available at affordable prices. There is the fact that contemporary art is not made widely available in places that the general public frequent to buy things for their homes.

These factors will be discussed under the following headings:

Contemporary art as challenge
The home as context: attitudes to the ways in which images are used in the home

 Home decoration
 Depictions
 Fine art and functional objects

Production: Reproductions, Multiples, Mass-production
Distribution: the ways in which contemporary art is made available for sale.

Once again it is necessary to acknowledge the generalizations in the following discussion, which is concerned with circumstances that seem sufficiently prevalent to be influential. There are exceptions to the characterizations made.

Contemporary Art as Challenge

In the 1996/7 Annual Report of the Arts Council of England the then Chairman, Lord Gowrie, wrote that '. . . the arts are by nature oppositional'.

In the catalogue to the much publicized *Sensation* exhibition of 1997, Norman Rosenthal wrote 'It is natural and easy to fall in love with what is preconceived to be right and proper, good or beautiful . . . But the chief task of new art is to disturb that sense of comfort'. Later in the same piece he said, 'The art of our century has continually confronted its audience with a series of dislocations that are meant to be enjoyable and, in equal measure, to jolt us out of our complacency' (Adams et al. 1997: 8–11).

Such rhetoric obviously militates against the domestic as a potential context for contemporary art. The critical and challenging potential of art is crucially important, but it is worth examining the realities. What 'disturbs' and 'jolts' is a matter for each spectator – depending on what he or she is accustomed to as 'normality'. Few people enjoy being disturbed in ways they cannot accommodate. Those who enjoy this culture of challenge are not greatly threatened by it because they are used to it. They are familiar with the rules of the game. It is their normality. To paraphrase Rosenthal, they live in a world in which it is 'preconceived to be

right and proper, good or beautiful', to 'disturb' and 'jolt'. For them it is, therefore, 'natural and easy to fall in love with' it. In other words they feel at home with it.

Challenging developments (at least, those recognized as significant) stem from existing aspirations, and are meaningful in relation to the known. They have a foot in existing conventions and, to that extent, are confirmatory to those who know the context. The definition of art as exclusively 'challenging' is one-dimensional. Images are more complex and multivalent. An image can be both confirmatory *and* questioning in its intention and in its reception. In the latter regard, what the spectator brings is crucial.

Much of the 'disturbance' in contemporary art exists, not in relation to ideas about 'life', but in relation to norms within a tradition of fine art itself – questioning existing notions of what counts as art, modes of representation, the boundaries of artistic practices. Hence the problem of wider audiences can be construed as one of education. It is often said that you need knowledge of art before you can engage with it comfortably. While there is truth in this, it perpetuates a false 'specialness' for art. Knowledge is necessary for engagement with any cultural activity – football, dog-racing, gardening. Initially, at least, it is acquired through participation and contagion – from friends and relatives – not thought of as 'knowledge' at all. It is a learning experience that engenders identification. It often begins at home.

Perhaps the most important objection to the emphasis on 'opposition' and 'disturbance' is that it misdescribes the work of many artists with questions to ask, issues to raise, new perceptions and ideas to explore. To make critical observations, to add to the perceptions and thoughts of others, is not necessarily to set out to 'oppose' or 'disturb', though sometimes it might be. The political potential of image-making is inherent, but to identify contemporary art exclusively in oppositional terms is inadequate. (The extent of its effect in such terms can be measured by the willingness of successive governments to fund it.) A vocabulary of expression, debate, curiosity, experiment, revelation is more appropriate – and these characteristics need to be discussed in ways that connect them usefully with other aspects of life, many of which are positive and celebratory.

> To see art as a particular process in the general human process of creative discovery and communication is at once a redefinition of the status of art and the finding of a means to link it with our ordinary social life. (Williams 1980: 53)

While the experiments of research scientists are not widely comprehended, they have a more productive relationship to life on the street. Correctly or otherwise they are regarded as extensions of daily attempts to survive in the world, a belief which engenders a relatively informed public critique. To achieve this for contemporary art, it would be necessary to see the experimental 'cutting edge' as an essential part of a continuum of activities extending to being useful and

available within the daily round – participating in the rituals of life and death from which, for most people, it is currently more or less absent. Examples of some movement in this direction are Sarah Lucas's birthday cakes, Yvonne Crossley's exhibition *Marking Times* at the Picker Gallery, Kingston upon Thames in 2001 and, in the same year, Welfare State International's exhibition *Dead* at the Roundhouse, London, both of which consisted of funereal artefacts – though most of these, for various reasons are unlikely to have wide influence (see Figure 11.14).

Continuities would be enhanced if it were more common for critics and curators to address wider uses of images, those currently excluded from definitions of contemporary art, contributing to the elaboration of appropriate critical frameworks and languages. This might extend to addressing visual imagery currently fulfilling these uses. It would not necessarily be to offer endorsement but it would involve forging persuasive critical arguments rather than dismissal by omission or assertion. The worlds of fashion and theatre enjoy this kind of continuity. The extremes of the cat-walk are seen as an extension of the high-street clothing world, both discussed with seriousness by the same critics. Both experimental theatre and,

Figure 11.14 Yvonne Crossley, *Family Life* 1998–99 Mixed Media 65cm × 55cm × 15cm (Photo: Laurel Guilfoyle).

for example, *Guys and Dolls* are included in the National Theatre programme, discussed by the same theatre critics, handled by the same directors, designers, and actors. Visual art criticism continues to confine itself to the terrain of high culture and associated venues, ignoring other kinds of imagery and, along with them, the interests of many people.

An effect of the exaggerated emphasis on challenge, opposition and disturbance as the defining characteristics of contemporary art is that work being produced which does not generate controversy is excluded from recognition as the art of our time. The aspirations of generations of fine-art students are affected accordingly.

The Home as Context: Attitudes to the Ways in which Images are Used in the Home

As noted in the Introduction to this volume, modernism defined itself in contrast to the domestic (Reed 1996) and that ideology continues to permeate the ways in which the contemporary-art world operates. It was also observed that, while there are plenty of examples of artists addressing the home as subject matter and using domestic interiors as temporary gallery spaces, this is very different from attempting to have work find a lasting place in the domestic context.

Members of the professional fine-art community can be said to lead double lives. They have one set of relationships with images at work and another in their homes. In their professional existences, images tend to be specimens of their kind, isolated for scrutiny. In their homes, as in other homes, images are integrated with lives and combine their identities as works of art with a variety of other roles – as souvenirs, gifts from other artists, records of places and events, contributions to the look and identity of the interior. In a sense, no more than a reconciliation between these double lives is called for in this chapter.

It is a complex situation. Most artists do not have a problem with the possibility that their work might *happen* to end up in homes. Much work sold in galleries does find a place in the homes of collectors. Work sold in that way usually goes to homes that will display it respectfully as 'art'. Indeed, such interior displays are the subject of attention in up-market style-oriented publications (Ellis et al. 1999). There are plenty of examples of group exhibitions (often seasonal) of small works aimed specifically at persuading people to buy for their homes. But such exhibitions are almost studio clearance sales: relaxed affairs for which serious ideological commitments are suspended as are differences in status among artists. These exhibitions also tend to reach initiates. Work sold in the general market place is likely to end up where 'art values' do not apply. This brings an unpredictability of use which is not always welcomed.

There is a long history of works of art being made for and used in the home (Gombrich 1999). Many of these works are now in great museum collections and are by artists well regarded in the contemporary-art world's perspective on art history. Of course these homes were often grand mansions or palaces (see Hearn et al.1998) and, within the lofty context of 'architecture' and, particularly, via commissions, the home is not much problematized today. It is the 'ordinary' home, hardly graced with the status of 'architecture', perhaps typified by notions of 'suburbia', which is undervalued. Commissions here are rare.

The *At Home With Art* project was an indication of the willingness of contemporary artists to explore the potential of the ordinary home if the circumstances of the commission were right. But such unusual commissions are very different from the day-to-day studio situation where, particularly for unestablished artists, work is largely created independently of the process of selling it. In the studio the destination of work may not be consciously considered. Indeed, the modernist inheritance is that such a consideration is an impurity and that artists should simply be pursuing their own preoccupations (Gablik 1987: 23). However, the underlying assumption is that the work will operate, in a general sense, within the values of the contemporary-art world context with all that that implies. As already stated, this affects the nature of the work itself. It is formed within an anti-domestic ideology.

Home Decoration

This wallpaper has a kind of subpattern in a different shade, a particularly irritating one, for you can only see it in certain lights, and not clearly then. But in the places where it isn't faded and where the sun is just so – I can see a strange, provoking, formless sort of figure, that seems to skulk about behind that silly and conspicuous front design.

There's sister on the stairs!

Charlotte Perkins Gilman *The Yellow Wallpaper* (Shulman 1998: 8)

Part of the marginalization of the domestic is a negative attitude toward the use of images in schemes of decoration. To say 'I wouldn't hang that on my living room wall' is thought to resonate of Philistinism. Close to this is an implicit rejection of 'the decorative' as, in itself, trivial. This might be a reasonable judgement of particular manifestations of decoration, but not in any implication that the 'decorative' is inherently trivial in its effects. The power of surfaces, in wallpapers – the most maligned of domestic phenomena – and fabrics, for example, should not be underestimated – particularly when coupled with their constant presence in the home. They provide material for the projection and recognition of constella-

tions charged with personal correspondences and meanings. Certainly not trivial and not, perhaps, adequately encapsulated by the term 'decorative'.

Depictions

> All art depends upon cutting off the practical responses to sensations of ordinary life, thereby setting free a pure and as it were disembodied functioning of the spirit . . .
>
> Roger Fry (Bullen 1981: 169).

While many people have images in their homes primarily because of what they depict, there is a continuing tendency in the contemporary-art world to relegate this to, at best, secondary importance. Put crudely, to like a picture of a horse because you are interested in horses tends to be treated as a form of Philistinism. But, while an image may not be a good work of art because it depicts a worthy subject, it does not follow that an interest in subject matter is vacuous. To like pictures of horses is not to like *any* picture of a horse. It is not to completely abandon critical judgement.

It currently amounts to a professional indiscretion for an artist to depict things that people like because people like them. (Though in the context of commissions and competitions this is less clear.) Within an ideology that celebrates artistic freedom this is strange, but there is no suggestion here that artists should, necessarily, take that road. It is, rather, that subject matter might be given a higher priority in the categorization of work, critical discussion, and curatorial practice.

The diminution of the importance of what is depicted in art is the product of the relatively recent emphasis on the formal characteristics of works of art as the location of their real value and significance. Ultimately, any content for a work of art beyond its own physical and formal characteristics was denied (Greenberg 1964: 100). Such ideas are influential, in a generalized and unfocused way, well after their logical realization has lost its dominance. It is obvious that many contemporary artists are intensely preoccupied with subject matter 'in the world'. Yet there lingers, perhaps as a matter of cultural 'style', a reluctance to give this aspect prominent status in the critical discourse surrounding the work. 'When you see art historians on the telly they often just talk about the formal things – but I don't see what else there is to talk about really,' says Richard Billingham (2001), Turner Prize nominee in 2001, whose images of his family are powerful observations of life and whose recent work includes observations of landscape.

To prioritize the formal characteristics of images or the things (physical, psychological, imaginary) to which we might take them to allude involves shifts in mode of attention. The resultant change in experience is itself of interest. The

fact that the a Jenny Saville or a Lucian Freud can be flesh *or* paint depending on our mode of attention, is surely one of the fascinations of looking at paintings. To deny either (as well as other possibilities) is grossly reductive.

Attention, in the critical discussion of images, to what they might be saying about life beyond art and whether or not it is worth saying, invites participation by people whose first interest may not be art. Emphasis on subject matter in the curation of exhibitions helps to engage particular audiences through their interests in life beyond notions of art. Such exhibitions also allow the bringing together of artists who work in different ways, complementing the more prevalent model of grouping artists by 'isms', media, mode of practice or shared intellectual concerns beyond the subject. The Hayward Gallery's *Spectacular Bodies* exhibition of 2000 was an example, taking a subject of wide interest – the human anatomy – and cutting across time and idioms in presenting the work of artists around that theme. Though concerned with a less tangible subject, Richard Wentworth's exhibition *Thinking Aloud* can be seen in a similar light (see Wentworth 1998).

Despite the apparent freedom associated with contemporary art, certain subjects are noticeably under-represented. Perhaps significantly, these subjects seem to be those most celebrated in the worlds of traditionalist art and the 'art and framing industry' – subjects that do find their ways into homes because of widespread interest in them. It is one of the characteristics of the contemporary-art world to strain to be where everyone else is not.

Fine Art and Functional Objects

'All art is quite useless.' Oscar Wilde, Preface to *The Picture of Dorian Grey*

(Lawler 1988: 4)

In many homes images are combined with functional objects and not distinguished in status from those that stand or hang independently. But it is in its distinction from utilitarian purposes that fine art most clearly defines itself . The belief is that fine art deals exclusively with intellectual and metaphysical matters which, incidentally, are often identified in the contemporary-art world with notions of challenge already discussed. By contrast, functional objects are assumed to be unable or, at least, less able to do so. This is associated with the intellectual separation between fine art and craft. In current practice the distinction between fine art and the decorative arts, crafts or design is applied with very vague criteria that can extend to prejudices connected with particular media (Becker1982: 359). Artists who work in certain materials associated with craft and function (glass, ceramics, textiles, for example) can have difficulty in gaining recognition within the fine-art terrain. Making work available in ways that target the home as potential context

can also result in work being categorized as craft or design rather than as fine-art.

While major art museums sell mugs and paperweights with reproductions of art on them, many in the contemporary-art world would argue that it trivializes an artist's work to appear on mundane domestic objects. In many such cases – with the work of old masters, for example – the artist had no role in the decisions involved in incorporating the work. It has been 'added' – often with limited concern for the resultant 'whole'. Cropping of works in such accommodations has been common. The quality of the reproductions is often poor. However, in principle, and given that concerns with quality should be rigorous, it is difficult to see why contemporary artists should not be involved in the application of their work to functional objects and – perhaps more clearly – in the application of their ideas and skills to the production of functional objects, a process which should involve them from conception to finished product. The *At Home With Art* project showed that contemporary artists are willing to be involved in the production of functional items through industrial methods of production.

There would seem to be no reason why the sculptural qualities of utilitarian objects, while sometimes limited by the demands of their utility, should not be rewarding in the same ways as 'pure' sculpture. As I asked in the catalogue to the *At Home With Art* exhibition, is Alison Wilding's ceramic sculpture (see Plate 36) less rewarding of attention because it *might* be used as a bowl? Is Permindar Kaur's imagery less significant simply because its 180cm x 180cm surface is a shower curtain? (see Plate 24) The curtain contains imagery extending themes explored in her previous work exhibited as fine art. Why should the imagery on utilitarian objects – or the objects themselves – not be rigorous or questioning, even disturbing? The case of objects such as fire screens and calendars, where functional dimensions hardly disrupt the image at all, make the question particularly acute. The briefest visit to the Victoria and Albert Museum demonstrates that the imagery of the so-called 'decorative arts' can be deeply moving in ways that are indistinguishable from experiences of fine-art objects. Such a visit also demonstrates how permeable the boundaries are.

Production: Reproductions, Multiples, Mass-production

It helps images to reach large numbers of people if they are available in large quantities. This is also accompanied by lower prices. But, while the multiple and the limited-edition print are widely accepted in the contemporary-art world, attitudes toward mass-production and reproduction are, to say the least, as mixed as are the reasons underlying them.

Mass-produced reproductions of paintings exemplify the issues. Given the current state of technology, their limitations are clear. However, photographic

reproductions are indispensable to professional and scholarly art activity. Few artists can sustain a professional life without them. Also, it is through reproduction in journals, exhibition catalogues and books that artists hope to widen and enhance their reputations. They are essential to academic exchange and debate. They provide evidence of the enormous quantity of art around the globe that is impossible to experience in any lifetime. In all of this the limitations of photographic reproductions are accepted. Yet there are antipathies toward the idea of reproductions to hang on the wall – as in domestic contexts – and relatively few painters in the contemporary art world see mass-produced reproductions as a positive extension of their professional activities.

It is reasonable to ask why willingness to accept the shortcomings of reproductions in the professional world should not be extended to their wider use. It is also reasonable to ask why higher priority should not be given to the acceleration of the development of the necessary technologies to achieve better and better mechanical reproductions. This is apparently left to the 'art and framing industry' when it could be the sort of research that the Arts Councils might fund in pursuance of their commitment to widening access. It seems that the inaccuracy of reproductions is not the real problem. Other reservations, perhaps largely unexamined, seem to be at play, perhaps related to the domestic, to notions of uniqueness, status and markets.

Negative attitudes toward reproductions extend to the idea that their proliferation damages the encounter with the original. It is true that previous experience influences perception, but the evolution of sound-recording technology was fortunately not stemmed on the grounds that the limitations and proliferation of recordings might undermine the experience of live music. The important truth is, surely, that despite the limitations of reproductions, something of the originals persists in them and is made available to people – often to those who might never experience the originals. This is as true for specialists in art as for anyone else.

The proliferation of mass-produced reproductions need not imply a change in the status of originals. If anything, experience shows that the 'aura' of an original, as Benjamin (1992 [1936]) termed it, appears to be enhanced through reputation acquired via reproduction (Painter 1996). Many artists are able to combine the making and selling of original paintings with the widening of their reputations through reproductions of their work, but most operate outside the contemporary-art world. In the words of the painter Clive Madgewick, who operates within the 'art and framing industry',

> My work is all over the world because it has been successful in reproduction. I know a lot of people in the art establishment frown upon that sort of thing. It's thought to be 'commercial'. But I'm happy with it. The reproductions are good advertising for my original works which are my main practice (Painter 1998: 70–1).

Multiples, which have respectability in the art world, are not 'reproductions' but objects conceived for repeated production. The concept and availability of multiples remains predominantly within the art world which limits the range of their effect. Also, though much cheaper than originals, they tend to remain beyond many pockets. This is because they are usually associated with limited editions. The idea of a multiple in an unlimited edition puts the concept under pressure. In the *At Home With Art* project, for example, the objects were conceived for mass-production in unlimited editions. Some were functional objects, some were not. While they were often referred to as multiples, it was difficult to see how that title distinguished Anish Kapoor's lamp from all the other mass-produced lamps in Homebase. Does an object have to be 'non-functional' to be a multiple? In which case, how do we distinguish Angela Bulloch's sound piece, in principle, from all other mass-produced wind chimes? Perhaps a multiple has to be produced by someone regarded as an artist? In which case is it not simply a way of implying 'specialness'? Who awards the status of 'artist'?

The 'artist's print' is a form of 'multiple', commonly produced in limited editions. The limitation of the print run is often said to ensure quality because there are only so many good prints that can be made from certain processes. Some processes are also very time-consuming. But the limited edition also ensures relative scarcity which, itself, attracts higher prices. It is possible to make artists' prints available in large quantities. An example of this was the School Prints scheme which, shortly after the Second World War, commissioned artists to produce original lithographs, printed in large numbers and sold cheaply to schools. Moore, Picasso and Matisse were among the artists who participated in the scheme.

The *At Home With Art* project showed that the requirements of mass-production are not intrinsically incompatible with the creative processes of contemporary artists. This is, perhaps, particularly so in the area of sculpture where facilities for reproducing work through casting techniques has a long history (Hughes and Ranfft 1997: 1). Since there is no 'original', mass- produced works are not 'second-best' – except to those whose pleasure in the encounter with an image rests, not in its visual characteristics, but in the knowledge of its rarity. So well established are such attitudes that some members of the general public thought that the *At Home With Art* objects could not, by definition, be art because they were mass-produced. Similarly, their status as 'art' was doubted because they were so inexpensive.

Distribution: The Ways in which Contemporary Art is made available for sale

Although there are interesting and welcome changes, such as the use of websites, contemporary art is mainly made available for sale through galleries which, though

basically shops, present themselves in a very specific way which is foreign to most shoppers. To the uninitiated it is not obvious that the visitor is welcome. The fact that the objects there are for sale is often not forefronted – an expression of a long standing and continuing ideological separation between art and the 'vulgarities' of commerce. The remoteness of such galleries is essential to the economic culture within which the work operates and is partly related to the security necessary to the handling of valuable goods.

To connect with uses for images in a wider range of homes, the work of contemporary artists has to be available where the general public goes to buy things for the home – including the garden. In such locations, unambiguously shops, where the conventions of the market are widely understood and objects are clearly priced, there is an increased possibility that images can be encountered by accident as well as by intent. Gift shops, souvenir shops, DIY stores, furniture stores, garden centres . . . At present these outlets are dominated by other image-makers.

Since the ways images are made available for sale mirror the priorities of purchasers, to show them outside galleries is to accept, if not celebrate, that they might be used and understood in ways that do not give first priority to prevailing notions of contemporary art. But, whatever reasons people have for purchasing images, they are ways into lives. We do not have to go all the way with Barthes (1977: 148) in the view that 'The birth of the reader must be at the cost of the death of the author', to know that, even within contemporary art galleries, many meanings are given to images that were not intended or imagined by their makers. But the fact that an image is performing roles as a gift, or as furniture, does not prevent it from having other effects perhaps more respected by the artist. Indeed, it is a way of giving it the opportunity to do so.

It is indicative of the real degree of popularity (unpopularity?) that contemporary art enjoys that it is not easy for artists to persuade mainstream retailers to stock their work. It is even more difficult to find manufacturers prepared to put up the money to mass-produce it. This is harder for artists without established reputations and no existing selling power. Perhaps the Arts Councils could assist in kick-starting exploratory projects on the *At Home With Art* model but on a more modest scale.

For artists, a willingness to explore alternative outlets might involve considering certain physical aspects of the work to be made available in this way – for example its scale and the demands of manufacturing processes necessary to production at low prices. It would also involve a shift in current custom and practice since the prestige of the venues in which artists exhibit are part of their professional 'track records'. It is common for artists to control carefully where they show their work and in what company. For many within those sectors of the public which prioritize 'art', there is the belief that where an image is displayed, and at what price, is

indicative of whether or not it actually is 'art'. This reflects the fact that, for most people, art is defined elsewhere.

References

Adams, B., Jardine, L., Maloney, M., Rosenthal, N. and Shone, R. (eds) (1997) *Sensation: Young British Artists from the Saatchi Collection*. London: Royal Academy of Arts in association with Thames and Hudson.

Barthes R. (1977) 'The death of the author', in *Image, Music, Text*, London: Fontana.

Baxendall, M. (1980) *Painting and Experience in Fifteenth Century Italy*. Oxford: Oxford University Press.

Becker, H. (1982) *Art Worlds*. London: University of California Press.

Benjamin, W. (1992 [1936]) 'The work of art in the age of mechanical reproduction', in *Illuminations*. E. Arendt (ed.) London: Fontana.

Billingham, R. (2001) 'The Turner Prize 2001', in *Tate, The Art Magazine,* No. 27, Winter 2001, 23.

Bourdieu, P. (1984) *Distinction*. London: Routledge & Kegan Paul.

Braden, S. (1978) *Artists and People*. London: Routledge & Kegan Paul.

Brighton, A. and Morris, L. (1977) *Towards Another Picture*. Nottingham: Midland Group.

Brunius, T. (1963) 'The uses of a work of art', *Journal of Aesthetics and Art Criticism*, XXII(2).

Bullen, J.B. (ed.) (1981) *Roger Fry, Vision and Design*. Oxford: Oxford University Press.

Button, V. (1999) *The Turner Prize*. London:Tate Gallery Publishing, 15.

Collings, M. (2001) *Art Crazy Nation*. London: 21 Publishing Ltd.

Csikszentmihalyi, M. and Rochberg-Halton, E. (1981) *The Meaning of Things*. Cambridge: Cambridge University Press.

Daley, J. (1998) 'Cuts in the Arts Budget? Let's Blame Mrs Thatcher', *Daily Telegraph,* 27 January.

DiMaggio, P. and Useem, M. (1978) 'Social Class and Arts Consumption', *Theory and Society',* 5(1) 141–61.

DiMaggio, P. and Useem, M. (1982) 'The Arts in Class Reproduction', in M.W. Apple (ed.) *Cultural and Economic Reproduction in Education*. London: Routledge & Kegan Paul.

Ellis, E., Seebohm, C. and Sykes, C.S. (1999) *At Home With Art : How art Lovers Live with and Care for their Collections*. London: Thames and Hudson.

Emin, T. (2000) 'I need art like I need God', in W. Furlong, P. Gould and P. Hetherington (eds) *The Dynamics of Now*. London: Wimbledon School of Art in association with Tate Gallery Publishing. 102–6.

Gablik, S. (1987) *Has Modernism Failed?* London: Thames and Hudson.

Gombrich, E. (1999) *The Uses of Images.* London: Phaidon.

Greenberg, C. (1964) 'Avant Garde and Kitsch', in B. Rosenberg and D.M. White (eds), *Mass Culture: The Popular Arts in America.* New York: New York Free Press.

Greene, D.A. (ed.) (1996) *Art and the Home.* Art and Design Profile No. 51. London: Academy Group.

Halle, D. (1993) *Inside Culture, Art and Class in the American Home.* Chicago: University of Chicago Press.

Hearn, K., Upstone, R. and Waterfield, G. (1998) *In Celebration: The Art of the Country House.* London: Tate Gallery Publishing.

Hughes, A. and Ranfft, E. (eds) (1997) *Sculpture and Its Reproductions.* London: Reaktion.

Lawler, D.L. (ed.) (1988) *The Picture of Dorian Gray.* New York: W.W. Norton.

Miller, D. (2001) *Home Possessions.* Oxford: Berg.

Painter, C. (1980) 'The absent public: a report on a pilot survey of objects hanging on walls in Newcastle upon Tyne', *Art Monthly*, 39.

Painter, C. (1982) 'The Uses of Art', *Aspects, A Journal of Contemporary Art,* 18, Spring.

Painter, C. (1986) 'The Uses of Art'. Unpublished PhD thesis, Newcastle upon Tyne Polytechnic (now University of Northumbria).

Painter, C. (1996) *At Home With Constable's Cornfield.* London: National Gallery Publications.

Painter, C. (1998) *The Uses of An Artist: Constable in Constable Country Now.* Ipswich: Ipswich Borough Council Museums.

Painter, C. (1999) *At Home With Art.* London: Hayward Gallery Publishing.

Painter, C. (2001) *Close Encounters of the Art Kind,* London: Victoria & Albert Museum.

Reed, C. (ed.) (1996) *Not at Home: The Suppression of Domesticity in Modern Art and Architecture.* London: Thames and Hudson.

Shulman, R. (1998) *The Yellow Wall-paper and Other Stories.* Oxford: Oxford University Press.

Walker, J.A. (1983) *Art in the Age of Mass Media.* London: Pluto.

Wentworth, R. (1998) *Thinking Aloud.* London: Hayward Gallery Publishing.

Williams, R. (1980) *The Long Revolution.* Harmondsworth: Penguin.

Wolff, J. (1982) *The Social Production of Art.* London: Macmillan.

Avant-Garde and Kitsch Revisited
Andrew Brighton

Popular Art, Modern Art and Cultural Policy Post-Cold War

> Where today a political regime establishes an official cultural policy, it is for the sake of demagogy. (Greenberg 1988 [1939])

Modern Art has been the official art of the North Atlantic democracies since the end of the Second World War in 1945. Evidence for this is easy to find. Look at the artists chosen by their governments for exhibition in the National Pavilions at the Venice Biennale. Go on to look at the predominant character of the art bought and given exhibitions by the museums and galleries of modern art that get some degree of public assistance in the West. However, this kind of art was not popular with the majority of the populations of countries from which they came. Often the opposite. Furthermore, if you also look at the character of the work, at the values it celebrated or denigrated, they were hardly in line with the conventional morality and values otherwise promoted by these states. The work did not overtly propagate the specific or general politics of the governments of these states. Indeed, this state-sponsored art came under attack from a number of powerful politicians.

In the period of the cold war serious art, art exhibiting relative autonomy and criticality, served an ideological purpose. It was an advertisement for Western liberty. The apparent arm's-length distance between governments and the cultural institutions they supported was a model of plural democracy as against the totalitarian homogeneity of the Soviet Union and Soviet Socialist Realism. Political attacks could be seen off by Western cultural bureaucracies on the grounds that the point was to win the hearts and minds of intellectuals, people working in the media, academics and the like. The American genius for what was then called 'mass culture' served the wider populous. If modernism then was the official art of the NATO countries, what has changed and what is the future of the relationship between art and the state with the departure of the external threat that created NATO, the Soviet Union?

With the end of the cold war, the tension between modern high culture and the state is in a new terrain. It is a complex geography, constituted by a number of

elements. Externally, the new threats to the West's hegemony are not coming from states run by modern technocrats, bureaucrats and other professional apparatchiks who claimed not only to be modern but also to be the future. The new enemies have little call upon Western intellectuals. It is tension internally between cultural and political elites. At its most concrete and intellectually trivial it is argument about levels of expenditure on culture. In Britain that is the level at which the argument tends to remain – i.e., the arts always want more. However, now that autonomy is no longer the required characteristic, the issue widens out. What should be the character and degree of political control over arts expenditure? Further, how should this expenditure relate to overall and related government social and educational policies? This raises questions as to what is it that certain kinds of cultural activities do that makes them deserving of subsidy? In current political discourse, these questions cannot be addressed directly, but they can be addressed indirectly by asserting answers. The art can serve the social and economic goals of the government because:

- art is good for people, so everyone must have it in their lives, particularly those who are 'excluded' from mainstreams of society
- the arts are part of the cultural industries that make a major contribution to the exchequer and employment.

These answers beg questions about the character of the art supported. Are there kinds of art that are not good for you; if so, should it be given public subsidy? What about the kinds of art that do not obviously contribute to the cultural industries? I want to address the former question. It raises broader issues about what is good and what is bad culture. It is within culture that social morality is propagated and it is within culture that the terms of political legitimacy are established. Daniel Bell is just one of a number of American right-wing thinkers who have argued that modern art is the enemy of social morality and of conventional democratic legitimacy.

Modern Art

> It is no accident, therefore, that the birth of the avant-garde coincided chronologically – and geographically, too – with the first bold developments of scientific revolutionary thought in Europe. (Greenberg 1988 [1939])

A new fact known in Europe and the United States for some time has entered the public discourse on art and culture in Britain. Modern art, the tradition of the avant-garde art of the last century, has a substantial if minority audience. The 5.2 million

visits to Tate Modern in its first year stamped this fact into the public mind. However, it should be said that Tate Modern's attendance figures will probably settle down to between one and two million a year. Further, the social profile of these 5.2 million was much the same as is normal for attending cultural venues. They were ABC1s in marketing jargon. They were people who have had education after leaving school. They were skilled and professional workers. In other words, while there are more middle-class people interested in modern and contemporary art in Britain than there used to be, there has not been a breakthrough to classless consumption of modern art. However, the fact of this substantial audience has ramifications and needs discussion.

If the avant-garde has triumphed, what is the citadel it has overcome, what army follows in the wake of this vanguard? How real and complete is this triumph, or does the avant-garde metaphor misconceive the critical nature of art? Some part of the answer to these questions has to propose an understanding of the social origins of the avant-garde. The *inteligiencja* was that stratum of nineteenth-century Russian society, small in number, who were educated but were not integrated into the apparatus of the state. They were without, or denied, the formal power and status their education qualified them to hold. Their education equipped them to criticize the state and society. The professions and the informal political economy of culture gave them terrains within which to gain some power and status. Their ultimate impact was enormous. For much of the twentieth century, huge numbers of people were ruled by 'vanguard' parties constituted of professional revolutionaries schooled in a particular discourse: Marxist-Leninism, a discourse that attributed to them a crucial role in history.

In an educated, knowledge-based economy in which aesthetics rather than need determine a rising number of decisions, a new form of life has come into existence: the life of a mass intelligentsia. The social history of the modern movement in the arts is the history of this form of life, this class culture. It is imbedded in the rise in number and power of a professional class, the class for whom cultural capital is the source of income and status and for whom criticality, reflexivity is a virtue. There is some ideological continuity with *inteligiencja*. Modern and contemporary art are predominantly erosive of tradition and conventional religious faith; they have tended to refuse moral certainties, to celebrate the sexually libertine and to hold the domestic in contempt.

Populism and Anti-Modernism

The encouragement of kitsch is merely another of the inexpensive ways in which totalitarian regimes seek to ingratiate themselves with their subjects. (Greenberg 1988 [1939])

Populism denies the condition of modernity. It hankers for a state of society in which people know by experience, they make their world directly. In such a society, expertise and complex systems would disappear. One of the ingredients in populism is nostalgia. In its Greek origin, nostalgia meant a longing for home and still carries that echo; the desire for the familiar, the habitual and the domestic. Nostalgia can be dangerous. Cultural and social nostalgia has some nasty precedents and potentialities. It tends to establish certain people, ways of life and culture as pleasing, honest, sincere, normal, natural and the opposition as offensive, dishonest, insincere, abnormal and unnatural.

There is ideological continuity in the opposition to the art of the intelligentsia. We can find it in Tolstoy's *What is Art?* (1969[1898]) as well as in the disreputable harangues of Stalinist apparatchik Zhadanov (1950). Herschell B. Chipp describes the art shown in the *Haus der Deutschen Kunst* in 1937 as typified by 'themes of heroism, familial duty, and work on the land'. In his speech opening the building, Adolf Hitler appealed to 'natural concepts about the nature and scope of art'. Because he based his politics and aesthetics on race, Hitler opposed 'so-called "modern art"' as being based on period. 'National-Socialist Germany, however, wants again a "German Art", and this art shall and will be of eternal value, as are all truly creative values of a people.' He goes on to say that to be German is to be clear, logical, and above all to be true and speak of a 'deep inner longing for such a true German art which carries within it the traits of this law of clarity'. '"Works of art" which cannot be understood in themselves from now on will no longer find their way to the German people' (Chipp 1971). Populist opposition of a far less repellent nature to some forms of modern art and the institutions and language that have supported them has not gone away. In the United States the history of Robert Maplethorpe and National Endowment of the Arts through to New York Mayor Giuliani's condemnation of the showing by the Brooklyn Museum of the *Sensation* exhibition are more recent examples, both of which were argued as defences of ordinary people's beliefs and values.

There is a populism and a concomitant nostalgia in Communitarian visions of the New Labour government that came to power in Britain in 1997. The affective resonance of 'a cohesive society' and 'the community' speaks to the same areas of feeling. They suggest that society should be like a family with the state enjoying the same uncritical loyalties and affections as beloved parents, or a village with its organic hierarchy. Hostility to culture that is not self-evident is also part of New Labour rhetoric. In the words of Gerry Robinson, whom New Labour appointed chairman of the Arts Council for England:

> Too often in the past, the arts have taken a patronising attitude to audiences. Too often artists and performers have continued to ply their trade to the same white, middle-class audience. In the back of their minds lurks the vague hope that one day enlightenment

might descend semi-miraculously upon the rest, that the masses might get wise to their brilliance. (Robinson 1998)

'Inclusivity', 'a cohesive society' and 'the community' – these phrases and the emotions they incite are the sentimental glue of current British government rhetoric. They are, strictly speaking, totalitarian concepts because they do imply a vision of total social integration. They have wider and now international purchase. They provide 'the vision thing' for the British government at home and abroad. They were the terms deployed by Tony Blair in the post-11 September 2001 call to war. They acquire a steely glint as the external and internal enemies of the Western democracies are redefined. These terms are not only sentimental glue. They have been for the Blair government the determining concepts of social and economic policy, and in particular of cultural policy. 'The Arts are central to the task of recreating the sense of community, identity and civic pride that should define our country', wrote Tony Blair in the 1997 Labour Party election manifesto (Blair 1997).

Serious Art

> True the first settlers of bohemia – which was then identical with the avant-garde – turned out soon to be demonstrably uninterested in politics. Nevertheless, without the circulation of revolutionary ideas in the air about them, they would never have been able to isolate their concept of "bourgeois" in order to define what they were *not*. (Greenberg 1988 [1939])

Anxiety and uncertainty are two of the primary pleasures and virtues of serious art in modern culture. Indeed, 'serious' is used here to demark art that elaborates itself beyond the familiar. It asks us to give value to something which offers no prior guarantee in, for example, morality or aesthetics or social utility. If anything, it erodes community and identity, and casts doubt upon civic pride. Serious art as a practice does, however, have social value. It does serve a public good. Its value is its criticality. However, the criticality of serious art is not the criticality of, for instance, social critique or of adverse judgements, although these may occur. Its criticality lies in its own critical condition. It thrives on crises, on the risk of vacuity. It risks being worthless.

The fundamental and largely ignored characteristic of the modern conditions of production for art is plurality. With the growth of a heterodox market in the mid-nineteenth century, Baudelaire bemoaned the decline of the state-supported Academies. Each artist had only the smallholdings of his or her talent to cultivate, rather than the wide landscapes of culture. What Baudelaire and others foresaw was the end of a culture of serious art: that institutionalized community of theory

and practice that was aware of art's past, that argued about what was consequential and inconsequential, that had the power to choose, collect and preserve what was of continuing value. The erosion of the academies by the rise of the middle-class art-buying audience and the growing status and influence of independent dealers and their artists threatened a dictatorship of banality: a trivial plurality limited by the tastes of an inexpert buying public. Art would become incapable of seriousness, incapable of elaborating itself beyond common sentimental life, knowledge and ideas.

What continued to concern observers from Matthew Arnold through to Greenberg was how serious art could be viable in a modern economy. They feared the consequence of the rise of the vulgar rich. In a way they were right – the academies did decline into exhibiting societies for supplying work to the plutocracy. However, what they failed to note was how modern economies inflated the value of knowledge and the way art was for some the very essence of the new cultural capital; art appeared autonomous, self-critical and self-aware. What was invisible to them was the massive expansion of their own strata, the professional classes: that class for whom high-status knowledge is the source of their income, power and status. They did not foresee that the largely artisan activity of art would increasingly be invaded by the educated, some with private incomes who could make the dependency on the plutocracy a very loose rein. They underestimated the consequence of a pioneering minority of the growing professional classes who were knowledgeable collectors of ambitious and demanding contemporary art. Above all, they did not grasp that some dealers would market art for its claim to seriousness rather than its popularity. Museums of art and academe widened and pluralized the institutional base of this alliance between serious collectors and gallerists in the twentieth century. Those museums massively expanded and took into the public realm the physical and discursive spaces in which judgements of value were perpetuated. The cultural pessimists did not foresee, in other words, the economic, class and institutional relations that sustain serious art in a modern economy.

Serious art's criticality is then both economic and ideological. What sustains its specific character and social value is its political economy. The serious artworld is at core an argument about value. It is an argument about aesthetic, moral, social and political or whatever value but it is also, and indissolubly, an argument about financial value. In particular, it is an argument about future value. In other words, the art market as a form of investment is at the core of what constitutes art as a public good. In argument about works of art made or enacted through exhibitions, books, articles, television programmes, in private conversations or what have you, we argue about the value of works of art and about what values can give works of art value. Serious art is a terrain of contesting values.

The unspoken history of modern art as recorded in museums, art-history books and courses and the whole apparatus of art's cultural memory is a history of a

particular part of the art market. Virtually all artists working since the 1880s represented in major museums and collections worked with commercial galleries. Further, most of them were given their first consequential exhibition by a commercial gallery. It is gallerists who propose artists for serious consideration; it is collectors, curators and critics, in that order of importance, who refuse or confirm their nominations.

But what about the other parts of the market in art made in our time? How is the market for serious art different from other parts of the art market? With what kinds of artist and art do they deal?

A Short Artworld Ethnology

> One and the same civilization produces simultaneously two such different things as a poem by T.S. Eliot and a Tin Pan Alley song, or a painting by Braque and a *Saturday Evening Post* cover. (Greenberg 1988 [1939])

In the mid-1960s, I had an epiphany. How an epiphany? If the larger but invisible structures of culture do determine our lives, they are like the gods. I glimpsed these gods when two incommensurable cultures met in the request for snow-capped mountains. It changed my life. Let my autobiographical tales serve as an attempt at ethnography.

At the time, I was a student at one of the most cutting-edge fine-art courses in London, at St Martin's School of Art and Design in the Charing Cross Road. A conventional art-school avant-gardist, I made abstract paintings while reluctantly satisfying the then compulsory national examinations in life drawing and figurative painting. I was entering the professional community of modern art and, via one of my tutors, also its recorded history. The artist John Latham had borrowed *Art and Culture* by Clement Greenberg, the most influential critic of the time, from St Martin's library. He had not returned it after repeated requests from the librarian. It emerged that one night at his house he, with his guests, had chewed the book up, and then dissolved the mush in acid, and the now liquefied book was in a test tube. Latham was sacked from St Martin's. He took the test tube, his letter of dismissal, a postcard from the library asking for the book and put them in a small attaché case, and exhibited them. The Museum of Modern Art in New York bought the piece. The postcard from the library read: 'Student in urgent need of Art and Culture'. I had made repeated requests for the book. It was I who was, and remains, in 'urgent need of Art and Culture'.

To have read Greenberg might have prepared me for, or shielded me from, the shock of my epiphany. *Art and Culture* is an anthology of Greenberg's essays published between 1939 and 1961. The first essay in the book, 'Avant-garde and Kitsch', sets out to distinguish real from ersatz art. In the final throws of

Capitalism, argues Greenberg, the only possible real art is avant-garde art. In a time of ideological confusion, it is prompted by a formal and historical self-awareness. As it is prompted by knowledge particular to itself, people cultivated in its specialist culture value it. A chain of gold ties this culture to a minority of plutocrats who financially sustain it. Alternatively, kitsch, pseudo-art, ersatz art serves up familiar emotions to a mass audience that has neither the knowledge nor the leisure to enjoy the demands of avant-garde culture. My epiphany was a concrete enactment of the cultural differences Greenberg described and conceptualized as the differentiation between avant-garde and kitsch.

I had a summer job working in an art shop in central London. It sold art materials and a few reproductions. A man came in and asked for a picture with snow-capped mountains. Asking for a painting by subject matter struck me as almost immoral or at least inept, a cross between admitting to a shameful desire and a naive solecism. I asked by whom did he want the painting. He said he did not know, nor care. He wanted snow-capped mountains. Eventually he explained that he had been on holiday to Switzerland with his wife. He wanted to buy her a memento. I was subsequently to learn that buying paintings to commemorate holidays sustained an economy of small art and craft galleries and local artists in holiday areas such as the Lake District and Cornwall and that images acquired on holidays are a major source of what hangs on people's domestic walls (see Painter 1986).

I was curious about my surprise at the man's request, curious about both what it said about my assumptions and what the man's request revealed. How was one to understand how John Latham's accumulation of objects placed in a case qualified for inclusion in MoMA, New York, but that a painting of snow-capped mountains was also valued? In other words, what were the assumptions of the art world the man had offended and what was the nature of his culture of pictures. Hand in hand with these questions went the aesthetic, ethical and political question: if they should, why should one of these be valued more than another?

The Royal Academy

> Self-evidently, all kitsch is academic; and conversely, all that's academic is kitsch. For what is called academic as such no longer has an independent existence, but has become the stuffed-shirt 'front' for kitsch. (Greenberg 1988 [1939])

A spectre haunts the arguments about the value of modern art. It is a spectre because it is largely unexamined; it has no written history or collections that demonstrate its changing character. It has many names, it is the 'academic', 'traditionalist', 'conventional', 'bourgeois', 'commercial' art against whose power avant-garde art and artists 'struggle'. These terms were in common usage in critical

and historical writing on modern art in the 1960s. Even if the differentiation between high and low culture has supposedly disappeared, in practice the moral and political import of these terms still remains in play. For instance, 'commodified', 'institutionalized' and 'fetishized' are the a priori concepts upon which much current art history builds its elaborations. This enemy, this spectre with many names, reappears in the rhetoric of conferring critical value upon an artist. Importance is attributed to artists' oeuvres by demonstrating their refusal of 'commodification', 'institutionalization' and 'fetishizing'.

My ability to hold this view of the enemy was undermined when from a cutting edge of art school I moved to what was perhaps the most rear-guard institution. I went to the Royal Academy Schools. In my mind, the Academy stood for reaction, stupidity and just sheer tedium but it would give me three grant-supported years to make paintings.

Some of the habits of mind of the Royal Academy belonged to a pre-Second World War professional culture of art. Before the war, artists who made a living by selling work dominated the Royal Academy. They sold to the plutocracy and to institutions. Predominantly, the paintings were of a domestic scale, they were destined for private homes. Much of the art depicted either the British well-to-do in portraits, or their possessions: horses and houses; or the objects of their affections: flowers, landscapes and animals. It was for these artists that Sir Alfred Munnings had spoken in 1948 when he attacked art experts in general and Anthony Blunt in particular, Picasso, Henry Moore, the patronage of the London County Council and 'foolish men writing in the press'. The authority to which he appealed was his patrons and their kind, 'I am right – I have the Lord Mayor on my side and *all* the Aldermen and *all* the City Companies,' declaimed Munnings (1955 [1948]). The Academy was not the bastion of academicism and its traditionalism was incidental to its primary values. It represented, articulated and replicated consensus values: common-sense morality and morality of common sense. The Royal Academy summer exhibition, said the illustrated catalogue in 1949, is 'aimed at preserving and developing a healthy tradition which keeps in touch with the perceptions and interests of normal people' ([Lamb] 1949).

If the RA was a dustbin of history, or at least art history as it is normally written, it had within it more than one kind of cultural debris. For instance, students at the RA Schools were required to begin with a probationary term of life drawing, the master of the first year was Charles Mahoney, his best-known work was a tempera mural in the Jesuit Oxford college, Campion Hall. He was a passionately committed Ruskinian. Art was about truth and bad art was dishonesty. As a Ruskinian, he was a ghost of a past avant-garde. Consensus art was not his aim; to represent nature was the core and impossible ambition he urged upon us.

In 1967, the head of the Schools, The Keeper, was a portrait painter, Peter Greenham. Hanging in the foyer of the Academy there was a painting by him of

the Queen. At one of the first social events of the term, in a search for an ideological companion, I made a disparaging remark about it to a third-year painter of abstracts. He grasped me by the lapels, he was a big strong lad, and said, 'He is a fucking good painter, go and look.'

I did and was treated to the revelation of a painting that negotiated its way toward evoking an appearance. This was the time when Greenberg's very influential essay 'Modernist Painting' had been published: in it he argued that the critical materialism of painting realized itself in an acute awareness of flatness. The defining characteristic of Modernist Painting was that it explored the picture plane, the pictorial or optical surface of a painting and its relation to the material surface. In Greenham's work one encountered a picture plane as sensible, as acutely aware of itself as any in the work of Greenberg's acolytes in London. Recognition of things was bracketed off, sacrificed in process of articulating the sensations of sight; an accumulation of precise judgements of hue, tone and intensity that collectively found and articulated a form. Conventional painting, but the conventions were apparently refound, retested each time. This was far from stupid and tedious. Yes, it was reactionary in subject matter and it denied the imperative of stylistic advance, but it was historically self-aware, it echoed back through Sickert and Gwen John to Velázquez. Further, such a reflexive representation of a head of state hardly served 'the task of recreating the sense of community, identity and civic pride' called for by Mr Blair (1997).

Greenberg's attempt to make a formal demarcation between kitsch (academicism, et cetera) and avant-garde (modernist art, et cetera) in this instance failed empirically. Clearly, however, his description of a difference was at best partial or at worst prescriptive but not empty. Compelling to some, it was influential on art theory, practice and the hanging of museums. Further, Greenberg's attribution of bad faith in 'Avant-garde and Kitsch' to kitsch, its ersatz nature, and commercial motivation was not born out in my experience by the character, nor indeed the financial rewards and careers, of the artists whom he would charge with producing academic kitsch. Modern serious art is not confined to Modernism.

Popular Painting

> Simultaneously with the entrance of the avant-garde, a second new culture phenomenon appeared in the industrial West: that thing to which the Germans give the wonderful name of *Kitsch*: popular, commercial art and literature . . . To fill the demand of the new market, a new commodity was devised: ersatz culture, kitsch, destined for those who, insensible to the value of genuine culture, are hungry nevertheless for the diversion that only culture of some sort can provide. (Greenberg 1988 [1939])

Paintings of snow-capped mountains, portraits of the queen, a book in a test tube, all these were and still are called art. What interested me then were the motives and assumptions of the people who made these works. Immediately after the Royal Academy Schools, I went to the Royal College of Art to do a thesis. It was entitled 'Popular, Traditionalist and Modernist English Painting Since 1945 with Special Reference to the New York School'. I sent questionnaires to the living painters most popular in reproduction between 1962 and 1970. I collected data on Royal Academicians and did interviews with some. I used data on current avant-garde artists by taking those who had been included in the Peter Stuyvesant Collection (1967).

The most important element in the thesis was the discussion of popular painting. Not because it was done well, on the contrary, but because it had hardly been done at all elsewhere. The contrast between the Stuyvesant painters and popular painters was most marked. The Stuyvesant painters had been full-time fine-art students, lived in London and had one-person exhibitions in commercial galleries that were reviewed. The popular painters tended either to be self-taught or to have attended evening classes. The few who had been to art school had done graphic design. If they had shown in London, it was in mixed exhibitions, in unreviewed galleries.

The Stuyvesant artists' work required particular ideas and knowledge about art. By the visual vocabulary it used and by the arguments of its makers and appreciators for its significance, it presupposed in one way or another a knowledge of the avant-garde tradition since Courbet. No such knowledge was required of the popular painters; the knowledges their work presupposed was of familiar subjects of everyday sentiment: landscapes, seascapes, and children. Much of the work celebrates an idea of an English identity.

One thing I did discover was that artists who had become popular in reproduction were often rather ashamed of it. Further, they often graduated to limited-edition reproductions or abandoned them altogether. Edward Seago, for example, had been a painter popular in reproduction and who had abandoned it long before I did my survey. He was also popular with the English establishment. He was a friend of the Duke of Edinburgh and taught the Prince of Wales watercolour painting. His work is not represented, however, in the national collection of British art at Tate. He specialized in scenes of rural Norfolk in which beyond a Cézannesque foreground, the sun dapples far-flung fields through Constablcian clouds. Some rural Hodge might be tending the fields or driving a pair of shire horses before the plough but no telephone wires, pylons or exercising NATO jets from the many air force bases in East Anglia shattered his English countryside. By rough priming of his canvases his thin paint appeared to have been heavily worked as if the product of a prolonged confrontation between painter and motif. However, the extremity of his tonal contrasts and the emptiness of his compositions owed much

to neo-romantic landscape photography – itself, of course, indebted to the kind of landscape painting Seago was evoking.

When I asked the popular painters what was the most important attitude painters should bring to their work, the most frequently recurring words were: sincerity, truth, honesty, search and integrity. In their more elaborated statements, these terms spoke for an unsystematic popularism. Honesty resided in truth to one's familiar culture, sense of self, et cetera. Some made these statements in the context of a rejection of the affected values and pretensions of modern art and fashion.

The conclusion of my thesis was that in popular, traditionalist and modernist painting one was looking at three different cultures of art. While the differences between the Stuyvesant artists and the RA members was to an extent, but not entirely, one of differences of generation in a changing artworld, the popular painters had little or no communication or common models of practice with the other two groups. None was demonstrably more venal than the other. The popular painters, rather than being a group of hacks cynically producing work for an audience they held in contempt, exhibited a very moral conception of what they were doing. The charge that could be made about their work and their statement about it was that it was without criticality, it was unreflexive. That is to say that they were not themselves, they did not make work for, nor did they share the ideology of, intellectuals.

Andrew Wyeth: Serious Populism

There was one anomaly for me among contemporary painters who were popular in reproduction although not in Britain, an artist some of whose work I did admire. An admiration I was surprised to find I shared. Perhaps in the autumn of his years Clement Greenberg became mischievous. There is a story that used to be told like a joke in London: in the late 1970s, the editor of a British art magazine went to see Greenberg. When asked who was the most important artist working in the United States, he replied, 'Andrew Wyeth, but you cannot quote me'.

Greenberg's supposed admiration for Wyeth inflames the issue of seriousness and its possibility. Wyeth has had some acknowledgement as a serious artist. There have been scholarly catalogues and books published about him. He has had major exhibitions of his work notably at the Metropolitan Museum in 1976. He is, for instance, included in the collection of the Whitney Museum of American Art, but by only one work, given and not bought. He only has one tempera in the Museum of Modern Art, New York. There is more at stake here than just a disinterested discussion of the paintings of Andrew Wyeth. He is seen as a painter for middle America and its values. His work stands as an antithesis to the cosmopolitan avant-garde.

Wyeth is probably America's most popular living painter and it is his 'constituency' that is part of the problem. He and his work has come to connote the middle-class middle America, the inexpert audience that is the American version of the historic threat to serious art. For an ambitious curator to advocate a Wyeth purchase or an exhibition was, and I suspect still is, professionally dangerous. Even though the historicist and Europocentric accounts of modern art have been challenged, gender assumptions about the avant-garde have been called into question, and the distinction between low and high art supposedly abandoned, there remains one boundary of the serious artworld that is ostensibly intact, the boundary with middle-brow culture.

Essential to the way in which art history and the museums institutionalized serious modern art is what they passed over in silence. While art for the middle-class homes and inexpert purchasers is bigger business than art for serious collectors and museums, it has no history, no criticism, and no place in the museum. If it appears in the accounts of modern art, it is as an unexamined spectre of inauthenticity against which authentic art struggles. For example, Norman Rockwell is mentioned in Greenberg's 'Avant-garde and Kitsch' as a token for all that avant-garde painting is not. Notoriously, the nearest to a reference to a particular 'kitsch' painting Greenberg got was to Repin battle paintings. Repin never painted a battle. An unmapped no person's land appears to exist between serious art and what might be called consensus art. What this hides is how serious art has shaped itself in opposition to consensus art. In the histories of modern cultural conflict, we have been told little of the army against which the avant-garde has been deployed.

If taken to be important, Wyeth is particularly dangerous because his work suggests the possibility of serious art outside the art historical map. For instance, in a museum or a history that treats art as a story of historical development, the question of where his work came from and to where it led would be an issue. His technical debt to a tradition of illustration, that of his father, N.C. Wyeth and Howard Pyle, could lead to the suggestion that they too should become part of the art historical narrative. With these illustrators through the door, would that other absentee from the Whitney, Norman Rockwell, be far behind?

However, the problem with Wyeth is not just with his audience, nor the traditions from which he comes. It is with the nature of his seriousness, it is the ideology of the work. His work is a contradiction, it is serious popular painting and it is populist.

The vast majority of modern painting we know to be most popular through the sale of reproductions realizes the intelligentsia's nightmare of banality. It is artefacts made, called and treated as art but without any developed discourse or mode of attention that attends to them as art. In such paintings, well-worn conventions evoke familiar emotions and values: the beauties of nature, appealing

children, soft erotica and sympathetic animals. This is the art of peripheral vision. The values it celebrates and the emotions it excites are for the most part propagated by other more influential media. Nearly all have overtly painted surfaces, some evoke the style of past high art. There is a more conceptual area of practice, hobbyist art. Here moments of sporting drama and vintage cars, ships, boats, trains, steam engines or birds are depicted for connoisseurs of detail. Precious sentiments and values captured in oils. However, the essential optic of most popular paintings is derived from photography. The mass-media use of photography and the other lens-based means of mechanical representation provide the core of pictorial common sense. We have learnt to dream like films.

Wyeth's debt to photography is not veiled in such painterly devices, but rather, its optic is exceeded in his linear precision. Forms are known more precisely than a mere record of light falling upon things. His mimeticism is so compelling that his means appear transparent, as if his was a painting without style. This transparency enacts the work's populism. It is an antithesis to Greenberg's argument that the self-conscious picture plane is the key site of modern cultivated sensibility's experience of painting. Wyeth's work incites us to believe that with our everyday capacity to read faces, stances and objects we can understand these paintings and that they do not require the cultivation of a special sensibility, a mode of attention and a knowledge of art.

If we attend to the surface of Wyeth's paintings, we encounter the aridity of tempera and extraordinary skill. High skill becomes overt when exercised in familiar pictorial conventions. The use of such conventions always runs the risk of a key term of Greenbergian disparagement: the charge of illustration – the charge that the image and meaning have been forced onto the canvas in indifference to the requirement for a process of making sensitive to the material nature of the medium. Wyeth replaces the reflexive picture plane with the puritan surface; he is not insensitive to his medium – rather, he uses the meanness of tempera, and his virtuosity is entirely lashed to its mimetic function.

There is a contradiction: Wyeth's work rewards informed reflection in ways that popular painting does not. For instance, the more you examine Edward Seago's devices the more obvious it is that the work is there to say more agreeably what has already been said, his paintings are like landscapes glimpsed from a comfortable train. Against this, Wyeth's best work is deeply pessimistic and extreme. He brings a prodigious technique informed by Northern European painting as well as by the tradition of Pyle and his father. His sophisticated manipulation of the viewer's pictorial position is at times cinematic. In the precision of his depiction, there is an almost theological belief in the value of the direct physical experience of the material world. All this is brought to bear on depicting a harsh landscape and the rural poor.

As I have said, Populism hankers for a state of society in which people make their world directly, to a condition before the division of labour. The self-build clapboard house constructed without architects and requiring only low-level technology, traditional skills and manual effort might serve as an emblem of such a way of life. Wyeth depicts such a house but it is in decay and occupied by an impoverished elderly couple, a crippled woman and her brother. They are the residues of a dead way of life; they appear idiots in the sense of being outside consequential social life.

There was a contradiction with the nature of Greenberg's arguments. Were they descriptive or prescriptive? Was he making a distinction of kind in 'Avant-garde and Kitsch' and defining a kind of painting in 'Modernist Painting' or did what he say simply follow from the superior aesthetic quality of the work that concerned him, just an attempt to rationalize its sources and character? A definition of kind would be illegitimate to Greenberg's later position because it would allow concepts to prescribe the conceptless nature of aesthetic experience. In the Kantian tradition, aesthetic quality is experienced rather than recognized.

Arguably, Greenberg's criticism is a footnote to Alfred Barr's selection and hanging in the Museum of Modern Art, and this contradiction is another form of the old art-gallery chestnut: are we collecting work of high aesthetic quality or are we recording, filling in a historical account of art? This question goes back at least to Eastlake's Directorship of the National Gallery in London and remains unanswered because both art history and museums are complicit in sustaining artistic value as having some independence from the relative democracy of the market. Presumably, a proper history of art would begin as a history of what was produced, bought, sold and used as art. It would be before any judgements of aesthetic value. Most art history has allowed the institutions of art to determine what is to be studied.

A museum of art chosen on grounds of quality alone would not be arranged chronologically, and perhaps an answer is to escape from the authority of art history. Is it is possible to imagine a room of Wyeth's work in the Museum für Moderne Kunst in Frankfurt? In each of the Museum's rooms are displayed a group of works by one artist. There is no chronology. Each grouping of work asks for a change of aesthetic gear rather than implying some authoritative historical thread or essential quality that runs through all the works displayed. It asks us to attend to the particularity of the works it shows. In that context, it would be easier to form a view of Wyeth's work less troubled by his institutionally anomalous position and the connotations of his audience. In such a regime, it is possible to admit the plurality of serious art without abandoning it to the plurality of the market.

Andrew Brighton

The Art Market

> No culture can develop without a social basis, without a source of stable income. And in the case of the avant-garde, this was provided by an elite among the ruling class of that society from which it [the avant-garde] assumed itself to be cut off, but to which it has always remained attached by an umbilical cord of gold. (Greenberg 1988[1939])

In the mid-1970s, I was a lecturer in the School of Art at Goldsmiths College. The then Warden of Goldsmiths, Richard Hoggart, was approached by the Gulbenkian Foundation to see if Goldsmiths would run, and he would chair, an enquiry in to the economic situation of artists in Britain. The sociologist Nicholas Pearson and I were the two Senior Research Fellows. Another sociologist, Josie Parry, subsequently joined us. The Gulbenkian Enquiry into the Economic Situation of the Visual Artist was not a happy experience. One reason was that it put together three modes of doing reports, the great-man (person) report, the committee report and the research-team report. As a recipe for conflict it certainly worked.

The particular area of research I undertook was to look at commercial galleries. I interviewed more than fifty gallerists in London and the five regions we used for our studies. They went from the most prestigious of international galleries in London to small galleries selling local paintings of local scenes to tourists in South Lakeland. The most important finding was for me to discover that the difference between the two was not just that the art was different, but that the economics and semiology of selling was different. For example, I have in mind two galleries both in the Bond Street area, the then undisputed centre of the London art market. Both were at the top of their sectors of the market. One had on its books some of the most internationally established modern artists. The other sold paintings by some of the most successful of twentieth-century painters working in the genres of hunting scenes, animals, landscapes, seascapes and mild male heterosexual erotica. The gallery was also part of a business that published reproductions.

One gallery was concerned with selling to people based on their immediate likes and dislikes. The other added to 'the client's' – never 'the customer's' – likes and dislikes a dimension of cultural significance. They sold a work by an artist rather than simply a painting. Indeed, many clients were 'serious collectors', private collectors with an expert knowledge of the area in which they collected. The former, which I will call the 'popular gallery', offered on its walls the full range of the art it sold. It rarely held one-person exhibitions and it rarely published catalogues. The 'modernist gallery', on the other hand, rarely had mixed exhibitions. It did one-person shows with catalogues, the catalogues giving the professional track record of the artist – exhibitions, purchases by public collections, commissions, art education and a bibliography – and making clear that the gallery sold work to museums of modern art. The popular gallery had not sold work to

public collections. The modernist gallery had an extensive private area where most sales were made. For them, exhibitions were a means of building reputations and not the primary site of sales. The popular gallery had little stock not on display, and sold most of its work off the wall.

The modernist gallery had a long-term commitment to building the reputation of an artist's oeuvre. They would keep some of their work in the gallery to show to clients. A museum retrospective was the consummation of their strategy. They offered a stipend to the artists in their limited stable who showed exclusively with or through them. The popular gallery would choose particular works to buy or take on sale or return from a much bigger pool of artists, many of whom, would show work in the same way with other galleries. They would continue to take work from artists who sold and to drop those that did not, whereas the modernist gallery would persist in 'working with' an artist who did not sell for a rather longer time.

The modernist gallery was dependent on a knowledge specific to art. For example, typically of both kinds of gallery, the sale of contemporary work was not their major source of income. For the modernist gallery, dealing in blue-chip works by major artists of the late nineteenth- and twentieth-centuries accounted for a high proportion of the gallery's income. Much of this activity did not manifest itself in any public exhibition. It was buying from one client or at auction and selling it on to another client or gallerist or public collection. It is an activity that requires expert knowledge of the art of the period and of those collectors and institutions that might want to buy it. In the case of the popular gallery, the reproduction-publishing was an important source of income. The provincial popular galleries I interviewed gained most of their income from selling frames and/or artists' materials. However, there was expertise – but a non-art – expertise at play in the popular market. There were galleries specializing in work depicting animals, birds, trains, aeroplanes or ships, and other areas of amateur enthusiasm in which the artist, the gallerist and many of the clients did have extensive knowledge.

What is the nature of the proposition implicit in modernist galleries' mode of marketing? Stated reductively it is something like: this artist and his or her work have a claim to continuing and growing significance: a significance that will increase the value of their work. That evaluation requires at least ostensibly a judgement informed by knowledge of contemporary and modern art. The work must be significantly different and to that extent must be implicitly critical of what precedes it and the concepts of art that gave significance to previous work. In bald terms, economic need requires that serious art sustain itself in crises, that it enacts an endless reflexivity, an endless destabilizing of norms.

Conclusion

Modern serious art's hostility to the habitual and familiar make it unsuitable to 'the task of recreating the sense of community, identity and civic pride that should define our country' or any other norm-building project. In this way, serious art does stand at a critical distance from the state. There is a complex of ideological and economic reasons why there is a tension between the cultural elite and political elite, between the values needed by the state and those of the educated. There are, however, practitioners of and markets for art that offers itself as pleasing, honest, sincere, normal and natural, which does speak for a desired social cohesion. It is what Greenberg called kitsch. While I am confident that serious art will continue in the private sector, my doubts are about the public institutions.

Financially, the public sector art institutions are relatively inconsequential to the income of contemporary artists in Britain – something like a contribution of around 10 per cent as against the private sector's 90 per cent (my informed estimate: see Brighton et al. 1985). However, the publicly supported and not for-profit arts institutions have a disproportionate influence because they make these arguments part of the public culture and debate through exhibitions, collecting and catalogues, and the critical and news coverage these receive. They do so from expertise and interests significantly different in kind to that of commercial gallerists. The public sector creates a mixed economy of argument. If those institutions are required to, or perceived to, make judgements based on social utility rather than value, they disappear from the debate. By making social engineering a determining requirement of arts funding, the state is in effect closing down the public sector's contribution to the contest of values; social instrumental-ism usurps the integrity and seriousness of their contribution. A rising tide of public-sector propagation of kitsch seems likely.

Modern serious art's hostility to the habitual and the familiar make it pro-foundly unsuitable to 'the task of recreating the sense of community, identity and civic pride that should define our country'. Kinds of art practice do offer themselves as unpretensious, sincere, honest art for 'normal people'. What I hope the observations above show is that cultural policies predicated on communitarian ideas are the enemy of serious art. Further, the reconsideration of the domestic is of value to serious art to the degree that it problematizes it, because it can contribute to the sustaining crises, not because it leads to democratic solutions.

Note

Parts of this essay were first published in 'Consensus Art: Serious Art: Greenberg: Wyeth', *Critical Quarterly*, Volume 42, No2 Summer 2000 pp132–136.

References

Blair, A. (1997) *New Labour because Britain deserves better* (fwd. A. Blair). London: Labour Party.

Brighton, A., Pearson, N. and Parry, J. (1985) *The Economic Situation of the Visual Artist*. London: Gulbenkian Foundation.

Chipp, H.B. (ed.) (1971) *Theories of Modern Art: A Source Book by Artists and Critics*. Berkeley: University of California Press.

Greenberg, C. (1988 [1939]) 'Avant-garde and kitsch', in *Clement Greenberg: The Collected Essays and Criticism, Volume 1, Perceptions and Judgement, 1939–1944* (ed. J. O'Brian). Chicago and London: University of Chicago Press, 5–22.

[Lamb, Sir W.] (1949) 'Introduction', *Royal Academy Illustrated*. London.

Munnings, A. 1955 [1948]) 'The President's Speech', *An Artist's Life* (abrgd. W.G. Lustcombe). London: Readers Union, Museum Press, 227–9.

Painter, C. (1986) 'The Uses of Art'. Unpublished PhD thesis, Newcastle-upon-Tyne Polytechnic (now University of Northumbria).

Peter Stuyvesant Collection (1967) *Recent British Painting: The Peter Stuyvesant Collection*. London: Tate Gallery.

Robinson, G. (1998) *An Arts Council for the Future*. London: Arts Council of England.

Tolstoy, L. (1969 [1898]) 'What is Art?', in A. Maude (ed.) *What is Art and Other Essays*. Oxford: Oxford University Press.

Zhdanov, A. (1950) *On Literature, Music and Philosophy*. London: Lawrence& Wishhart.

Index

Index

Index

Index

Turner, J.M.W., 101–2
Turner Prize, 12, 26, 157, 207

uniqueness, of art works, 171–3
Unit One, 64
unlimited editions, 9, 186–8, 234

valued objects, 55–6
Van der Velde, Henri, 59
Van Gogh, Vincent, 110
Vasari, Giorgio, 99, 109, 111
Venturi, Robert, 44
vernacular ceramics, 59–60
Vettriano, Jack, 102–3
Victoria and Albert Museum (V&A), 11, 57, 105–6
Victorian style, 164–6
Visual Arts and Galleries Association, 11
Vogel, Susan, 70
Vollard, Ambroise, 61

Voss, Andy, 69

wallpaper, 62, 69, 83, 85, 229–30
Walser, Robert, 45
Warhol, Andy, 43, 45–6
Wentworth, Richard, 8–9, 49, 56, 231
Whiteread, Rachel, 46
Wilde, Oscar, 43
Wilding, Alison, 4–5, 8–9, 159, 190–3, 232
Wimbledon School of Art, 7
women
 applied arts, 62–3, 64
 household ethnography, 117–20
 and Impressionism, 36
 see also feminist art
Wycth, Andrew, 250–3

Young's brewers, 11

Zhadanov, A., 242